Hertfordshire
COUNTY COUNCIL
Community Information

2 8 OCT 2003

2 2 MAR 2004 2 1 OCT 2007
5/08

MAR 2001 1 9 APR 2004 - 8 APR 2009

APR 2001 1 0 AUG 2005 - 8 JUL 2009

1 3 APR 2002 2 8 JUL 2009

26ᵗʰ April 2002 2 5 NOV 2005 2 0 APR 2010

1 9 AUG 2002 2/56 10/12

0 2 JUN 2003 1 7 JUN 2009

Please renew/return this item by the last date shown.

So that your telephone call is charged at local rate,
please call the numbers as set out below:

	From Area codes 01923 or 020:	From the rest of Herts:
Renewals:	01923 471373	01438 737373
Enquiries:	01923 471333	01438 737333
Minicom:	01923 471599	01438 737599

L32

Salvador Dalí

Meryle Secrest

Salvador Dalí
The Surrealist Jester

'The heart of another is a dark forest.'
Russian proverb

Weidenfeld and Nicolson · London

First published in Great Britain by
George Weidenfeld & Nicolson Limited
91 Clapham High Street, London SW4 7TA
1986

ISBN 0 297 78992 9

Printed and bound in Great Britain by
Butler & Tanner Ltd, Frome and London

To my children
Cary, Martin and Gillian
and their children

Contents

Illustrations

A fifty-foot French bread commissioned by Dalí to illustrate a lecture in Paris, 1958 (*Popperfoto*)

With his pedal-powered 'ovocipede', Paris, 1959 (*Popperfoto*)

The inhabitants of Figueres staged a bull fight in Dalí's honour in 1961 (*Popperfoto*)

At an exhibition in 1964, Dalí said he needed the microscope to see his work in oils on tiny honeycombe-like metal cells (*Popperfoto*)

Publicizing an exhibition of lithographs in Paris in 1971 (*Popperfoto*)

Making a spectacle of himself in Barcelona in 1966 (*Popperfoto*)

Huntington Hartford, Gala and Dalí with his *The Discovery of America by Christopher Columbus* (*Bettmann Archive*)

Casting the bronze cover of *The Apocalypse* (*Photo by Paul Almasy*)

Dalí and the Meter Monument, France (*Copyright © by A. Reynolds Morse, 1974*)

Dining with Thomas Hess in Paris (*Thomas B. Hess Papers, Archives of American Art, Smithsonian Institution*)

Dalí's Teatro Museo in Figueres (*author*)

The Torre Galatea in Figueres (*author*)

Autographing his memoirs in a Paris store, 1970 (*AP/Wide World Photos*)

Gala's castle in Pubol (*author*)

Sabater and Dalí leaving the Centre Georges Pompidou, 1979 (*AP/Wide World Photos*)

Dalí leaving the clinic in Barcelona, 1984 (*AP/Wide World Photos*)

Acknowledgements

Any biographical enquiry presents problems unique to it, but the biography of Salvador Dalí brings into sharp focus a dilemma that bedevils most, if not all, such undertakings to a greater or lesser extent. Despite his confessions via television, radio, countless interviews, 'as told to' books and his lengthy volumes of autobiography, or perhaps because of them, he has been enormously successful in imposing his own view of himself on the public and suppressing all others. The story behind two previous books about him, *The Case of Salvador Dali* by Fleur Cowles and *In Quest of Dali* by Carlton Lake, neatly illustrate the way he has reacted. The first author genuinely believed in Dalí's eccentricity, if not actual madness and, since her view dovetailed into the image of himself that Dalí was intent upon projecting, she was given every advantage, biographically speaking. It is significant to note that Dalí initialled every page of her manuscript before the book's publication in 1959. By contrast, a decade later, when Carlton Lake came to write his account of extensive conversations with Dalí, and the charade he witnessed in New York and Paris, his subject was willing to talk in the apparent belief that he would have control over the finished work. Once it became clear that he would not, he abruptly terminated the discussions.

One can see both sides of this particular issue, which seems essentially insoluble. This was why I did not press very hard to gain my subject's cooperation. As far as I know, he never did learn that this book was being prepared. The volume of published material and the number of people in Paris, New York, Barcelona, Figueres, London and elsewhere who knew him well made an independent study a plausible undertaking. In fact, the amount of information has been so great that the task of selecting a single detail or anecdote from among many relevant details and anecdotes has been daunting. I was aware that I must exercise 'the subtle tact of omission', as Walter Pater described it, if the biography was to be made to fit inside a single volume.

Since Spanish and French biographical writings are based on very different traditions from English and American ones, there has been no attempt that I could find to make a thorough study of the Dalí family in genealogical terms, much less in terms of myths, expectations, foibles and recurring emotional patterns down through the generations. I am able, thanks to the enlightened and extremely informed help of a member of that family, to sketch in the broad outlines. Similarly, it has been surprisingly difficult to discover published works dealing, for instance, with family relationships in Catalonia and

sexual mores at the turn of the century. Published studies tend to focus on the political situation, while European sociological-psychological studies do not specifically deal with the Catalan experience. Dawn Ades's remarkable book, *Dali and Surrealism*, is the first to deal with his art in terms of Dalí's own psychological investigations of his childhood, an approach to which I have tried to add some supporting evidence.

So far, no effort has been made to build an archive of reminiscences of all the people who have known Dalí at some stage in their lives, of infinite value to future scholars, one would have thought. So many people have important contributions to make. For my part, many of the best anecdotes could not be made to fit into the text. Alexander Eliot, former art critic for *Time* magazine, and his wife Jane, who were close friends of the Dalís when they all lived in New York, recalled the curious way the friendship came about. On meeting Eliot for the second time, Dalí literally bolted. Jane Eliot then decided that he really wanted to be invited to dinner, and she was right. My former colleague on the *Washington Post*, Judith Martin, recalled that, in the days when she was covering Diplomatic Row for the paper, there were parties for Dalí on successive evenings. The first night she met the great man, expressed her enthusiasm for Spain, and was invited to visit them in Port Lligat. When she began to write down her name Dalí told her not to bother. He absolutely never forgot a face. She would be welcomed with open arms whenever she chose to come. The next night she met the great man again. He did not remember her.

Numbers of people whom I would have loved to meet rebuffed my overtures. André Thirion, author of *Revolutionaries without Revolution*, an indispensable account of the Surrealist movement, wrote a curt letter of refusal in which he expressed his views about people who commercialized the lives of others. Boris Kochno, another grand old man, expected me to rearrange my time so as to make myself available on the date when he was free to see me, and was gravely offended when I did not. Maurice Curiel, a Parisian jeweller who sells copies of Dalí's medallions in precious metals, did in fact see me, but refused to answer any questions. Then he asked whether I would like to buy a medal. When I politely said I was sure I could not afford one, he fixed me with his eye: 'But surely your publisher can afford it? He cannot be much of a publisher if he can't.' Mafalda Davis, another business associate of Dalí's, handed me an enormous drink and told me about her two decades of professional and personal contacts with Dalí. I found this legendary lady tiny, black-haired, in a pink satin negligée and matching coat, lounging against a pink silk couch; her apartment was jammed with the china, candelabra and other *objets* by Dalí for which she acted as his contractor. She showed me a batch of telegrams that would be included in the book she was writing about Dalí.

Those who spoke ill of him, she said, should remember that if it were not for him they would be starving on the street. Another business associate, Jean-Claude DuBarry, was also an attentive host, although he could be formidable when crossed. The first time I went to meet him at his apartment he was not there. Since I was standing outside the main door in the rain, I left. Shortly thereafter he rang up. Far from apologizing for having been late, he roundly berated me for not having waited for him.

For every friend or former friend of Dalí's who ignored my repeated letters and telephone calls, there were always people like Amanda Lear willing to explain at charming length why they could not be interviewed. Dalí's sister, Ana María Dalí, also declined with great graciousness. I never managed to make contact with Dalí's Spanish lawyer, Miguel Domènech, and similar attempts to make contact with his former associates, Captain Peter Moore and Enrique Sabater, were unsuccessful. However, Dalí's close friend, Antonio Pitxot, and his wife, received my husband and myself at their home in Cadaqués. Ramón Guardiola, former Mayor of Figueres, cheerfully interrupted his busy law practice to meet me twice and talk about the particular aspects of the Ampurdán temperament, and had me in tears of laughter. Robert Descharnes, Dalí's indispensable spokesman, has gone out of his way to be helpful on many occasions in Paris, New York and Figueres, and been most courteous and generous of his time. Dalí's New York lawyer, Michael Ward Stout, has provided much invaluable information and help, and has patiently answered my endless questions.

I am particularly grateful to Mme Cécile Eluard Boaretto who, through her daughter, Claire Boaretto, has been enormously helpful in enlightening me about the circumstances surrounding the early life of her mother, the late Gala Dalí, information that has never before been made public. My special thanks also go to Joan Kropf, curator of the Salvador Dalí Museum in St Petersburg, Florida, who was instrumental in bringing about my meetings with A. Reynolds and Eleanor Morse. No two people know more about Dalí, understand him better, or have had a more devoted friendship than Mr and Mrs Morse; no two people have been more patient, willing, generous and helpful. I cannot thank them enough. I would also like to thank Francisco Verges Bosch, who directs the Teatro Museo Dalí in Figueres, his gentle secretary Laura Cervera, and the efficient and helpful secretary of Salvador Dalí at the Torre Galatea, Maria Teresa Brugués.

Invaluable information was provided by other friends and former associates of Salvador Dalí who were willing to be interviewed. My grateful thanks go to Dawn Ades, Eileen Agar, Carlos Alemany, Martin Bailey, Prof. Anna Balakian, Roland and Felicie Balaÿ, Mrs Alfred H. Barr Jr, Bettina Bergery, Juan-Luís Buñuel, Sir Hugh Casson, Benjamín Castillo ('Tío Ben'), Pascual

Pesudo Castillo, Jean Chalon, Sylvan Cole, Fleur Cowles, Sra Montserrat Dalí de Bas, Mme Lucia Davidova, Baron Alexis de Redé, Diane Deriaz, Jacques Dopagne, Alexander and Jane Eliot, Prince J. L. de Faucigny-Lucinge, Albert Field, Michael Findlay, Jean-François Fogel, Joseph Foret, Craig Frizzell, David Gascoyne, Ernest Goldstein, Martin Gordon, Lawrence Burnett Gowing and Jenny Gowing, Yvonne Halsmann, Renilde Hammacher-Van Den Brande, Lily Harmon, Derek Hill, Mme Jean Hugo, Sidney Janis, Prof. Temma Kaplan, Mrs Jean Levy, Mme Lidova, the Mayor of Figueres Mariano Lorca Bard, M. and Mme L. A. des Longchamps, James Lord, Dr Alexander Lowen, Phyllis Lucas, Edouard MacAvoy, Marilyn McCully, Henry McIlhenny, Conroy Maddox, Mme Juliet Man Ray, Pierre Matisse, Dame Alicia Markova, George Melly, Catherine Perrot-Moore, Edwin Mullins, Mr and Mrs William I. Nichols, Eric Osterweil, Paula Pelosi, Klaus Perls, Michel Petit-Jean, Lionel Poilâne, Dr Henri Puget, Alfons Quinta, John Richardson, Ronald Rolly, Luis and Gloria Romero, Marie-France Saurat of *Paris Match*, Meyer Schapiro, Lucien Scheler, Ted Schemp, Sr Gonzalo Serraclara de la Pompa, Naomi Sims, Ray Sullivan, Agnes Tanguy, Rafael Santos Torroella, Lucien Treillard, Denise Tual, Peter Tunnard, and Esteban Vicente.

My further thanks are due to the following people who gave help, advice, information and their valuable time: Sir Valentine Abdy, Prof. Victor Alba, Timothy Baum, James Bentley, director, The Filson Club, Mary Blume, L. Erik Calonius, Jean-Claude Carrière, Riva Castleman, Whitney Chadwick, Richard Chapman, Mme Berthe Cléyrergue, Col. John A. Codrington, Prof. John A. Coleman, Edward Crankshaw, Stuart Denenberg, Joanna Drew, director of art for the British Arts Council, Mme Teenie Duchamp, Mme Yves Elléouët, Mrs Jimmy Ernst, Nina Espírito Santo, Jean-Charles Gateau, Prof. Peter Gay, Martha Gellhorn, Julien Green, Maia Gregory, Prof. John Hale, Mr and Mrs H. J. Heinz II, Horst, Thomas Hoving, Robert Hughes, Edmond de la Haye Jousselin, Prof. King, chairman of Modern Languages at Bryn Mawr College, C. A. B. King, Dianne Klein of UPI, Michael Korda, Carlton Lake, Mrs Mary Lasker, Robert J. Lehmann of *Vogue*, Michael Leja, Alexander Liberman, Mrs Ann Loeb, John L. Loeb, Herbert Lottman, James Markham, Meli, Jean-Claude López de Ayora of the Hotel Meurice, Paris, Prof. Gloria Orenstein, Tony Penrose, Gwen Powell of Photo Library, News Limited of Sydney, Australia, Anthony Read, Paul Ricard, Ned Rorem, Maestro Mstislav Rostropovich, Dr Pierre Roumeguère, Mrs Mary Ryan, Freddie Schab of the William Schab Gallery, George L. Smith, Prof. Nathaniel Smith, Isaac Stern, Audrey Stevenson, Mrs Graham Sutherland, Robert D. Valette, Suzanne Van Langenberg, Library and Syndication Manager, National Magazine House, London, Nicholas Fox Weber, Jacqueline Bograd Weld, Robert Wernick and Carter Wiseman of *New York* magazine.

ACKNOWLEDGEMENTS

I would particularly like to thank the following institutions and members of their staff for information that has been vital to this study: Bob Brown, area director for the Boston office of the Archives of American Art, for putting me in touch with Mrs Jean Levy; William McNaught, Francine Tyler and Mrs Hammond of the New York office of the Archives for much courteous help; Cynthia Ott and Garnett McCoy of the Washington office of the Archives for similar kindnesses. I am indebted to the Art Dealers Association and its public relations director, Susan M. Wasserstein, to the Arts Club of Chicago, to the Carnegie Institute, to the experts at Christie's in London and New York, and particularly to the sage advice and frank help of Michael Findlay. I am particularly indebted to Evelyne Pomey, director of research facilities at the Centre Georges Pompidou in Paris, for her absolutely invaluable help and for giving me access to the enormous archive of material dealing directly with Dalí's career. I would like to thank Cindy Cathcart of the library at *Vogue*, and Diana Edkins, curator of archives, for their courteous help. I am particularly indebted to Juan Luís Cebrián Echarri, editor in chief of *El País*, Madrid, for his prompt replies to my questions and the invaluable research material which he generously provided from his files. I would like to thank M. Douvenel and Gabriel Peri, archivists at the Musée d'Art et d'Histoire in Saint-Denis for allowing me to study in the Paul Eluard archives and for generously making photographs available. I am indebted to Rosa Maria Malet Ybern, of the Fundación Joan Miró, Barcelona, for her advice, to Hugh T. Stevenson, Assistant Keeper, Department of Fine Art, at the Glasgow Art Gallery and Museum, and similarly to Thomas Messer of the Guggenheim Museum and Cathy Henderson, research librarian at the Humanities Research Center, the University of Texas. I am immensely indebted to Martin (Tim) Heymann FRICS, agent for the Edward James Foundation at West Dean, Chichester, for taking hours of his time to discuss the life of the late Edward James, show me through the estate and provide research materials. I would like to thank Anna Winand of the International Center of Photography for courteous help, to Lynn Pearson and Virgilia Pancoast, of the International Foundation for Art Research, to Nancy Little, librarian of M. Knoedler & Co., for courteously allowing me to study in the library and for providing me with much assistance, to Robert G. deMuro, Federal Postal Inspector, for making himself available for questions on numerous occasions, to Rona Roob, archivist, and other members of the staff at the Museum of Modern Art for extensive help and advice, to the staff of the National Gallery of Art, for similar help and information, to the Cultural Relations Office of the Embassy of Spain and the Embassy's press office for answering my many questions promptly and helpfully, to Michel-Jules Strauss, director and head of the paintings department of Sotheby's, London, for discovering a fascinating letter by Edward

James, to the staff of Sotheby Parke Bernet in New York, to David V. Koch, curator of manuscripts at the Morris Library, Southern Illinois University, and Barbara Rhea for their prompt attention to my pleas and for access to the Caresse Crosby archives, to Simon Wilson, curator of the Tate Gallery, for his help, and also to Paul N. Perrot director of the Virginia Museum of Fine Arts. I would particularly like to thank Eugene R. Gaddis, archivist of the Wadsworth Atheneum, for the many courtesies extended and for giving me such a clear picture of Dalí's introduction to the American art world. I would also like to thank Rosemary Wilton, of BBC-TV's documentary programme *Arena* for her courtesy in providing me with a screening of the documentary about Luis Buñuel and for arranging to let me see other programmes in the BBC-TV archives. Many other institutions and individuals extended large and small courtesies, and I beg to be excused from naming them all, hoping they will understand and accept my warmest thanks. One person whom I would particularly like to thank is Dr Christopher Maurer, the distinguished Lorca scholar of Harvard University, who listened patiently to my problems, provided me with much invaluable material, including Dalí senior's letter to Lorca that I had not known about, and personally brought back from Spain my copy of Ian Gibson's monumental study of Federico García Lorca.

It was my great good fortune to be helped in the early stages by some patient and talented researchers. My warm thanks go to Virginie (Poucette) Isbell, for her splendid enterprise and plain hard work under some difficult conditions. I was most grateful for the special expertise and unstinting help of Jacqueline Chénieux. Louisa Buck responded most promptly to my requests for help with the British Surrealist movement, providing valuable information and research material. Most of all, I want to thank Mme Olivier (Liliane) Ziegel, one of the most extraordinary people I know, whose patience, tact, inexhaustible energy and great generosity of spirit made my work in Paris infinitely easier. I cannot thank her enough.

To my literary agent, Murray Pollinger, go my warmest thanks for his vital role in this project. My London editors, John Curtis and Alex MacCormick, have given me their usual perceptive criticisms, encouragement and advice. I want to make a special mention of my gratitude for the friendship, sensitive comments and goodwill of Jennifer Josephy, and to note that our association has passed its first decade. Long may it thrive. Finally, I am so grateful for the optimism, encouragement and plain endurance of my husband, Thomas Beveridge. He has to be the gentlest critic a writer ever had.

CHAPTER ONE
The Dalí Affair

Salvador Dalí, father, to Salvador Dalí, son:
'You will die alone, ruined and betrayed.'

A little girl sat in an open doorway, holding a fat black kitten in her arms which she was propping into shape as if it were a rag doll. She scarcely looked up, but asked in a sweet clear voice, 'Do you want to see the house of Gala-Dalí? It's through there.'

The assumption that strangers could only have arrived for one reason – and the implication that dozens of others had been there already – was at variance with the somnolent calm of the tiny village in Catalonia, north-eastern Spain, to which I had come. Nothing appeared to have stirred since the Middle Ages. Old stone houses with narrow windows spaced haphazardly on their façades enclosed a tiny square that was not even paved; the only sounds were a dog sniffing in the dust and the distant grunting of a pig. The little girl had nodded towards an archway and a passage leading upwards around a corner. Beyond it were flowering vines, caged roosters, white doves, an open bin filled with corncobs, and leaves just turning yellow. On the left were other houses and stables and, on the right, girded by high walls, was the castle of Pubol itself, the by now famous setting for what had become the Dalí Affair. The window of what had been the painter's bedroom was boarded up and, where wooden boards met the top of the frame, the stone was blackened and charred. I had come to Spain not knowing what to expect and had stumbled on a drama of major dimensions.

When the idea of writing a biography of Salvador Dalí had been launched two or three months earlier, I was stimulated and intrigued by the possibilities such a subject presented. Like those of Magritte and de Chirico, Dalí's pictures seemed to have at least as much literary content as formal painterly values. D. H. Lawrence, writing that he was in favour of art, not for art's sake, but his own sake, added, 'One sheds one's sicknesses in books, repeats and presents again one's emotions in order to master them.' Rather than taking the usual art-historical approach and discussing the life only as it bore directly upon the art, one might, in the case of Dalí, as with D. H. Lawrence, attempt to look at the work as coloured and ultimately directed by the experiences of a lifetime, and particularly those of early childhood. But to do this one would

7

have to hurdle the obstacle presented by the artist's view of himself. For decades Dalí had successfully convinced all comers – whether in journalism, radio, television or film – that he was what he seemed, that is to say the jokester *par excellence* whose one enduring theme was the absolute nature of his own worth. One searched, in the credulous accounts of his outrageous remarks, his maddening references to himself in the third person, his obscure and garbled explanations, his pranks calculated to *épater les bourgeois* in true Surrealist fashion, and the equally odd antics of his entourage, for the man behind the smokescreen.

However, if one looked to Dalí himself – his autobiography, *The Secret Life of Salvador Dalí* (1942) for instance – one was more confused than ever. How much was sheer braggadocio, how much clear fabrication, and what truths might be concealed? Where was one to find a judicious assessment, since his closest associates seemed to have adopted enthusiastically the same obfuscatory vocabulary, not to mention the master's uncritical view of his own genius? Had the mask, as the mime Marcel Marceau demonstrated in one of his most inspired skits, become the face?

I discovered that people whose opinions I valued doubted that Dalí's life deserved such an examination. One distinguished art historian thought that Dalí would ultimately be judged a minor member of the Surrealist school. Another grumped that Dalí was so surrounded by 'various sorts of moral transvestites' that it was hardly worth the effort. John Richardson, the art historian, who was at work on a biography of Picasso, thought such a book might have value only if it were critical enough, because Dalí had so exploited his own psychological abnormalities that he had trivialized the gifts he had undoubtedly begun with. He hinted that to penetrate the circle of associates surrounding Dalí would not be easy. Some people even suggested that Dalí had become a virtual prisoner in the castle of Pubol, this twelfth-century manor that he had bought for his wife, Gala, and in which he had lived since the night of her death in June 1982.

I was not unprepared, therefore, when my letter in May of 1984 to the grand old man himself, along with the gift of a book, went unacknowledged. I then contacted A. Reynolds Morse, a geologist by training, inventor of machinery for making plastic parts, and his wife Eleanor, of Cleveland, Ohio, who had spent a lifetime amassing a major collection of Dalí's works. The Morses, who eventually gave unstinting help and advice and granted numerous interviews, were most reluctant at first. They did, however, send me one of their books about Dalí and allowed me to study in their museum in St Petersburg, Florida, which now houses their collection and which has a superb library of books, articles and manuscripts. Other phone calls and letters followed, and a date was finally set for an interview in Cleveland. As

I was about to make travel plans, a letter arrived from the Morses. After discussing the interview, they had decided not to see me. There was the pressure of other business; besides, they were still gathering information for a book they might eventually publish themselves. Morse called it 'our own ultimate version of the polymorph'.

Behind the explanations it was not difficult to find some hurt feelings. Elsewhere, Morse has recounted how he had gone to the castle of Pubol in October 1983 and been turned away at the door by Dalí's lawyer, Miguel Domènech. Evidently the collector felt he had been badly treated by the 'man-monster' and those he called his 'minions', and was washing his hands of the Dalí Affair.

Could it be that this famous man, in his eighty-first year, was being kept in virtual isolation? The fact that the two people best qualified to scotch what might simply be a malicious rumour were anxious to avoid comment of any kind only served to sharpen my curiosity. I had always admired the method, still considered experimental, used by A. J. A. Symons in his biography of the erratic and enigmatic Baron Corvo, otherwise Frederick Rolfe, an unknown British writer, published half a century ago (*The Quest for Corvo*, 1934). Realizing that the standard biographical form would be inadequate for his purpose, he had dispensed with it and instead described the method he used to investigate and uncover his subject's life. It was a method that seemed particularly apt for a biography of Salvador Dalí. If there were no final truths to be discovered, because it seemed probable that I would never gain access to Dalí's own archive, and if the normal paths of reconstructing the life by means of close documentation were to be denied me, it might be possible nevertheless to sketch the scene, interview the witnesses, discover some clues, reveal the broad outlines, and arrive at some hypotheses. I had flown to London and was tracking down the surviving members of the British school of Surrealists when the first stirrings of the Dalí Affair began.

On Friday morning, 31 August 1984, there was a modest paragraph in the British papers. Dalí had been in a fire. While he slept, early on Thursday 30 August, flames had started in his bedroom. He had suffered first- and second-degree burns to his right leg but his doctor, Juan García San Miguel, said they were minor. There was no immediate explanation for the accident.

That there might be slight cause for concern was hinted at in reports that Dalí's health had been weak in recent months. This was already apparent from news articles that followed Gala's funeral in 1982. It was stated that he had become obsessed by his own death and talked of nothing else. He was bedridden and, with evident irritation, rang an electric bell that reverberated throughout the castle every few minutes, while four nurses attended him

around the clock. Since he was refusing to eat he was being fed intravenously and his weight dropped steadily. In December 1983 it was down to 110 pounds. Some weeks later, by mid-January 1984, it had dropped to 106 pounds and by the time of the fire it was only 100 pounds. He slept little, had to be helped to walk, and no longer went outside. All but a few of the castle's windows remained shuttered night and day. The doctor said that there was basically nothing wrong with him and talked about psychic depression and the need of a return to work.

'When I try to talk to him about routine affairs, he tells me not to trouble him with derisory issues. Everything except death is derisory for Dalí,' said Robert Descharnes, a French photographer and writer who had known Dalí for thirty years and had become his chief spokesman and amanuensis. Descharnes divided his time between an apartment in Paris and trips to Pubol and, at every return, would be berated by Dalí for having left him. The two other men around Dalí, the lawyer Domènech, brother-in-law of a former Spanish prime minister, and Antonio Pitxot Soler, a Catalan artist who had known Dalí all his life, agreed that their friend was almost pathetically dependent upon their constant presence. They periodically gathered to meet reporters and explain once again that the master refused all requests for interviews.

Some months after that, at the time of his eightieth birthday in May 1984, the reports were more positive. The artist was talking about painting again, was eating solid foods after months on a liquids-only diet and was asking for wine. A reporter for Reuters was allowed to peep through the keyhole of Dalí's bedroom and saw the master tackling an omelette. Then, to general amazement, Dalí emerged from seclusion to pay an impromptu visit to the museum he had opened in his birthplace of Figueres as a permanent memorial to his own work in 1974. For almost two hours he walked through the corridors, leaning on his silver-tipped cane, accompanied by his manservant, Arturo, Pitxot and a nurse. He looked happy and was overheard to say, 'I want to work. I want to see my gallery.' Given his advanced age and physical frailty, his recovery seemed against the odds. The clue to his inner drama came again from Descharnes. Dalí had realized at some crucial point that he could not go through with his plan to starve himself to death and had risen like the proverbial phoenix from the ashes of his own grief.

There seemed no real cause for concern when Dalí was admitted to the clinic of Nuestra Señora del Pilar in Barcelona on Friday evening, 31 August, the day after the fire, particularly since the master had been well enough to make another tour of the museum beforehand. Dressed in his smoking jacket and wearing a white turban, Dalí lay in the back of his midnight blue Cadillac and was driven the twenty-two miles to Figueres. There, lying on a stretcher,

surrounded by Pitxot, Descharnes, Francisco Verges Bosch, who directs the museum, and numerous members of the press, he was photographed as he inaugurated a memorial to Gala. Some two hours later, at around midnight, he arrived at the clinic. The transfer was simply a precautionary measure, his doctors said. Although accounts in some French and British papers were still cursory, others grew longer and *El País* of Madrid, Spain's largest newspaper, considered the news important enough for its front page on Sunday 2 September. The painter was burned not only on both upper legs and his right arm, buttocks and groin, but the burns were more serious than first reported: second- and third-degree. They covered eighteen per cent of his body. Their healing was made more difficult by the poor state of his health. The word malnutrition was used for the first time.

Four days later there were more front-page articles. Dalí had consented to a skin-graft operation during which skin would be removed from other areas of his body and grafted to his legs and groin. The burnt skin was threatening to turn sceptic and, without the operation, doctors would not give him forty-eight hours to live. Asked for his consent, and witnessed by a Barcelona notary summoned for the occasion, his lawyer, a photographer, and a reporter from Spain's national radio network, the painter gave a croak which was interpreted as *sí*. Immediately a team of six surgeons began to prepare for the delicate and lengthy undertaking. Plainclothes police stood outside the door of the artist's hospital room on the fourth floor of Nuestra Señora del Pilar, and Descharnes, Pitxot, and Domènech moved into an adjoining suite where a secretary opened letters and took telephone calls around the clock. Among them were personal messages from King Juan Carlos and Felipe González, the Prime Minister. Since Picasso's death, Dalí had been regarded by the Spanish as their greatest living painter.

What had actually caused the fire was the subject of much speculation. Three versions circulated: first, that a half-extinguished fire in the fireplace had caught the bedroom alight; second, that an electric light was at fault, and third, that there was a short-circuit in his bedside electric bell. This last was the most popular version and the eventual explanation was that somehow the bell had short-circuited, the spark had jumped back to the walls, and these, since the castle was so old, contained saltpetre as insulating material, a highly combustible substance. It was said that anyone who had visited the castle would realize how easily a fire could take hold unperceived by those in adjacent rooms. The ceilings were high, the rooms were vast and considerable smoke would have to be generated before enough of it drifted out under Dalí's door and along the corridors. How long it took before flames set the canopies and cushions on Dalí's fourposter bed on fire, and how long he battled with them alone, was not known. At some point a nurse rushed

in and was driven back by the smoke. She then ran to get help from Robert Descharnes, asleep on the floor below, and summoned a member of the paramilitary civil guard always on duty at the castle.

Descharnes arrived and was, in turn, driven back by smoke and fumes. He went out of the room to catch his breath and, as he returned, saw the silhouette of Dalí in the flickering light. The artist was on his hands and knees and, half-asphyxiated, crawling towards the door. The three of them – Descharnes, the nurse and the civil guardsman – carried him, still conscious, to safety.

Anonymous sources told *El País* on 6 September that Dalí made such perpetual use of his bell push that it frequently broke down. Those same sources stated that Dalí was fascinated by the tiny spark that was produced in the pear-shaped bulb whenever he rang, and that he enjoyed playing with it in the privacy of his chamber. Perhaps this was the reason why, as was stated by a former nurse, his imperious ringing was sometimes ignored. Or perhaps, as she stated, the household staff believed that his constant buzzing was a symbol of his 'monstrous egotism' and that, in not catering to his every whim, they were really doing what was best for him.

Everything seemed to hinge upon exactly what had happened that morning of 30 August. It was also apparent that Dalí himself had not been questioned, whether because he was incapable of answering was not clear. Had his staff neglected to have the bell push repaired, even though its sparking indicated a possible fire hazard? Had the artist insisted that they should not repair it? Had the fire begun of its own accord? Did Dalí try to ring the bell, which short-circuited and caught him up in flames? Given the particular area burned, was there a shred of merit in the scandalous rumour circulating in Barcelona that the cause of the accident could be attributed to Dalí's well-advertised fondness for auto-eroticism? Could it be that the bell had indeed rung, and the staff had ignored it? Was the sudden silence, and then the smoke, what finally roused one of the nurses? It was, said *El País*, 'a profoundly disagreeable mystery'.

The chief state lawyer for the Gerona province, Francisco Martínez, promptly announced an investigation into 'everything concerning the Dalí affair'. By this he meant far more than the facts of the fire, puzzling though these were. Why, it was asked, was Dalí, although extremely weak and virtually bedridden, apparently left unattended despite the round-the-clock presence of nurses, servants, associates, and policemen? Why, when it became evident that he needed expert hospital attention, had more than forty hours elapsed? Why was he not driven straight to Barcelona but to his museum in Figueres? Why was he suffering from critical malnutrition? The sum of $2,000 a month paid to each nurse, princely by Spanish standards, was another sore

point, as if this somehow had sinister implications. Meanwhile the cause of all the controversy was travelling, *Le Figaro* reported eight days after the accident (7 September), 'the road to Calvary', and the next forty-eight hours would be decisive. The lobby of Nuestra Señora del Pilar was turned into a television studio and teams of doctors gave press conferences.

Even before the official investigations began, those around Dalí were making public statements of their position. Dalí had not been attended by a night nurse because he would not have anyone permanently installed in his room and wanted the door kept closed, they said. Forty hours had elapsed because Dalí refused to be taken to hospital at first, agreeing to go only if he could visit his museum in Figueres. They denied that he was suffering from malnutrition and reacted indignantly to further charges made by Rafael Santos Torroella, a well-known Barcelona art critic and writer, and another friend of thirty years' standing. Both said that they and other old friends had been prevented from visiting Dalí.

A similar accusation was made by members of Dalí's family, who asked for a separate judicial enquiry into the causes of the fire. Gonzalo Serraclara de la Pompa, Dalí's second cousin, some years his junior, who had acted in the past as his unofficial adviser, was spokesman for the family group, which also included Dalí's sister, Ana María, and a cousin, Sra Montserrat Dalí de Bas, a widow Dalí had known since infancy. Serraclara claimed that the painter was 'surrounded by strangers who kept him from the affection of his family'. Sra Dalí de Bas said that for months she had begged Domènech to be allowed to visit her cousin and was repulsed.

Possibly in response to such charges, Ana María Dalí, with whom he had not been on good terms for decades – she once publicly called him 'an old clown' – was invited to his bedside. Two versions of this poignant meeting were given later. The first was that brother and sister looked at each other wordlessly, with tears in their eyes, until Ana María, overcome with emotion, silently withdrew. The second, which Descharnes later said he had corroborated in a conversation with nurses who were present, was that Dalí made feeble efforts to rise from his bed so as to physically eject her.

Behind the claims and counterclaims, the conflicting versions of events that seemed impossible to verify or disprove, was a further aspect to the Dalí Affair. The value of the artist's personal collection of his own work had been estimated at $78 million. Even though a sizeable part of that, valued at $26 million, and consisting of paintings, prints, drawings and objects, had been given by the painter to his museum in Figueres, that still left the major portion, $52 million, in his hands. Since his will had not been published, it was not known exactly what the eventual disposition of this private collection would be. His lawyer, Domènech, had stated that 'all his personal collection

will go to the people of Spain'. What did this mean? Would Dalí's collection stay in his native Catalonia, or would it belong to all the Spanish people and end up in Madrid? One Catalan commented, 'There is too much money surrounding a lonely old man.'

In the middle of these speculations, a Spanish artist told the *Sunday Times* of London that he had forged drawings, watercolours, and oils with the full blessing of Dalí and his wife. The artist said that he had begun imitating styles at the age of eight and had moved on to Dalí in 1973 at the request of the painter's wife. The offer had been made in all seriousness, he said, because the painter's own hand trembled so badly that he could no longer draw. Hardly had this astonishing statement been published than rumours of fake paintings, with fake certificates of authenticity and fake signatures, became widespread. There were, it was claimed, tens of thousands of blank pages on the art market signed by the master himself, guaranteeing in advance tens of thousands of fakes.

'Too much has been going on behind the scenes,' declared Pierre Argillet, a French art publisher and friend of Dalí's since the 1930s, who has established a Dalí museum of his own in his château Vaux le Penil outside Paris. 'The trio of friends has put all others aside and kept Dalí's business affairs for themselves.' Shortly afterwards he and Descharnes came to blows in Barcelona's Hotel Ritz and, as luck would have it, in the presence of reporters. As for Xavier Cugat, he joked on Spanish radio that, 'I am sure they will save Dalí's shoes because there will always be a buyer.'

By the time I arrived at the Barcelona clinic of Nuestra Señora del Pilar, over a month after the accident, Dalí's improved health was clearly visible from the lack of television cameras. As late as a week before there had been crowds of reporters milling in the lobby: now the only inhabitants of the halls were obviously visitors or calm-faced nuns and mothers with new babies. Repeated attempts to reach Descharnes, Domènech or Pitxot by telephone having failed, perhaps because my name proved unpronounceable to Spanish tongues, I had decided to go there in person. Dalí's name was on the door of Room 401, prominently placed near the elevator; I saw no signs of activity. In the adjoining suite I came upon Descharnes opening letters, which he was sorting into neat piles with the help of a secretary. He was a short, stocky figure in his mid fifties, wearing glasses, an open-necked shirt, and the kind of fixed expression one would expect of a man who had been harassed for weeks on end.

His opening remarks concerned the vultures that were bound to gather around a dying man and the folly of believing anything one read in the European press. From the beginning, the true nature of Dalí's burns had been

vastly exaggerated. Perhaps the doctors were responsible for overstressing the complications even minor burns could have for an elderly man. What was more, Dalí could not possibly have been suffering from malnutrition. This was evident from the fact that the doctor now treating him was the one who had always attended him at Pubol. If I understood his precisely enunciated French correctly, the logic of what he said escaped me. He continued, 'Fortunately Dalí is an ascetic because if he had not weighed so little [by this I assumed he meant had so little fatty tissue] he would not be recovering so well now.' In the middle of this explanation the lawyer Domènech entered the room and was briefly introduced. Descharnes leapt up to inform him that Dalí was very much better. His buttocks had healed and so had his hand. The two men clapped each other on the back with large smiles. Descharnes explained that the world-wide press response Dalí's accident had elicited had been a great boost to his vanity. Once again he was the centre of attention.

He went on to say that Dalí's decline dated from an illness three or four years earlier, but recent business pressures were also responsible. It was well known that Dalí had always completely depended upon his wife to deal with these matters. Descharnes indicated that the troubles began when Gala became less lucid and could no longer cope with legal contracts. It seemed important to him that I understand he had nothing at all to do with Dalí's business affairs.

As for refusing to see people, that was easily explained. He and Domènech quoted a Spanish proverb to the effect that every man tried to put up a front until he died. Dalí's vanity would not allow him to expose himself to the pitying smiles of old friends who might see him in his present sad state. This was one reason why it would be difficult to arrange an interview for me. In any case Descharnes was quite sure that Dalí would not discuss his family and childhood.

Descharnes explained that the feeding tube entering his nose and thence going down his throat made it difficult for Dalí to articulate clearly and sometimes he was the only one who could understand him. Dalí was often incoherent because a kind of paralysis that affected his ability to swallow was also affecting the muscles of his mouth. In extracts from a taped interview with Dalí, published later by *Paris Match*, that Descharnes said he had made a few days before the accident, Dalí spoke at length of the reasons why he could not swallow. The trouble was that his saliva was as thick as mud: it was a pool of mud, he said. Whenever he tried to speak or coughed an enormous wave of saliva would fill his whole mouth preventing him from swallowing. As for food, that would bring on such a violent coughing fit that he would be forced to throw up whatever he had just eaten. That these remarks were apparently contradictory was not discussed with Dalí by Desch-

arnes. And in fact, despite what seemed physical causes, exhaustive medical tests at the clinic had established that the real causes were psychological.

Another sore point was that Dalí's sister and cousins had brought a suit against the three men. Descharnes was obviously biting back other words when he described it as ill-advised, but others were more forthright. When I spoke to Sr Verges, he practically hissed his indignation that Dalí's family who, he said, had had no contact with him for thirty years, should now take a passionate interest in his welfare. He made it plain he thought he knew the reason why. What no one seemed to realize, both men said, was that Dalí hated, even detested, his family, and wanted nothing to do with any of them. Later, when I took up the matter with Sra Dalí de Bas and Sr Serraclara, this point was readily conceded. Serraclara said that he had not seen Dalí since a visit he made to the painter shortly after the death of Gala. Relations between Dalí and his sister, his junior by four years, had been difficult for decades, mainly because of the hostility between the two women, he said. However, he had managed to remain on good terms with both sides for many years. Then, some months after Gala's death, he went to see Dalí on his sister's behalf. Could she not come and visit him? he asked. Dalí called him a 'traitor' for having plotted such a scheme – for even talking to his sister, it seemed – and turned him out of the door. Serraclara, who viewed what was obviously an ancient family feud with considerable detachment, thought it a pity that the artist, who obviously needed a confidante since his wife's death, was unable to turn to the person who had been the inseparable companion of his youth.

Serraclara was not the only bystander to be caught in the crossfire between Dalí and his sister. Because the Pitxot family had been linked through long ties of friendship with Dalí's family for over a century, Sr Pitxot obviously felt under a particular obligation to try to reconcile brother and sister. 'I have done the impossible to try to get this family together,' he said. However, since the fire, the judicial enquiry that had been started at the family's request had made things infinitely worse. 'I have already testified before a judge three times, and I was not even there [when the fire took place],' he said in mid October. 'It is very disagreeable.' What seemed to hurt most was that, despite his close friendship with Ana María Dalí, his name had been included among those to be investigated. Whether Srta Dalí might have felt, as her brother appeared to do, that her friends betrayed her if they sided with her 'enemies' could not be known, since she refused to be interviewed.

There had been persistent rumours for several years that the artist was suffering from Parkinson's disease. Whether or not this was true was a subject of speculation, since much hung on whether the artist had continued to paint and draw, and in particular the eventual disposition of a large group of late

works. Between July 1981 and April 1983, in less than two years, Dalí was said to have painted ninety-two canvases. This average of one painting a week seemed astonishing when one considered that, at the height of his creative powers, Dalí seldom completed more than a painting a month.

James Markham, then bureau chief for the *New York Times* in Madrid, who attended a press conference held by Dalí at his museum in Figueres in 1980, that is to say some months before this amazing output began, noted that Dalí's right hand was shaking uncontrollably.

'"You see how my hand is trembling?" Dalí asked the assembled journalists defiantly. "Well, look now." Then he held the shaking hand still.'

Dalí's evident ability to steady his hand seemed to confirm that he was able to continue work although, curiously, the recent paintings published – there are a number in a new book by Descharnes – show a most un-Dalí-like diversity of styles. If accepted by the art market, such a large group would have a minimum value of $9 million, perhaps more.

Descharnes did concede that Dalí had been helped by Isidor Bea, a Barcelona artist who has collaborated with him for years. But, he insisted, 'They're still true works by Dalí.' Quite what that might mean was highly ambiguous, since Dalí always insisted that the slightest evidence of his hand, be it as little as a scrawl mark, was enough to transform the work of another artist into a genuine Dalí.

How good these paintings might finally be considered to be was another imponderable. James Markham continued, 'Turning slowly, Dalí unveiled a horrible painting he had completed during his isolation in Port Lligat: a grotesque, lurid purple beast, recumbent. Its title: *The Happy Horse*.'

'It is a little rotten,' commented Dalí drily. 'I don't know if you can see that it is a horse, or a donkey, but you can see that it is rotten.'

Though Dalí lurched between Spanish, French, and Catalan, Markham was at pains to state that Dalí was coherent and back to his old irreverent form. Some four years later, Descharnes and Pitxot said that this was still true. Here again their critics asserted otherwise. Argillet claimed that the painter had not been in full possession of his faculties since 1981. A psychiatrist who had treated the artist said, 'All of a sudden he yelled aau-uueeuuumnios. So I answered ruruburu, and the conversation ended.' His diagnosis: advanced cerebral sclerosis. Helga Ferrer, the former nurse, said, 'Dalí suffered enormously. He looked as if he was observing his own death. He hardly spoke, constantly sobbed and spent hours making animal noises. The painter constantly had hallucinations. He thought he was a snail and lived trapped by the fantasies of his brain.' She also said, 'In two years, I only understood one coherent phrase: My friend Lorca.'

These reports of what seemed clear mental deterioration were difficult to

reconcile with the bulletins, issued by his associates, that the painter had recovered his will to live, particularly after he was installed in a three-room suite adjoining his museum in Figueres in October 1984. However, some statements contradicted each other. That all was going well appeared to be the substance of remarks by Descharnes a month after Dalí left the clinic. He had gained weight, was having physiotherapy, had overcome his aversion to light, and was allowing the curtains of his room to be opened during the day. Yet three days earlier Pitxot said that Dalí's lack of progress was a source of concern. He was 'sad and disconsolate'. He 'only rarely pulls himself out of his dark thoughts'. A third report came by way of a friend who had spoken to Dalí's servants and was told that, optimistic bulletins to the contrary, Dalí was being prevented from doing the one thing he wished to do, which was to die. After Dalí's midnight departure from Barcelona – he left in his Cadillac with reporters and photographers in hot pursuit – television viewers were appalled to see an emaciated old man in a wheelchair, wearing a black-and-white pinstriped suit and his furry white turban, his lower lip dangling and his eyes glazed, being pushed towards the exit. Perhaps it was true, as a celebrated Spanish doctor was quoted as saying, that 'the follies he invented have ended by dominating him'.

Here, then, were the main outlines of the Dalí Affair. The events of the autumn of 1984 had thrown a brief light on the artist's life and the picture that was revealed was a sorry one: old friends cast aside, family members embattled and embittered, a career in disarray, business affairs in chaos, the central player weak and ill, perhaps plunged into madness, and those around him polarized into factions with who knew what alarums and excursions still to come. So many of them had chosen, for whatever private reasons, to enmesh their lives with that of this particular main player, and appeared destined to follow the same tortuous path to the bitter end. In such an atmosphere, who the real prisoner might be and who the jailer, seemed a moot point.

The castle of Pubol, a mile from the tiny village of La Pera, had the twin advantages of a commanding view over the idyllic landscape and formidable stone walls. However, since it was built on rising ground the walls were not high enough to conceal from view those who lived on the other side of the main gateway, with its automatic answer phone and buzzer. Cameramen who had staked out their positions ahead had discovered that, if they clambered up a bank on the opposite side of the road, their view over the walled garden was spectacular. Since Dalí's arrival, the wall had been further heightened by three to five feet, with only partial success.

At midday on that hot October day of my visit, two photographers were

keeping watch opposite the gateway. One of the young men, son of a photographer who had known Dalí well, said that he had often been inside the castle, which, for all of its evidence of Dalí's hand – frescoed ceilings, *trompe l'oeil* wall decorations, paintings, and *objets* – was furnished in the austere and formal manner preferred by his late wife. They had been waiting for five hours because a collection of over two hundred paintings that had been on exhibit in Italy, most belonging to the artist, was on its way back from the frontier. Their assignment for their newspapers, *Los Sitios* of Girona and *Punt Diari*, the local paper for that part of Catalonia, was to photograph the unloading of the trucks, this being an indication of the extent of the interest in Dalí's artistic patrimony. The possibilities for photography seemed limited and the arrival of the paintings uncertain. I waited for a while and then drove off. As I did so, one of the photographers waved and the other ran down the street towards the gate. Next day, pictures of the paintings' arrival were on the front pages.

CHAPTER TWO

'Myself Alone'

'It was during my childhood that all the archetypes of
my personality, my work, and my ideas were born. The
inventory of these psychological materials is therefore
essential.'

SALVADOR DALÍ, *The Unspeakable Confessions of Salvador
Dalí*

Some years ago a reviewer of Salvador Dalí's autobiography made the per-
ceptive comment that the book had been written as if its author had never
lived. The book's air of insubstantiality, of having been invented by a fan-
tastical and hallucinogenic, if not ethereal, imagination, is appropriate, given
the particular circumstances of Dalí's birth. For the truth was, as he never
ceased to explain later in life, almost in terms of the Ancient Mariner seizing
the reluctant Wedding Guest, that he was the second Salvador. He had been
born twice and was therefore a double self, half a person, someone who did
not really exist.

Even though Salvador Dalí occasionally pretended that the actual date of
his birth was unknown, as the municipal archives were destroyed during the
Spanish Civil War, the prosaic truth is on file in the civil register of the
Ministry of Justice in Figueres. So is the fact that the first son of Salvador Dalí
i Cusí and Felipa Domènech, named Salvador Dalí i Domènech, was born at
eleven in the morning on 12 October 1901, in Figueres, in the province of
Girona, in that part of Spain called Catalonia.

It is also established that this first son, also named Galo and Anselmo for
his paternal and maternal grandfathers respectively, died on 1 August 1903,
at the age of twenty-one months of what was described on the death certificate
as 'catarrh with gastroenteritic infection'. The second Salvador was born on
11 May 1904, at 8.45 in the morning in the same house, No. 20 Carrer
Narcisco Monturiol in Figueres, no doubt in the same bed. In other words,
the interval between the death of the first Salvador and the birth of the second
was just nine months and ten days. If the bereaved parents planned to replace
their lost son, they succeeded almost immediately.

It is an axiom of Hindu cultures that children who die young are reborn
shortly thereafter, and taken as such a commonplace by their parents that a

number of studies have been made of the occurrence. In cases described in the literature the children themselves, almost as soon as they could talk, have insisted upon their memories of other lives and have taken their new parents to meet their former relatives. However, in the case of their second son, Salvador Felipe Jacinto Dalí i Domènech, it was the parents who were absolutely convinced that their dead son had been reborn. They implanted the idea on the pliant young mind. They bore witness to the newcomer of his reincarnation in a new guise.

Perhaps the most emphatic believer in this supposedly miraculous event was Salvador Dalí's father, the notary of Figueres whose image would recur with dreamlike repetitiveness in his son's work. This learned, stubborn, perplexing personality seemed almost possessed by the notion. In that part of Spain it is not customary to name a son after his father and even less customary to name a baby after a dead child. In fact it is looked on with superstitious disfavour, in the conviction that the name will transmit to the second the fate of the first. The fact that the baby's mother was vehemently opposed to the repetitious christening would indicate that she believed her second son had been placed in peril of his life.

Any attempt to make a careful record of the family history of the Dalís is doomed to be cursory. Facts are scant, memories elliptical, and the most elementary dates difficult to establish. Even those who know the story well are hesitant, as if in silent agreement that less balanced and successful members of a family are best buried in the recesses of the collective memory. Dalí, who enjoyed painting his past in lurid brushstrokes, is uncharacteristically mute in some areas and unreliable in others. In writing about his brother later in life he attributed to him a power of personality that a child less than two years old could not possibly have displayed. It all took place, he claimed, three years before his own birth and his brother had died at the age of seven or, he sometimes said, of five. 'My mother was completely bowled over by the precocity of this brother, his ... grace and beauty were for her subjects of exaltation.... She was never able to get over it.' Young as he was, his brother was unmistakeably a genius. His supernatural intelligence had overheated his brain, Dalí insisted. Perhaps this is the origin of the belief to which Dalí clung through every retelling: that his brother had died of meningitis. This terrible affliction, named for an inflammation of the coverings of the brain and spinal cord, or meninges, is associated with a bursting headache, sometimes delirium, and convulsions. It seems to have been connected in Dalí's mind with the memory of having seen, as a child, a boy with an enlarged head and small body suffering from spina bifida or hydrocephalus (water on the brain).

There may be a further explanation. It was believed in those days that a

blow on the head could cause meningitis. If Dalí's father had struck his son – and it is rumoured that he did – and if that son subsequently died, to the agony of bereavement would have been added some intense feelings of guilt. The death certificate, which should settle the matter, presents another imponderable, one that could have been written to draw a veil over the painful truth. Dalí's friends and close associates insist that, although his memory for factual details is quite unreliable, and although he sometimes transposes events, he can never be faulted on essentials. So it may well be that as the death of the first child receded into the past, he became a completed being, a shining ideal to be held up to the boy who followed him. In such an atmosphere actual age becomes irrelevant; the distorted memory bears the truer witness. Similarly, Dalí's insistence upon meningitis as the cause of death is oddly persuasive. One begins to wonder whether he may be making an allusion to a central truth, one that is pivotal to an understanding of his father's state of mind and the atmosphere into which he was born.

Early photographs of Dalí's father, Salvador Dalí i Cusí, are in marked contrast to the bloated, balding, defeated figure his son portrayed in later years. Here is a vigorously intelligent and handsome man, of an almost icy intensity, hardly the person one would expect to dedicate his life to the tedium of authenticating documents. However, if one looked for colour and drama behind that respectable façade, one would not have far to seek. With his usual panache, Dalí claimed that he had traced his genealogy back to Arab roots, dating from the time of Cervantes. On the other hand, the distinguished Catalan writer Josep Pla, who knew father and son and wrote about them both, had a theory that the Dalí name, which is rare in that part of Catalonia known as the Ampurdán, had originated with a certain Colonel Peter O'Daly, an Irishman who fought with Lord Cochrane, Nelson's indispensable aide at Abukir and Trafalgar. For a time O'Daly had been governor of the tiny but strategically valuable Medas Islands, which lie off the Mediterranean coast of Spain south of Cadaqués and which have been claimed by various countries, including Britain. Pla theorized that Colonel O'Daly, or his descendants, had settled on the mainland.

Pla traced the Dalí family back to a certain Dalí i Ragué (it is customary in Catalonia, as it is in Spain, for children to use their mother's maiden name after their father's), a blacksmith of Cadaqués. His only son, Salvador Dalí i Cruanyes, born in Cadaqués early in the nineteenth century, had a son Galo Dalí i Viñas. Here I part company with Pla to take up the family history as told by one of Dalí's relatives. The grandchild of a blacksmith had joined the middle class as a stockbroker, had moved to Barcelona and married a widow, María Teresa Cusí, from Rosas on the coast near Cadaqués, who already had a young daughter named Catalina. The first son of this union, born in 1862,

was named Salvador after his grandfather. A second son, Rafael, was born some fourteen months later. Very little is known about Galo Dalí except that he gambled on the stock market, lost in a crash, and threw himself off a third-floor balcony. At the time of his death his elder son was a teenager.

His widow, María Teresa, was as careful with money as her husband was reckless. She had managed to save for the education of her sons and was further helped by her daughter's husband, Jose María Serraclara, later mayor of Barcelona, a man of generosity and means. Rafael, the younger, became a doctor and stayed in Barcelona, while the future notary moved to Figueres.

The status of law and lawyers in Spanish society is worth remarking on here. At the close of the nineteenth century some kind of degree was required before one could qualify for a government appointment. A sizeable percentage of students in the ten university towns therefore sat for the easiest: a law degree. It was said that every steward, land agent, surveyor, architect and financier – even some bullfighters – was a doctor of laws in those days.

The law courts, however, gave no protection to the Spanish people. 'The separation of the powers is a thing that has never existed in Spain and judges and magistrates were simply Government employees who took their orders from above,' Gerald Brenan wrote in *The Spanish Labyrinth*. 'They condemned and acquitted at the word of the Civil Governor.'

The position of notary, however, was a far more respectable calling than this would suggest, or than Dalí, with his multiple images of an ink-spattered minor functionary with filing-cabinet drawers for brains, cared to imply. As the state's official witness to legal transactions, the Spanish notary was empowered to act in fiduciary, escrow, and other matters of financial estate management and trust, if not licensed to plead in the courts. Since his signature could not be bought, he was far more respected than a judge. The Spanish notary in particular was known for his knowledge of the law and the fact that he was honest. If as the son of a suicide he had laboured under a social stigma and had felt compelled to prove himself, as notary of Figueres he had captured it all: prestige, recognition, and social respectability. In an early photograph one can find more than a hint of a radical and rebel, but by middle age the look has vanished, to be replaced by the complacent stare of the self-made man. Everyone called him 'the money doctor'.

Those who knew Dalí senior make much of his erudition and alert intelligence. It was said that he could talk wittily and searchingly about almost anything; his curiosity embraced art and music as easily as it did politics and the hair-splitting points of law. Born in Cadaqués, he was forever faithful to it, and took his family every summer to the house, that still stands, on the Playa d'es Llaners. Sra Montserrat Dalí de Bas, the artist's cousin, who is the same age and spent many summers with the Dalís, remembered Dalí senior

as an arresting personality. 'He was full of humour and always agreeable,' she said. 'He was up to date on everything that was happening, whether in politics or art.'

Josep Pla thought that what people found most amusing about the notary was his ability to espouse a dozen conflicting positions simultaneously.

He jumped on everybody's bandwagon, and every time with his absolutely definite, indestructible, ingrained, granite-like conviction. He was never one to take the defensive, but was always trying to win people over. He always attacked, with sarcasm and gesticulations which reverberated throughout the region. It may be that he travelled along extravagant orbits, but whenever he contradicted himself he did so with impressive conviction, without the least possibility of falling into any form of scepticism. He was never a sceptic. He was permanently militant, both during the period when he did not go to Mass, but also in the period when he did.

Another cousin, Dalí's junior by some years, added that the notary's militancy often took an ominous turn. 'He was a difficult man, very honest but with a violent personality,' he recalled. 'He was always having fights. One day, as a notary, he had prepared the papers for two parties to sign but only one appeared. So he sent the man off in search of the second party to the agreement. The man returned at length to say there was no reply. 'Have you knocked hard enough?' the notary wanted to know. Unconvinced, Dalí's father went to the door of the man's house with a hammer and banged on it, bang, bang, bang. He was like that. I have seen the two brothers [referring to Rafael] so wild, that I had to leave.'

Dalí told a similar story. He had been sick and his father had sat up all night with him. Next morning the notary was exhausted and left word that he was not to be disturbed. However, shortly after he fell asleep a peasant from Figueres, one of his clients, insisted on seeing him and began to make loud and cutting remarks about lazy public servants who spent their mornings sleeping it off while honest folk such as himself had to work, even on Sundays. The notary overheard and was up in a trice.

He grabbed the man by the collar, with a yell, and they both lurched out on to the stairs; they went on fighting each other all the way down to the sidewalk, then in the public square, right under my windows. I ran to the balcony and watched through the bars as my father and that man rolled over and over on the ground, tearing at each other. My father's sex organ, breaking out through the fly of his drawers, now as the two wrestlers tugged back and forth, dipped into the dust and beat against the ground

like a sausage. When my father got mad, the whole rambla of Figueres
held its breath.

What one can gather from Dalí's childhood is that, in addition to everything
else, he had the bad luck to resemble his dead brother to a startling degree.
There was the same colouring, the same lively awareness, the same appar-
ently precocious development. Perhaps because of the high rates of infant
mortality of the day Spanish parents were known as models of tender sol-
icitude; Dalí's mother was the quintessence of all-giving, all-loving maternity.
But that seemingly fortunate son, endowed with every possible advantage,
his every whim indulged, was by nature hypersensitive to emotional nuance.
It is evident that, at an early age, he became aware that he was not being
loved for himself. When he looked into his mother's eyes what he saw was
not his own reflection, but a ghost.

A child's predicament in not being loved for himself – or, more precisely,
being valued for what he is not – has been studied, and some authorities
believe that the precociously gifted child is most at risk. His finely tuned
senses ensure that he will pick up the unconscious message. He, more than
others, will school himself to play his role in a Pirandelloesque reality. He
may even lose contact with what he really thinks and feels; the mask will
become the face.

Some in Dalí's circle have minimized or dismissed his comments about his
dead brother as fantasies of an overactive imagination. However, Dalí's cousin
and the former Mayor of Figueres, Ramón Guardiola, both believe that Dalí
stated the problem exactly. His cousin said, 'They made comparisons between
the two every day. They used the same clothes and gave him the same toys.
They treated him as if he were the other one and Dalí got the impression that
he didn't exist. It became the source of all his problems.'

Dalí has described the situation he faced: 'We would be walking along the
street for example and they would say to me, "The other one sneezed when
he passed by here, be careful." Or they were forever repeating things like
how good-looking he was and the like.' He told a French psychiatrist that
whenever he went out his mother would say, 'Take a muffler, cover yourself
up; if not, you'll die like your brother ... of meningitis.' Contemporary
accounts of Spanish children paint portraits of youngsters required, even in
the mildest weather, to wear the inevitable *bufanda*, a woollen scarf wrapped
around the neck and head to ward off the danger of a breeze, making such
solicitousness on the part of Dalí's mother seem almost routine. However, her
words make her fear transparently clear: his name doomed him. At times
Dalí believed that his brother was an early version of himself, coupling the
remark with a slighting self-reference: 'I was much less intelligent,' he wrote.

Yet even this understated the matter. He said, 'finally I wasn't myself any longer; I was my brother.'

A famous French portrait painter, Édouard MacAvoy, who painted Dalí and had many conversations with him while he worked on preliminary sketches, said that Dalí talked of almost nothing else. 'He had the idea that he had actually become his brother and at night he would go to the cemetery, to his brother's tomb, his hands folded in prayer. His exact words were, "I no longer know whether I am alive or dead." '

A large photograph of the first Salvador hung in his parents' bedroom. It was of a lovely child decked out in lace. The photograph was regularly retouched, and each time Dalí went into his parents' room and looked at it, he felt an unreasoning terror. He could not sleep because his head was full of thoughts of putrefaction and death. 'I managed to drop off to sleep only at the thought of my own death and by accepting the idea of lying at rest inside the coffin.'

Hanging beside the photograph of the dead boy was another image, a reproduction of Christ on the cross by Velázquez. There must have been a moment when Dalí's mother, who was a devout Roman Catholic, though her husband was an atheist, or his nurse Llúcia, perhaps even the maid, told the little boy that his namesake had gone to heaven to join the dead Saviour, the *salvador*. Dalí himself said in 1980, 'The thought of my brother was anguishing. Even today I'm anguished by it.'

Dalí makes very few references to his mother. One is aware of her background presence in his autobiography, and she occasionally moves to the forefront, bending over him with the tender words, 'Dear heart, what do you want?' He loved her, he said. That was all. There was only a fleeting reference, in one of his innumerable interviews, to his irritation, amounting to exasperation, at the pressures he felt coming from her.

About his father Dalí was far less reticent. He was the sun of his father's life, he said, and it drove him to despair, again because

his look was addressed as much at my double as at me personally. As far as he was concerned I was only half of myself, one being too many.

My soul was wrung out with grief and rage beneath this laser beam which ceaselessly scanned it looking for the other who no longer existed. And I have carried in my side a bloody wound that my father, unmoved, unfeeling, ignorant of my anguished feelings, scoured incessantly with a love that battered me like a bludgeon.

Figueres is in Catalonia, on the northern edge of the fertile plain of Ampurdán, bordered on the west by Aragón and by Valencia to the south: in the corridor

between the Iberian Peninsula and Europe. Not just the French but successive waves of Greeks, Carthaginians, Romans, Visigoths, Franks, and Moors have beseiged and conquered Catalonia and been driven out in their turn. It is a point of pride for the region's six million inhabitants, about one-sixth the population of Spain, that their state was once a Mediterranean empire, that Catalans have waged three wars for political independence, and that they were safeguarding the rights of the common man before the English had the Magna Carta.

From the sixth century BC, when the Greeks arrived and founded the colonies of Empuriae (Ampurias) and Rodae (Rosas), bringing with them the techniques of navigation, the Catalans have been Mediterranean traders. Their prosperity, industry, and enterprise have been legendary, along with their advanced capacity for self-government and sense of nationhood, a bourgeois island in an ocean of feudalism. Gerald Brenan has described Spaniards of the upper classes in the seventeenth century, the period following an immense empire-building, as effectively ruined by wealth.

Spanish pride, Spanish belief in miracles, Spanish contempt for work, Spanish impatience and destructiveness, though they had existed before in Castile, now received a powerful impetus. Especially Spanish contempt for work. After 1580 the few cloth industries that had grown up in Castile declined and Spaniards became a *rentier* race, a nation of gentlemen, living in parasitic dependence upon the gold and silver of the Indies and the industry of the Low Countries.

If this was often the fate of victors, the same could never be said of the Catalans. A seventeenth-century Jesuit Father described them as 'robust, strong, chaste, hardworking, mechanically gifted, with foresight and prudence', an opinion that has invariably been repeated. Furthermore, in contrast to their neighbours, whose political systems operated for the benefit of the landowning class and ignored the rest, Catalans had been famous for their ability to treat the humblest among them evenhandedly, the same Father noted. In the middle of the nineteenth century Richard Ford, an English traveller, observed that

the Catalans are the richest of Spaniards, because they work and produce the most ... their roughness and activity are enough to convince the traveller that he is no longer in high-bred, indolent Spain.... Rebellious and republican, well may the natives wear the bloodcoloured redcap of the much prostituted name of liberty.

Like the Celts the Catalans have their own culture, their own literature and, what is rare in the modern world, still speak their own language. It is Latin in origin, differing markedly from Castilian Spanish, and having affinities with Provençal. They have always looked towards the sea and their illustrious past, when 'the fishes in the Mediterranean did not dare to take the bait if they didn't find the shield of Catalonia on it'. In Sicily naughty children are still threatened with the words, 'Do as I say or I'll call the Catalans.'

The Catalans have an acute sense of their rights, like the British, and, by inference, feel injustice acutely. Their expression, *no hi ha dret*, 'it is not right', has echoes of the British, 'it isn't done'. Their word *seny*, which has no exact English or Spanish equivalent, has overtones of the French *sagesse*, but implies common sense and prudence rather than knowledge. *Seny* is the height of good sense, and *perdre el seny*, 'to lose one's good sense', means to go beserk. When a situation is not sensible, the way it ought to be, Catalans believe the only sensible thing to do is *perdre el seny*.

Since by his own admission Dalí's art is largely autobiographical, one would expect scenes from the town in which he spent his childhood to figure in his works. The cityscape of Figueres, however, with its modest squares and blocks of apartment buildings, their stolid exteriors giving no clues to the life within, is almost absent from his paintings. One has only a few details from his writings and the memoirs of his sister, Ana María, to suggest the life that was lived there. In *Salvador Dalí vu par sa soeur* she writes that the building in which they were both born was at the intersection of the two most central streets of the town. Their first-floor apartment had a balcony running along its length. This overlooked the beautiful garden of a noblewoman, planted with chestnut trees, the topmost branches of which skirted the balcony. Most important in that sultry climate, it faced the setting sun, so that for much of the day it was in shadow. It appears to have been trellised by their mother, who hung it with cages of canaries and turtledoves. Great pots of tuberoses and lilies scented the air and the children played all day in the shifting shadows.

Ana María gives a charming picture of the times when her father would take over the whole street for an evening of dancing. The notary was a fervent admirer of the Spanish composer José María (Pep) Ventura, who had died in Figueres at the end of the nineteenth century and was famous for the music he wrote for the *sardana*, a traditional Catalan dance. The whole street would be perfumed, as was traditional. Then dancers were hired and friends invited to watch, from the scented balcony, the moonlit spectacle in the street below. If, after the performance ended, guests had climbed to the terraced roof of the building, they would have heard the night sounds of crickets from the encircling fields.

Dalí was ten and Ana María six years old when they were uprooted from this enchanted setting. Their parents discovered that the noblewoman's garden had been sold as the site for a new apartment building and that their precious 'gallery', as they called it, would be completely hemmed in. By chance another building, grand even by the standards of that ostentatious epoch, was being built a few doors away, at the corner of the Placa Palmier and the Carrer Caamaño. She and her brother would never forget the bitter day when those enormous chestnut trees with their rose-coloured flowers and bird-haunted branches were cut down. It was painful to have to dismantle the pergola under which their grandmother had stood patiently ironing the week's laundry, and where their mother offered titbits to her caged canaries between her teeth, while her children watched openmouthed. To Ana María the departure was the end of an idyllic period.

The family spent their summers in Cadaqués, the fishing village on the Mediterranean coast where Dalí's father was born and where they had a house. Nowadays the journey by car over the bleak hills separating it from Figueres takes about an hour but, when Picasso went there in the summer of 1910, it took six or seven hours and two changes of horses. The thin soil of these mountainous hills yielded important harvests of grapes until the phylloxera epidemic of the 1870s and 1880s wiped out the vines; even today the slopes are minutely terraced and olives are still grown for their oil. However, the handful of inhabitants – the permanent population is still only 1,500 – had always turned their faces towards the sea. In the days of sailing ships one could embark for America from a beach at Cadaqués, and two- or three-masted sailing ships could be seen at anchor until the First World War. Many of the inhabitants were pilots by profession, but fishing was also very important. When the season was good, fishermen's wives carried their baskets to the nearby port of Rosas, walking three hours there and three back.

Cadaqués was isolated but even in those days it was not unknown. Artists made a summer pilgrimage there, much as they were doing to St Ives on the Cornish coast, drawn by the subtle contrasts of barren cliffs in granitic greys, ochre soil, the muted silvery greens of the olive leaves, and the white fishermen's cottages with their shadowy interiors and slanting, pebbled alley-ways. Picasso began one of the most important periods of his work in Cadaqués, and other artists followed: Duchamp, Man Ray, Magritte.... The poet Federico García Lorca, who would become a close friend of Dalí's, was entranced by it, writing, 'I think of Cadaqués. To me it is a landscape both eternal and present, but perfect. The horizon rises constructed like a great aqueduct. The silvery fish come forth to bathe in the moon.'

The Dalí house may still be seen some distance from the village on a black shingle beach called the Playa d'es Llaners. It is now surrounded by other

villas but in Dalí's early years it stood in isolation, a stark white silhouette against a monochromatic background. There is nothing to charm the eye, simply a square façade with windows facing the sea. A kilometre or two away, on the other side of Cadaqués, is an even less appealing bay, Port Lligat, which was to play a pivotal role in Dalí's life. He wrote that the coloration was minimal: 'Only the olive-trees, very tiny, whose yellow-tinged silver, like greying and venerable hair, crowns the philosophic brows of the hills, wrinkled with dried-up hollows and rudimentary trails half effaced by thistles.' Yet this dour landscape, which he described as ravaged by age, was 'miraculously beautiful'. He learned the contours of each rock by heart and observed his surroundings so exactly that he could trace the path of the descending sun and calculate the precise moment at which, the rest of the landscape being in shadow, the last rays would bathe a single rock with a shaft of purple light. Outline, mass, density, contrast, and the point at which the earth vanished into the sea: these would become the leitmotifs of his painting. In the 'mineral impassiveness' of this forbidding landscape a solitary and intently observant boy would later project 'all the accumulated and chronically unsatisfied tension of my erotic and sentimental life'.

A famous photograph of the Dalí family shows them on the Playa d'es Llaners, seated in descending order upon a rock and as dressed up for an outing on the beach as an English family at Torquay. There is Dalí's mother, her placid, plump and handsome features creased in a slight frown, and Dalí's father, genial, a pipe in his mouth and hat well pulled down over his forehead to conceal his disappearing hairline. At their knees sits their son, expression-less, perhaps six years old, wearing a Russian-looking blouse, his short cropped haircut serving to accentuate his prominent ears and his thin knees above long black socks. Next to him one sees the slight figure of his mother's young sister who always lived with them, Catalina Domènech Ferrer, known as 'Tieta', bending protectively towards the little Ana María. A dear old lady, all in black, sits in a white rocking chair, Dalí's maternal grandmother, Mariana ('Ana') Ferrer Sadurni. Dalí remembered her as a tiny little woman, usually dressed in black bombazine, whose white hair, twisted into a small bun, was getting so thin on top that her rosy pink scalp shone through the few strands combed back from her forehead. She ironed and did the sewing and, perhaps when she was going blind, was painted by her grandson seated beside a window of their house in Cadaqués, a dim silhouette against the brilliant, sunlit scene outside. There were their neighbours, the young Ursula ('Ursulita') and Tona Matas, who also lived at No. 20 Carrer Monturiol and, since they were Argentinians, took *mate* (Paraguayan tea) every day at around six. Dalí was particularly awed by Ursulita Matas, who used to take him for walks in the park and who seemed to his seven-year-old eyes to be

the quintessence of Edwardian beauty and fame, since she was said to have been the inspiration for a character in the book, *La Ben Plantada* ('The Well-Planted One') by the Catalan novelist Eugenio d'Ors. In particular there was Dalí's nurse Llúcia, whom he also later painted when she was old and half blind; she was poor, but always optimistic, and watched him while he played on the beach. Ana María wrote that Llúcia had been a part of the family since the birth of the first Salvador, and that their mother had breast-fed her own babies, in contrast to the usual practice of middle-class Spanish mothers at that time to hire wet nurses.

[Llúcia] was a large strong woman. Her face was completely round, as if sculpted in clay, and wore an expression of profound benevolence. All of this tender feeling seemed to have expressed itself in her nose, shaped like a potato, which we often talked about with much affection. Llúcia's nose! The very incarnation of patience and honesty! Underneath this beloved nose was a mouth that was always smiling.

In that household filled with women, Llúcia had a special place in Dalí's heart. The image of her half-bent back as she sits on the beach occurs often in Dalí's paintings, as do the backs of other women important in his life: his sister and his wife Gala. 'I pressed myself closer and closer against the infinitely tender, unconsciously protective back of the nurse, whose rhythmic breathing seemed to me to come from the sea, and made me think of the deserted beaches of Cadaqués.'

So much of Dalí's autobiography is transparently designed to confuse and befuddle the reader with what he artlessly calls 'false' memories, that he went to careful lengths to explain that, in one particular case, he was not dreaming but actually did see a vision: of a seated woman's back. It was a Sunday morning. He had gone to the bathroom, meeting his father on the way, had chatted for about fifteen minutes, and returned to his bedroom. Opening the door, he clearly saw a 'rather tall' woman seated beside the window, in three-quarter view, wearing what looked like a nightdress. Quite sure that he was not dreaming, he decided to slip into bed so as to examine the phenomenon more closely, but when he turned his head for a split second the image vanished. That he was unusually affected by visual impressions and that these had an almost hallucinatory effect on him seems beyond question. Dalí adds in his memoir a story told by his father, 'who is the last person in the world to be given to this kind of thing'. Once when he was barely three years old Dalí was playing on a large terrace while several members of his family looked on. He suddenly stopped his game and stared at something he appeared to see, though they saw nothing, drew back in fright and was in tears for the

rest of the morning. Everyone was convinced he must have seen some terrifying apparition. This experience was linked in Dalí's mind with a strange experience his father had had in their house in Cadaqués. About to take a boat ride with his family, the notary returned at the last minute to get a handkerchief and was surprised to hear footsteps descending the stairs. He looked and clearly saw his mother, who had died eight years before. When he told his family about it he was pale and upset.

That the dead might indeed return was one of Dalí's most poignant fears. In the apparent belief that he loved to be frightened about such matters his nurse Llúcia, on the surface a model of sunny reassurance, liked to tell a particularly hair-raising story about Marieta, the wife who returned from the dead to haunt her husband. Marieta would climb the stairs one by one while her husband, in the room above, begged her to leave him in peace. Just as Marieta arrived at the last step Llúcia would pause for dramatic effect and then pounce on Dalí, screaming 'I've got you!'. It is not surprising that he wrote, 'Then I heard anguish ascend the stairway of flesh of my naked body step by step.'

The impression one receives from Dalí's writings and reminiscences is that his parents were almost boorishly bourgeois and lacked the most elementary interest in the arts. This is at variance with the picture his sister draws of their mother and father. Not only did her father plan fêtes in honour of the composer he so fervently admired but he also tried to commission some well-known authors of the day – Maragall, Llongueras, Ignasi Iglésias, Trullol – to write verses for Pep Ventura's immortal dances. In the eyes of Ana María he sits inside their apartment listening to an old recording of Gounod's 'Ave Maria', perhaps an excerpt from *Lohengrin* or his favourite opera, *The Pearl Fishers*, by Bizet. Outside, rustling past them in the gallery in a soft white dress, in pursuit of her flowers and birds, their mother sings in a melodious voice,

> *Era en ma vida, la nit encar*
> *dormia l'anima sense somniar;*
> *una mirada, despertar vol*
> *tota confosa de veure el sol ...*

Even their physically unprepossessing grandmother had a marvellous talent. She could cut elaborate pictures from sheets of white foolscap with a pair of tiny scissors and could keep her grandchildren enraptured for a whole day.

Snick, snick, snick would go her little scissors until trees laden with minute leafage, oxen whose horns were outlined upon a precipitous hillside, olive

groves, little towers and spires would detach themselves against a void, while even the smoke of a distant railway train passing along her hollow horizons would come into being in amazingly minute silhouette,

and her lap was covered with a snowfall of tiny paper clippings. When asked she would modestly reply that she had done it all her life. Their mother had an equally facile gift for drawing, one even her son mentioned. Using coloured pencils she could invent cartoon strips portraying the adventures of fantastic animals on a long strip of paper. This she folded to form a booklet that unfurled like a paper fan to reveal its sequence of miniature pictures.

Dalí claimed that he began to draw as a baby, covering the high sides of his crib with pictures of animals as soon as he could hold a pencil. When Ana María was a little girl one of their favourite games was making transfers. She wrote that they would be happy for hours, littering tables and chairs with crumpled bits of paper as they made designs in colours so hallucinatory they made her think of children's dreams. It seems clear that drawing and colouring were an essential part of Dalí's childhood long before he met the extraordinary family to whom he gives major credit for starting him on his road.

When Picasso was studying art as a young man in Barcelona he was a frequent visitor to a café-beer-garden-cabaret called Los 4 Gats, a haunt of the young Catalan intelligentsia, and where many up-and-coming artists showed their work. One of them, Ramon Pitchot, was making a name for himself in Paris as an Impressionist and was exhibiting views of Cadaqués, where he bought a house. Maria Pitchot de Gay, nicknamed Nini, his sister, was an opera star who performed all over Europe. Dalí believed that she had sent them a postcard from St Petersburg which was the inspiration for the Russian blouse he was wearing in his photograph on the Playa d'es Llaners. Nini was frequently in Paris during the winter season and, from there, would organize trips to Cadaqués for family and friends. In the summer of 1910 the visitors included Picasso and his wife Fernande. Others in the family were equally involved in the arts. Ricardo was a cellist and Luís a violinist; with their sister Nini they had given concerts of chamber music for King Alfonso XIII. Pepito, although a lawyer, had an advanced sense of colour and design. He was a close friend of Dalí's father, so that when Dalí became ill with a throat infection, he was invited to the handsome estate the Pitchots owned outside Figueres to recuperate.

Antonio Pitxot, the close friend of Dalí who is the son of Ricardo Pitchot, thinks this visit took place around 1910–11 when Dalí was six or seven years old. Since Dalí's memory is so precise and detailed it is possible that the visit took place later than this. On the other hand, whatever vague memories he

had of it could have been embroidered when he came to write his auto-biography in 1941. Be that as it may, it is clear that the stay at the Muli de la Torre (The Tower Mill), located on a plain some two hours from Figueres by horse and cart, was decisive for his future. At breakfast on his first morning Dalí found himself in a dining-room with walls completely covered by oil paintings and coloured etchings by Pepito's brother Ramón. If this Catalan artist has been awarded a footnote in the history of art it is because of his friendship with Picasso rather than for his work. To the eyes of a boy, however, his paintings provided an intensive course in the main movements in art in Paris at the turn of the century.

The earliest Pitchot owed everything to the characteristic style and subject-matter of Henri de Toulouse-Lautrec. Pitchot's principal work, however, followed Impressionist and Neo-Impressionist experiments with colour and light. Then as interest developed in ever-closer adherence to optical illusionism by such painters as Seurat and Pissaro, Pitchot's placement of colour became ever more precise and the size of his brush-stroke ever more minute until it had dwindled to *pointillisme*. This particular technique seems to have excited Dalí most. He wrote,

as one looked at [Pitchot's paintings] from a certain distance and squinting one's eyes, suddenly there occurred that incomprehensible miracle of vision by virtue of which this musically coloured medley became organized, transformed into pure reality. The air, the distances, the instantaneous luminous moment, the entire world of phenomena sprang from the chaos! ... But the paintings that filled me with the greatest wonder were the most recent ones, in which deliquescent Impressionism ended ... by frankly adopting ... the *pointilliste* formula. The systematic juxtaposition of orange and violet produced in me a kind of ... sentimental joy like that which I had always experienced in looking at objects through a prism.... There happened to be in the dining room a crystal carafe stopper, through which everything became 'impressionistic'. Often I would carry this stopper in my pocket to observe the scene through the crystal and see it 'impressionistically'.

It is fascinating to see that Dalí's instinctive choice of a technique based on scientific discoveries and dependent upon *trompe l'oeil* was made at a tender age and based on emotional affinity rather than calculation, or a desire to imitate.

Dalí was provided with a set of oils and canvas and given as a studio a large, white-washed room where it was sunny all morning, in which ears of corn and sacks of grain were set to dry. Each day he would set to work on a

pile of drawings, then tack them up around the walls, and each day Pepito Pitchot would come to inspect the results, shake his head and laugh. Dalí's conviction that he had found his goal in life was so emphatic that when, one day, Pitchot announced that he would ask Dalí's father to engage a drawing teacher for him, Dalí protested indignantly that he did not need one, since he already was an Impressionist painter.

In the room in which he was painting Dalí had noticed a handsome old wooden door riddled with worm-holes that was being stored there. He decided to paint on it a composition that had been obsessing him for some time, an immense pile of cherries. Using the outside border as the natural frame for this painting, he set to work on the inside panel, painting cherries with oils squeezed directly from the tube: vermillion for the bright side of the cherries, carmine for the dark and a touch of white as highlight. Before long dozens of cherries stood in handsome relief all over the door. Then it was pointed out to him that he had forgotten to paint their stems, so Dalí set to work eating some of his real-life models and gluing the discarded stems in place. The cherries looked more realistic than ever, and Dalí had a further inspiration.

I have already said that the door ... was riddled with worms. The holes these had made in the wood now looked as though they belonged to the painted pictures of the cherries. The cherries, the real ones, which I had used as models, were also filled with worm-infested holes! This suggested an idea which still today strikes me as unbelievably refined: armed with a limitless patience, I began the minute operation ... of picking the worms out of the door – that is to say, the worms of the painted cherries – and putting them into the holes of the true cherries and vice versa.

I had already effected four or five of these bizarre and mad trans-mutations, when I was surprised by the presence of Señor Pitchot ... silently observing what I was doing.... This time he did not laugh, as he usually did about my things; after ... an intense reflection, I remember that he finally muttered between his teeth, and as if to himself, 'That shows genius', and left.

Dalí's declaration when he was seven years old that he wanted to be Napoleon and that his ambition had been growing ever since is often quoted as proof of his blatant egotism. Here is someone not only precocious enough or audacious enough to predict he will become a genius, but one so naïve, or so incorrigible, that he flaunts it. Whether he expected everyone to burst into amazed applause, or be outraged at the shamelessness of his admission, is difficult to judge, since the tone of his memoirs is highly ambivalent. Behind

it all is the frame of reference that his writings set up for all he was to say or do: that he was so different, special, and absolutely unique that he could not be judged by ordinary standards. The reader, however, is likely to become increasingly sceptical and conclude that everything Dalí wrote was a joke at the reader's expense.

Yet those of his friends who believe Dalí is telling the truth here are correct. He most desperately wanted to be thought a genius, as is shown by his careful note about the opinion of a man he admired. Nothing less than immortality would do for a boy making a heroic effort, day after day and hour after hour, to prove his uniqueness. To construct an idealized personality, one that is omnipotent, is considered one of the ways in which children can compensate for an inadequate sense of self-worth. It is also axiomatic that the greater the deficiency felt, the larger and more grandiose the ambition.

Dalí seems to have discovered that he could prove his difference by being different at an early stage. On one famous occasion, when he was barely two years old, he had hurt the nurse he loved and thrown a temper tantrum. He never forgot his father's remark, that this new baby would not be like the other one. If the first Salvador had been a model of good behaviour then he would be incorrigible. If the first Salvador had never given his parents a moment's pain then he, the second, would make them face his stubborn rages. These soon became legendary. Ana María wrote that he was an adorable brother, affectionate and sentimental, but as stubborn as a mule, and loved in spite of his temper tantrums. Dalí explained that he had decided to be badly loved for himself, rather than well loved for being someone else.

Two aspects of his parents' reactions were working to make the situation worse. Young as he was Dalí knew that they could not bear to lose him, if not for his own sake, than for the person he represented. He therefore held a despotic power over them. Dalí's parents lived in a kind of terror that a hasty word would send their child into a fit of rage that must, in their imaginations, lead to illness and death; his most frivolous whim must therefore be granted. Ana María described another occasion when her brother was out walking with his parents and nurse Llúcia, who sported a pretty kerchief on her hair fixed securely in place with hairpins. Dalí wanted it and began to pull it off without further ado. His father remonstrated; Dalí redoubled his efforts. Llúcia began to wail in pain; Dalí was clamped onto her hair. His father seized him and tried to pull him off and his mother, in a panic, hooked onto his father. In the middle of the street everyone was screaming, and all because her brother absolutely insisted on having his way.

The only hope, Ana María wrote, was to distract him. On another occasion as he was being taken to a fair at the Castle of San Fernando in Figueres, Dalí decided that he wanted the red and yellow flag flying over the castle. 'I want

it! I must have it!' he roared. His father narrowly averted disaster by some hastily summoned stories. 'We did not know how to avert these crises,' his sister wrote, 'until we understood that there was only one remedy: when Salvador took a certain fancy, whatever it might be, one must not refuse his demand, but get him to think about something else.'

The inability of Dalí's parents to deal with his rages was compounded by their remarks. They made the elementary error of complaining about their son's incorrigibility in his presence. Observing her son climb down a slope and over a clump of prickly bushes, his mother said to her friends, 'He's always got to do just the opposite of everyone else – going down the steps was too easy for him!' And, when he changed his mind, 'See how capricious he is,' she remarked in his hearing, with melancholic pride. 'The whole day he's done nothing but ask to come to the fountain, and now that we've reached it he doesn't want to go there any more.' 'Do you know what Salvador has done now?' became the catchword for family and friends. He wrote, 'Everyone would prick up his ears, prepared to hear about one of those strange fantasies which were utterly incomprehensible, but always had the power to make everyone laugh till the tears rolled.'

Although Dalí was clearly a sturdy, healthy little boy, his mother's anxiety did not seem to abate. Whenever he played in the park she would remain standing, the better to watch him. He would be allowed to leave her side but the distance he could travel would be carefully defined and he would be warned not to get hurt. Dalí was four years old by the time his sister was born, yet she has clear memories of her brother's tears and storms if he awoke in the middle of the night to find himself alone. 'My mother had to pick him up again because he would only quiet down in her arms. She often passed long nights, seated on the bed, her child on her knees. Scarcely would she fall asleep than he would wake up and start crying again.'

This smothering attention ensured that Dalí would be kept in a state of infantile dependence, denied the forays into autonomy and self-reliance normal for his age. When he was old enough for school he would watch in helpless admiration as his playmates demonstrated their mastery of shoe-laces. For example, '[I] was capable of remaining locked up in a room a whole afternoon, not knowing how to turn the door-handle to get out; I would get lost as soon as I got into any house, even those I was familiar with; I couldn't even manage ... to take off my sailor blouse which slipped over the head, a few experiments in this exercise having convinced me of the danger of dying of suffocation.' Such dangerous solo ventures had to be avoided at all costs for fear of their terrible consequences. Elsewhere in his autobiography he noted casually that, to his family, he was always 'the child'.

Among those who tried to laugh off Salvador's crazy antics was his father.

That worried smile did not fool his son, who sensed that it betrayed 'the anguish of menacing doubts about my future'. Before long it became a kind of deadly game, which he played with increasing skill. 'Each day I looked for a new way of bringing my father to a paroxysm of rage or fear or humiliation and forcing him to consider me, his son, me Salvador, as an object of dislike and shame. I threw him off, I amazed him, I provoked him, defied him each time more and more,' he said. He routinely wet the bed. His desperate parents bought him a handsome red tricycle, which was stored on top of a cupboard, and which would be his as soon as he stopped. 'I was eight years old, and every morning I would ask myself, 'The tricycle or peeing in the bed.' And after thinking it over dispassionately, sure of humiliating my father, I would pee on the sheets.'

No child was cleverer at manipulating the adults around him. Once, after screaming with rage, Dalí lost his voice. Observing the effect on his horrified parents, he used it immediately as another weapon for getting his own way. 'On another occasion when I happened to choke on a fish-bone my father, who couldn't stand such things, got up and left the dining room holding his head between his hands. Thereafter on several occasions I simulated the hacking and hysterical convulsions that accompany such choking just to observe my father's reaction.'

As he correctly observed, he had become an anarchist, in automatic and methodical opposition. 'It was only necessary for someone to say "black" to make me counter "white"! . . . My continual and ferocious need to feel myself "different" made me weep with rage if some coincidence should bring me . . . into the same category as others. Before all and at whatever cost: myself – myself alone! Myself alone! Myself alone!'

CHAPTER THREE

The Boy from Tona

'I am but mad north-north-west; when the wind
is southerly, I know a hawk from a handsaw'
HAMLET

At a time when to dress up children in elaborate finery was the norm, Dalí
was a special case. There are winsome photographs of him at the age of three
or four, in a long cloak, his delicate features framed by a hat and one ear
prominent – his ears always did stick out – and his chin almost buried in
an elaborate ruffle, wearing gloves and carrying a walking-stick. In every
photograph he is decked out with similar sartorial finesse. Trips to the beach
at Cadaqués were an occasion for yet another costume, to judge from paint-
ings he later made of himself, such as *Myself at the Age of Ten When I Was the
Grasshopper Child* (1933) or *The Specter of Sex-Appeal* (1932). In these and
other works he is dressed in a matching outfit of short trousers, a long-sleeved
blouse with natty sailor collar, and a big beret. He wrote:

> I alone wore a sailor suit with insignia embroidered in thick gold on the
> sleeves, and stars on my cap ... I was the only one, moreover, who wore
> well-shined shoes with silver buttons. I was the only one to bring hot milk
> and cocoa put up in a magnificent thermos bottle wrapped in a cloth
> embroidered with my initials. I alone had an immaculate bandage put on
> the slightest scratch.

He was wealthier than the children at the town's communal school, to which
his free-thinking father sent him in order to avoid enrolling him in one of the
Christian or Marist schools he should have attended as a matter of family
status. The effect was to make Dalí feel particularly important. The more his
clothes proclaimed his preciousness the more he, with a kind of rapt
complicity, preened and pivoted. He would not get his feet wet, not he, nor
peel off a glove, let alone soil his delicate self by contact with the realities of
hunger, dirt and want. All his life he would remember particularly beloved
outfits: the ermine cape he received one Feast of Kings (Twelfth Night), and
a matching gold crown studded with topazes, a costume he adored. 'At the

39

age of six I wanted to be a cook. At seven I wanted to be Napoleon.' He was a king: absolute monarch of the household.

Dalí's comments indicate that he was aware of the compensatory role played by this elaborate game of trying on a new disguise, one he continued all his life: 'my life is one tragical sequence of exhibitionism,' he said in 1957. The child seduced by his parents into thinking he is someone else, learning the lesson only too well, comes to value only his image. The more idealized and grandiose the appearance, the more worthwhile he must therefore be. In Dalí's case the need to look magnificent and unique was further fuelled by his determination to have others accept him on his own terms. The less he believed in his own intrinsic worth, the more necessary such an assertion became. And, where exterior appearance was concerned, parental directives for once aroused no defiance. No doubt the more ruffles they placed around his neck, the calmer he became, the more blissfully absorbed, and the more he smiled at the image in the mirror.

Not surprisingly, Dalí resisted the idea of going to school where he might savour the most unfamiliar experience of being overruled: he was dragged through the streets by his father, roaring in monarchical outrage. Dalí, with his usual unreliability as to dates and proper names, misspells his teacher's name and says he was seven at the time, yet a photograph in his auto-biography testifies that he was enrolled in September 1908, at the age of four. He was presumably at the right psychological moment to learn, but had the misfortune to fall into the hands of Sr D. Esteban Trayter who spent his classroom hours asleep, only waking long enough to inflict painful punishments. Dalí, preternaturally aware, his olive pallor contrasting with the vivid complexions of other pupils, watched the chaos of the classroom in silence, recording in exact detail, for instance, his teacher's immense handkerchief, peppered with ochre stains from the snuff he took, or the complicated patterns his ragged schoolmates fashioned from tiny pieces of paper, or the amazing skill with which they tied and untied their shoe-laces. Then, with nothing left to observe, he would stare at the great vaulted ceiling of the schoolroom, tracing the outlines of its watermarked and bumpy surface until he could, like Leonardo da Vinci before him, conjure up at will a whole world.

Like many only children he was completely unprepared for the rough-and-tumble world he encountered and in a particularly vulnerable position. Anxiously hovered over at home, his every whim acceded to, he was, at the same time, thwarted in the normal urges towards independence and self-reliance that every child exhibits, until he no longer even felt them but passively waited to have everything done for him. Such a child, decked out in bows and ribbons, is the automatic target for every bully on the block. No

wonder they pulled off his shining shoes with their silver buttons and fought over them. No wonder he felt martyred by his own inadequacies.

Dalí's fetish about grasshoppers has been described in great detail. One might be tempted to think it an elaborate fantasy invented in the service of self-dramatization were it not that many witnesses attest to its existence. It came to symbolize everything about himself that he detested: his emotional infantilism, his morbid fear of death, his feeling of being the helpless victim of circumstance, and, above all, his aloneness. The problem began one day when a girl cousin decided to play with the grasshoppers found in great numbers in the fields around Figueres and Cadaqués. She threw one at him, not quite dead and a slimy mess, and it landed on the back of his neck. Dalí thought his world was coming to an end. 'Still tonight, as I write these lines,' he recorded in 1941, 'shudders of horror shoot through my back.'

Of course he screamed and of course his parents rushed to rescue him. But then somehow his schoolmates found out and he made the cardinal error of throwing a first-class fit. The performance naturally delighted his audience. It became the latest lark to maim some insect and present it to Dalí in as many ingenious ways as possible – between the pages of a book, for instance – and then wait for the certain response.

> In school my fear of grasshoppers finally took up all the space of my imagination. I saw them everywhere, even where there were none: a greyish paper ... would make me utter a shrill cry which delighted everyone; a simple pellet of bread or gum thrown from behind that struck me in the head would make me jump on my desk with both feet, trembling ... mortally anguished by the fear of discovering the horrible insect ...

What was most horrible for him was that, even though on the point of death, these loathsome crushed objects retained the ability to spring and clutch him with their jagged legs, 'as if all of a sudden the spring of their capacity for suffering had reached the breaking-point, and they had to fling themselves, no matter where – on me!' What reverberations the sight of a half-dead insect may have set up in Dalí's unconscious, already overburdened with thoughts of death and putrefaction, can only be guessed at. There are obvious parallels between this particular passage and the other one in Dalí's autobiography in which he describes the dead woman, climbing the stairs and finally pouncing on her hysterical husband with a scream of, 'I've got you!'

When Dalí went to Figueres communal school he knew the letters of the alphabet and how to write his name; by the end of his stay there, he had forgotten both. Dalí's father was obliged to swallow his principles and enroll his son in a school in which he was bound to learn something – that of the

Hermanos de la Doctrina Cristiana called 'Les Fosos' by the Figuerans. Ana María's memoirs establish that Dalí went there in the autumn of 1914 when he was ten, the year they moved to the Placa Palmier. There Dalí continued to live in a world of his own invention, but no longer in peace. His teachers, versed in the art of compelling a child's attention, resorted to 'the cruellest ruses and stratagems'. He immediately rose to the challenge. They had given him a desk near the window of classroom 1, and every afternoon the heavy wooden shutters would be drawn back to reveal cypresses silhouetted against a backdrop of the Pyrenees. Obviously bored by school, Dalí would escape by the nearest exit. He wrote, 'at a given moment, just before sunset, the pointed tip of the cypress on the right would appear strongly illuminated with a dark red ... while the one on the left, already completely in shadow, appeared to me to be a deep black.' When his teachers discovered their elementary error they moved Dalí away so that he could no longer see his trees. He, with implacable determination, managed to reconstruct the visual nuances by staring in the direction of the forbidden view. He was able to imagine how the scene must look by what was happening in class, saying to himself, 'Now we're about to begin the catechism, so that the shadow on the right-hand cypress must have reached that burnt hole with a dry branch coming out of it ... the mountains of the Pyrenees must be mauve.' He added, 'I did not want anyone to touch me, to talk to me, to "disturb" what was going on within my head.'

This extraordinary passage is one example among many of the power of his gifts, along with proof of the fortitude with which he could triumph against heavy odds. Unfortunately, this rare and desirable trait had already been soured by the continuing struggle between Dalí and his parents and, far too often, bent in the service of thwarting and frustrating adult expectations. And, in a school run along disciplinarian lines, that same tenacity of purpose was brought to bear against another tempting target. That these symbols of authority all wanted him to study was all the argument he needed for not reading, writing, or learning. So while his classmates raced ahead he, surely the cleverest child in the class, perversely stayed behind. What was more, he did it as deliberately as he had looked at the red tricycle before wetting his bed. What would thwart and frustrate everyone the most? There was no question about that, and so 'I still wrote nonchalantly, with thousands of blots and characters of bewildering irregularity. This was done on purpose, for I really knew how to do it well' – done, one assumes, for the sheer pleasure of exerting his powers. Then one day, by accident or design, he was given a new notebook of particularly beautiful paper and the artist in him got the better of the rebel. With great excitement he proceeded to fill it with exquisite lettering. Naturally, he won a prize for penmanship.

Despite the immense satisfactions to be had from continually enraging everyone it must have been galling, nevertheless, to be considered the stupidest child in the class. And so, at a certain point, he decided to give everyone a glimpse of his brilliance. When his teachers made the mistake of conceding that he had them completely mystified, he seized at once on the new opportunities afforded by this state of affairs. Reciting pieces learnt by heart was a nuisance, particularly since one was expected to answer questions afterwards. So Dalí leapt up and flung away a book that he had apparently been reading intently. Then he stood on his bench and quickly jumped down in terror, holding out his arms as if to protect himself from some frightful vision. Once again, he was the centre of solicitous attention, urged to go for a long walk and fed calming cups of herb tea. No doubt his teachers gave each other meaningful looks and shook their heads. He wrote, with transparent satisfaction, 'finally the superiors ceased altogether to attempt to teach me anything'.

One of Dalí's attention-getting devices was so successful that, with variations, he used it for years. Although one gathers he was an indifferent athlete, he was a strong swimmer and naturally good at jumping. He eventually won the championship in high and long jumping in his gymnastics class. This ability was quickly put at the service of larger goals. Dalí told a friend that he threw himself down a flight of marble steps at the age of five in order to gain his father's attention. Given his unreliability with respect to dates, it nevertheless seems likely that he began to soar off into space some time before the age of ten. 'How many times, walking peaceably in the country ... had I suddenly felt the irresistible desire to jump from the top of a wall or a rock whose height was too great for me; ... knowing that nothing could prevent this impulse I would shut my eyes and throw myself into the void,' he wrote.

Elsewhere he describes climbing onto the roof of the laundry on the top floor of their house and growing dizzy at the thought of the nothingness below him. Then he would have to fight against 'the almost invincible attraction that I felt sucking me toward the void'. That a staircase was a powerful symbol with multiple meanings for him, whether being mounted, one ghastly step after another, or as the pinnacle from which one plunged into oblivion, is evident from a famous passage in his autobiography in which he describes jumping off an enormous flight of stairs at school. He ended at the bottom, bruised but miraculously intact, to the astonishment and admiration of his classmates. Such a reaction to this spectacular, daring 'leap into the void', was so gratifying that, four days later (still aching, one assumes), and choosing his moment with care for maximum effect, he took another fantastic leap, screaming by way of added encouragement. The response was equally wonderful; he hardly felt the spreading bruises.

At first his exhibitionism was impulsive rather than calculated, a kind of blind striking out at those who would have confined him within the straightjacket of another's personality. By the time he made his famous leap, however (in 1920), such acts were coolly planned and weighed in advance. Whatever would Dalí think of next? With a single marvellous display he had riveted everyone's attention on him, and now he could manipulate their mean-spirited curiosity with all the arts at his command. He could, as he liked to say later, 'cretinize' people at will.

I shall always remember a certain rainy October evening. I was about to start down the stairs. The yard exhaled a strong odour of damp earth mingled with the odour of roses; the sky, on fire from the setting sun, was massed with sublime clouds ... my upturned face was illuminated by the thousand lights of apotheosis. I descended the stairway step by step, with a slow deliberation of blind ecstasy so moving that suddenly a great silence fell upon ... the play-yard. I would not at that moment have changed places with a god.

To conclude that Dalí was simply manipulating those around him would be unfair and incomplete; as has been noted, the main purpose of such acts was self-defence. One must believe Dalí is being truthful when he asserts that he was painfully shy: 'the slightest attention made me blush to the ears; I spent my time hiding.' The only way he knew of conquering his timidity, which perhaps he called cowardice, was by an act of the maddest folly. That there could be an alternative obviously never occurred to him. He chose (as it were) between desperate alternatives: to remain in agony, shrinking when spoken to, or to hurl himself against fate in a spectacular act of defiance. Death, or disablement, might be the result, but at least he would have the glow of others' amazement and approval, which would, if only temporarily, put paid to his self-doubts and make him feel godlike.

In short, he acted as if the way to solve one dilemma was by substituting another. One sees another example of this in the solution he invented for bringing the grasshopper game to an end. He bent a piece of paper into a 'cocotte', in the rough shape of a rooster. Then he pretended that this scared him much more than a real grasshopper did. 'When I saw a grasshopper I did my utmost to repress the display of my fear. But when they showed me a "cocotte" I would utter screams and simulate such a wild fit that one might have thought I was being murdered. This false phobia had an immense success ...'

To this ingenious method of dealing with life Dalí brought his developing skills as a raconteur and practised all the right blinks and knowing winks in

a mirror as he memorized his lines. To tell stories was, after all, part of life in Figueres at the time. People gathered in each others' houses, ostensibly to talk about current events, but mostly to tell one tall story after another. As Dalí recalled:

> Looking out on the street ... they could watch their fellow-citizens passing by, the sight of whom was a lively stimulant that kept the conversation welded to the immediacy of happenings in the town. Hilarity hovered over this predominantly masculine gathering like a whirlwind.... At times the strident roar of ... laughter could even be heard ... in the street, mingled with the choking coughs and ... plaintive screams of those who exceeded all bounds and went into ... convulsions.

Anyone who could excite such a reaction had, after all, a potent new weapon at his command. Dalí mastered the art to such a degree that eventually (according to Mayor Guardiola, no mean raconteur himself) his approach to humour was the very essence of the Ampurdán. It was of course outrageous, it was virtually unanswerable, and it served to illustrate the particular way in which a people, independent for centuries, had maintained their vigorous independence of mind no matter what the odds. To illustrate the particularly ironic quality of the Ampurdán sense of humour, Guardiola told the story of a certain mayor of Figueres who went by a house and noted that, on a wall without windows, someone had painted a beautiful window. It was complete with open shutters and flower pots. When the owner was asked why, he replied, 'To let in more sunlight.'

Guardiola and Dalí both tell the same story of a well-known local writer, Jean Carbona, who held court every evening at the Casino, then as now a favourite haunt of Figuerans in search of a game of cards and a quiet chat over coffee or cognac. As Dalí wrote,

> The invariable subject of conversation at his table was his mausoleum. He wanted to have a magnificent tomb built. He described it to us in detail and everybody chimed in.
>
> One evening the man who was scouting for the ideal place ... came on the scene. 'Señor Carbona,' he said, 'I've found it – a perpetual view of the Gulf of Roses, a guarantee that no other building will ever be put up between the grave and the sea, no sea breeze, no mountain wind, and very cheap to boot.' Carbona listened impassively, then said, 'I'm not interested in it any more.' Everyone was floored. For six years, there had been talk of nothing else. Why, they asked, this change of heart?
>
> 'I thought it over,' Carbona said. 'What if I don't die?'

The same writer, who was a friend of Dalí's father, used to visit them in Cadaqués, according to Guardiola. One summer evening the two men sat together watching the moon rise over the sea. Then Dalí's father turned to his guest and said, 'Have you ever thought about the mystery of the night, the symphony of the sky and stars?' Carbona replied, 'I'm not interested.' Dalí's father persisted, 'But doesn't it make you reflect on the great philosophies and religions, the possibility of life in other worlds, the poetry of the universe?' Carbona: 'I haven't really thought about it.' Dalí's father became even more eloquent and his guest ever more bored. Finally Dalí's father said, 'But what if I told you that in six minutes the darkness would vanish and the sun would come up out of the sea? Wouldn't you think you had gone mad?' 'Not at all,' replied Carbona. 'I would think the sun was mad.'

Guardiola also points to the particular regional dishes of the Ampurdán as further evidence of the paradoxical, not to say extremist, nature of the people who live there. Dishes are either sickeningly sweet, such as sausages doused in sugar, or horribly salty, sometimes both at once. There is no question that food – 'scattered grapes, boiling oil, fur plucked from rabbits' armpits, scissors spattered with mayonnaise, kidneys, and the warble of canaries' – loomed large in the youthful artist's imagination. Since to go into the kitchen was one of the very few things absolutely forbidden him, his day revolved around ways to sneak in there despite everyone, and 'snatch a piece of raw meat or a broiled mushroom on which I would nearly choke'. But, were he to become ill and not feel like eating, calling forth his parents' irrational conviction that he was doomed to die, he would be absolutely incapable of swallowing. Guardiola recalls Dalí telling him that, on one occasion, he refused food for three days until his parents, and particularly his father, were almost beside themselves. Finally he announced, 'Perhaps I will be hungry in Cadaqués.' To move the household, involving as it did complex preparations and an arduous journey of six or seven hours over the mountains, was no mean task. Such was their terror and his despotic power over them that the whole family undertook the trip. Dalí was silent until they reached the highest point of the journey, from which one began the descent into Cadaqués, and which offered a panoramic view over the bay of Roses, and then announced, 'I am hungry now.'

Perhaps Guardiola is right in thinking that the Tramontana had a contributory role to play. As everyone knows who lives on the plain of Ampurdán, the Tramontana is one of the most perverse, wretched and relentless winds known to mankind. It gains velocity and iciness as it sweeps across the Pyrenees to the defenceless plain, where it sometimes reaches such strength that, Dalí liked to say, one could lean one's weight against it and go to sleep. It is part of local lore that, when the Americans wanted to install a

radar device on the mountain above Roses, and put up a machine to measure wind velocity, the Tramontana blew it down. The ungovernable nature of this mean-spirited wind, which can spring up at any season, sending clouds of gritty dust into the air, breaking branches and making shutters crash, is blamed for whatever misfortune afflicts Figueres. If a man loses his reason, everyone knows why: his wits have been touched, people say, by the Tramontana.

As has been noted, her children saw Felipa Dalí as a woman of exceptional patience, an adoring, forgiving mother. According to Ana María Dalí, Sra Pitchot used to say that she had never known anyone give herself to her children with such a selfless passion. No one hovered over them with more tender concern and no one was a better audience. Looking at her son's drawings, she would say, 'Yes yes, if he says he is going to draw a swan, he is drawing a swan; and if he says it's a duck, it certainly must be a duck ...' Since she feared the outside world, she took pains to keep her children playing safely at home, and regularly invited crowds of others to keep them amused. Then she and her sister, Tieta, would spend hours devising entertainments. One of the children's favourite treats was watching the silent films of Charlot and Max Linder, and since the Dalís owned a primitive machine with a hand crank, their mother would patiently reel away hour after hour while Tieta wound and unwound the ribbons of film.

Shadowy as she is, one gets the impression that behind the perfect image of motherhood was a competent, practical woman who ran the household efficiently and well, perhaps even balanced the books; the indispensable central figure. Women were patient, strong, loving, in control of their feelings, and selfless; men were dependent, childlike, brilliant, impractical, and self-absorbed. One finds the united dedication of the womenfolk in this Catalan household analogous to that given by Jewish women in traditional families, particularly to the oldest son, along with the same boastfulness about male successes. One also finds, in this particular case, just a touch of fond condescension mixed into the Dalí equation. Women might be lesser figures whose own ambitions were sublimated by furthering those of their menfolk, but they could take comfort in their superior strengths. What is unexpected about Ana María Dalí's memoirs is the grown-up tone of her reminiscences. Born in May 1908, and four years her brother's junior, she continually groups herself with her mother, her aunt, her nurse, and her grandmother – the four women in attendance on the household, not counting cooks and maids – in her motherlike discussion of his childhood. 'We', she writes, ignoring the fact that she was then a little girl, 'were concerned about his grades or his illnesses and devised ways of coping with his temper tantrums.'

That Dalí saw her in like fashion can be seen from the sketch he made of her in 1925 or 1926. Dressed in a flapper's outfit, she kneels on a chair in front of a door holding her infant brother in her arms, a contemporary Madonna.

The major point made by the memoir she first published in 1949 is the idyllic nature of their childhood. The apartment in Figueres was spacious and beautiful, their parents indulgent, cultured and caring, and the house in Cadaqués even more wonderful, life there even more remarkable. They lived for the summers, going barefoot among the rocks, swimming in the sea all day long and, at night, absorbing the beauty of their surroundings. No doubt the village was bathed in that glowing, sparkling clarity which Josep Pla saw as the virtue of the Tramontana: 'Within three hours after the onset of the Tramontana, the sky is converted into . . . a dome of pure lines . . . the horizon seems to come closer, and things like the olive trees, the cypresses, the mountains and the dazzling sea, are seen in obsessively perfect outline.' While making reference to her brother's temper tantrums, Ana María attempts to correct what she sees as his mythical version of their childhood, published seven years before. Of course he never gave her a terrible kick on the head, or tried to throw a little girl off a tower or beat a little boy mercilessly, or any of the other disgraceful, crazy things he described. He was an exemplary being, tender, full of charm and thoughtfulness, brilliant from the cradle, who had a single shortcoming: a kind of wild streak. His parents did their utmost to wean him of that, with love and patience. If they never quite succeeded, the cause was his sheer perversity. He obviously had no reason for unhappiness, living such an idyllic life. She reproves him gently, she is respectful about his genius, and demonstrates, by means of long descriptions, that they were inseparable from earliest childhood. Further, she draws a portrait of a united father and son:

The following year, Salvador was to begin his studies for the baccalaureate . . . [My father] decided to take him to some meetings in Figueres on agriculture and the mysteries of procreation. Leaving the last of them, my father walked back slowly along the Monturiol towards the house, his son on his arm. Their two silhouettes were reflected in the shopfronts. One of them, a little bent, venerable, with white hair, blue eyes and a serene gaze; the other young, tall and slim, with black hair and penetrating eyes. But both faces had the same look of intelligence and benevolence, the fundamental basis of their noble temperaments.

Friends thought that Salvador was jealous of his baby sister and one would expect him to be, particularly since he was shuffled off to school soon after she was born. If she ever had cause to resent his superior position, there is

no hint of it in Ana María's writings. The great thing about their childhood, she wrote, was that they each had a lap – she, accepting the presumably lesser one, that of their aunt. Her references to her father are similarly benevolent, particularly with respect to his influence on their education. Perhaps it was unusual for a Catalan father to include his small daughter in discussions on such questions as astronomy, for instance. Yet in Cadaqués she was shown the same constellations as her brother by means of powerful binoculars, taught the same fables by heart, along with, no doubt, the same lore of the sea and the names of the winds that Dalí could reel off: the Migjorn, the Ponent, the Llevant, the Xaloc, the Llebeig, the Mestral, and the Garbi.

Dalí's father has to be given credit for the fact that his son's intellectual curiosity was stimulated at an early stage. His library was exceptionally well stocked and one gathers that he must have restrained himself from exhorting his son to go there, because Dalí read steadily and had looked at every single book within two years, according to him. These must have been the years between eight and ten, to judge from other evidence. Perhaps the atmosphere in the household was such that ideas, whatever their origins, were the subject of the liveliest continuing debate, pounced upon with such avidity that it would never occur to anyone to make a duty out of such a pleasure. And so, as a matter of course, Dalí read philosophy precociously early, concluding that he could do better than Nietzsche had in *Thus Spake Zarathustra*, and approving of Voltaire, particularly his *Philosophical Dictionary*. He was overcome with admiration for Kant, even though he did not understand a word, soaking up such learned discourses as if obeying 'a violent necessity for the spiritual nourishment of my soul . . .'. At length he would come to understand Kant and Spinoza and base his own researches on Cartesian foundations. Then, one day, he read a definition of 'identity' by one of these philosophers – which one he did not remember – and wept.

A good Catalan father, to judge from the Catalan humourist Santiago Rusiñol, always had a practical goal in mind. 'Make a good businessman of him,' Esteve told his wife in the famous novel *L'Auca del Senyor Esteve*, (*The Story of Mr Stephen*). 'Educate him the way he ought to be educated: to be serious, modest, prudent, a good payer and a good collector, and practical – above all, make him practical.' For the elder Dalí, other considerations were paramount. He was a follower of the Catalan educator Francisco Ferrer, later executed for his beliefs, a dedicated Anarchist who founded the *Escuela Moderna* in Barcelona to teach children about liberty and social equality. The high-minded tone of this and other Anarchist schools can be judged from the fact that schools founded to teach working men to read and write exhorted them to abjure vice and alcoholism, as well as religion. For the Anarchist movement in Spain was as atheistic as it was collectivist, anti-materialist and

anti-authoritarian. In this, as in other aspects of Dalí's intellectual development, his father's influence was immeasurable. Like others of the Catalan intelligentsia and educated middle class during the reign of Alfonso XIII (1902–31), Dalí senior chafed under the tight political control imposed by the government in Madrid, the authoritarian tone of which was designed to prevent secession by the richest province in Spain. By the same token, agitation was more or less constant to reorganize Spain into a federal republic that would give Catalonia and other regions control over such matters as schools, roads and cultural life. And in fact, for a brief time while Dalí was an adolescent, from 1914 to 1923, the region did administer its own hospitals, libraries, and schools, and celebrate its own traditions. This limited self-government was to be swept away in 1923 with the rise to power of General Miguel Primo de Rivera. It then, as at other times in the past, became a crime to publish Catalan nationalist literature, use the language, or dance the *sardana*, let alone fly the flag. To the end of his life Dalí considered himself an anarchist, although some thought the label misapplied. And, during his youth and young manhood, he believed with his father that the power of the Church must be broken: 'since I observed that my father was not going to church, and that my mother did, I considered the Church to be only women's business,' he said.

Although Dalí's father has been called a *'bon bourgeois'*, he himself would not have used the label. As a notary, he would have grouped himself with middle-class professionals, journalists, lawyers and college lecturers and, when he spoke about destroying the power of the bourgeoisie, he would have meant bankers, businessmen, and owners of factories. The latter were hated in Barcelona, as elsewhere in industrialized Europe, for the ruthless suppression of constant strikes, demonstrations, and other uprisings, symptoms of the desperate need for better working conditions among factory workers which included women and children. One is safe in assuming that the Dalí household heard some vehement denunciations, because to hate the bourgeoisie, however he defined it, was a lifelong theme of Dalí's: 'I am, and I have always been, against the bourgeoisie,' he said in 1969.

To support Catalan independence at that period was, *ipso facto*, to promote the dissemination of its culture, for the two issues were synonymous. The more a Catalan's political freedom was curtailed, the more pride he took in his poems, plays, prose, music, dances – and art – by way of compensation; to encourage their expression was an act of political defiance. If Dalí is right in believing that his father feared an artistic future for him, there is no doubt that the latter also had reason to be proud of his son. To have a creative genius under one's roof was further proof of Catalan superiority; it was as good as waving the flag.

Dalí's father bought him Gowans' art series, a collection of small monographs about masterpieces which Dalí said had a decisive effect on him: 'I came to know by heart all those pictures of the history of art.' He took pains to nurture his interest, buying 'books, all kinds of reviews, all the ... tools I needed, and even things that constituted only a ... fugitive caprice'. Fixing exact dates for Dalí's childhood is always a problem and so one cannot know whether Dalí's encounter with Siegfrid Burmann, a German portraitist and landscape painter, at Cadaqués in the summer of 1914, actually was the first time he was given a palette and tubes of paint, as one authority states, or does indeed post-date the painting experiments at the home of Pepito Pitchot, as would seem the case. It is known, however, that Dalí studied the rudiments of drawing and watercolours at Les Fosos, had extra lessons after hours and, once he began using oils, took to them with a vengeance.

He seemed to race off in a new direction with every artistic stimulus. That he was influenced by nineteenth-century painters of genre scenes is shown by the copy he made of a gentle Dutch interior, the work of the Spanish artist Manuel Benedito y Vives. He admired the seventeenth-century Dutch artist Gerard Dou, one of those in the Gowans' art series, and also Eugène Carrière, one of the founders of the Salon d'Automne, whom his father much admired. Asked as a young man which Spanish painters he admired most, Dalí gave, with Picasso, the name of Modesto Urgell, whom he called the 'Catalan Böcklin', and Mariano Fortuny. He called Fortuny 'the inventor of anecdotal colourism and the Meissonier of our country'. James Thrall Soby has pointed out that, unlike Picasso, Dalí cannot be considered precocious since he had not developed a consistently mature style in youth. In fact, he did not settle on one until he was in his mid twenties. Neither was he destined to follow the prevailing artistic trends towards Cubism, Futurism and Abstractionism, although he experimented with these styles as he did with everything else. His instinctive interest was in artists whose highly developed techniques were put to the service of telling a story.

For Dalí, subject matter lay all around: a mauve boat on a turquoise sea, an orchard in flower, the hills behind Cadaqués, cows grazing in a meadow, cypresses in a landscape, or his grandmother, sewing peacefully by a window. He worked all summer and, in eloquent testimony to his boredom, doodled in the margins of his textbooks all winter, turning prosaic diagrams into bizarre masks, sprightly constructions, odd amoeba-like shapes. One of the most charming testimonials to his inventiveness is a cartoon strip he drew to amuse his nine-year-old sister while she was ill in bed. Further evidence of his father's pride in his progress is described by Ana María: 'One year ... my father organized an exhibition ... in a small room of the house, and invited all our friends. My father, with the optimism and enthusiasm of his

ebullient personality, celebrated his son's success with a feast of sea-urchins on the terrace.'

To prepare for his baccalaureate, Dalí was enrolled in the secondary school run by Marist friars. Ana María states that he joined the Municipal School of Drawings in Figueres, directed by Don Juan Núñez, at the same time. According to her, Dalí was soon top of his class and his teacher's favourite pupil: 'This good friend was, for Salvador, an intelligent professor who understood his extraordinary gifts and guided him adroitly, never doubting that he would become a great artist and master of the art of drawing.'

Dalí called him a fine draughtsman and particularly good engraver, who had received the Prix de Rome and revered drawing and craftsmanship above everything else. He would explain 'the mysteries of chiaroscuro and of the "savage strokes" (this was his expression) of an original engraving by Rembrandt ...; he had a very special manner of holding this engraving, ... which showed the profound veneration with which it inspired him ... I would come home with my head full of Rembrandt.'

Dalí's exhibition at home was followed shortly afterwards by the first showing of his work in public, in the Municipal Theatre in Figueres, a building that would become inextricably linked with his name. That exhibition, in the summer of 1918, was followed by a second in January 1919. The magazine *Amporda Federal* noted that the young man had enormous gifts: 'The man who feels the light like Mr Dalí Domènech, whose being vibrates before the elegance of a fisherman, who, at the age of sixteen, makes bold use of ... lively and stylish brushstrokes, ... who possesses such a denuded sense of the decorative as his charcoal drawings show us ... is an artist ... who will attain fame.'

While still an adolescent, Dalí began to show a gift for critical writing, along with a facility for long descriptive passages, that was almost as pronounced as his artistic talent. At the age of fifteen he founded a magazine called *Studium* with some of his friends and, during its six months of existence, wrote for it steadily. He published his first poem and wrote a series on 'The Great Masters of Painting'; to him these were Goya, El Greco, Dürer, Leonardo, Michelangelo, and Velázquez. He also wrote short stories, one of which, although existing only as a fragment, serves to describe his view of himself at the age of fifteen or sixteen. Hedged in as it is by clichés and romantic conventions, the passage nevertheless provides a clear description of his state of mind and the intense emotional outlet that painting gave him:

He had a marvellous idea for a canvas; in the foreground, the courtyard of a ... whitewashed house which ... revealed ... a great profusion of colours; in the middle of the courtyard, a luxuriant cherry tree loaded with

fruit ...; in the distance, the whole plain ... reverberated with ... light and ... warmth ...

... he forced himself to translate what he felt in his heart, what nature told him ... indefatigable, athirst for art, drunk with beauty, he looked through his eyes with their clear retina at nature ... bathed in sunshine and gaiety, and he fell into ecstasy at moments, then went back to work again on the battered canvas, agitating his bony and nervous hands.

Writing prose, poetry, essays; drawing and painting – it conjures up an image very different from that of a boy who refused to learn and barely managed to pass his end-year exams. Left to his own devices, Dalí turned his extraordinary intellect to the task of learning everything at once. 'The fact is that from the time I arose, at seven in the morning, my brain did not rest for a single moment. ... My parents would always remark, "He never stops for a second! He never has a good time!" ' He seemed frantically determined to make up for all those lost hours, that almost demonic determination to conjure up the forbidden landscape. Given Dalí's automatic opposition it was fortunate for him that his father hesitated over an artistic future; had he been urged in that direction he might have blotted it out as deliberately as he ruined his school copybooks. As it was he had something to prove, and he pushed himself to the limits. 'I still had to invent ... a great philosophic work ... which was called "The Tower of Babel". I had already written five hundred pages ... and I was still only on the Prologue!'

Even more than most budding artists, Dalí seemed fascinated by self-portraits and did a number of them, notable more for their shifting moods than mastery of the medium. An early painting in blue and rose shows him perched on the edge of a chair battling with a canvas, the sea visible through open windows. In another work he makes a precise study of the shadows on his forehead and his neck is exaggeratedly long. He began to use a kind of shorthand for his own features, a blank face with black eyebrows that met in the middle. In another portrait of the same period his features are blurred and one sees a single, mesmeric eye. He is frail and poetic, or he is demonically energetic or, in yet another portrait, romantically mysterious. He looks out from the brim of an enormous hat heavy-nosed, sloe-eyed, and full-lipped, with a pipe in his mouth, debonair and self-assured.

Exactly when Dalí's father gave his consent to an artistic career is difficult to judge. One expert believes that this did not take place until after the death of Dalí's mother in 1921. However, Ana María wrote that, once Dalí began to do well at drawing school, which was some four years earlier, 'My father conceived the idea that, after having finished his studies, his son should dedicate himself entirely to his art. But, fearing that the road to success would

not be easy, . . . he also wished to give him the same profession as [Don Juan] Núñez, so that the material side of his life would be better assured. . . . This idea seemed perfect to my brother.' Since Dalí never lost an opportunity to stretch a point at his father's expense, his sister's memory is probably more to be trusted here. It is of small consequence, but it is an indication of the continual struggle between father and son.

According to Dalí, they fought every day. His sister said the fault was her brother's:

> When, during one of these explosions, he is wrong he absolutely refuses to recognize it and won't give up. He defends his point of view with childish stubbornness, looks for a thousand ways out, a thousand improbable explanations to present his conduct or his extravagance as simply a sign of his sparkling wit and genial temperament. However, nobody is less convinced than he is of the validity of his case. And so his arguments become aggressive and end by making all discussion impossible because, not knowing how to extricate himself, he resorts to cynicism, guile and outright lies.

As other observers have made clear, if Dalí was aggressive, obdurate, and outrageous in argument, he had learned his tactics at close quarters. When one reads Dalí's account of his childhood, what gives rise to the deepest concern is the casualness with which he describes the times when he attacks a schoolmate – and, despite his sister's reassurances, one is forced to believe that he often did. He also makes sure he has inflicted a savage blow. He seems to take special pride in his own violence and, particularly, a lack of any motive. The boy who had been made a martyr to his fears was hitting back blindly, anywhere and at anyone, the more anonymous the better. That his actions made no sense appealed to the Dalí he was deliberately inventing, someone whose actions baffled everyone: 'I exaggerated to the maximum my taste for mystification.'

One begins to build a tentative portrait of the Dalí family as capable of desperate gestures and violent self-assertions, of tender attachments or vendettas. There was the self-destructiveness of Dalí's grandfather that culminated in suicide. Then there was Dalí's father, with his erratic mood swings and membership in a political movement whose members believed in 'one supreme act of violence to end all violence', clearly a man of severe inner tensions and ready to combat the dangers he saw all around, whether actual or imagined. An anecdote illustrates this. It is said that when Tieta took the young Dalí and his sister to the circus, his father armed him with a knife in case the wild beasts should attack and Dalí, as man of the party, be

forced to hack his way out. Another anecdote demonstrates Dalí senior's attitude towards death and the grimness of his courage. Dalí said his father suffered intermittently from toothache all his life. 'The pain was so great that even after all his hair had turned white he would still weep bitterly. One day he smashed his fist upon the table and cried out: "I'm capable of resisting my toothache for all eternity, as long as I never die!" '

Dalí made a revealing admission when he was in his mid thirties: speaking of his dislike for his father, he said, 'I substituted a grasshopper for his image.' Here was the constant torment of his life; someone likely to spring without warning. Dalí cites two occasions when his father actually hit him. The first, he says, was when he was told that a comet was passing the Earth. Thinking he had seen its tail, he ran to the window in great excitement, colliding with his infant sister and kicking her in the head. He was beaten for that and also for another occasion on which, after being taken to a certain movie by his father because he insisted, he walked out. In short, he was punished for what was a genuine accident on the one hand and, on the other, for a reaction that might be considered exasperating but certainly not worth a beating. When would his father summon up a strained smile, although exasperated beyond endurance by his son's outrageous behaviour, when would he be sarcastic, when would he jump up and leave the room, and when would he roar with rage and lunge at his tormentor? No wonder his son never knew which way he would jump.

The provocations continued. Dalí's ambivalent attitude toward money was much remarked upon later in life. While he appeared to be money-focused and tight-fisted, particularly when it came to paying for services rendered, his ability to throw money away was legendary, along with a kind of comical helplessness about handling it. The friend of his early manhood, the famous Spanish film-maker Luis Buñuel, described an occasion in Madrid when he and the poet Federico Garcia Lorca asked Dalí to go across the street to buy some theatre tickets. 'Dalí was gone for a good half hour, only to return without the tickets,' Buñuel wrote. ' "I can't figure it out," he said. "I just don't know how to do it." ' Others describe the way Dalí's father would have to sew money into his collar when he went off alone or he would give it all away.

Whatever convoluted meanings money may have had in a family with memories of a gambler's bitter talent, there is no doubt that it was one of the areas in which the most destructive battles took place between father and son. One assumes that Dalí's father, by dint of great effort, had achieved a comfortable income. He certainly thought of himself as barely surviving, as the following declaration written in 1925 shows:

I have kept my word, making assurance for my son that he shall not lack anything that might be needed for his artistic and professional education. The effort ... this has implied for me is very great, if it is considered that I do not possess a personal fortune, ... great or small, and that I have to meet ... obligations with the sole ... gain of my profession, ... and that this gain ... is a modest one.

Dalí must have had it impressed upon him that financial sacrifices were being made on his behalf, because he immediately spent every penny he could wheedle from his parents. In one case he made short shrift of what he had by giving his schoolmates ten-*céntimo* pieces for every five *céntimos* they gave him. No doubt his father was outraged to learn about it, which would have been the point. There is something equally wrong-headed and obdurate about his father's reactions to this insolent unconcern. Rather than teach his son how to handle money and value it, the 'money doctor' went around after him paying the bills in restaurants and stores and, when Dalí went to the theatre the ticket was at the box office. Perhaps Dalí thought his father's money, like his love, was counterfeit. He could, his sister observed, always tell a genuine bank note from a fake simply by looking at it.

Dalí's explanation for his reckless games with money was that it was one more way to prove to everyone that he was mad.

I began now to be a subject of intriguing controversy: Is he mad? Is he not mad? Is he half-mad? Does he show the beginnings of an extraordinary but abnormal personality? ... One thing at any rate was ... certain: everything abnormal or phenomenal that occurred was automatically attributed to me; and as I became more 'alone' and 'unique' I became by that very fact each day more 'visible' ...

If to be 'mad' or 'crazy' was to be different, therefore noticed, therefore actually seen by his parents and others for what he was, a unique being, the more they labelled him as mad the more successful his campaign. His assessment of the dilemma he faced has a kind of intransigent logic. Since his parents' 'rational' view of him was actually manic, and since every word they spoke exacerbated an already impossible situation, then he would oppose their 'rationality' with his irrational behaviour.

When he was young his father used to threaten that, if he did not improve, he would end up like the 'Boy from Tona', a kind of vagabond jester and clown who, at the time, was popular throughout Catalonia. It was a bit like the threat that the gypsies would get you, but for Dalí it held no terrors. His instinctive sympathies were towards such outcasts. Another figure he admired was 'La Monos',

a singular woman, always covered in make-up and colourfully dressed, who was a popular figure in the old quarters of Barcelona. . . . The children used to run after her, workmen stopped their work . . . and men in the bars left their drinks to shout after her some coarse pleasantry. She was like . . . an irrational and absurd irruption into the life of the town.

Dalí explained that the Clown from Coria and the other jesters in the paintings of Velázquez were important people. They were the people who spoke the truth; 'I am a little like them, and I also tell the truth, and I must be allowed to tell it.'

The Voyeur

'A dream can be told literally.'

The memoirs of Ana María Dalí provide important clues to Dalí's childhood, since they reflect so transparently the attitude of the adults around her brother – loving exasperation. With the best will in the world, all those surrounding him continued to blunder in tragically misguided directions, while believing that they were giving him every advantage and treating him as he himself wanted to be treated. They never understood that they were rubbing salt into his psychological wounds. They also could not have realized that, by succumbing to their fears and expectations for the second Salvador, they were seriously compromising his hopes for a normal life and keeping him in a state of enraged emotional dependence. He was, to the adults of the household, 'the child', a monstrously spoiled, precocious infant who had to be amused, placated, petted, humoured, and protected from life. Having ensured that his son's normal emotional and sexual development would be blighted in this fashion, Dalí's father, who was nothing if not inconsistent, would in a fit of irritation remark that Dalí was 'too much of a baby for his age', as his sister noted.

> One day our parents went to visit an ailing friend and, on their return, announced that she was pregnant.
> 'Well, then, don't go back, so that you don't catch anything,' my brother advised in all seriousness.

That such a remark might have concealed a kind of Till Eulenspiegel wisdom did not seem to have occurred to Dalí's family. This and other double-edged comments were interpreted as sheer childishness, to be ended at once by hustling him off to a lecture on the birds and bees (the agricultural conference already referred to). Ana María Dalí does not describe a further aspect of their sexual education, which had the worst possible effect on her highly impressionable brother. Her father's idea of educating them was to leave a graphically illustrated book on venereal disease open on the piano. Dalí told an interviewer, 'I was terror-stricken.' To warn one's children

58

against sexually transmitted diseases in an epoch before antibiotics seems perfectly prudent, but to consider educating them with a graphic medical textbook insensitive, to say the least. It so frightened Dalí that he could not discuss the subject publicly until middle age.

The subject he did choose to discuss would, one assumes, have been taboo during his childhood. Small boys of his generation seldom escaped the threats that awaited them if they were found to be masturbating. Despite the near-universality of the phenomenon (ninety-three per cent of males and sixty-two per cent of females, according to one author), Victorian parents considered 'self-abuse', as it was called, such a terrifying symptom that it justified everything from mechanical restraints to threats of actual castration. A Spanish physician warned that such self-abuse would produce a lengthy list of symptoms, beginning with consumption, convulsions, and epilepsy and ending with loss of one's intellectual faculties and eventual madness. Should the culprit somehow cling to life he would most certainly be impotent.

This learned opinion, which appears to have been widely held by doctors in the United States as well as Europe, persevered into the twentieth century. 'It is often stated that masturbation is a cause of insanity, epilepsy and hysteria. I believe it to be more likely that the masturbation is the first manifestation of a developing insanity,' declared a Harvard University professor of pediatrics as late as 1920. However much weight may have been given to medical opinion there was no question about the all-pervasive influence of Catholic teachings. Dalí's friend and contemporary, Luis Buñuel, wrote as follows:

Our sexual desire has to be seen as the product of centuries of repressive and emasculating Catholicism, whose many taboos – no sexual relations outside of marriage (not to mention within), no pictures or words that might suggest the sexual act, no matter how obliquely – have turned normal desire into something exceptionally violent. With rare exceptions, we Spaniards knew of only two ways to make love – in a brothel or in marriage ...

Despite his and his father's intermittent atheism – both would eventually become fervent Catholics – Dalí was taught by friars and, as an early diary entry testifies, went to church where he confessed his sins and received the sacrament. Early in 1920, when he was fifteen, he wrote:

My mother wants it this way. Besides it is very interesting and is the thing to be done. In the confessional a well-fed and overweight clergyman covered me with the old, fading purple shade. '*Ave Maria purissima*' ... he

sighed raising his eyes to the sky. I answered like a robot, 'Bless me, father, for I have sinned.'

That same month the diary hints that in his adolescent view such urges were temptations of the devil, to be resisted on moral grounds, as the following passage suggests: 'During the afternoon my soul has been the place of a fight between my desires and ... willpower ... they won and I felt so rundown and unhappy.' Guilt and remorse are even more clearly stated in his autobiography. He felt in the grip of an awful compulsion, which he struggled to overcome or at least hold under tight control. In short, he was experiencing the normal stages of adolescence and, it is clear, pronounced heterosexual urges. Although the following extracts from what appears to be a voluminous diary are only for the month of January 1920 – if others exist, they have not been published so far – they are full of references to girls. He sees, in a window, the sister of a student friend to whom he has given a romantic title: 'Today I have seen the lady of the nights. She was recovering from sickness, sitting behind the window; with a melancholy mien.' Two days later he could be found hanging around the night school to watch the 'pretty art students' as they left classes. When a strange girl in a railway station began staring at him intently he gave her one of his best smiles. He kept a lively correspondence going with another girl. On the day of a big festival, he went out with a friend on the prowl for two other girls they had half arranged to meet. When, some hours later, they parted on the Rambla, 'Carmen was smiling sweetly and commenting about the possibility of our going together into the countryside ... during Sunday afternoons ... to walk; why not?'

Dalí went to a soccer match with the same friend a week later, restless and excited, hoping to see the same girls, then to a theatre where film showings were being alternated with live performances. He wrote, 'A huge crowd, mainly soldiers and out-of-town people, were frenetically, rhythmically applauding a chorus girl who was "quite well built". She winked and was making faces at a group of students.' They went walking around the town; yet another girl called them over. 'We had a lot of fun,' he wrote. Later the two boys roamed the town, 'happily talking about the conversations and fun that we would have tomorrow'. Such artless and unclouded descriptions of encounters are completely at variance with the picture Dalí painted in his autobiography. Instead of many pretty girls there was just one girlfriend who, he chillingly explained in graphic and highly elaborate prose, he decided to make absolutely miserable. By then perhaps he had become ashamed of his own positive impulses, but at the age of fifteen they were very much in evidence, demonstrating normal longings and considerable empathy:

When it was dark we went to the Xirau's; after that I went to sit on one of the boulevard benches.... There I saw enamoured couples ... walking before my eyes, showing their happiness ... up and down, up and down, whispering their rapturous feelings. They gazed at one another and in their faces there was a smile of happiness ... I thought about how happy they must be; and I smiled.

Dalí at fifteen was, then, a boy of tender responsiveness who hung around with girls, played soccer, billiards, and cards, went to the cinema, looked wide-eyed at chorus girls, confessed his sins to please his mother, wrestled with his algebra homework at one in the morning, and was late for school next day. One would expect him to take a keen interest in dress, as he does: 'A bunch of boys, pretending to be elegant and distinguished ... were wearing those narrow shoes, extravagantly coloured caps, narrow and [tight] suits which they probably had kept from the time of their first communion ...' One would expect him to be a bit of a hypochondriac, and he is. Finding that he had a temperature, he went straight to bed and, although he felt perfectly fine next morning, stayed in bed 'to avoid complications', watching the sunshine pour into the room through his net curtains. One is not surprised to learn that, witnessing a traffic accident in which a dog was killed, he 'was so scared when the accident took place' that he jumped into a ditch and got really dirty. He recorded the incident as if a bit shamefaced; it was, he wrote, 'a new subject to laugh and joke about'. It is evident from the diary that he was often called on to conduct the class at art school, and he invariably notes that he had 'done quite a good job'. He was working on one of his many self-portraits, and reading a book on art history avidly: 'Feverishly my eyes skim the pages. They were thirsty for ideas ...' At that particular moment he was still in the grip of the French Impressionists, especially Manet, Degas and Renoir, whom he intended to make the guiding spirits of his life. It is interesting, in view of the proficiency he would display later, that he gave the ability to draw well short shrift. 'I devote all my efforts to the colour and the feelings,' he wrote to one of his uncles. 'I just couldn't care less if one leg is longer or shorter than the other.' Colour and feelings were to be analysed, whether in oils or in his 'Impressions and Private Memoirs' as he called his journal. The Dalí family went on a picnic by the sea, choosing a spot on a small hill where a tablecloth had been spread, with four stones at each end. There they attacked a *garota*, a soup made from sea-urchins, and while his father made appreciative noises Dalí admired the glass objects on the table-cloth, mesmeric in the sunlight, and the way the sea curved inland through a series of small, glittering bays.

One is not prepared for the bulk of the comments in his diary, which centre

around politics and world affairs. In Barcelona, the latest in a series of assassinations and bombings by terrorists was thought, by the Dalí family evidently, among others, to be planned by bourgeois organizations so as to give the authorities an excuse to declare a state of emergency. Dalí noted in his diary for 7 January: 'Today a magnificent armed attack took place against one of the vilest men; he was really a fully-fledged terrorist. Fifty shots had been fired against the car of the loathsome Graupera.' However, Graupera was not yet dead, causing the diarist to quote the saying, 'Bad grass never dies.' More than 140 workers were in prison, a newspaper had been banned, trade unions suspended, and workers locked out of their jobs. When the lock-out ended after eight weeks, Dalí was contemptuous, asking:

What is the value of . . . appointed authority in front of the righteous man who has a high concept of what he should do? If according to what they said, the lock-out was the moral action to take, they had to stick to it under any circumstances. And if not prepared to act in this manner, then why start the lock-out?

World events received the same detailed daily comment. The Red Army was battling against the White, the latter heavily supported with money and equipment by the British and their allies, and winning. Kolchak, commander of the White armies, had just been captured. (He went on trial as a traitor and was shot a month later.) The forces of Communism were triumphing. 'I read now the unbelievable news that the Allies have stopped their blockade,' he wrote. 'The might of the Reds is today a reality that nobody tries to disguise.' He was following, in Germany, the demonstrations being staged by the Spartacus League, the political party founded by Karl Liebknecht and Rosa Luxemburg. These two 'communist martyrs', as he called them, had been arrested and murdered by Army officers the year before. However, the Spartacus League was too weak and he doubted it could succeed. In the spring, as everyone expected, the Red Army would attack Prussia, and when the workers united to support the invaders, there was a real chance of bringing to an end the 'loathsome militarism of the German people . . . If that does not occur,' he added with unusual prescience, 'then a much worse war is going to happen.' It will be clear from this and previous comments that Dalí was a Communist. He was actively proselytizing, tackling a substitute teacher without, one gathers, marked success, and lecturing any friend who would listen about the virtues of 'Communism, spiritual life and soul'.

It is not clear exactly which particular branch of leftist thought the Dalí males supported, the likelihood being that Dalí and his father were united in

their political views. However, that they were good Catalans and therefore
in favour of self-government and opposed to the forces of oppression wherever
they were to be found, is clear in everything Dalí wrote at this time. No one
living in Figueres could possibly have remained aloof, given the temper of
the times, or have avoided taking sides. As one distinguished leader of a
Conservative Catalan faction, Francesc Cambó, put it in 1917, 'Considering
the circumstances in which the country finds itself, the most conservative
thing is to be a revolutionary.' Dalí himself knew victims of political repression.
After talking to the father of a friend who had been imprisoned in the infamous
Montjuich jail in Barcelona, he wrote, 'He had fought twice against the police,
knocking them down with bottles. These events which, of course, honour the
person to whom they happened have greatly attracted my attention.' Passing
soldiers on parade he could hardly restrain his feelings of hatred and indig-
nation. 'My mind revolted [at the sight] of the murderers' organization!' No
decent person could fail to be moved by the courage of the oppressed.

Our workers have been hunted and badly treated, only because they
defended basic principles or moral issues! For these issues during many
centuries the working classes have given their lives. But principles and
moral issues are something that do not exist among the disgusting bour-
geoisie [which] ... is acting so stupidly that we will only feel contempt for
them.

Meantime Dali kept up his commentary on events closer to home. His sad,
emaciated professor of algebra had just died and he felt 'in the innermost part
of my soul as if I had a gall bladder of acute bitterness ...! Poor man! We
said ... he was so good, he endured from us so much.... He was a man who
fulfilled his duties.... But I have the feeling that he really was not getting
any happiness from being alive.' Meanwhile, Dalí took notes on the weather,
wrote to a girlfriend and struggled with his private temptations. 'I felt re-
comforted by the thought that the one who realizes his sins has already done
a lot,' he reflected. 'But this thought, is it not also a temptation?'

In the autumn of 1921 Dalí left Figueres to take the entrance examination
in drawing for the San Fernando Academy of Fine Arts in Madrid in the
company of his father and sister. None of his early self-portraits do justice to
his looks. There is always a subtle distortion, either in size of nose, length of
forehead or thickness of neck to mar the effect. Photographs, however, testify
that he was exceptionally handsome, with finely cut features, mesmeric eyes,
and a shock of thick black hair. Like most young artists of the period, he wore
his hair untidily long. His sideburns were exaggerated and he invariably had

a pipe (his father, it should be noted, was a pipe-smoker) dangling from the corner of his mouth, although it was never lit. He carried a cane topped by a gilded eagle with two heads and liked to affect a velvet jacket. The result was all that could be desired: 'Soon we won't be able to go out with you. We're made a show of every time,' his father complained. This was Dalí's signal to redouble his efforts. He substituted long trousers for short ones, worn with stockings and sometimes puttees, topping this outfit with a full-length waterproof cloak and large black hat. Despite these heroic efforts he still managed to look irresistible.

Dalí, at the age of seventeen, might have been trusted to take an entrance examination alone. However, his father was convinced that everything would go wrong if his son were left to his own devices, despite the reassurances of Dalí's drawing teacher, Sr Núñez, that Dalí drew so well that he could not fail to be admitted, whatever happened. By insisting on accompanying his son, by openly fretting – while the examinations were in progress, he paced up and down in the courtyard outside – by, in short, a lack of faith and any under-standing, Dalí senior once more set the stage for a tremendous battle of wills. As before, Dalí demonstrated his willingness to make himself miserable towards the greater goal of thwarting and frustrating his father. This time the stakes were even higher, the gamble the most desperate he had ever made.

The examination required applicants to submit a drawing from the antique. They were given six days to complete the project and the rules specified that the drawing must have the exact measurements of an Ingres sheet of paper, with the same margins. Dalí was given as model a cast of Baccus by Jacopo Sansovino, and he set to work. The first two days passed without incident. Then, on the third, the janitor who often chatted with Dalí's father while he paced, suggested that his son could not possibly be accepted because his drawing was too small and therefore his margins unacceptably large.

My father was beside himself from that moment. He did not know what to advise me – whether to start the drawing all over again or to finish it as best I could in its present dimensions. The problem troubled him all during our afternoon walk. At the theatre that evening, in the middle of the picture, he made everyone turn round by suddenly exclaiming, 'Do you feel you have the courage to start it all over again?' and, after a long silence, 'You have three days left!' I derived a certain pleasure from tormenting him . . . but I myself was beginning to feel the contagion of his anguish, and I saw that the question was actually becoming serious.

On the fourth day Dalí resolutely rubbed out his drawing, fully prepared to take his father's advice. No sooner had he done so than he was paralysed.

His competitors were all far ahead of him and had already begun to touch up their shadows. By the fifth day they would be almost finished, with plenty of time for the all-important final corrections that could not be hurried. Whereas he had nothing, and a precious half hour had already passed while he was erasing his work. He began again anxiously, trying to measure exactly so that his drawing would have the correct margins. Any student could have done it, but the harder he tried, the worse the result. At the end of the time he was back at the beginning, staring at a blank page.

It was immediately obvious to his father that things were worse than before. 'Now you have only two days left. I should have advised you not to erase your first drawing,' he told Dalí. Neither of them could eat that night although Dalí's father kept urging him to finish his meal, or he would be in worse shape the next day. The subject obsessed them both and even Dalí's sister, aged thirteen, looked upset. Dalí went to bed. His father tossed and turned all night, 'assailed by insoluble doubts – I should have erased it, I should not have erased it!'

Next day Dalí made a determined effort. He could have drawn Bacchus in his sleep. The drawing was large enough, all right; it was too large. 'This was worse than anything, a much worse fault . . . Again I erased it completely.'

By now it is obvious from his minutely detailed account that Dalí was on a collision course. He consciously believed that his father was right and set about following his advice but, unconsciously, he was antagonized and compelled to resist, even at the cost of his future career. Since his father was blind and deaf to the hidden message – that Dalí would draw exactly as he saw fit and no one would stop him – the situation was bound to go from bad to worse.

'If you don't pass the examinations,' Dalí's father said, 'it will be my fault and the fault of that imbecilic janitor. If your drawing was good, which it seemed to be, what would it have mattered whether it was a little smaller or larger?'

Then I whetted my maliciousness and answered, 'It's as I've been telling you. If a thing is well drawn, it forces itself upon the professor's esteem!'

My father meditatively rolled one of the strands of white hair that grew on each side of his venerable skull, bitten to the quick by remorse.

'But you yourself told me,' he said, 'that it was very, very small.'

'Never,' I answered. 'I said it was small, but not very *very* small!'

. . . Then my father paced back and forth in the room in absolute consternation. Suddenly he took a crumb of bread, and put one knee on the floor. 'Was it as small as this,' he asked, in a theatrical pleading tone, showing me the crumb with one hand, 'or as big as that?' – pointing to the cupboard with the other hand. My sister wept.

On the final day Dalí set to work and finished a beautiful drawing in an hour, complete with all the shading. It was perfection. He spent the rest of the time admiring it. 'But suddenly I became terrified as I noticed one thing: the figure was still small, even smaller than the first one.' He found his father reading the newspaper, a pathetic sight, unable to ask the terrible question to which his pitiless son gave the terrible answer. He was admitted, of course, despite his flouting of the rules. It was one more reason to consider himself the winner on all counts.

Once Ana María and his father had returned to Figueres, Dalí's natural penchant for hours of uninterrupted and dedicated effort reasserted itself. He avoided the temptation to talk to other students, go for leisurely strolls through the city or to the cinema. He even reveals that he was capable of handling money by his inadvertent comment that living only cost him a *peseta* a day, the price of his tram fares. His father had pulled strings to have him admitted in the Residencia de Estudiantes, which was cheap, very comfortable and looked, according to Buñuel, who was already there when Dalí arrived, like the campus of an English university. It would provide Dalí with a spectacular introduction to Spanish intellectual life. If this was immediately apparent, he ignored it. He shuttled from his room to classes and back again, locking the door behind him. On Sundays he spent the day copying pictures at the Prado.

He had already abandoned his Impressionist style. Gone was his love for Manet, Degas, and Renoir; he had begun his first Cubist paintings, directly influenced by Juan Gris. This new enthusiasm, however, presented enormous problems because, he discovered, his teachers at the San Fernando Academy were recommending French Impressionism as interpreted by Spanish painters of genre scenes – not just Impressionism, in other words, but the most watered-down and mediocre imitations of it – and resisting all other ideas. Not only had they never heard of Juan Gris or Georges Braque, or any of the new movements, but they had abandoned the teaching of classical methods. When he enquired anxiously how to mix his oils, the way to spread the colours, blend the tones, and other secrets of the art, they would reply that, since everything was made iridescent with light, as the Impressionists taught, he should colour his shadows purple – the doctrine he had thoroughly studied and already rejected. What seems to have irritated him most was that, while he longed for rigour, method, objective training, they espoused anarchy. Their students must be left free to paint exactly what they saw. Dalí's exasperated reaction, when he was assigned to paint a Gothic statue of the Virgin, was carefully to depict a pair of scales. At the end of the week the teacher who had arrived to correct and comment stopped in frozen silence before Dalí's exactly delineated offering. The culprit ventured, 'Perhaps you see a Virgin

like everyone else. But I see a pair of scales.'

That Dalí should find himself out of sympathy with the mood at the San Fernando Academy was not surprising. Barcelona at that time was a far livelier centre for the arts than Madrid and far more in touch with the Parisian avant-garde, notably through a series of exhibitions held at the famous Dalmau Gallery. As early as 1912 Dalmau had organized an exhibition of Cubists, and perhaps Dalí saw an exhibition in 1920 that displayed a wide range of styles then very much in vogue in Paris. He would have further educated himself on the latest movements through the Parisian art review, *l'Esprit Nouveau*, and *Valori Plastici*, the Italian art magazine. His works of the period show that he was trying to learn every lesson at once: Pointillism, Fauvism, Futurism – Dalí seized on each in turn only to abandon it. His imitations of the masters – Matisse's *The Dance*, for instance, and Picasso's Blue Period – were shameless. Whether he was willing to admit it or not, one sees in the constant search a continually evolving mastery of composition and technique, as well as a dramatic improvement in his ability to draw. He was also designing. He executed the cover for *Amporda Federal*, the mouthpiece of the Catalan separatists, in about 1921, and made a watercolour design for a biography of Pep Ventura, the composer his father admired so much, the same year. He illustrated books of poems, *Les Bruixes de Llers* (*The Witches of Llers*) by Fages de Climent and *L'Oncle Vicents* (*Uncle Vincent*) by Puig Pujades. A few months after he enrolled in Madrid, in February 1922, he exhibited in a group show, his first at the Dalmau Gallery. Flatteringly, eight of his canvases were selected. The following year, 1923, some of his paintings were shown at the Figueres public library.

In view of the subjects he chose to paint a few years later, it is interesting that Dalí's canvases of this period are unadventurous: Cadaqués, a friend sprawled on a beach, trees in blossom, a jug, the lane to Port Lligat, sketches of gypsies, or his sister Ana María turned towards the back of a chair, her head resting awkwardly on her arm. They are less daring than a subject he chose to paint in 1921: *Voyeur*, a highly stylized figure of a man in profile seated on a *chaise-longue* in front of windows in which one catches glimpses of women in states of undress. In one there is a pair of shapely legs; in another a woman's back; in a third a figure seems to be pulling off a stocking. There is also, in the upper right-hand corner, the back of a man and woman, the woman's head seeming to rest on his shoulder, his arm around her waist. Yet for the voyeur in the painting, curiously enough, these scenes do not titillate or arouse. He is slumped in his chair, unseeing and uncaring, as if deeply dejected by the display. A similar theme is treated in a fragment of a work in storage at the Dalí Museum in Figueres dating, probably, from about the same period. A young boy, his hands on his knees, is seated on a chair,

his eyes fixed as if on an unseen mirror. In the background a man, flashing a wide grin, has his hands on a fleeing woman.

That two of Dalí's early works have a related theme would be enough to make one wonder whether some family secret – too shameful to be revealed in that flagrantly exhibitionistic work, his autobiography – were being described. This could well be the case. Early in 1921 Dalí's mother died in a hospital of cancer at the age of forty-seven. During his mother's illness Dalí's father was having an affair with Aunt Tieta. He married her four years later.

No details are available, but given the main outlines one is justified in reading further significance into the fact that Dalí's early portrait of his father, painted during the same crucial period, 1920-21, contains the running figure of a woman in the background, wearing a very short skirt. Her features are not indicated, as one would expect if Dalí were including a portrait of his twelve-year-old sister or his mother. And, if it were his mother, why would she be wearing such a short skirt? No, someone else is obviously being alluded to here, and one notes that the outline of the woman's hair closely resembles the hairstyle Tieta wore in a family photograph on the beach ten years before. It is perhaps simply an interesting coincidence that preparatory sketches for his father's portrait juxtapose the notary's rotund and fully clothed figure with that of a nude.

Had the affair been going on for years beforehand? When did Dalí first learn about it? Did Dalí's father know that his son knew? The message suggested by the picture of the boy catching sight of an image through a half-open door would seem, from the broad smile of the male, to be that the affair was flagrant and that the boy, hands limply on knees, was powerless to resist. That whatever was going on behind closed doors was making Dalí miserable is, however, the clear message of *Voyeur*. Curiously, a book published in 1891 proposed that a man who was having sexual relations with two women simultaneously risked syphilis, the argument being that licentious behaviour was all that was needed for disease to erupt. Whether Dalí's father believed this and was led to warn his son against a calamity all too likely to afflict him is an open question. The book on the piano with its warning of the horrors of a prostitute's bed could also be seen to convey the message that, since the danger was so great, a man had better stay close to home. Incest, or near-incest, was to be preferred on the grounds of sexual hygiene.

Dalí never made a public statement about the circumstances surrounding his mother's death and father's remarriage. Even if his father had behaved impeccably, an adolescent with such extraordinarily high standards of behaviour, who had suddenly lost the mother he adored, might well resent the woman who took her place and begin to blame his father for her death, however irrationally. The suddenness of his mother's death, or the fact that

the truth may have been kept from him, would have added to the trauma. In the single reference to his mother in his diary for January 1920 there is no hint that she is ill. He described her and his aunt prosaically making the beds while they enthused poetically over the beauty of Beethoven's *Kreutzer Sonata*. A year later she was dead and he was devastated. Nevertheless there is no doubt that Dalí also had good reason for his suspicions and perhaps refers to them in his diary entry for 31 January 1920. Writing to a girlfriend, he said, 'I ... told her how desperate I was.' Some clue to his state of mind can be gathered from his comment, written in 1941, that 'In the middle of my chest I felt the thousand-year-old cedar of Lebanon of vengeance reach out its gigantic branches.' In 1962, after his father died, he made a slightly less ambiguous reference to the effect her death had on him: 'I had to achieve fame before avenging the affront afflicted on me by the death of my mother.' Somehow he would take his revenge but for the time being he who delighted in baring his soul to the world could not utter a sound.

CHAPTER FIVE
'I Advance Hidden'

Pero ante todo canto un común pensamiento
Que nos une en las horas oscuras y doradas.
No es el Arte la luz que nos ciega los ojos.
Es primero el amor, la amistad o la esgrima.

FEDERICO GARCÍA LORCA, *Oda a Salvador Dalí*, 1926

In that first year of life at the Residencia, 1921–2, Dalí seemed to one of his friends, a young poet named Rafael Alberti, to be work-obsessed, reclusive and diffident.

> I was told he worked all day sometimes forgetting to eat or arriving in the Refectory when the meal was over. When I went into his room, . . . I could hardly get in because . . . the floor was covered with drawings. Dalí had a formidable vocation, and at that time, in spite of his youth, he was an astonishing draughtsman. He drew as he wished, from nature or from his imagination. His line was classical and pure. His perfect stroke, which recalled the Picasso of the Hellenistic period, was no less admirable; outlines jumbled with rough marks, blots and splashes of ink, lightly heightened with watercolour, already heralded the great Surrealist Dalí of the first Paris years.

Reclusive or not, Dalí was ready to describe his paintings at voluble length in his strongly Catalan-accented Spanish, sometimes with considerable dead-pan humour. In one painting something that looked like a bundle of hemp was actually a dog vomiting, and in another what looked like tricorns tangled with tufts of hair on what might be a bed was actually two moustached members of the *Guardia Civil* making love. He was nothing if not articulate, logical, coherent, and to the point, in the opinion of another friend of those days, the Barcelona art critic Sebastià Gasch. 'He gave you the sensation that, having laboriously solved a series of moral and aesthetic problems, he had managed to secure certain crystal-clear ideals regarding the divine and human, and now he was explaining this with absolute clarity.'

Dalí wrote that his ascetic life at the Residencia came to a sudden end one day when Pepín Bello, not a poet or painter 'but a gentle and wholly

unpredictable medical student' happened to walk by his half-open door and noticed two very fine Cubist paintings that Dalí had just finished. Luis Buñuel said he was the one who first caught on to the fact that the peculiar young man who, for a reason he had forgotten, they called 'the Czechoslovakian painter' was a superb artist. In any event, the outcome was agreed: the Residencia coterie, more or less connected in philosophy with the 'Ultraists', the Spanish avant-garde admirers of Dada, Cocteau, and Marinetti, instantly adopted Dalí as their newest adherent. Apart from Bello, the poet Alberti, and another poet named Hinojosa, there was a young 'Ultraist' of acknowledged genius: Federico García Lorca. He was the elder son of a wealthy Granada landowner, five years Dalí's senior, who had come to the Residencia in 1920, at the age of twenty-one. In the tradition of his social class, he was taking a law degree at the University of Granada while he studied piano and guitar, collected, arranged, and performed folk songs from all over Spain, drew in ink and coloured pencils, and, of course, wrote poetry.

Thanks to Buñuel and Lorca, Dalí had an early introduction to the most important literary cafés in Madrid, where one might meet a famous novelist and biographer like Ramón Gómez de la Serna of an evening, order coffee and a glass of water, and begin a lengthy conversation about the latest literary scandal or political event. 'Sometimes an author would read one of his poems or articles aloud, and Ramón would offer his opinion, which was always respected and sometimes disputed.' They all trooped off to restaurants and there were monumental drinking bouts. According to Dalí, this was his first experience of going on a bender. Dalí also had something to offer; he would become the link between the 'Ultraists', Lorca in particular, and the literary and artistic avant-garde in Catalonia. He was writing almost as much as he was painting, poems, prose and articles on aesthetics in *l'Amic de les Arts* and other publications. Like other young Catalan intellectuals he was in revolt against all that was traditional, folkloric, and quaint about the past, including the *sardana*, and declared that the future of art lay with the machine. He may have agreed with the Italian poet Marinetti, also a dramatist and later a friend of Mussolini, that 'a new beauty ... a roaring motorcar, which runs like a machine-gun, is more beautiful than the "Winged Victory of Samothrace" ', although he would have expressed it with a somewhat less martial emphasis.

His enthusiasm ... for man-made objects [the telephone, gramophone, adding machine] springs from what he describes as his anti-artistic viewpoint, or rather from his horror of the illegibility, confusion and visual inefficacy of the conventional 'artistic'. The objects of the modern world

are by contrast clear, clean and pure. Dalí's 'hygienic soul', as Lorca described it, already shuns the emotional.

Another of his friends, Sebastià Gasch, made a less diplomatic comparison between the clarity and brilliance of Dalí's ideas and the troubling image he presented as a human being: 'His face, with skin as tight as a drum and as shiny as enamelled porcelain, was brown and seemed to have been recently made up as if for the theatre or the cinema. . . . In that hard, stiff, inexpressive wax doll's face, his tiny, feverish, terrible, menacing eyes shone with extraordinary intensity.' They were, Gasch added, the eyes of a madman.

There seems little link between the tough young intellectual Gasch described and the Dalí of the 1920 diary who, when a little boy's dog was run over, reassured the child immediately that his parents would buy him another one, or who empathized with striking workers and denounced social injustices, or who went to a recital and then floated home in a blissful haze, his thoughts full of the beauty and mystery of art. What Gasch saw was the same person Dalí described when he decided to have his long hair cut off. He wrote, 'With the age-avid mouth of the Medusa of my anti-sentimentalism, of my anti-Faust, I spat the last unprepossessing hair of my adolescence upon the pavement of time.'

He would have liked to act generously towards a fellow artist who admired his work unreservedly and who was desperately in need of an encouraging word himself. His instinctive responses were all in that direction. But 'the aesthetics of my attitude commanded me to act in just the opposite way'. Having turned him away with a cruelly flippant remark, Dalí reproached himself inwardly: 'I had sacrificed him! Yet another victim to the growing dandyism of my mind.' He might have liked to give money to a little old beggar woman in rags, the kind of outcast with whom the younger Dalí would have instinctively identified. Instead, he bought a vast quantity of gardenias and showered the old woman with the useless gift, looking back as he walked away until, in the moonlight, she was 'a little black mass with a white smudge . . . which was all I could see of the basket filled with flowers which I had left in her hands – hands gnarled like vinestalks and covered with sores.' He could no longer afford the luxury of empathy and sentimental gestures. He had to steel himself against the world's suffering, the desire for human contact, take a scalpel to the tender and vulnerable parts of himself or to whatever deflected him from his secret purpose.

At about this time Dalí began to make a discovery that was to form one of the cornerstones for his subsequent theories about creative method. The San Fernando Academy was shabby and sparsely furnished, and its student body

meagre. When it was announced that King Alfonso XIII intended to visit it, frantic efforts were made to improve the look of the building and give that royal personage the impression, by means of much running between classrooms, of a large and lively student body. At the end of the farcical performance Dalí was outraged. He ought to have denounced the authorities to the King; since he had not, it was up to him, he felt, to stage a protest of symbolic dimensions. Once everyone was at lunch he went to the sculpture room, emptied sacks of plaster into a basin, turned on the tap, and watched with growing satisfaction as a river of wet plaster flooded out of the basin, all over the floor, under the door, into the corridor, and even down the stairs. It was a majestic sight, almost as glorious as the burning of Rome.

Once back in his room he was 'seized with a mad laughter which gave way ... to a growing uneasiness'. Glorious as the gesture was, it seemed excessive, even for him. How was he going to talk his way out of that one? More to the point, what did it all mean? He simply could not understand why he had done it. 'Was I really mad? I knew that I certainly was not. But then, why had I done this?'

At the height of this all-too-real dilemma he woke up. The reality of what had actually happened flooded back; after the King left, he had taken the tram back to the Residencia and flopped on his bed exhausted. It was midday; he had slept for just an hour.

The discovery that sleeping in the daytime could lead to dreams so vivid that he actually thought they had happened was immensely significant for him. A few years later he would decide that it was possible and desirable 'to systematize confusion and thus to help discredit completely the world of reality'. However, for the time being it was enough to know the fantastic persuasiveness of a dreaming state. He was convinced that he was a genuine phenomenon, and therefore beyond limits, constraints, accidents of birth. He described one of these moods of exhaltation in which he found himself running through the streets of Madrid hoping to be noticed. When this did not produce the desired result, he began to make leaps into the air. This was certainly worth watching. He was delighted. 'Blood is sweeter than HONEY!' he yelled, punctuating each battle-cry with one of his admirable high jumps. In the middle of one of the best, he happened to collide with a fellow student whom he knew only slightly. He shouted 'HONEY!' into the astonished young man's ear and made a spectacular exit by leaping onto a tram. Next day he learned that the student was telling everyone, 'Dalí is crazy as a goat!'

In the autumn of 1923 Dalí was expelled from the Academy for a year. Significantly, in view of what was to happen three years later, the issue

centred around the questionable competence of those in authority. Numerous candidates were in competition for the vacant post of teacher of painting, and several artists with reputations had submitted canvases, which the academicians decided to exhibit ahead of time to the student body – a bad tactical error. Predictably, Dalí found them all hopeless with the exception of one, Daniel Vásquez Díaz, who seemed slightly less bad than the others, since he was at least an adherent of Post-Impressionism, if not Cubism. Before long Dalí found himself principal spokesman for the merits of Vásquez Díaz, with an enthusiastic following. There was a formal meeting; each candidate expounded on his methods of teaching, the academicians retired to make their choice and when they announced their verdict it was not Vásquez Díaz. Dalí, however, had been expecting the worst. It was simply one more example of 'the thousand injustices and unedifying episodes of which the tapestry of ... Spanish history is woven', he concluded, true to his high-minded and political activist beliefs. In the middle of the president's speech he rose quietly and left the meeting. What Dalí did not know was that this gesture of protest – polite and dignified, as he thought, since he did not interrupt or slam the door as he left – had been followed by a student uprising, at the end of which the academicians had been obliged to lock themselves into a classroom. Dalí's silent departure looked like the signal. He must be the ringleader, it was decided, and he was suspended for a year. For once, if one can believe him, it really was not his fault.

It hardly seemed to matter. Dalí was, as ever, following his own course and spent a year (1923–4) at home in Figueres painting and writing with his usual single-mindedness. His emphasis, from the very start, was on being published and exhibited, and he was always working towards that end. There is no proof that father and son continued their daily discussions about politics, but this seems likely, particularly since that year marked the rise to power of General Miguel Primo de Rivera, the new Captain-General of Catalonia, who proclaimed himself dictator in September 1923. Primo de Rivera had been supported by conservative Catalan groups at first, because he had stated that he would not repress Catalan culture. However, shortly after his coup, when he treacherously made it a crime to publish Catalan nationalist literature, use Catalan in public institutions, including the church, dance the *sardana* or fly the Catalan flag, militants were sought out for particular attention. At the end of May 1924, when anarchists gunned down the Barcelona city executioner, the government undertook a round-up of all known anarchists. Dalí's father may or may not have been the real offender, as Dalí liked to imply later – his father's literature, presumably politically seditious, having been found in his son's room – but Dalí was equally implicated. In any event, Dalí was the one who went to jail.

The actual length of time he spent in prison is difficult to establish. Some authorities say he went there on 24 May, spent nine days in solitary confinement in Figueres and a further twenty-six days in Girona. Dalí himself refers to a month. Later studies establish that he was jailed shortly before 31 May (perhaps 24 May) and was released by 1 June, which would make it a week. More important, however, than the length of time was Dalí's reaction to it. He always stated that he had had a wonderful time.

In my cell I learned to enjoy life in an exceptional way ... I was forced to hunch up over my own fate. I recall that they brought me small sardines in cans; my enjoyment was sublime: a little more oil, a little more bread, and always the same sardines that I would have spit out if I hadn't been in prison. The inquisition always forces those people with a very strong moral make-up to get the most out of their ... ideas.

It is possible, since Dalí runs the two events together in later writings, that he was refusing, for reasons of political expediency, to take offence on the second occasion in which he felt himself to be unfairly singled out and made a scapegoat. However, the phrase 'those ... with a very strong moral make-up' contains a clue. He would have had plenty of time to ruminate on the fate surely awaiting him if he did not learn to keep his political ideas to himself. It is, one concludes, a lesson he never forgot.

Dalí was back in Madrid in the autumn of 1924, where he enrolled in the Free Academy of Julio Moisés, renewed his friendship with Luis Buñuel, of whom he painted a fine portrait, and was in even closer touch with Lorca. The poet was invited to spend the Easter holidays with Dalí's family in Figueres in the spring of 1925 and went to Cadaqués, where he was predictably moved to verse by the beauty of the setting. It was 'real and eternal, but perfect', he declared. He was flirtatiously brotherly with Ana María Dalí, then aged sixteen and still wearing her hair in girlish curls at the back of her neck. 'Lucky you, Ana María, mermaid and shepherdess at the same time, olive dark and white with the cold foam. Little daughter of the olives and niece of the sea!' The three of them were inseparable in Cadaqués, where they spent several long summers, walking on the beach, sometimes dancing – Dalí did a marvellous Charleston – or spending lazy evenings over dinner, while they listened to the music of guitars and the mesmeric voice of the poet reciting his verses in praise of a golden world. No doubt they were also the first to hear his lengthy poem in honour of Salvador Dalí, his art, his world, his life, his looks, his goals. 'I sing of that anxiety about image that you pursue without respite,' he wrote, 'the fear of emotion which awaits you on the

street.' And further, 'I will not praise your defective adolescent paintbrush, but I will laud the perfect direction of your arrows.'

Buñuel considered Lorca the finest human being he had ever known. 'He was his own masterpiece. Whether sitting at the piano imitating Chopin, improvising a pantomime, or acting out a scene from a play, he was irresistible. He read beautifully, and he had passion, youth, and joy. ... He was like a flame.' Dalí had a very similar reaction: 'The personality of ... Lorca produced an immense impression upon me. The poetic phenomenon in its entirety and "in the raw" presented itself before me suddenly in flesh and bone, confused, blood-red, viscous and sublime.' One writer dates their friendship to 1922–3, but since Dalí drew a bookplate for Lorca in 1921 (a matador hovering over a bull), one may assume that the friendship began almost at once.

Few could resist Lorca. Buñuel recalled that when Lorca arrived at the Residencia two years later than he himself did, he had already published a prose work, *impresiones y paisajes*, in which he described the trips he had made with his sociology lecturer and other students from Andalusia. Gregarious and knowledgeable as well as sublimely talented, Lorca soon knew everyone who mattered and his room at the Residencia was by common consent the meeting-place. In contrast to Dalí, whom Buñuel remembers as a timid young man with long hair and a deep voice, wearing a bizarre assortment of clothes, Lorca, although he lacked Dalí's classic features, was always impeccably dressed, with beautiful ties and manners to match. Together he and Buñuel would lounge on the grassy open spaces behind the Residencia while he read his poems, slowly and gracefully. For Buñuel it was an introduction to a completely new world, marred only by a dreadful rumour that was making the rounds. One day he could stand it no longer, and challenged Lorca: 'Is it true you're a *maricón?*'

There may have been, as Buñuel said, 'absolutely nothing effeminate or affected about Federico', but there was no doubt about the nature of his loves. Some writers have given the impression that Lorca was enamoured of Ana María, but Dalí has consistently said, according to Buñuel, that 'Lorca nurtured quite a grand passion' for him. Dalí told an interviewer,

He was homosexual, as everyone knows, and madly in love with me. He tried to screw me twice. ... I was extremely annoyed, because I wasn't homosexual, and I wasn't interested in giving in. Besides, it hurts. So nothing came of it. But I felt awfully flattered vis-à-vis the prestige. Deep down, I felt that he was a great poet and that I did owe him a tiny bit of the Divine Dalí's asshole.

This assessment was made in 1966, thirty years after Lorca had died, but even in 1941 Dalí was assuring readers of his autobiography that he never had been, or would be, a homosexual.

The situation, it seems, was more complicated than that. If one subscribes to the view that photographs can be unconsciously self-revelatory, there are clues in those taken of Dalí in the summers 1925–7 when he was closest to Lorca. One sees Dalí in poses that could fairly be called vampish. (One could never say the same of Lorca, who always presented the vigorous male image Buñuel remarked upon.) He is, for instance, seen in a one-piece swimsuit at Cadaqués, waving from the tip of a rock with the sea behind him, his right arm in a graceful curve, for all the world like Miss Universe. Again, one sees him in a wicker chair, head turned towards a shoulder that is artistically hunched, his arms crossed, with a smouldering look. There is also a photograph of him in his studio at Figueres during his Cubist period, probably 1923–4, pretending to be Nefertiti and wearing a skirt.

Dalí discussed, with disarming frankness, moments of his childhood when he experimented with being a girl, and even painted himself as a baby girl. He refers to occasions when, after dressing up in his king's ermine cape, with the crown on his head, and picking up the golden sceptre, he surveyed himself in the mirror and then 'pushed my sexual parts back out of sight and squeezed them between my thighs so as to look as much as possible like a girl'. In his fantasy world the bitter rivalry between the two kings had not been settled and never would be settled. As he said when in his sixties, ' Every day I kill the image of my poor brother, with my hands, with kicks, and with dandyism.' He might have added that the battle was fought out on every level of awareness. At the end of a long, fantastical description of a reverie, he wrote, 'I was he, and since he was the real thing, all my autocracy was directed against the false one ... "I effaced the rival false king." ' When he wrote this, Dalí was reading Freud's *Interpretation of Dreams* and presumably the rest of Freud's writings, and this led him to a lengthy examination of the complicated cross-currents of feeling that, there is no doubt, had him in a constant inner turmoil in his early twenties. He desperately needed to explain himself to himself, and his explanation for wanting to be a girl was entwined with the idealized self he was deliberately constructing to replace the intolerable sensation of not knowing who he was. His explanation: 'the absence of the male sex organs in the idealized Dalí ... constituted one of his most advantageous attributes, for I have desired ever since to be "like a beautiful woman"'. The long-term effect of living with a doting mother, one whose fears were put to the service of protecting him from every conceivable danger, real or imagined, and who communicated such an intense fearfulness, had left him emotionally immature, his normal drives towards self-reliance and

independence gravely stunted. She had robbed him of a sense of his own masculinity and kept him clinging to her mentally, along with his childish image of her as all-powerful, while at the same time giving him good reason to fear a close relationship with a woman. By fantasizing that the woman possesses a penis, it is believed that the male transvestite overcomes what is a very real fear of castration. In psychoanalytic terms, he identifies with a primitive type of powerful mother figure, sometimes called a 'phallic woman'; paradoxically, he feels more of a man when wearing a woman's clothes. In Dalí's case, he was solving the double sexual and personal dilemma at one stroke.

Dalí's statement, that men did not interest him, is supported by the psychoanalytic belief that transvestism and homosexuality are totally independent phenomena. Once he had recovered from the flattery of being pursued by a brilliant poet, Dalí would have found the relationship irritating and even alarming. There is a pen and ink sketch of Lorca by Dalí (1926–7) in which the romantically dressed Lorca, with a moustache, beard and pipe, is seen removing what looks like a soft object from a pouchlike shape. Given the importance Dalí would attach to this particular symbolism a few years later, it was a sinister gesture.

Two works by Dalí, one of them his beautifully composed portrait of Buñuel, the other a still-life titled *Siphon and Small Bottle of Rum*, were shown in a group exhibition in Madrid in the summer of 1925. That winter, when he had just turned twenty-one, Dalí had his first one-man show at the Dalmau, the best gallery in Barcelona. It was, to say the least, an auspicious debut.

The young man who had grandly announced that drawing meant nothing to him had now shifted his artistic emphasis: to draw well was supremely important, and he quoted a maxim of Ingres: 'Drawing is the probity of art.' As the critics were quick to appreciate, the young artist had taken his lessons to heart. The portrait on the cover of the catalogue, that of a seated woman's back, with what looked like houses and the hills of Cadaqués in the background, was admirable from every point of view. She was, in fact, Ana María, his favourite model for that period, and she appears in a number of sketches and paintings, from the front, the side, and the rear. In another marvellous study she is depicted at a window, staring out to sea at a tiny yacht in the far distance, one foot poised behind her.

With the exception of one early landscape, the seventeen paintings shown were all recent. In their emphasis upon a strictly formal, classical approach, their geometric rigour and detachment, they reflected Dalí's commitment to what was being called the 'New Aesthetic'. Interestingly, however, one of a series of admiring reviewers thought he sensed someone else struggling for expression. He wrote,

Close attention to these works tells us that he has not resolved the aesthetic problem as well as one might have believed. The most curious and stimulating aspect of this extraordinarily interesting exhibition ... is exactly the struggle which, silently, and perhaps without knowledge of the artist himself, is going on in his spirit between the theories of the 'New Aesthetic' and the realistic tradition. Ingres, Picasso, an academic salvo, the systematic suppression of emotion, tend to strangle a temperament closer by inclination to romanticism. This observation is suggested ... by the duality of concept one sees in a number of his works. How can it be that in areas at the core of his landscapes and seascapes, those which harmonize with the subjects in the foreground, the technique is more ardent, sinewy and spontaneous than in other fragments of the same painting? Why is it that, in the same study of a person, the clothes and accessories are very often treated with a far more expressive brush?

Speaking of Dalí's brilliant composition *Venus and a Sailor*, painted in memory of the Catalan poet Salvat-Papasseit, who had just died, the same reviewer wrote, 'We often find a certain resemblance between the spirit of the dead poet and that of the young painter from the Ampurdán. Beneath this aspect of the avant-garde one finds a romantic.' The comments by this anonymous critic were more telling, but certainly similar in kind to those made by Dalí's teachers, who did not think he was a born painter because he lacked feeling. 'He is very serious,' Dalí quoted them as saying, 'he is clever, successful in whatever he sets out to do. But he is cold as ice.'

Dalí frequently announced his intention of beginning Lorca's portrait, but it never materialized and the poet had to content himself with a severe early still-life by Dalí, painted in 1924. He hung it in his room at the Residencia and, in a bow tie, hands crossed over his knees, posed beneath it for his photograph. Dalí did, however, contribute essays for a short-lived magazine called *gallo* directed by Lorca and a group of his friends, and designed the sets and costumes for Lorca's play *Mariana Pineda*, which was performed in a theatre in Barcelona in the summer of 1927. The production seemed to cement their union and proclaim it to the world. A caricature of Lorca that appeared in a magazine at that time shows Dalí in the lower right-hand corner bowing his head as if in amused obeisance to the other's triumph.

There were, however, important differences of philosophy and approach between the two men. To Dalí there was something disgustingly sentimental about the way Lorca espoused folklore: 'He had an enormous dose of romanticism, something I find unacceptable. He was much too fond of the Gypsies, their songs, their green eyes, their flesh that looked as if it were moulded with

olives and jasmine: all the crap that poets have always loved.' Dalí later wrote to their mutual friend Gasch,

> I remember the interminable arguments that would go on until three or five in the morning. ... At that time in the Students' Residence everybody was reading Dostoievski; the Russians were in vogue. Proust was still unexplored territory. Lorca was indignant at my indifference toward these authors. [But] ... whenever he made reference to the interior world, he would leave me absolutely indifferent, or rather, it struck me as something extraordinarily disagreeable. I rejected every human emotion, and at that moment I became a devotee of geometry; my preferences only had room for purely intellectual sentiments.

There is no doubt that Dalí cut Lorca out of his life brutally. Lorca was one more sacrifice to his 'dandyism', to his aesthetics, to his scorn for tender feelings, construed as weakness, to his rejection of the romantic side of his nature, and also, in this case, to a genuine feeling of having been violated. He betrays this in his comment that, at a particularly bad period of his life, 'another shadow, that of Federico García Lorca, came and darkened the virginal originality of my spirit and of my flesh'. But that such callous acts, seen through the rosy lens of heroic defiance, were part of the mood of the times, is undeniable. Buñuel wrote regretfully about their habit of indulging in *chulería*, which he defined as 'typically Spanish behaviour, a blend of aggression, virile insolence and self-assurance'. It was, no doubt, while in the grip of *chulería* that Buñuel and Dalí decided to write a poison-pen letter to the poet Juan Ramón Jiménez, whom they knew well and, in fact, sincerely admired. They justified their decision by telling each other it was a gesture of political heroism, something that would subvert the monarchy at one remove, since Jiménez was the most prestigious man they could think of. They were probably both drunk.

> So we composed a frenzied and nasty letter of incomparable violence ... We told him he was a dirty bastard, a queer, we went further than any impudence ever dreamt of by the Surrealists. We dumped on all his writings ... Buñuel developed qualms, and was hesitant about mailing the letter. I was slightly irritated, and so we finally sent it off.

This piece of gratuitous nastiness, about which Dalí was later very contrite – 'I committed the cruelest act of my life' – can be dated fairly close to the spring of 1928, because in March of that year Dalí was still railing to Lorca about the unspeakableness of Jiménez: 'he is, I think, the supreme head of

poetic putrefaction, the worst putrefaction of all, because beside him that great pig and vulgarian Rubén Darío by the virtue of his execrable taste takes on a certain South American gracefulness.' Perhaps the attack on Jiménez was Dalí's way of working himself up to an adequate pitch of unjustified rage against Lorca. If so, he soon succeeded. A month later, after receiving Lorca's newly published collection of poems, *Romancero gitano*, Dalí wrote him a long letter denouncing his work as 'retrogressive, stereotyped, commonplace and conformist'. Lorca, who was the soul of courteousness, simply remarked to their mutual friend Gasch that he had received an opinionated and penetrating critique from Dalí. However, the blow could not have been better calculated to wound: with it, Dalí frustrated, enraged, and alienated his dearest friend.

At Christmas, 1925, just a month after the great success of Dalí's first one-man show in Barcelona, his father began to gather the growing number of reviews into a large scrapbook. In it he wrote a lengthy statement outlining his assessment of the progress his son had made so far. He went over all the old ground: his and his wife's original reluctance to see their son dedicate himself to art, given the almost insuperable obstacles to be overcome, and the compromise that had been agreed upon. They had given in, he added, mainly because their son was intellectually so lazy that he would never apply himself to anything else. The statement was written in the awareness that Dalí's final examinations were a few months away. Once Dalí had the official title of professor of art in his pocket it would be an easy matter for him to obtain a secure position and a steady income. 'In this way I would have the assurance that he would never lack the means of subsistence, while at the same time the door that would enable him to exercise his ... gifts would not be closed.' It was clear from this message, which Dalí senior evidently meant for all eyes, that he was pleased with his son's progress. If some problems at school remained, his son was less to blame 'than the detestable disorganization of our centres of culture'. His son had already completed two courses and won two prizes, one in art history and another in colour painting. In fact, if Dalí had a problem, it was that he was too busy painting to pay proper attention to his work. This was the reason, his father was artlessly convinced, why he had not done better.

He would have liked Dalí's public success to have come later, once his professorial future was secured. However, he had to confess himself content, 'for if it should happen that my son would not be able to win an appointment ... I am told that the artistic orientation he is following is not completely erroneous'. Despite his caution, it was clear that the notary expected his son to pass with flying colours. Nothing seemed more likely to both of them, and

this presented an acute problem for the son in the spring of 1926. Passing the examination would lead inexorably to teaching. However, if he could somehow return home empty-handed, he might be able to convince his father to let him study in Paris. How could he avoid winning, unless he could think of some audaciously clever way out?

Salvador Dalí was told to present himself for the art history part of his examination on 11 June 1926 at 12.30 p.m. At the appointed hour the examiners were convened, but the candidate was not there. He telephoned to ask if he could come to the second session three days later, 14 June. Permission was granted. The day came, the candidate presented himself and was invited to choose three subjects at random. He then replied, 'No; none of the professors of the School of San Fernando being competent to judge me, I retire.'

Certainly nothing like this spectacular rebellion had ever been seen at the Academy before. There was every chance that his ruse would work. However, it was remotely possible that, given his artistic success, the examiners might swallow the insult and give him another chance. Or Dalí may have feared pressure from home. At any rate, in the eight days that followed Dalí let it be known in Barcelona artistic circles that his art history teacher had refused to let him take the examination, a transparent lie since the teacher was away at the time. He spread the further rumour that, in the face of such evident injustice, the president had convened a new jury which awarded him a prize. All this the disciplinary committee, meeting on 22 June, seemed to have heard and rightly recorded in the minutes. Dalí was expelled.

'On my arrival in Figueres I found my father thunderstruck by the catastrophe of my expulsion.' Dalí goes on to state in his autobiography that, immediately afterwards his father, along with his sister, posed for one of his most successful pencil drawings. 'In the expression of my father's face can be seen the mark of pathetic bitterness which my expulsion from the Academy had produced on him.' In the droop of his father's mouth and his sagging body one can perceive the expression Dalí describes, indeed see it twice over, since two very similar pencil sketches exist of Dalí's father and sister. One is in the Museo de Arte Moderno in Barcelona; the other is owned by Dalí's cousin Sra Montserrat Dalí de Bas of Barcelona. The inference is that, victory being so sweet, Dalí prolonged the pleasure of recording, with Ingres-like exactitude, his father's acute disappointment. It suits the portrait he is painting of himself. However, in this case the facts cannot be made to fit since both versions have the wrong date; the sketches were incontestably drawn the year before.

Blood is Sweeter than Honey

'that familiar solitary pleasure, sweeter than honey'

Dalí's first exhibition in 1925 at the Dalmau Gallery in Barcelona was the most prominent of a chain of events that would take him straight to Paris. The art dealer, Josep Dalmau, was a retired painter who had become 'a bellwether for the members of the vanguard in Catalan art'. Dalí described him in similar terms, adding that he 'looked as though he might have just stepped out of a painting by El Greco'. Dalmau was particularly respected for having nurtured the career of Joan Miró, the Catalan painter eleven years Dalí's senior, and had given him his first one-man show in 1918. He went even further by arranging for Miró's second one-man show in Paris three years later. By then Miró, who was Barcelona born and bred, having come from Montroig, a small town on its outskirts, had moved to Paris and made his own link with an even more influential Spaniard, Pablo Picasso.

The line Dalí-Dalmau-Miró-Picasso was therefore direct but, even easier than that, Dalí already knew Miró through his family connections. Lorca had his own connection to Picasso through the Spanish Cubist painter Manuel Angeles Ortiz and the great man himself, who had happened to be visiting Barcelona, had actually gone to see Dalí's work. He particularly admired the pick of the group, Dalí's portrait of a back view of a seated Ana María. Subsequently Picasso's dealer Léonce Rosenberg wrote to ask for photographs of Dalí's other works. Since all of these connections had already been made by the time of Dalí's final examinations, it is no surprise that he was convinced, with all the strength of his powerful personality, that if he played his cards right, he could 'put them all in my bag with one sweep'.

It would have been evident to him from the start that his eventual goal would be Paris. In his diary of January 1920 he records a conversation with an artist who was on his way there. As Dalí described it, Paris, with its wide boulevards and stimulating artistic atmosphere, was the only true environment for an artist. He wrote, 'And his eyes were shining with happiness and his heart was longing for this desired future.... We spoke for a long time about art and the spirit; and when saying goodby I grasped his thin, bony hand.'

Dalí had good reason to fear a violent reaction from his father to his newest idea, but here again luck was on his side. 'One day I received a telegram from Joan Miró, who at this period was already quite famous in Paris, announcing that he would come and visit me ... accompanied by his dealer, Pierre Loeb. This event made quite an impression on my father and began to put him on the path of consenting to my going to Paris.' Miró was generously admiring and prepared to help Dalí make his way. He subsequently wrote to Dalí's father urging him to let his son spend some time in Paris: 'I am absolutely convinced that your son's future will be brilliant!' It was not altogether easy, however. The dealer Loeb looked closely at Dalí's works, but did not write with an offer of the magnificent contract Dalí had been expecting. Loeb believed the young artist had not yet found his true direction. 'Work, work,' he advised; 'we must wait for the development of your undeniable gifts.'

On 11 April 1926 Dalí went to Paris and Brussels for two weeks. He was twenty-two years old and, in typically Dalí family fashion, was accompanied by his eighteen-year-old sister and his stepmother, Tieta, so that he would come to no harm and they could take him by the hand as he crossed the street. They all visited Versailles, the waxworks museum, the Musée Grévin, and the studio of Jean-François Millet in the village of Barbizon in the forest of Fontainebleau. However, for Dalí, the real reason to be in Paris was to meet Picasso.

As soon as I arrived at 23, rue la Boétie, I knew right away that the jet buttons of his eyes had recognized me. I was 'the other one', the only one capable of playing up to him. To tell you the truth [he added in a conversation published in 1973] I know nowadays that the world was a bit too small for both of us. Happily, I was young then!

I respectfully offered him a gift, another girl of Figueres, like the one he had appreciated. I took my time about unraveling it – it was as well-wrapped as a mummy – but a very lively painting emerged from the wrappings and it seemed to me that the painting expanded beneath his gaze. Picasso spent a long time in minute scrutiny of the work and it had never seemed so beautiful.

Picasso took him up to his atelier on the floor above and spent a wordless two hours showing him an enormous number of paintings.

Each of us knew who the other one was. Our mutual silence was charged with the strongest possible current of feeling. When I arrived I had told him I wanted to meet him before visiting the Louvre. He accepted this compliment, that would have stunned a Spanish grandee, with Olympian

assurance. It was my way of acknowledging the lead he had over me. We were in 1927 [actually, 1926] and I knew I had to show my mettle in order to eclipse him. He must have smelled a rat, and our final look was full of reciprocal understanding and defiance.

Although Dalí liked to boast, later in life, that all the omens were favourable and he was convinced that Paris would soon lie at his feet, in fact three more years would pass before he actually went to live there. He must have taken the measure of the great Spaniard who, even at this premature stage, he was determined to surpass, and realized just how far he had to go. Once he returned to Figueres he began to experiment more or less directly with Picasso's ideas, as is evident from several works painted at this time, notably *Figure on the Rocks* (also known as *Reclining Woman*), a Harlequin with empty eyes, dated 1926–7 and a *Still Life by the Light of the Moon* (1927), all distinctly Cubist or Neo-Cubist in mood. He was working extraordinarily hard since he showed twenty new works at his second one-man show at the Dalmau only a year later, on 31 December 1926. He also painted the exquisite still-life *Basket of Bread*, chunky slices of bread of almost supernatural vividness juxtaposed against a black ground; a haunting study of the rocky coastline around Llaner, which would become a familiar backdrop for his later style, and *Figure on the Rocks*, in which the diminutive figure of a nude is posed against massive cliffs lit by a dying sun. In other words, he was still vacillating between a Vermeer-like concentration on intense literal representation and semi-abstraction in a multiplicity of guises.

It is clear from the study made for a now ruined work, *Blood is Sweeter than Honey*, that a major shift was taking place some time in 1926, no doubt towards the end of the year. Dalí is naturally at pains to give the impression that this important new direction, which would usher in the great period of his painting and bring him fame and fortune while he was still in his twenties, came out of thin air. He is of course right in that the themes he developed were his alone, but one can make a safe guess that the vocabulary he chose to use did not appear in red letters emblazoned across the sky. Dalí discovered it, and the chances are that he did so as a result of his trip to Paris.

Dalí had already been introduced to the *scuola metafisica*, the 'Metaphysical School', which had developed between 1915 and 1920 out of the works of Giorgio de Chirico, Carlo Carrà, and Giorgio Morandi.

... the *scuola metafisica* had directly prefigured the reaction against purely abstract art which Surrealism in general and Dalí in particular were to exemplify so forcefully.... The movement had proposed to explore the deeper roots of man's existence, to create an art of metaphysical incan-

tation arising from inner perception and experience. It had emphasized the artist's salvation through philosophical speculation, his comfort in the enigma, his retreat to the dream.

Dalí experimented briefly with the ideas of Carrà from 1923 to 1925 but, at that stage, took no interest in the work of de Chirico. However, his knowledge of the *scuola metafisica* would have given him the basis for an immediate understanding of a new movement, Surrealism, which was well established in Paris by the time he got there, and to which he would make such a major contribution.

The movement, led by the poet André Breton, who had originally trained as a psychiatrist, was, as Barbara Rose has written, an 'aggressive assault' on the traditional values that had governed Western civilization before the catastrophe of the First World War. 'Born into a world of disintegrating social, cultural and geographical boundaries ... the poets and painters who eventually called themselves Surrealists were pledged to inventing a new art that programmatically transgressed boundaries.' The principles of the aesthetic rebellion had first been formulated by Breton in company with the poets Louis Aragon, Philippe Soupault and Tristan Tzara, and the movement given the name of Dada. Early in the 1920s, however, the original Dadaists had parted company and Breton had assembled a bigger group of writers, poets and painters in Paris around the enlarged concept of Surrealism. By the time Dalí arrived there, the first Surrealist Manifesto had been published, the first Surrealist exhibition had just been held – among those who exhibited were Miró and Picasso – and Breton was about to assume control of a vastly influential new review, *La Révolution surréaliste*.

One of the early members of Breton's group was Yves Tanguy. An apprentice in the merchant navy, Tanguy happened to pass the window of the art dealer Paul Guillaume and had seen a painting by de Chirico, *The Child's Brain*. The experience changed his life. He at once began to paint and within two years was launched on a major artistic career. André Thirion, a trade-union official, prominent member of the French Communist Party and writer, who knew Tanguy in the 1920s, described him as 'a man of few words. He always looked as though he were dressed in a trenchcoat (even after he'd taken it off), and his demeanor was modest but assured. He never spoke about his painting ... He was almost apologetic about his work and never aspired to any success. He sold next to nothing and readily gave away his drawings and canvases to the shrewd people who asked for them.'

Tanguy met Breton for the first time in December 1925, and when Breton assumed the position of editor of *La Révolution surréaliste* in March 1926, one month before Dalí's visit, Tanguy was numbered among its future contribu-

tors. That year Tanguy was to experiment with his first Surrealist paintings and the development of his mature style. The earliest examples of this appeared in *La Révolution surréaliste*, 15 June 1926.

The similarities between the early Surrealist experiments of Tanguy and those of Dalí have been remarked upon. Dawn Ades thought it was clear. 'Tanguy's *Il faisait ce qu'il voulait (He Did What He Wanted)*, has the same kind of figures scattered ambiguously through earth and sky and Dalí borrows the ghostly configurations.' Soby saw reminders in Dalí's work of the poetic devices of Max Ernst, but also emphasized the broader links with Tanguy: 'the general tonality has the shimmering iridescence of the latter's works of this period. Moreover, the tilted, broad perspective of Dalí's canvas, scattered with minute objects which cast heavy shadows, is closely allied to that in such Tanguy paintings as ... *Mama, Papa is wounded!* of 1927.' In making comparisons between the two artists both art historians cited later works and did not make the early link between Dalí's major shift of 1926–7 and the Tanguy works which pre-dated that shift. Tanguy's canvas titled *The Storm (Black Landscape)* (1926), which could be a vision of the disturbed ocean floor, with its floating bodies, its mysterious cone-shaped objects, its scattered clouds, even the strange amorphous shape in the lower left foreground, which could be a rock or foetus, is perhaps the most convincing and direct evidence in support of the thesis that Tanguy showed the way.

Soby and Ades are content to point out the resemblances; José Pierre, who wrote the introduction to a retrospective exhibition of Tanguy's work at the Centre Georges Pompidou in 1982, is sarcastic on the subject. ' "Yves Tanguy did not launch his delicate messages in vain," Salvador Dalí wrote at the beginning of 1928. No doubt what he meant by that was that such "messages" had not fallen on a (particular) deaf ear.' Pierre went on to cite Tanguy's first drawings in his new style in *La Révolution surréaliste* as the inspiration for Dalí's experiments and what, in his view, looked like 'a systematic hypertanguyzation' if not outright plagiarism. Pierre Matisse, the art dealer who knew Tanguy from childhood – they went to the same school – and later sold his work, thought that Dalí had looked at Tanguy's experiments and made his own from these basic ideas. 'The abstract forms of Tanguy's in an environment sometimes remind one of the landscape in Britanny; the dolmens sticking out of the ground, the rocks moulded by the seas and the horizon always in the background. . . . It was the germ of an idea, translated and transfixed into Dalí's vocabulary.' There is also the testimony of Agnes Tanguy, niece of the artist, who remarked that Dalí once said to her, years later, '*J'ai tout piqué de Tonton Yves* (I've snitched everything from your Uncle Yves).'

The evidence remains inconclusive and circumstantial, but in dealing with

the issue of which artist can lay claim to have been the greater innovator, Tanguy would seem to have the edge. His distinctive, pictorial composition of curious objects and a figure against a deep landscape of the 1926 summer are reflected in *Blood is Sweeter than Honey* and serve Dalí as a major point of departure for his important composition *Little Cinders* (*Cenicitas*), that he worked on for the whole of the following year, 1927–8. Other works, *Apparatus and Hand*, also 1927, and *Surrealist Composition*, 1928, make the link between the two men very clear. If one is looking for further evidence one can also cite the veined torso in *Surrealist Composition* as having affinities with Tanguy's veined man in *Le Phare* of two years before. The 'finger-phallus', a symbol Dalí was to call his own, as Pierre points out, can be found in Tanguy's drawings of an earlier period. What is more important than these borrowings between artists, which one can always find between members of the same group, is that Tanguy and Dalí soon set off in distinctly different directions. For Dalí, whatever he saw in Tanguy gave him the crucial shift in style he needed to meet the criticisms of the dealer Loeb and put him on the path he sought with such unswerving single-mindedness.

Dalí described the method he devised for the paintings of this new period at some length. 'I would awake at sunrise and, without washing or dressing, sit down before the easel which stood right beside my bed.... Thus I spent the whole day seated before my easel, my eyes staring fixedly, trying to "see", like a medium ... the images which would spring up in my imagination.' These images were whatever visions rose to the surface; 'the profile of a rabbit's head, whose eye also served as the eye of a parrot.... And the eye served still another head, that of a fish enfolding the other two. This fish I sometimes saw with a grasshopper clinging to its mouth. Another image which often came into my head ... was that of a multitude of little parasols of all the colours in the world.' He then resolved to paint the inner visions as accurately and carefully as possible, and allow instinct alone to dictate where and how they should be placed on the canvas. That he realized just how major a breakthrough he was making is clear from a letter he wrote to Lorca in the autumn of 1927: 'Federico, I am painting pictures which make me die for joy, I am creating with an absolute naturalness, without the slightest aesthetic concern, I am making things that inspire me with a very profound emotion and I am trying to paint them honestly.'

Dalí's first attempt at *Blood is Sweeter than Honey* is designed as a beach scene in which the sharply angled shoreline cuts the canvas into rough triangles. In the foreground there is the rotting carcass of a donkey and the torso of a nude, hands, head and feet bloodily chopped off, the blood appearing to run towards what might be an oddly shaped swimming-pool. A male head, with

closed eyes, perhaps the author of this curious dream, lies on his ear along the shore's edge and various ambivalent shapes that might be needles, nails, cones and elongated forks, are scattered about, all casting lengthy shadows. This first version was very much enlarged upon and extended in a highly complex second painting shown at the Saló de Tardor of Barcelona in 1927. All the objects have multiplied. The shoreline has become a mountain slope colliding, perhaps, with a planet, and at a pivotal central point there is an object very like an inverted Cleopatra's needle. Lorca, much impressed, called the final work 'a forest of apparatuses'. The painting was bought by the Duchess of Lerma and now, according to Descharnes, is beyond repair.

Dalí explained that the title phrase, which he liked so much that he reversed it and used it for a painting of a nude some fifteen years later, was an expression used by Lidia, the widow of a sailor and mother of two young men, who lived in Cadaqués. Remarking on one occasion that a bloodstain was easy to remove, she added with a malicious look and a distinct erotic emphasis, 'Blood is sweeter than honey.' She explained, 'I am blood and honey is all the other women! My sons' (this she added in a low voice) 'at this moment are against blood and are running after honey.'

As everyone knew, Lidia was, if not actually mad, certainly very peculiar. When Picasso stayed in Cadaqués as the guest of Ramón Pitchot, he had taken an interest in her case and lent her two books by different authors, which Lidia's particular imagination succeeded in running together into a single long work. By the time Dalí knew her she had convinced herself that she was the model for the heroine in the novel by Eugenio d'Ors, *La Ben Plantada*, a character actually modelled, as Dalí knew, on Ursulita Matas, the friend of his childhood. Since d'Ors also wrote a daily newspaper column, poor Lidia was absolutely convinced that he was sending her messages in code and would settle down for a lengthy explanation of what, she had decided, the innocent paragraphs really meant. No doubt she was a sad case, but there was something so inventive in the felicitous discoveries she made, 'that one could not fail to wonder at the bewildering imaginative violence with which the paranoiac spirit can project the image of our inner world upon the outer', Dalí wrote admiringly. She was not crazy about some things, as anyone in Cadaqués could tell you: 'just try to sell her a bad weight of fish or to put your finger in her mouth!' But she did, no doubt about it, see reality decidedly askew. Dalí gave her the same respectful attention he had given, as a boy, to *La monos* of Barcelona or the jesters of Velázquez. She was the wise fool who spoke the truth: for in reality, he believed, blood *was* sweeter than honey.

If one discounts Dalí's relationship with Lorca, one has to believe that he was, as he wrote, still a virgin. To Buñuel he seemed completely lacking in

sexual drive: 'His sex life was practically nonexistent. As a young man, he was totally asexual, and forever making fun of friends who fell in love or ran after women.' Dalí's autobiography presents another picture; it is full of attempts either to pick up women off the street or find an attractive prostitute in a brothel. All of them had to be rejected on aesthetic grounds, or so he would have the reader believe then. He describes several determined attempts to follow women in Paris, none of which succeeded despite his 'most passionate glances'. He would be forced to return to his hotel room alone, where he would sit in front of a mirror and, with thoughts of the feminine charms he had seen but not conquered, accomplish 'the rhythmic and solitary sacrifice.... I wrenched out the ultimate pleasure with all the animal force of my clenched hand, a pleasure mingled as always with the bitter and burning release of my tears – this in the heart of Paris, where I sensed all about me the gleaming foam of the thighs of feminine beds.' It was so frustrating that he was sometimes in despair. Yet, if one can believe him, he knew in that year – 1929 – that he was about to meet a perfect woman whose perfect form he had imagined and fantasized about since childhood. 'With all my soul I wanted her,' he wrote. 'Once more I wrenched from my body that familiar solitary pleasure, sweeter than honey, while biting the corner of my pillow lighted by a moonbeam, sinking my teeth into it till they cut through the saliva-drenched fabric. "Ay, ay!" cried my soul.'

CHAPTER SEVEN

The Little Russian Girl

Je n'ai jamais aimé que Gala
Si je nie les autres femmes c'est pour affirmer cela
Que je n'ai jamais trouvé une femme à part Gala
Pour me donner un peu envie de vivre
Et beaucoup envie de me tuer.

PAUL ELUARD, *'Chanson pour Gala'*

Gala, the woman Salvador Dalí was to marry, is sometimes referred to as the Muse of the Surrealists – to André Breton she was *'la femme eternelle'*, and occasionally as mother of the art movement, a title she detested. 'You can call me anything, call me *merde*, but don't call me *ma mère*,' she once retorted to her husband's most devoted collector, A. Reynolds Morse.

Gala Gradiva, Galarina, Galuchka Rediviva, Galuchkineta, the quintessence of mysterious, eternal womanhood – all these appellations Gala would have sought. They are also appropriate, for so little was known about her, particularly her childhood and upbringing, that such respected sources of information as *Le Figaro* were reduced to sketchy, if not inaccurate, information for obituaries published when she died in the early summer of 1982. Such basic information as the correct date of her birth is still in question. It has been given as 1893 and 1895; her daughter believes it was 18 August 1894. Dalí's lawyer, Michael Ward Stout, has reason to believe it was in 1890, which would have made her ninety-one and not eighty-seven, when she died.

What Gala's early life was like, who her parents were, how she was brought up, the early story of her life in Russia, by what circuitous route she arrived in Paris, how she became an integral member of that brilliant circle by the early 1920s – such questions seemed irrelevant. She was a marvellous enigmatic figure with something of the insouciance of Kiki of Montparnasse, the famous model and chanteuse of the 1930s, and a great deal more aesthetic sensibility. Such was her allure that it used to be said, rather fatuously, that if a Surrealist had had a particularly creative burst, 'Ah, well, he was in love with Gala then.'

To ask for more information about Gala would be to threaten her exalted, almost mythological status, as seemed to have been decided by tacit consent. If one did, however, one got nowhere. 'The secret of all my secrets is that I don't tell them,' she once said.

The secret of all her secrets, so successfully concealed once she arrived in Paris, was that her father was her father in every respect save his name. The story, which has been pieced together by Gala's daughter, Cécile Eluard, and her granddaughter, Claire Boaretto, from the meagre information given by Gala, is that she was the second of four children. She was born in Kazan, a university town that, by the nineteenth century, had a prosperous merchant class and an intelligentsia attracted to Western ideas of democracy and nationalism. Gala's mother Antonine married Ivan (erroneously believed to have been the administrator of a Russian prince). Gala's legal name was Helena, or Elena, Deluvina Diakonoff, the name she took from her mother's husband, as did her sister Lida and her two brothers, Alex and Kolke.

However, none of them were his children. Shortly after her mother's marriage Diakonoff disappeared and her mother never learned his fate. Since she could not legally remarry, she defied convention, in the fashion of Anna Karenina, to live with a lawyer and bear his children. It is known that he was Jewish. That he was probably a convert to the Russian Orthodox Church can be adduced from references in early letters of Gala's: 'No one has the right to change [his religion], whether Jew, Catholic or Orthodox,' she wrote. 'Perhaps this is the reason why my father is unhappy.'

This version is disputed by Dalí's principal spokesman, the art historian and photographer Robert Descharnes, who has had many conversations with Gala's surviving sister, Frau Lida Jaroljmex of Vienna. (Gala's brothers are believed to be dead.) According to Descharnes, Frau Jaroljmex said that her mother's first husband died, that their father was their mother's second husband, and that they bore his name. (This version cannot be confirmed, since efforts to contact Frau Jaroljmex have been unsuccessful.)

If one assumes for the sake of argument that Gala would be unlikely to tell her daughter she was an illegitimate child if she were not, one must conclude that to be a middle-class child in pre-Revolutionary Russia, whose parents had an irregular relationship, would have been no easy matter. This indeed could explain the stubborn and miserable look on the face of the adolescent Gala that one sees in early photographs, defying the world to do its worst. There is also the comment, to her fiancé, when she was twenty-two years old (or twenty-six, depending upon which birth-date is used), that 'I was very tired and very sad, I thought of everything that was most sad in my unhappy life – when I was a little girl it was the "sadness" of my parents.' Dalí used to say later that Gala, as a little girl, lived in a house through which the wind blew. He obviously intended to be taken metaphorically. When he was writing his autobiography he noted that Gala had given him permission to tell her story but that he refrained from doing so. No doubt the fact that each of them had painful family secrets was one of their first bonds. Dalí wrote, 'Gala's

secret and my secret formed the two evenly balanced scales of our justice.'

In Moscow Gala learned French, took drawing lessons, and had a mother who, she said, was 'a courageous woman who loved her children' – these are some of the meagre pieces of information to be gathered. According to Jeff Fenholt, who knew Gala in old age, her father was politically very well connected in Moscow. He defended Communists during their rise to power, serving as an attorney to the Tsar while managing to remain on the fence. After the Revolution he defended the enemies of Communism. He never left Russia.

Gala also lived in St Petersburg as a university student, as is established by a memoir, published in Russia, written by Anastasia Svetaieva. Gala is described as an independent girl of strong opinions, with flowing hair, who invariably wore a sailor suit. 'Her look would penetrate and attract as much as the wilful movements of her mouth,' Svetaieva wrote. They talked about poetry and art and about Gala's occasional and overwhelming desire to run away; an urge to reject everything when life became unbearable. Gala had felt this way since childhood; her old friend did not say whether she had actually run away from home. Gala was acutely shy in those days. However, when something really amused her, she would burst out laughing and take her companion's hand; an enchanting trait.

Mme Lucia Davidova, who first met Gala and Dalí in New York in the early 1940s, was sure that Gala would have met considerable social ostracism for being the daughter of a Jew, let alone an illegitimate one. 'Russians were horrible to Jews,' she said. 'My father, who was very liberal and always taught us that they were as good as we were, would have felt no contradiction in adding, "I played tennis with Boris and a Jew"'. Mme Davidova did not find Gala a particularly engaging personality. 'I hate to say it, but I felt a class difference between us. She didn't speak like a Muscovite or someone from St Petersburg. To me she was an ordinary person with no polish, not well brought up, a girl from nowhere.'

Dalí mentioned that Gala had a long mental illness as an adolescent. One finds numerous references, in Gala's early letters, to her belief that she was emotionally unstable and liable to fly off the handle. She wrote, 'You must not forget that I am an hysteric and far, far too nervous for my age and physical strength. The least thing makes me beside myself.' She took sudden, raging dislikes to people, which she explained by the comment that she was insane. She called herself 'vicious' for wanting to wear perfume, and 'putainesque' (whorish). She also wrote, 'I am so bad that I am proud of it.'

Dalí noted that Gala's mental illness had physical symptoms. 'One evening Gala vomited twice in the course of our walk and was seized with painful convulsions.' She had been genuinely ill of tuberculosis at the age of eighteen

and had been sent to the sanatorium of Clavadel at Davos to convalesce. There she met a seventeen-year-old Frenchman who had also been sent to Switzerland to convalesce because he had been spitting up blood. His name was Eugène Émile Paul Grindel, later known as Paul Eluard and a distinguished poet.

Paul Eluard was the son of an accountant who was comfortably off; he had made a good living from the subdivision and resale of lands. His mother was a dressmaker. Photographs from his stay at the sanatorium of Clavadel show that he was extraordinarily well-dressed and self-assured, even elegant, with fashionably long, smooth hair, a high forehead, a sensuous mouth and a curious, high-bridged nose that gave his face an air of asymmetrical distinction, although he could never be considered handsome. Numerous photographs were taken of him at every stage of his relatively short life – he died in 1952 at the age of fifty-seven – and many statements can be found confirming the allure of his personality.

André Thirion wrote that Eluard was a man of few words,

but whatever he said he said well; he rejected everything that might ruffle his life. He was tall, slender, blond, with a poet's noble and faraway gaze.... His manners were distinguished and serious, and slightly condescending. At thirty, his hands trembled like those of an old man; his voice also trembled when he read, but he managed to draw very poignant effects from this. When he recited his own poems, his voice at first was blank, almost noncommittal, unintoned. Slackenings and heightenings of the timbre made the poem sound like a declaration or a warning, and the final words resounded for some time ... Well dressed, in good health, he looked like *someone*.

Jack Lindsay, who described his friendship with Eluard just after the Second World War, called him a spellbinding conversationalist.

Perhaps if one had tried to write it down with the echoes still lively in one's ears, one might have managed to catch some of the rich hurrying tones evanescent in their gay and sad glints of fancy, of self-mockery and tenderness ... a fidelity of impulse and sudden perceptions, small and sliding, but given ultimate breadth and harmony by his personality.

Diane Deriaz, a circus acrobat with whom Eluard fell in love when he was fifty and she was just twenty, recalled that he was a prince among men, with a poetic view of life. 'When he spoke, all at once there was such an aura of beauty that one's feet left the ground.' Others commented on the complex

mixture of his personality, a blend of expansive friendliness, reflective tenderness and inflexible reserve. To Robert D. Valette, the writer who was Eluard's son-in-law, his peculiar charm had to do with a quality of tenderness that was almost feminine. It was, however, allied with an ability to become monstrously and irrationally angry. Diane Deriaz confirmed this: 'One time he came to see me at the circus and we had a new lasso number by a Mexican couple with whom I was friendly. He made a violent scene: "I refuse to allow you to talk to these people, because I sense they are pro-Franco," ' he raged. Eluard was, for the last decade of his life, very pro-Communist.

Everyone knew that he adored women. When Dalí first met him in 1929 at the Bal Tabarin, Eluard was accompanied by a beautiful woman dressed in black sequins; nevertheless, 'his sensuous eyes lit up every time they followed a feminine figure'. Eluard himself wrote, 'And it is always the same avowal, the same youth, the same pure eyes, the same ingenuous gesture of her arms about my neck, the same caress, the same revelation. But it is never the same woman.' When Diane Deriaz met him, she thought Eluard was not particularly interested in a normal relationship. She noticed that he always seemed to have a liaison with a couple and, since it was sexual, it was not particularly to her taste: 'Two in the bed is enough; when there are three or four, it's St Lazare.' She also thought that he liked the woman in his life to sleep with other men, which could have been his way of forging a link with the other male in the trio. That there was considerable self-doubt behind the image of an accomplished Casanova is hinted at in Lindsay's memoir. Temporarily a bachelor, Eluard was poking gentle fun at himself for being alone and ignored by the opposite sex. He was 'conjuring up fantasies of a man islanded in an oceanic tumult of women, who tried to storm the house but were beaten off by a dauntless concierge; of a man lost in a world wholly without women, wandering in eerie streets where even the shop-window dummies refused to notice him.'

There are numerous photographs of Gala at Clavadel, most of them in the company of Paul Eluard. She sits on a window ledge, tiny and indomitable, with Eluard in the background. She lies back on a reclining chair, eyes dutifully raised, with Eluard standing behind her. She goes for a walk in a fashionable greatcoat, neatly, even decoratively filled in at the neckline, beside Eluard in tweeds and a floppy-brimmed hat. She is Pierrette to his Pierrot, wearing white satin pyjamas and a white ruff, youthful and ardent, her strong chin jutting forwards and giving her a remarkable resemblance to her future mother-in-law. At seventeen, Eluard was already launched on a career; his *Premiers Poèmes* were published in 1913. When war broke out he was mobilized, serving first as a hospital orderly and then a volunteer at the front. The experience of trench warfare would lead him to write some deeply felt

pacifist poems which, risking censorship, he published at his own expense.

Eluard was also an accomplished artist whose early drawings have a Beardsley-esque sinuosity of line and some of that artist's mordant vision. His obvious literary gifts, his love of art – of all the Surrealist poets, he was the one most interested in painting – his intelligence, wit and good looks had an instantaneous appeal for Gala. When Eluard returned to Paris and she went back to Moscow, they considered themselves engaged.

Four years were to pass before they could marry. That Gala was deeply, even fanatically, committed to the relationship is certain. She wrote to Eluard, 'My father said that I was ill with love, I was genuinely mad. He actually seriously considered taking me to a doctor.' It is known that she left Moscow for Paris in 1916, although not the route she took. It is also not known whether she travelled alone. That would have been extremely unusual for the time and highly disapproved of: 'A girl of good family could not go out alone. She couldn't even go to the cinema by herself,' Davidova commented. Valette thought Gala 'aged' at that time in order to get out of Russia.

Her letters to Eluard in 1916–17, while he was at the front and she was living with his mother at St Denis, a Parisian suburb, just before their marriage, add greatly to the picture one has of Gala at the time. She was studying drawing and learning French with the goal of getting a diploma in order to become a professional translator. She was reading omnivorously, Guillaume Apollinaire, Jules Romains, André Salmon, as well as Tolstoy and Dostoevsky, whose writings she loved above all others. She was making drawings and trying to write poetry in Russian, although she despaired of that. She was losing her own language, she wrote.

She did not particularly look forward to becoming a housewife. Her mother always called her 'The princess of the pea' because she had never lifted a finger, even for herself.

I detest housework: it brings nothing and it uses up the energies, the pathetic small energies of little women. It is daily and has to be redone every instant but it brings nothing like the work of a man, money with which one can buy books. But I understand that this kind of work is necessary. I find dirt repugnant, I am afraid of it.

She would do it for him and do it well. 'I will do everything but I will have the air of a woman who does nothing.... You will see that everything will be very well organized and very clean.... But no one will see me at work, not even you.'

She was desperately, almost frantically, in love with Eluard. He called her 'my little girl' and gave her the name of Gala. She called him 'my dear little

boy', 'my dear and dorogōí maltchik', 'my dear little very good and very spoiled boy', 'my husband my own completely absolutely and entirely mine (I insist upon it)', and 'my absolutely unique boy who is for me and for always'. He was her dear adored spoiled baby and she was his little mother, his sister, and his wife. She wanted nothing else in the world but him. Her letters are full of anguished, semi-incoherent pleas to take care of himself, not to put himself in danger, to stay out of forests in case he catches a stray bullet, and to come back to her so that they can live the life of domestic intimacy she has planned, live for love alone. She went nowhere and saw no one. She lived only for the day she would see him again. She could not lose him because 'If I lose you I lose myself as well'. She was by nature very obedient and would do absolutely everything he wanted. 'It seems to me that when one returns from that filthy front one will be happy to see at home one's wife prettily dressed and perfumed (because, don't be annoyed, I bought some perfume as well but I promise you that I won't use any of it until you come, you will see, the bottle will be full) ...'

Since she lived only for him, since she had proved her love by leaving her family and coming to Paris, and since she did everything for him, he must reciprocate. She wrote, 'I buy your obedience at *no matter what price.*' He must be hers alone, she insisted, write every day and not look at other women 'because it could be there are some pretty ones, like the other time in the métro'. She seemed to see his mother as a potential rival: 'Your mother is really in love with you.' Above all he must never suggest that there had been anything wrong about the things they did together.

> Do not ask me if ... all our past caresses seem dirty to me. Don't say that. You don't know what you are saying.... Harder and more atrocious words you could not imagine.... It is not just some caresses, it's my whole life, it's the best and most holy sacred part of me.... Detest me, insult me if you like, but not my love for you.... If I do everything with you – 'the strange things' – it is for the certain reason that with you, because I love you, everything is pure, everything is beautiful, everything is right.

In years to come, Eluard carried a photograph of Gala nude in his wallet, which he willingly showed to his male friends; 'it revealed a marvellous body that Eluard was very proud to have in his bed'.

Gala was a devout member of the Russian Orthodox Church. She became a Catholic upon her marriage to Paul Eluard in February 1917. They set about living the quiet, domesticated existence she imagined for them. A year later their only child, Cécile, was born. Her granddaughter always thought

that Gala had not particularly wanted a baby and certainly not a girl. 'The good thing was to have a boy,' Claire Boaretto said.

After being demobilized Eluard worked for a time with his father in the office of the municipal surveyor of St Denis, published books of poetry and, in 1920, started his own review, *Proverbe*. Although Gala is never seen in this light, there are indications that she played an important editorial role in Eluard's career as a poet, particularly in the early years. She is known to have contributed at least one 'Surrealist Object', a complicated contraption comprising a box, metal antennae and sponges, that was listed among the other works by Valentine Hugo, André Breton, Giacometti and Salvador Dalí in 1931. It would be unfair and misleading to see her simply in terms of her ability to arouse the sexual and creative passions of a group of brilliant men. Had she been born in another generation she might have found her way to a distinguished career of her own. As she told Eluard, she was not naturally attracted to the role of housewife and far too intelligent, talented and head-strong to remain in the background.

Eluard had first met André Breton by chance at a performance of Apollinaire's *Couleurs du Temps*, when he mistook him for an old friend. The two men were formally introduced in 1920 and Eluard soon became one of Surrealism's earliest and most dedicated adherents. He was a star member of the powerful group of poets and painters clustering around Breton, Soupault and Aragon: Max Ernst, Giorgio de Chirico, Hans Arp, Benjamin Péret, and Robert Desnos, a novelist and poet. In the winter of 1922 one of the most interesting converts to Surrealism, another young poet named René Crevel, who had some training in the techniques of spiritualism, began to teach other members how to induce hypnotic trances. One of the best subjects for the trance state, Robert Desnos, '*talked surrealist* at will' while in a trance, Breton noted in his first Surrealist Manifesto, and was soon capable of slipping into a trance state wherever he was, even at a café, where his steady stream of word-play seemed to be inspired. The whole purpose of the game was to release the unconscious, along with the instincts to create, but events soon took an ugly turn. 'Crevel began making chilling predictions, prophesying disease, madness and death for his friends. . . . Eluard was pursued by Robert Desnos brandishing a knife.'

Eluard, who was comfortably off in those days, was an astute collector of books and *objets d'art* and when he bought paintings they were chosen with discrimination. He seemed to have a gift for friendship, managing to remain on easy terms with a wide variety of painters, writers, dealers and musicians – Picasso was one of his best friends – even when the Surrealists *en masse* had excommunicated him. As a result, he and Gala provided the raw material for poems, sketches, and portraits, and this, coupled with Eluard's standing as a

poet and theoretician and his undeniable value as a patron, catapulted them to prominence. By the time Salvador Dalí met them they were, he said admiringly, 'the very salt of Paris', with their *couture* clothes, their expensive luggage, their self-assurance and their blasé attitudes. What was happening in their intimate life is more difficult to pinpoint, but it is evident that, after three or four years of marriage, there was an estrangement. This is hard to understand in light of the letters Eluard continued to write to Gala for a quarter of a century, until 1948. They have been published and show him to have been extraordinarily devoted. He was more than just gallant, nostalgic, and parental; he was almost ferociously ardent. He wrote paeans of praise to her body, inch by beautiful inch, to her perfumed movements, their perfect sexual encounters, their joint accord and immortal love, letters that continued without a break. No matter whom Eluard loved, lived with or married, Gala was the only woman in his life, he said. No wonder she kept every one of his letters until the day she died.

All of this is hard to reconcile with their joint behaviour. Eluard was perhaps more comfortable with Gala as a symbol, rather than a real human being. One gets the clear impression from his poetry that he wanted to think of her as an extension of himself: 'She has the shape of my hands, she has the colour of my eyes, she is engulfed in my shadow ...' Or perhaps these words served as an incantation for a deep unease and fear that the reverse was becoming the case, as one might gather from the line, '*Et beaucoup envie de me tuer*'. Her fierce little protests that he must obey her, since she did everything for him, may have been far too demanding at close quarters.

For Gala, to be ceaselessly admired, revered, put on a pedestal and her beauty proclaimed far and wide, was no doubt all the more important for being compensatory. A great part of her sense of herself seems to have been wrapped up in her physical appearance and bodily charms, and she seemed to need ceaseless reassurance on that score. It was said that when she met Eluard shortly before his death in 1952, when she would have been fifty-seven years old, she said, 'Paul, I want to give you some pleasure', and opened up her blouse to reveal her still handsome breasts. But she was insecure, and therefore vulnerable to Eluard's almost ceaseless infidelities. Angered once too often, she may well have decided to get even, and found it ludicrously easy. There is also the hint that their sexual relationship was never quite the same after the arrival of Cécile. Eluard's statement, that 'children are the death of love', has, however, to be taken with a grain of salt.

The painter Max Ernst had introduced the Dadaist movement to Cologne in 1919, where he lived with his wife and baby boy in a top-floor apartment that was the meeting-place for a constant round of visitors, from Hans Arp and Paul Klee to Tristan Tzara and Lyonel Feininger. Then in November

1921 Paul and Gala Eluard came for a six-day visit and the two men were instantly attracted; they discovered that they shared the same attitude towards life, its joys and conflicts; they found their temperaments compatible and remained close friends for more than twenty years. Eluard immediately began to write a new collection of poems, *Répétitions*, for which Ernst provided the collages, and bought two of Ernst's paintings.

As for Ernst, his biographer Patrick Waldberg has described the multiple allure of Gala's seductive and at the same time forceful, if not aggressive, personality; the charm of her manner and the piercing intensity of her gaze which seemed to clear away everything that was trivial and inessential. He found her irresistible. The one person not caught up in the mutual admiration society was Max's wife Lou Ernst. She was trying hard, at that stage of their marriage, to mould herself completely to her husband's needs, drop the friends he did not like, stop playing her violin, read only the books he liked and become an extension of him. Without a doubt the effort backfired. Ernst fell in love with the fascinating newcomer and she was more than receptive. According to Lou Ernst, Gala tried to set things up for her with Eluard so as, she believed, to be left a clear field with Max. Failing in this, Gala composedly took on both men.

Lou Ernst called her 'this almost silent, avaricious woman' and 'that slithering, glittering creature with dark falling hair, vaguely oriental and luminant [sic] black eyes and small delicate bones, who had to remind one of a panther'.

Max Ernst and Paul and Gala Eluard ended up living together, a relationship that is explained by the futility of ever understanding 'a Russian woman's dark soul' or, the besotted state of Ernst or the long-suffering gallantry of Eluard. Whatever the poet's private motives for agreeing to this indignity may have been, and even if one posits that the relationship may have had its desirable voyeuristic aspects, it became too much for him to tolerate. He and Ernst actually came to blows and, in the spring of 1924, Eluard left to get as far away as possible from the whole problem by travelling to Venezuela, Tahiti, Panama, New Zealand and Australia. He was never coming back. His parents, who had found out about the irregular relationship, were outraged. Gala was thoroughly frightened. She immediately set out in pursuit and caught up with her husband in Saigon. Ernst arrived a few days later, not, as it would seem, to plead his case, but the reverse. Eluard, he and Gala said, was taking it all too seriously. Eluard came home with his wife and Ernst stayed on in the Far East for some months. The *ménage à trois* was over but the uneasy links between them continued for some time. It is said that when Gala met Dalí in 1929 she was still trying to make up her mind about Ernst. Her remark, supposedly to Sir Roland Penrose, was that she chose Dalí

because she thought he would make more money. The remark is either sheer invention on her part or attributable to Gala's desire, later in life, to make herself seem irresistible, since, by the time she met Dalí, Ernst had divorced and was remarried.

It is also believed that Dalí snatched Gala from under her husband's nose and that only Eluard's selfless renunciation of his own desires can explain the conspicuous lack of jealousy that he demonstrated during the whole affair. Whether there was more to it than that is worth discussing in a later context. It is known for certain that Eluard was off in amorous directions of his own. He had met and was having a series of rendezvous with Alice Apfel, whom he called La Pomme, a pretty young woman who looked like Gala and whom André Thirion thought was 'fickle and voracious'. Eluard had also met Nusch, a German girl of exquisite looks, then in her early twenties, who eked out a living working as a model for sentimental postcards and as a walk-on at the Grand Guignol. 'Dressed in a harum-scarum sort of way, homeless, penniless, starving, she was ready to turn a trick with someone just to have a warm place to sleep. Eluard was deeply moved.... The poet was not insensitive to the physical appeal of his new conquest, but an immense pity also warmed his heart.' After the Eluards were divorced in 1932, Nusch became his second wife.

What is not well known is that, some months before Dalí's momentous discovery of Gala, the Eluards had decided to live apart. In June 1929 Eluard found an apartment for Gala on the rue Becquerel, an act of profound significance for her since it meant that she would be living alone for the first time in her life. He had other distractions; she had no one and, even after Dalí had fallen madly in love, it would be months before they joined forces for good. Eluard wrote to her constantly during that period, whether he happened to be with 'une petite amie' or not, sending her money and running small errands for her in Paris.

Gala, my sister, my friend, my lover, your letters give me much delight. And more, I love you and you are the only and greatest mystery of all for me. Mystery of your beautiful body, so young, against mine, so voluptuous and which is always offered to me, of your marvellous eyes. I love you, I love no one but you. You can be sure, absolutely sure.

He ended with, 'I embrace you terribly everywhere.' He seemed to take the view that Gala was free to amuse herself with a momentary conquest but that it had nothing to do with the solidity and durableness of their relationship. He expected her to come back, and when, early in 1930, it occurred to him that she might not, he was despairing: 'Gala, if the thought came to me that

everything might be over between us, I would be truly like a man condemned to death, and what a death. My little girl, when are you coming back?' He put all such thoughts out of his mind. By then Max and his new wife, Marie-Berthe, were living in a spacious apartment on the boulevard St Germain, where his son Jimmy often stayed. The *coup de foudre* between Gala Eluard and Salvador Dalí was the latest Surrealist gossip. Ernst's young son, who had met Dalí, could not understand how any woman could choose a 'small, almost skeletal apparition with big intense eye-pupils in a chalk-white face' over his father or Paul Eluard. He did, however, find the fragile Spanish painter shy and friendly. His father, who had made some remarkably dour and sinister sketches of Gala, her eyes menacing in a pointed little face, said, 'I hope she doesn't tear him into little pieces'.

CHAPTER EIGHT

'Paris is Mine!'

'Slowly the pawns of fate were falling onto the proper squares of my chessboard.'

ANDRE PARINAUD, *The Unspeakable Confessions of Salvador Dalí*

In the early spring of 1929 Dalí returned to Paris, where he was taken under Miró's wing and introduced as a bright new talent. He met Tristan Tzara, leader of the Dadaists, and the group of young artists who had been signed up by that talent scout Pierre Loeb, who had thought Dalí not yet good enough. So much for his judgement, Dalí decided, with a contemptuous reference to the dealer's 'grocery shop'. He had lost his chance. Miró took Dalí to La Coupole, that 'holy place' in Montparnasse where, if one waited long enough, one could see every big name in Paris: Derain, Kisling, Brancusi, Ehrenburg, Zadkine. While trying to affect a properly nonchalant attitude, Dalí stared and stared.

One evening Robert Desnos was at the bar. He insisted on being taken to see Dalí's canvases and reacted with enormous enthusiasm. Nothing like this had ever been seen before; Dalí would take Paris by storm. Even if Desnos could not afford to buy anything, his compliments were a step in the right direction. Dalí also met Breton at his habitual café in the Place Blanche and took the measure of that formidable personality. 'I could see Breton's blue eyes looking fixedly at me.' Breton distrusted him and with good reason. Dalí had made up his mind that, since the Surrealists were the only group with an adequate showcase for his talents, he was going to make a bid for power. He was going to take over.

At Miró's urging, Dalí had himself measured for his first dinner jacket at a tailor's on the corner of the rue Vivienne where, he learned, the Comte de Lautréamont, otherwise known as Isidore Ducasse, had lived in the nineteenth century. This was a most favourable omen as far as Dalí was concerned, since his first major book illustrations would later be for that novelist's *Les Chants de Maldoror*.

Properly attired, Dalí went to his first high society dinners, making the acquaintance of those avid patrons of the *avant-garde*, the Vicomte and Vicomtesse Charles de Noailles, whose support would be so crucial to him. By his own admission he was too awed to make much of an impact. Maxime

Alexandre, a young writer from Strasbourg who played a modest role in the Surrealist movement, recalled meeting Dalí one evening at the café Cyrano with Miró. He was 'a very shy young man wearing the suit and stiff collar of a shop clerk, . . . and the only one among us who wore a moustache'.

Had Dalí been as anonymous a personality as he appeared to Alexandre he never would have made the spectacular début that he did in the brilliant Paris circle he joined almost immediately. Once he got past his immediate stage-fright, he was 'a peerless writer, talker and thinker', Buñuel said; he called him a genius. Winthrop Sargeant would eventually write that 'he is a somewhat shy, likeable man with a kindly disposition, an inquisitive, intelligent face and an air of childlike gravity. When he is arguing a point or telling a story he seems desperately anxious to please.' Margaret Case Harriman later called him 'a small, dark, darting young man . . . and romantically good-looking. . . . When he talks, his eyes, hands, and shoulders move excitedly, but in his rare moments of silence he has a knack of falling into a relaxation so profound that it somehow suggests that he has stopped breathing.'

André Thirion, the French author who wrote a lengthy memoir about his encounters with Surrealists, recalled that he was 'slender, shy, phlegmatic, well-mannered', and talked inexhaustibly,

[talk] which his natural humor and his Spanish accent sprinkled with comical effects. But he knew when to hold his peace, and he would hold it for a long time, curled up, attentive and serious, in an easy chair. Enormously intelligent, he was obviously capable of wrecking any mental construct whatsoever simply because he was so marvelously funny; he could make everyone but himself howl with laughter.

There was no doubt, however, as Thirion, Buñuel and Miró all knew, that Dalí was completely lost in Paris. 'He couldn't even cross the street. His only means of transport was a taxi. He fell down several times a day,' Thirion recalled. He was afraid of almost everything, from travelling by boat to insects in general. He could not buy shoes because he was unable to expose his feet in public. He was the absolute victim of rigorous habit. Each day he ate the same things in the same restaurants and took the same walks. His ability to lose his keys and his wallet, and leave his change behind was already legendary. Whenever he went out, he hung on to an elaborate cane and always carried a little piece of driftwood from the beaches around Cadaqués to ward off evil spirits. The fact that he could not even take the Métro, when he first arrived in Paris, was a serious inconvenience for someone on a limited budget. Fortunately he was cured of that particular phobia by the painter

Pavel Tchelitchev, who took him into the depths – Dalí laughed with sheer terror until tears came into his eyes – and then left him there alone.

When he announced [Dalí wrote] ... that he had to get off ... I clutched at his coat, terrified. 'You get out at the next stop,' he repeated to me several times. 'You'll see "Exit" in large letters. Then you go up a few steps and you go out. Besides, all you have to do is to follow the people who get off.'

'And suppose nobody got off?'

Dalí, who was used to commanding an instant reaction from parents and relatives more than willing to pander to his slightest whim, was horrified. He could not believe anyone could abandon him so callously. That it might be good for him to be forced to rely on his own initiative never crossed his mind, although it certainly must have occurred to Tchelitchev. To his utter amazement he accomplished this impossible feat. 'Reaching the surface, I stood haggard for a long time. I felt I had been spewed out of some monstrous anus.... And, O miracle! my lucidity, my pride, my strength returned instantly ... with increased power. I understood I had just been through a great initiation.'

What Dalí was aware of at this time, more than his inability to deal with ordinary life, was his fits of mad laughter. These were becoming uncontrollable. His desperate attempts to prove his difference by feigning madness had been a magnificent success. The more he succeeded, the more something inside himself drove him onwards, towards ever more stupefying demonstrations of his uniqueness. More than feigned madness was involved, however. A part of him actually wanted to go mad and was courting the idea, feeding off it, plunging headlong in that direction.

Dalí had always had a tendency to laugh out of nervous embarrassment. It was disturbing him even at the age of sixteen. 'During lunch when I was commenting on the unhappy end of our good professor of mathematics, and although I was sincerely affected, I felt an irresistible desire to laugh. I do not know why.' Now, perhaps, he was getting away with something no one in the world, and certainly not his father, would have considered him capable of. He, the son of a notary, an absolute nobody, was being handed around in Paris from one exalted group to another as if destined for fame. He was so obsessed by this secret victory that he was convulsed with laughter. Part of the fun of it all was the sweet revenge. He would summon up comical scenes of people he knew with imaginary loads of excrement on their heads, visions in which, no doubt, his father loomed large, and roll on the ground in hysterics. He laughed and laughed until the tears rolled down his cheeks. But

that was the biggest joke of all: the tears were real. He knew this, in the deepest part of himself. 'My laughter was no frivolity; it was cataclysm, abyss and terror.' Dalí was staring over the brink and what made him draw back in horror was the loneliness he saw there.

He was laughing because he had given superb expression to his private world of revolt, eroticism, decay, and death and this piece of *merde* was being heralded by everyone as a remarkable act, a work of genius. He had made an anti-film, and this attack on the bourgeoisie was writing his signature in letters of fire. They were masochistically begging for more. He was making them eat shit and like it.

Dalí later described Luis Buñuel as the 'messenger' of his fame. According to his grandiose version, Buñuel had written a mediocre film script that he brought to Figueres to show Dalí, one that Dalí immediately denounced for the cheap trash it was. Buñuel, taking no offence, at once saw the superior merits of a film script that Dalí had already written, which needed only a few revisions and a title, the more inappropriate the better. The idea appeared, as it were, full-blown from Dalí's imagination, testifying, to get the order straight, to 'my genius and Buñuel's talent'.

What Buñuel has to say is worth recording as a corrective. According to him, there was no Dalí scenario. During his stay in Figueres he happened to describe a dream he'd had in which an elongated cloud had sliced the moon in half, like a razor blade slitting an eye. Dalí matched that with a dream of his own: he had just been dreaming about a hand crawling with ants. Why not make a film, Dalí asked. It was a genuine collaboration, an ideal meeting of the minds, Buñuel continued. Both of them sat down to work and the script wrote itself.

Our only rule was very simple: no idea or image that might lend itself to a rational explanation of any kind would be accepted. We had to open all the doors to the irrational and keep only those images that surprised us.... The amazing thing was that we never had the slightest disagreement; we spent a week of total identification.

'A man fires a double bass,' one of us would say.

'No,' replied the other, and the one who'd proposed the idea accepted the veto and felt it justified. On the other hand, when the image proposed by one was accepted by the other, it immediately seemed luminously right and absolutely necessary.

That spring in Paris, Buñuel shot the fifteen-minute film in two weeks, with a skeleton crew of five or six, 'and most of the time no one quite knew what he was doing'. Dalí arrived on the set a few days before the end and spent

most of his time pouring great pots of sticky glue into the eye sockets of rotten donkeys; he also made a brief appearance as a priest. To add to everyone's sense of what was fitting, the film's leading man, Pierre Batcheff, committed suicide on the final day. Buñuel was so emotionally involved himself that he was ill for several days after shooting the film's most ghastly sequence in which he appeared to slice a human eye with a razor. (The sequence was actually filmed in a slaughter-house using the eye of an ox.)

Despite Dalí's attempts to prove the reverse, the film's success was as much Buñuel's as his own. 'Scorning the technical pretensions and failures which characterize so-called avant-garde films, his production was simple and precise, with an infallible sense of *tempo* ... the result was more than an arresting spectacle – it was a stupefying experience,' Marcel Jean commented. At the time the medium of film seemed perfectly suited to Dalí's obsessive and original ideas. It was not only Dalí's first Paris success, since it pre-dated the show of his paintings by a month but – and this must have brought the most delirious tears to his eyes – it was a *succès de scandale*.

This debut was not to take place until October 1929. In the late spring *Un Chien Andalou* was finished but not yet booked for a public showing – Buñuel had no idea what to do with it. It looked like a complete failure to Dalí. 'It seemed to me that it needed at least half a dozen more rotten donkeys, the roles of the actors were lamentable, and that the scenario itself was full of poetic weaknesses.' He had, after all, come to Paris with a larger goal in mind, that of finding a dealer who would give him a one-man show that autumn. Camille Goemans had offered a contract, 'but this contract kept being put off from day to day', he wrote in 1941. (By 1976 he was explaining that he was keeping Goemans in suspense while he pondered his response.) He returned to Spain to his paintbrushes and laughing fits, which his father took as harmless. ' "What's going on? That child laughing again!" my father would say, amused and preoccupied as he watered a skeletal rosebush.'

Nevertheless, a series of letters was being exchanged on the question of the all-important contract – Dalí does not specifically say so, but it is obvious that they were written by his father – and an agreement had been reached by which, in exchange for Goemans's right to act as agent for all the works Dalí would paint that summer, Dalí would be paid 3,000 francs. It was also agreed that Dalí would make his all-important debut in November. Goemans would have a percentage on the sale and would retain three canvases. All these details, which had been worked out by Dalí's father, were judged honourable by him. He 'rubbed his hands ...'.

That August Camille Goemans came to visit the Dalís in Cadaqués, accompanied by René Magritte, his wife and Luis Buñuel. Goemans was most enthusiastic about *Le Jeu Lugubre* (*Dismal Sport*), which Dalí was just finishing

and which Goemans was to sell before the opening to the Vicomte de Noailles. The others, who took up residence a few days later in the Hotel Miramar, were Paul, Gala, and Cécile Eluard.

To know exactly when Dalí determined to make the break with his father and strike out on his own would be fascinating but unfortunately the question is unanswerable. Based on the evidence one can only assume that he decided this some months before his one-man show in Paris. Whether he had made his plans before Gala Eluard's arrival, and this decision accounted for his hysterical fits of laughter, is the really interesting issue, but there are no clues. One can only observe that events followed each other in rapid succession and that Dalí has always been at pains to present himself as the innocent victim of circumstance. A marvellous woman took him up and saved him from madness and, following that, his father took unreasonable offence where none was meant and abandoned him as heartlessly as Tchelitchev had in the Métro.

However, to believe that some kind of plan was not already in his thoughts would be to ignore the single-minded ambition that he consistently displayed, his ability to cover his traces, and the masterful way he invariably handled his father. He had orchestrated his departure from art school so that, while no one could accuse him of failure as an artist, he was forever disqualified from a career as an academic. He had plotted his arrival in Paris with the utmost care. He had hammered out his unique artistic vision. He had proved to his father that he could make money. He of all people knew just how dependent he still was on his father, for his food, his brushes, his clothes and the roof over his head, and he also knew how far he still had to go. It is hard not to believe that there were some very practical reasons for the sudden allure of Gala Eluard. One may have been her status in the sanctum sanctorum of Surrealism. To throw in his lot with her would bring him an important step closer to his goal as its leader. The second may well have had to do with the atmosphere of luxury and ease surrounding her that summer. She symbolized professional opportunity and also financial security. But to believe that Dalí's actions that summer were motivated purely by practical considerations would be to distort the issue. There was also the fact of his hysterical fits of laughter at the abysses opening up before him if he struck out on his own, if he dared defy his father, if he attempted a sexual relationship, all of them equally horrifying. Faced with the frightful impasse, he jumped.

Dalí has always presented the story in terms of recurring images. Just before Gala's arrival he was having waking dreams and hallucinations, one, in particular, of a woman's back. This had been one of his most persistent and haunting memories, recalling the days when he had leaned against the rocklike comfort of his nurse as she sat on the beach. Ana María is invariably

presented, in his paintings, from the rear, usually seated but occasionally at full length. Gala was also linked with his earliest memories of school. Sr Trayter used to have a kind of optical theatre and among the slides he showed his class of children was one of a little Russian girl. She was riding in a troika, swathed in white furs, and pursued by wolves. The image has strong overtones of the Snow Queen, in Hans Christian Andersen's story of the same name, who also appears in a big white sleigh, wrapped in a white fur cloak and cap, and whisks the boy hero of the story off to her frozen world. Although, in Dalí's dream, he gets colder and colder, he thinks he is getting warmer and finds her infinitely alluring because he is wounded – a fragment of broken glass from an evil mirror has lodged in his heart. Whether this was the unconscious message of Dalí's memory can only be conjectured. He came away with an impression of the little girl's fixed expression – interestingly, the Snow Queen also stares steadily at her victim – and her gaze, at once proud, wilful, and infinitely sweet. She was his little Russian girl, a part of him.

Dalí went on to relate that he met Gala for the first time on the terrace of the Hotel Miramar one evening and had an aperitif with her and her husband. Next morning he was about to join them on the beach in front of his house when he caught sight of her, already seated. 'And her sublime back, athletic and fragile, taut and tender, feminine and energetic, fascinated me as years before my baby-nurse's had. I could see nothing beyond that screen of desire that ended with the narrowing of the waist and the roundness of the buttocks.'

There is a further element in the story Dalí tells about Gala. He went to meet the Eluards that first evening on the Miramar terrace wearing a bizarre outfit: a silk blouse of his own design with enormous puffed sleeves, a low neckline, a necklace of fake pearls and a bracelet. The term he used to describe this costume, 'bachelor-girl', made it all perfectly clear. He wanted to make sure that this disturbingly beautiful woman received the right message, that he was sufficient unto himself and did not need her or anyone. He had another laughing fit.

Next morning his costume for their rendezvous on the beach was even more elaborately symbolic. The description of it goes on for pages in his autobiography: a shirt, scissored to show off one of his nipples, a bared shoulder and his navel; hair tousled, armpits and knees bloodied, another necklace, an enormous red geranium behind an ear, trousers on inside out, and the final finishing touch, a grotesque stink that he had manufactured himself from fish glue, aspic, and goat manure. 'I opened the window wide, and stood there, hideous and superb.'

At that moment he saw Gala's back and instantly came to himself. His whole attempt to show that he was a transvestite and probably cracked in

the head as well, to warn off a normal human being with the revolting fact of Dalí at close quarters, was stopped dead. In his autobiography he told himself, 'You look like a regular savage', but in later years he explained himself more clearly: 'Like Jupiter's lightning, the strength and dazzle of life overwhelmed me.' He was astonished at the sudden springing to life of his twin, his ideal, and stunned by the strength of his longing, not just for her, but all that was normal and life-enhancing. He would have liked to go to her naked, his hands outstretched. He did not dare do this, but at least he could clean himself up. It took a long time to wash away the stench. Once he managed to make an appearance, he was still in the grip of his lunatic laughing fits. Speechless, he sat at her feet, 'attentive as a dog to her slightest whims ... my life dangled from her gaze'. Dalí rightly considered it one of the turning-points in his life.

That whole year was full of such moments, all of them shifts in the direction of self-awareness and reality. One could hardly call his wild swings of mood and blundering acts those of a man in full control of himself. He was 'a child of genius lost in the world, the horrible world teeming with stupidity as well as monsters with mandibles, claws, and talons' who faced an 'abyss of terror'. One can see something of this in the photographs taken of him that year. He is thin to the point of anorexia, with deep hollows in his cheeks, around his mouth, and under his eyes – in a year or two, he would look like a changed man – and his stare has something of the glitter and menace described by Sebastià Gasch, the Barcelona art critic.

His break with his father, sister, and aunt was brutal, and even Gala, the woman who was his saviour, felt the brunt of his irrational outbursts. He had driven a wedge between the two halves of his nature, the precociously mature, thinking, analysing, intellectual self and his profoundly immature, raging, and primitive emotional needs, or what he called the savage and atavistic in himself. However, Dalí had had the wit to throw in his lot with a group of intellectuals who could take such taboos as masturbation with equanimity, who encouraged each other to discuss such subjects, who in short mentioned the unmentionable, and this alone must have been a release. Like the Surrealists, Dalí was deeply influenced by Freud and probably Krafft-Ebing as well; being Dalí, he had by then diagnosed his own case with textbook flawlessness. That extraordinary, detached, icy intelligence was brought to bear upon the turbulent disturbances boiling beneath the surface since, as he somewhere sensed with acute panic, he had to build a bridge between them. His great triumph was his ability to draw from both sides of himself as he painted the series of works that would establish his fame. The compositions and the insights flooded out of him. The work was his strongest release and, as he knew, his exorcism.

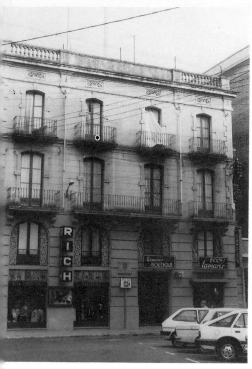

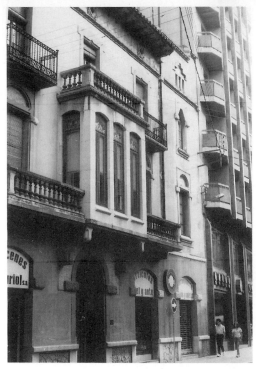

Dalí's birthplace in Figueres

Part of the first-floor apartment on the corner of plaça Palmier and carrer Caamaño to which the Dalí family moved when Salvador was ten

With some Surrealist friends, 1929–30: (*front row, left to right*) Tristan Tzara, Dalí, Paul Eluard, Max Ernst, René Crevel; (*back row*) Man Ray, Hans Arp, Yves Tanguy and André Breton

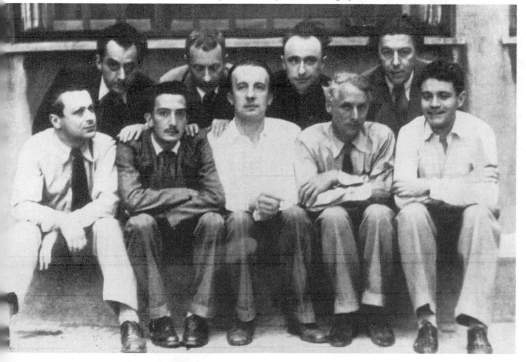

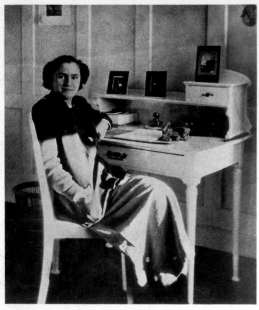

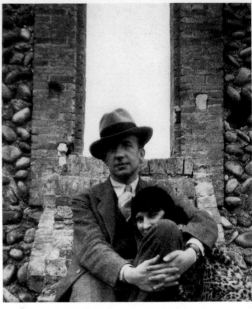

Gala recuperating from tuberculosis in a Swiss
sanatorium in 1912

Paul and Gala Eluard on holiday in 1931,
photographed by the French Surrealist painter
Valentine Hugo

With the organizers of the 1936 International Surrealist Exhibition in London: (*back row, left to
right*) Rupert Lee, Ruthven Todd, Dalí, Paul Eluard, Roland Penrose, E.L.T. Mesens, George Reavey,
Hugh Sykes Davies; (*front row*) Diana Lee, Nusch Eluard, Eileen Agar, Sheila Legge and a friend

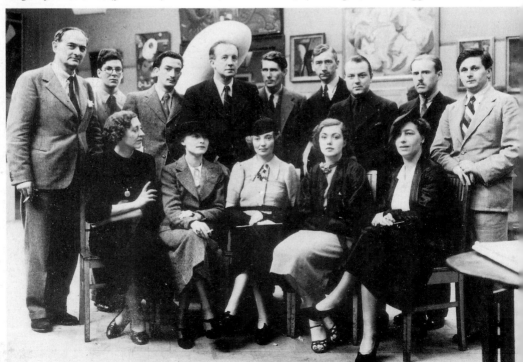

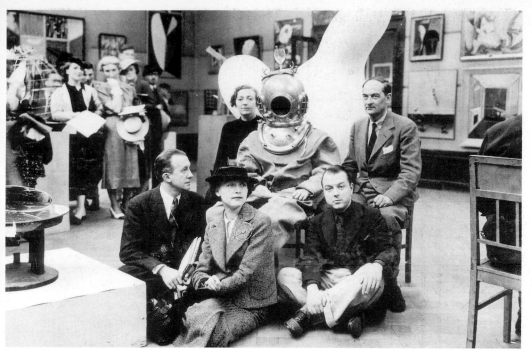

Dalí at the New Burlington Galleries, in the diving suit in which he gave his lecture at the
International Surrealist Exhibition with (*from left*) Paul and Nusch Eluard, Diana Brinton Lee,
E.L.T. Mesens and Rupert Lee

Still is his diving suit, Dalí points out a detail of his painting *The Dream* to his wife Gala and Paul
Eluard, with Roland Penrose in the background

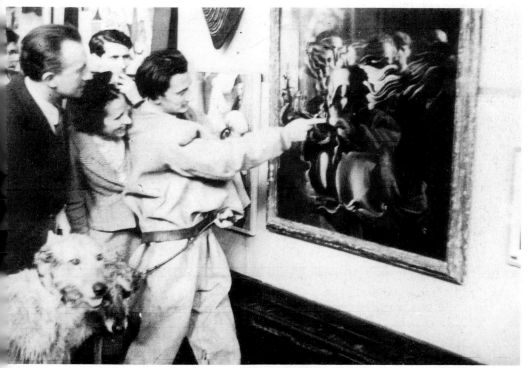

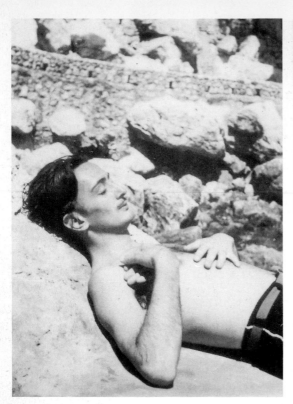

Gala and the Princess de Faucigny-Lucinge at the seaside

Relaxing on the beach

Port Lligat as it looked when Dalí first went to live there

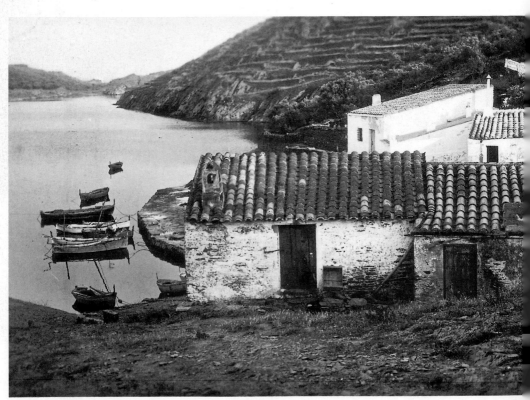

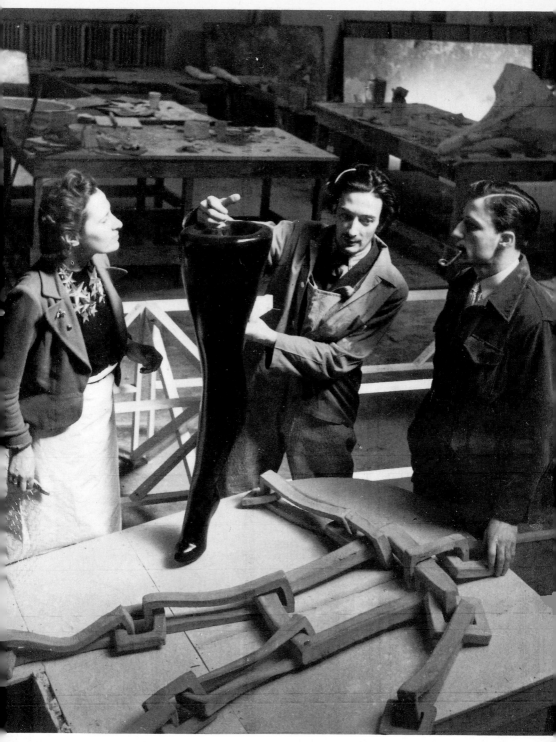

Gala and Dalí at work on his exhibit *The Dream of Venus* for the 1939 World's Fair in New York

A prewar photograph of Dalí
and Gala on holiday with
Caresse Crosby (*on Dalí's
right*) and a friend

In Connecticut in 1939,
photographed by art
historian James Thrall Soby

At a picnic at Westport,
Connecticut, in 1940

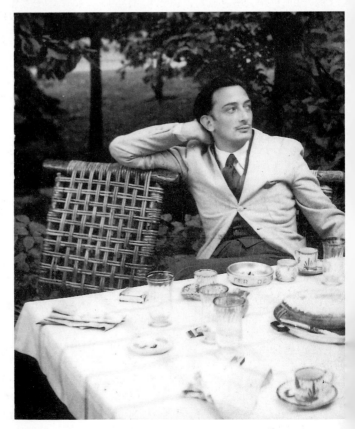

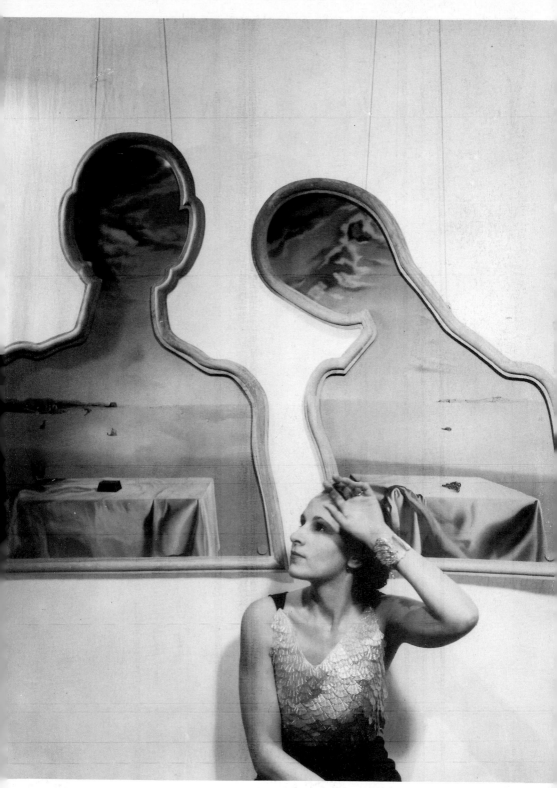

The photograph of Gala by Cecil Beaton which appeared on the cover of Dalí's poem to accompany his painting *Metamorphosis of Narcissus*

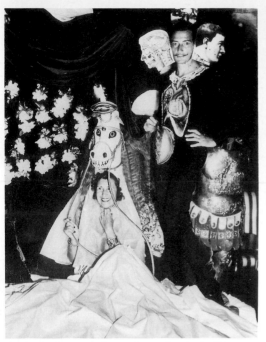

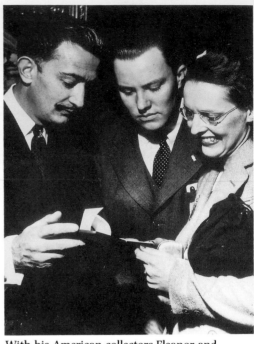

At the Bad Dream fancy-dress charity ball in California, 1941: Gala, wearing a horse's head, reclined on a red velvet bed at the head of the main table, while Dalí, with three heads, was attired in a satin appliqué top and black tights

With his American collectors Eleanor and Reynolds Morse, Knoedler Gallery, New York, 1943

A small boy watches Gala and Dalí make a meal of sea urchins

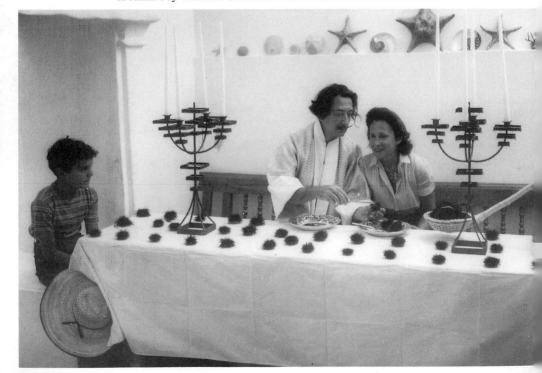

By the time Dalí came to paint *Le Jeu Lugubre* he had definitely settled on the style he derived from de Chirico, Tanguy and, to a lesser extent, Miró and Ernst, and had painted a series of remarkable works exploiting the themes by which he would become known. His extraordinary *Apparatus and Hand* of 1927, now in St Petersburg, Florida, which takes a step further the iconography he first developed in *Blood is Sweeter than Honey*, appears to have been his first reference to masturbation. Other works such as *Baigneuse*, a torso with a swollen right hand on a beach, *Bather*, 1928, and *Unsatisfied Desires*, 1928, deal more or less clearly with the same theme. *Cenicitas* (*Little Cinders*), on which he worked during his nine months' compulsory military service in 1927, is almost a compendium of the symbols and hallucinatory images he was beginning to refine. There are skeletal donkeys, disembodied female torsos, and broken birds, floating heads, eggs, and fingers – the list goes on and on, but one of the most striking images, which could be Dalí himself in profile, with reddened eye and gritted teeth, suggests, by the superimposition of disembodied breasts, the transvestitism that was obsessing him at the time.

Le Jeu Lugubre was a perfectly clear and straightforward statement of the intense guilt that, for Dalí, accompanied masturbation, but with something new added, the first reference to a theme that was to appear again and again, fear of castration. A bearded figure in the lower right foreground is half carrying a youth, almost naked except for one sock, whom he appears to have castrated. So far so good, but this triumphant figure has, apparently, soiled his short pants with faecal matter in the process. Soby commented of this and other works of the same period,

> The pictures in general are crowded with implements of persecution, particularly with sharp instruments symbolic of mutilation; they swarm with fetishes direct from Krafft-Ebing's case histories – slippers, keys, hair and so on. They are, moreover, largely concerned with what Dalí called the three cardinal images of life: excrement, blood and putrefaction.... In painting these images he was attempting to release the dark, repressed poetry of the subconscious.

Soby added that had anyone objected to Dalí's paintings on the grounds that they were sacrilegious, ugly, or scatalogical, they would not be refuted by the artist. 'It has to be said once and for all to art critics, artists, etc., that they need expect nothing from the new Surrealist images but disappointment, distaste and repulsion,' Soby wrote. However, he had reckoned without the special problem of the figure in the lower right corner of *Le Jeu Lugubre*. What worried the group of Surrealists who watched the artist making his final

additions to this work was that, instead of illustrating a formerly taboo subject, he might merely be expressing his phobias and stood revealed as having the particularly nasty one of a desire to eat faeces.

It is surprising in view of Gala's fastidious disgust with such things that she agreed to question Dalí on their behalf. She must have taken the right approach, because Dalí's immediate impulse, which was to boast about his coprophagic impulses in order to make himself 'even more interesting and phenomenal', faded with the realization that this was absolutely the wrong thing to say. She had, after all, made it clear enough: 'If those "things" refer to your life we can have nothing in common, because that sort of thing appears loathsome to me.' Wallowing around in excrement, as far as Gala was concerned, was going too far even for a Surrealist. In short, she was offering Dalí another opportunity to back away from her, but he refused to be deterred. There was something straightforward and honest about her, he wrote later; he could not disappoint her. When he had another laughing fit, she knew why and touched him. She looked at him with her penetrating, intuitive gaze, took his hand, and said, 'My little boy! We shall never leave each other.'

He wanted her, resisted her, was enraged by her. She had come to 'destroy and annihilate' his solitary world and he attacked her with reproaches he knew were unjust, that 'she prevented me from working, she insinuated herself surreptitiously into my brain, she "depersonalized" me. Moreover I was convinced that she was going to do me harm.' Two of the canvases he was painting at the time, *Les Accommodations des Désirs* (*Accommodations of Desire*) and *Visage du Grand Masturbateur* (*Face of the Great Masturbator*) were, he wrote, expressions of his heterosexual anxiety. On several occasions Dalí said that in his youth he had compared his sexual organs with those of his schoolmates and found himself very poorly equipped. 'I had read a ... pornographic novel in which the Casanova on duty related that, when penetrating any woman, he heard her hymen break like a watermelon. Thereupon, I said to myself, "You are certainly incapable of making a woman break like a melon."' Gala, he thought, was about to discover the awful truth and in the process of seducing him she would somehow split him up into little pieces and wipe him off the map. Such thoughts were accompanied, as they had been when he was alone in Paris and trying to accost strange women on the street, by revengeful sadistic fantasies: 'I took revenge in my dreams on what haunted and frightened me. I possessed my beloved like a brute, I tore her dress, laid bare her breasts, tattered her underclothes, and impaled her on the ferocious stake of my upstretched cock.' He took her for long walks along the coast and had fantasies of hurling her into the sea. He threw rocks instead with such vigour that he felt her sense his intention and

it immediately brought him to a halt. In fact, with Gala he could not sustain his fantasies: 'as soon as I was actually with her, her eyes, her voice, her smile swept away my fancies. Once more I was headlong into love and fear.'

Gala, Paul and Cécile Eluard spent the month of August in Cadaqués. Gala wanted Dalí to do something for her, but she would not tell him what it was. Buñuel, however, seemed to have, like a medium, the ability to plumb the depths of this secretive Russian soul. One day he, along with Dalí, Gala, and Cécile, went for a picnic among the rocks. Buñuel happened to say that the view reminded him of a painting by a second-rate Spanish painter.

'How can you bear to say such stupid things!' Gala shouted at me. 'And in the presence of such gorgeous rocks!'

By the time the picnic was over, we'd all had a great deal to drink. I've forgotten what the argument was about, but Gala was attacking me with her usual ferocity when I suddenly leapt to my feet, threw her to the ground, and began choking her. Little Cécile was terrified and ran to hide in the rocks.... Dalí fell to his knees and begged me to stop; I was in a blind rage, but I knew I wasn't going to kill her. Strange as it may seem, all I wanted was to see the tip of her tongue between her teeth. Finally, I let go.

This was most definitely not what Gala wanted, or was it? Early in September 1929 Paul Eluard tactfully returned to Paris, taking Cécile with him. Gala planned to return to Paris early in October. She remained enigmatic; Dalí more and more in the grip of frenzied desires. Back up the path towards the rocks they went. There Dalí gave her a kiss to end all kisses – it sounds, from his description, as if he bit her – and pulled her head back by the hair. Then he said, 'Tell me what I should do now. Tell it to me obscenely so I can become a man and an animal.' He had practically written her script himself and she was most uncooperative. She said in the most composed way possible that she wanted him to kill her.

Throttled on the rocks, so that the tip of her tongue showed between her teeth? Heavens, no; Dalí could not cope with all that violence. Poison? One could not be sure and besides it might be painful. How about a push off a high cliff? There was the possibility of an awful panic on the way down. Gala made it clear that the main thing was total surprise and immediate success. Dalí had nothing to fear because she would leave a suicide note that would give him a foolproof alibi. She talked about the crime he was going to commit 'with the ... precision of a director setting up a key scene'. She had reasons, one gathers from Dalí, related to her past, her 'secret', but he did not reveal them and neither did Gala. The more she talked the calmer and more cour-

ageous she seemed and the more he admired her. Was it an inspired stroke, as he later believed, to disarm him, and turn him from thoughts of murder and mayhem to those of ecstatic union? 'This friendly invitation was their moment of truth. One sees such moments often in psychotherapy. This kind of shock opens the way for a real Renaissance,' commented Dr Pierre Roumeguère, a French psychoanalyst.

Dalí always discussed his love affair with Gala as if she were a goddess whose divine function was to save him from himself. 'Gala drove the forces of death out of me', beginning with 'the obsessive sign of Salvador, my dead elder brother; the Castor whose Pollux I had been, and whose shadow I was becoming. She brought me back to the light through the love she gave me.' It is a view shared by Dr Roumeguère, who has studied Dalí for longer than anyone else.

> You know, Gala is an Alpinist of destiny. She realized that Dalí was a genius and that this would be her great work.... She found this sorry-looking invalid; she was going to mother one of the great men of his epoch – with Picasso – , literally blow up his personality, while completing him, for although she has been much criticized, I personally think she was the source of his life, his mother, his sister, his inspiration, his wife, his lover.

Gala soon metamorphosed into Gradiva, the heroine of a short novel by Wilhelm Jensen titled *Gradiva: A Pompeian Fantasy* (1903). In it a young archaeologist falls in love with a plaster cast of a classical Greek relief, a beautiful woman. He becomes obsessed with the image and visits Pompeii, where he discovers a young girl who bears an uncanny resemblance to his ideal. The girl realizes that he is ill and frees him from his distorted view of reality. Freud took the novel as the point of departure for an essay that the Surrealists quoted in support of their conviction that the artistic symbol forged the vital link between reality and unreality. According to Dalí, Gala symbolically stood between him and madness. 'She cured me of my self-destructive rage by offering herself as holocaust on the altar of my rage to live. I did not go mad, because she took over my madness.'

Gala is always described as a formidable figure, a frightening woman, as can be adduced from Buñuel's berserk conviction that he must render her harmless if not actually immobilized. That fierce little demon had to be choked out of her. Even had Dalí not been in the grip of some violent anxieties he would, nevertheless, have made a wide circle around someone as tough, determined, ruthless, 'phallic' as Gala was. But this was exactly the point. In joining up with her, he would no longer need to look for the androgyne

within himself because Gala was his twin, his double, his other half. He placed the same kind of stress on Gala as an extension of himself as Eluard had, no doubt for similar incantatory reasons. By identifying with her, he could effect the necessary transformation that would allow him to disarm her, see her in terms of her other side. There is no doubt that Gala's personality was as strongly split as his own. That other part of Gala, that uncanny intuitive understanding, that infinitely patient ability to submerge herself into her loved one, was the side he chose to see and exalt: 'Gala became the salt of my life, the steel of my personality, my beacon, my double – ME.' He had discovered the secret truth about her, which was her vulnerability, the terror she concealed behind a pugnacious façade. She had been able to confide her fears in him, as she had done in Eluard. This revelation that she, too, was pursued by demons freed Dalí to make contact with his bedrock strengths.

To call Gala the source of Dalí's existence, to say that she discovered him and moulded him single-handed, is to misplace the emphasis. No man as hounded by all the anxieties to which Dalí so freely admits, could possibly have let down his guard and allowed such a fierce little presence into his life, let alone taken her to bed, if he were not feeling equal to the task. He was clearly the initiator as he himself makes clear: 'the asker, the inciter, the calculator.' His astonishing success in Paris, and his willingness to confront, in his art, a host of irrational terrors, giving them full reign; these were the factors that gave him the courage to seek greater autonomy. Gala might have put her hand in his but he was the one who chose. The person who saved Dalí in that crucial year of 1929 was himself.

Dalí's creative energies seemed inexhaustible. While courting Gala he was also painting at top speed a number of brilliant works subsequently exhibited in Paris, including a portrait of Paul Eluard that was also shown at Galerie Goemans, 49 rue de Seine. The poet in jacket and tie is shown in the form of a bust floating over a vast plain, surrounded by symbols which recall works of the same Dalí period: grasshoppers, ants, lion's heads, and disembodied hands. The relationship between the two men is difficult to understand at this period since it seems that their budding friendship was not affected by Gala's infidelity. Judging from the portrait, Dalí hardly feels the cocky triumph one would expect of a younger man who has just snatched away the sitter's wife. For his part, as has been noted, Eluard treated Dalí in an exceptionally forbearing and civilized manner. Rather, Dalí seems to be surrounding Eluard with evidence of his own obsessions and fears as if their love for the same woman gave them a common bond. Biographers of Paul Eluard have interpreted one particular poem to suggest that Eluard saw his triangle with Max Ernst as incestuous by virtue of his quasi-fraternal feelings. The thought is

somewhat reinforced by Eluard's later letters to Gala in which he calls her his sister.

As for Dalí's own state of mind, he makes his first veiled reference to the family drama he may well have stumbled across in *Les Plaisirs Illuminés* (*Illumined Pleasures*). There is an older man reaching for a frightened, fleeing woman, a naked boy peeping through a keyhole into a shadow box, and a hand gripping a bloody knife. Dalí also made a sketch in Indian ink on paper, presumably not exhibited at the time, called *The Butterfly Chase*, in which two naked women, their legs spread wide apart, are leaning over a large butterfly net with a long handle, which they are obscenely exploring, while a bearded man in the background embraces them both. On the left one sees a naked little girl attempting to distract one of the women in a kind of anxious supplication. An even younger child looks on in bewilderment, sucking his fingers, and the spectral head of a baby hovers in the centre of the composition. This grouping in disguised form and with minor variations was to appear again and again in Dalí's paintings. One can, without much stretching of the imagination, interpret it as Dalí's direct allusion to his terrible family secret. One is struck by the horrid absorption of the two women in their task, the bemusement of one child, the pathetic attempt by the older one to change everybody's mind, and, hovering over them all, a shameless, smiling male face. The worst aspect of the sketch is its implication that children are being prematurely initiated and sexually exploited in a particularly blatant and revolting way. No doubt it is the way Dalí felt and it must have sickened him. To exhibit such a drawing was obviously out of the question, but that Dalí felt impelled to make some kind of statement, throw down the gauntlet, is clear. What he did exhibit in November was a chromolithograph of the Sacred Heart. Across it Dalí had scrawled in bold black letters '*Parfois je crache par plaisir sur le portrait de ma mère*' ('Sometimes I spit with pleasure on my mother's portrait').

Dalí spent Christmas in Figueres that year and it was one neither he nor Buñuel would ever forget. 'At first, all I could hear were angry shouts,' Buñuel wrote, 'then suddenly the door flew open and, purple with rage, Dalí's father threw his son out, calling him every name in the book. Dalí screamed back while his father pointed to him and swore that he hoped never to see that pig in his house again. The rage of the elder Dalí was perfectly understandable ...'

Dalí said later that the two split over Gala. When he broached the subject of marrying a Russian his father dismissed the idea as unthinkable. He accused Gala of being a drug addict and was convinced, since Dalí seemed to have some money, that he must have become a narcotics dealer. That and other things were said – Dalí senior was a master of the outrageous state-

ment – but Dalí's drawing of the Sacred Heart was the immediate precipitating factor, made worse by the fact that Dalí's father read about it in a newspaper article by Eugenio d'Ors. Whether one reads the drawing as an attack on the church, which would have been perfectly Surrealistic, or as an attack on Dalí's own mother, recalling her oft-repeated question, 'Heart, what do you want?', it was a scandal.

There is no doubt that the drawing was carefully assessed by its author for its ability to attack his father at his weakest point. Having rejected his wife for her sister, he would be compelled to defend her more or less vehemently, depending on the strength of his guilt feelings; to let such an affront pass without comment would mark him, in a sense, as a partner in the crime. He had to continue the charade of bereaved husband, loving son and mourning daughter; to suggest anything else was tantamount to a public confession which was, one has to conclude, what Dalí was really making. Dalí, who had spent so many years driving his father to the absolute limit of his endurance, and whose favourite fantasy, he claimed, was the thought of sodomizing his dying father, here admits to some of the outrage he feels at having been robbed of his sexuality and robbed of himself. As for his father, a quarter century of swallowing insults was as much as he could take.

'I do not know whether you were aware that I had to throw my son out of the house,' Dalí's father wrote to Federico García Lorca on 16 January 1930. The pretext of the letter was to send the poet a newspaper review praising a production of his play, *The Shoemaker's Wife*, but Dalí's father knew his views would get a sympathetic hearing from Lorca. He continued,

> That was very painful for all of us but for reasons of dignity it was necessary to take such a desperate resolve. In one of the pictures of his exhibition in Paris he was vile enough to write these insolent words, 'I spit on my mother'. Supposing that he might have been drunk when he wrote it, I asked him for an explanation which he refused to give and he insulted all of us once again.

He concluded, 'You can well imagine the sorrow that so much nastiness (*porquería*) is giving us.'

The letter reveals that Dalí's father immediately jumped to the conclusion that his son was spitting on his mother and not her portrait. In other words, he was not taken in by whatever hair-splitting rationalizations may have been offered. It is also revealing of Dalí himself. One would have expected him to find some excuse, however transparent and lame. To deny his real intentions would have been characteristic but, on that fateful night, he had the courage of his convictions. He was defiant, insolent and vile in his father's

eyes. In fact, he even insulted 'all of us' once again. Just exactly what Dalí did say on that fateful night will never be known, but the odds are that he spoke his mind about his mother's death and that his aunt, now his step-mother, was not spared. (She ended her days in a mental hospital, a fate, it is said, that Dalí considered retributive.) As for Ana María Dalí, she took her father's side and broke with her brother then and there. She does not mention the incident in her memoir but, instead, blames the influence of the Surrealists for turning a loving brother into a monster. 'The destructive ideas of Sur-realism arrived in Cadaqués with the force of a torrent, and as they burst, brimming over with hatred and perversity, they destroyed the peace of our hearth and made us victims of this baleful movement which Salvador had the bad luck to join.' Since her father was still alive when she was writing and since by then father and son had reached a fragile reconciliation, she obviously thought it the better part of diplomacy to avoid a very sore subject. No doubt she felt similarly as far as Gala was concerned, although there was clearly no love lost between the two women. Ana María would have been inhuman not to resent the spectacular appearance of this seductive and apparently predatory woman who was abandoning her husband and child without a backward glance, so as to assume the role in her brother's life that had been hers alone. One can catch a glimpse of the fine line she tried to draw in not antagonizing either personality. Based on Dalí senior's willingness to write scorching insults in a letter to his son's friend, one can guess just how implacable and vindictive he became. His father's curse was soon known all over Figueres and Cadaqués, 'which was subscribed to by all right-thinking people', Dalí wrote ironically. The myopia of Dalí senior is worth noting. He can observe his son rolling on the ground in hysterical fits of laughter without being alarmed in the slightest, so long as the son conforms to the picture he has of him as irrational, eccentric, childish and dependent. But once that son tackles him, he chooses to feel mortally insulted rather than face up to some hard truths. One gathers, from the letter he wrote to Lorca, that one of the things that galled him the most was that Dalí had found someone to pay his bills, which obviously robbed him of a role and the power to threaten. No one with an ounce of self respect, he wrote indignantly, would take this woman's money and food. No doubt the husband did not object because they both planned to extort a sizeable loan from Dalí at the right moment.

As for Dalí, one can see the famous incident as a trauma that marked him forever or as a step in the direction of mental health. Faced with such repressive fathers, other sons have done violence to their own resentments, anger and fears of impotence and stared into an abyss; Dalí wanted to live. He used his art as a catharsis and then found the strength for a direct

confrontation. He has made such a public spectacle of his fears and inadequacies that one is apt to forget how brave he was.

In the long months that followed her meeting with Dalí, Gala was making some complicated manoeuvres of her own. She appears to have continued normal married life with Eluard in between dalliances with Dalí – first at Sitges, just south of Barcelona, then at Carry le Rouet on the Côte d'Azur. The arrival of Dalí seemed, as perhaps the arrival of Max Ernst had done, to act as a sexual stimulus to Eluard. As late as February 1931 Eluard was asking her why she had not yet sent him photographs of herself in the nude and describing a long erotic reverie in which he saw her 'completely nude with your legs separated and you were taken by two men, in the mouth and in your sex. . . . And I imagine, this afternoon when I am alone, everything you have to give, the boldness of your body in the service of your passionate frenzy. And I gently masturbate.' He wanted her to send him pictures of herself in the place where she made love. He planned to make love to her in the presence of Nusch, who would be reduced to the expedient of self stimulation. The letter clearly implies that his fantasy would be as sexually stimulating to Gala as it was to him and that keeping two men on a string was very much part of the fun. Perhaps Gala did not have to try particularly hard to convince Eluard that she still needed him while she waited for the Dalí affair to resolve itself. There is no doubt that she was in love with Dalí. On the other hand, he had no money and neither did she. Given her extreme parsimony, it would be unlike Gala to let go of one lifeline before being sure of another.

That she was extremely close to Eluard is clear. She understood him and was used to getting what she wanted from him. She was not above using emotional blackmail if it was not immediately forthcoming: 'My Gala, I really can do without your reproaches at the moment telling me I don't love you and don't pay attention to your affairs,' he wrote, with one of his few flashes of irritation. He went on to describe how hard he was battling for a few sous and continued, 'No my little girl, my only one, I adore you, believe me. . . . If you knew how much I would like to come to Cadaqués. And find money for you, lots of it.' It is not exactly clear what had happened to his income. Cécile recalled that her grandmother, who at first had a large country house in Montlignon with gardeners and a chauffeur, lost it all; she did not remember when. Eluard certainly gives the impression, in letters of this period, that he is selling his books, paintings and *objets d'art* in order to keep them all afloat. That her delicate juggling act may have caused Gala some inner stress is, however, suggested by the fact that she was ill twice. Early in 1930 she was taken to bed with pleurisy and left so weak that she was exhausted by the

least effort. She was tearful and depressed, according to Dalí. Then, early in January 1932, she was operated on to remove a fibrous tumour from her uterus which, one gathers from Eluard, had caused continuing problems. Dalí was so frightened he wept for a week.

At the same time Gala seems to have dealt brilliantly with the whole problem of Cécile who did, in any event, have her father and grandmother and was old enough to go to boarding school. Since Gala was only having a little fling, in Eluard's eyes, the question of a permanent arrangement did not arise until much later. References to Cécile are sparse in his letters. He does tell Gala that she had scoliosis (a spinal disorder), but Gala was not to concern herself in the slightest because it probably was not serious. Somehow or other he would manage to send her off to Switzerland for a cure. Only much later does Eluard gently remind Gala that she has a daughter. Cécile loved her so much, and thought her mother did not love her. Every time she spoke of Gala, tears came to her eyes. Claire Boaretto explained that Cécile never blamed her mother for what happened. If her mother did not want her, the little girl thought that there must be something wrong with her. When Eluard established contact with Gala at the end of the Second World War, after a five-year silence, Cécile simply appended a postscript. She called her mother 'Little darling Gala', an appellation that surely speaks volumes. Her father had said everything, she wrote. The rest could wait until they all met. 'We miss you and I love you so much.... Write to us.' They would always be asking for letters.

At the very moment of confronting his father, Dalí was at the absolute peak of his career. The Vicomte de Noailles had bought one of his paintings and André Breton another. In fact the whole show was sold out. Dalí was astonished by the equal success of *Un Chien Andalou* and the news, from Buñuel, that the Vicomte had given him a million francs which seemed an absolute fortune, to make a second and longer 'talking picture' – in 1930 it would be only the third movie with a soundtrack to be made in France. As before, Dalí and Buñuel were to collaborate on the screenplay and they got right down to work that Christmas of 1929; since Dalí had just been thrown out of Figueres they went to Cadaqués.

It should have been another spectacular meeting of minds, but it was a calamity. It is difficult to know why these two brilliant men who had seemed in absolute accord a matter of months before should now be so at odds. Their versions are conflicting. Dalí said that Buñuel kept trying to distort his mythic visions, which were meant to 'translate all the violence of love, impregnated with ... Catholic myths' into a kind of elementary anti-clericalism. Buñuel's version is that Dalí meant – here he quotes one of Dalí's letters – to expose

'the shameful mechanisms of contemporary society', whereas he felt the film to be about a frenzied and doomed love affair. Both agreed that not very much of Dalí remained in the final scenario, which has not prevented contemporary art historians from treating L'Age d'Or (The Golden Age) as part of Dalí's oeuvre.

In terms of its images, L'Age d'Or made the eyeball-cutting scene in Un Chien Andalou look tame. The scenes included, Marcel Jean wrote,

> a blind man being ill-treated, a dog squashed, a son killed almost wantonly by his father, an old lady slapped, an unconsummated love-scene dominated by the violence of frustrated actions, and symbolic images like that in which the heroine sucks with rapture the big toe of a marble statue.... As a final shock to the sensibilities, the Comte de Blangis, [the Marquis de] Sade's protagonist in Les 120 Journées de Sodome, appears in the guise of Jesus Christ.

There was no more nonsense about the bourgeoisie being made to swallow its merde and like it. The forces of decency rose up in the guise of right-wing royalist and anti-Semitic groups, who attacked the cinema in full battle-dress, hurling ink at the screen, throwing stink-bombs, firing guns, breaking seats and smashing glass. An exhibition of books and pictures in the lobby was torn apart and several paintings trampled underfoot. The paintings were by Miró, Ernst, Tanguy and – by virtue of the good luck that seemed to follow him everywhere – Dalí. After that things were never the same between Dalí and Buñuel. Buñuel, who was forced to leave his job at the Museum of Modern Art in New York during the Second World War, was convinced that part of the trouble stemmed from Dalí's autobiography, which had just been published and which made his anti-clericalism clear. For his part, Dalí believed that in L'Age d'Or, 'Buñuel betrayed me'. In 1939 Buñuel asked Dalí for the loan of a few hundred dollars and was flatly turned down. In the 1960s Dalí sent Buñuel a cable to join him immediately, to write the sequel for Un Chien Andalou and Buñuel replied with a Spanish proverb, Agua pasada no rueda molino (Once the water has gone over the dam, the mill won't run any more). But the real problem between them was Dalí's support of the Franco regime, which Buñuel could not stomach. His son, Juan Luís, said his father did not want to see Dalí again because, 'I know I will fall in his arms and cry and drink champagne, and I don't want to forgive him.'

With a sell-out show, money should have been pouring in, but Goemans was in arrears. One day Dalí received a letter from the Vicomte de Noailles, who had heard that Goemans was going bankrupt. He offered to help Dalí over this hurdle financially by paying for an important picture in advance.

(He also introduced him to a new dealer, Pierre Colle.) Gala stepped in at this point with a shrewd piece of business advice, assuming the role that she was to play for the next forty years. The sum, she and he agreed, should be 29,000 francs. Gala went off to Paris to salvage what she could from Goemans and Dalí broke the news to de Noailles, who was most agreeable. The slip of pink paper, his cheque, was placed on Dalí's desk and carefully considered. 'The check assumed the shape of a case full of ingots, or turned into meals, fabrics, clothes.... An army of imaginary valets whirled respectfully about me,... attentive to my slightest whims.... By the time Gala got back, I was giddy with gold.'

They decided to use the money to buy a tiny fisherman's hut at Port Lligat, one room four metres square, with an adjoining storeroom three steps up which they would convert into a kitchen with a shower and toilet. To take a foothold in the most miserable possible spot, a single room on a bleak coastline, but to do so a mere two kilometres from the spot inhabited by his family, sleeping on feather beds, the place he had lived in all his life – that was typical of him. He might be thrown out but he refused to budge. Gala, to her credit, was completely supportive, not only of his painting – he had begun working on a *trompe l'oeil* canvas, *L'Homme Invisible* (*The Invisible Man*) – but of his writings. She had found some disjointed notes that she, with infinite care and patience, had transcribed, encouraging him to recast them into a 'theoretical and poetic work', which finally appeared as *La Femme Visible* (*The Visible Woman*). Whatever he suggested she enthusiastically agreed to because 'Gala wanted only what I wished'.

Meanwhile Dalí senior had irrevocably banished him. There is no doubt that by the time the fateful letter arrived, Dalí was stricken with remorse. He declared as much at a conference in Barcelona in the spring of the following year, 1930. Eugenio d'Ors had completely misread the intent of his Sacred Heart picture, he said. Far from being offensive and cynical, it had its origins in a conflict of moral order very similar to the common, indeed universal, phenomenon of dreaming of assassinating someone whom one dearly loves. He expanded on the same theme at greater length in 1952, shortly after his father's death. The inscription had 'only a psychoanalytical value, and didn't diminish the filial love I felt for my mother', he explained. A decade later he was still on the defensive about it, as was apparent to Reynolds and Eleanor Morse when they, quite by chance, found an illustration of the picture and showed it to Dalí. 'He hit the ceiling,' they recalled. 'This is a disgrace,' he said. 'It's not true at all. I loved my mother very much. It was a nightmare; I had a bad dream. It was an irreligious thing; nothing to do with my mother at all.' He seemed to protest too much.

Upon receiving his father's letter, alone in Cadaqués, his immediate reaction

was to shave his head. (Curiously, Eluard was to do exactly the same the following summer when he joined Dalí and Gala at Cadaqués in the company of Nusch.) The question of hair – whether and how much – was fraught with significance for Dalí in his early twenties. He almost always shows his father in his paintings with a full head of hair and a beard, though he had neither. Dalí himself flirted with a pencil-line moustache, which appeared and disappeared before coming back for good. He was sporting one again when, rounder and visibly softened, he sat with a radiant Gala for their photographs in the summer of 1930. When he had first decided, as a student, to abandon his hairstyle of mad genius for one more in keeping with an Argentine tango dancer, which seemed like the last word in elegance to him, he felt a momentary panic. 'What if the story about Samson were true?' '. . . for several minutes I lost faith in myself.' Once on the street, however, with the sound of the barber's door slamming behind him, he felt as if he had turned his back on attitudes he had outgrown. One gains the strong impression from his autobiography that he went through the identical emotional stages after his father's letter. He buried his black locks in a hole on the beach along with a pile of sea urchin shells; then called for a taxi to take him to the train station in Figueres. He was going straight to Paris and Gala.

The road from Cadaqués which winds up towards the mountain pass of Peni does, as Dalí says, afford the departing guest numerous vantage points from which to view the village as it dwindles into the distance. There is a point, which he knew well, at which it has become a tiny speck, and every time he left he never failed to turn around for one last, lingering glance. But this particular time, as the taxi took the bend in the road, he let the vision slide away; staring straight ahead.

CHAPTER NINE

The Conquest of the Irrational

'My whole ambition in the pictorial domain is to
materialize the images of concrete irrationality with the
most imperialist fury of precision.'

DALÍ, *Conquest of the Irrational*

The period beginning in 1926–7 and ending approximately with the Second
World War has to be considered the great period of Salvador Dalí's art,
although the artist would probably disagree and so might some curators and
collectors. Even they would, however, have to concede that the artist's
compositions at this time were particularly prodigious, fresh, inventive and
masterful. However personal the inner vision, Dalí's Surrealist canvases speak
in symbols that conjure up answering echoes in the viewer's imagination.
They are evocative, haunting even, although one might not completely
understand why such recurring images of grasshoppers seem menacing, or
discover the meaning of the seemingly random tiers of plant and animal
forms, the clusters of ants, the squadrons of anonymous little men on bicycles
with sugared almonds on their heads. What, for instance, can possibly be
meant by the two men in the distance that one sees in *Plaisirs Illuminés?* Are
they embracing or grappling? Why does that egg-shaped object, marked out
by dotted lines as if on exhibit in a medical museum, have a hole in it through
which one can see what looks like a ball of twine? Why does the hair of the
boy peeping through a keyhole into a shadow box seem to be made of snails
and seashells? What is the reason for that look of panic on the face of the
lightly clad woman in the foreground, who seems to be merging into a wave,
and why is the man behind her trying to caress her chin? What are we
supposed to make of the shadow in the foreground, like that of the photo-
grapher recording the whole scene, the outlines of which suggest a woman
holding a baby? Why do these images tug at one's sense of inner unease
unless they somehow speak to the universal vocabulary that all of us are said
to possess?

'For me, the essential thing was to tell our life by any mythological means,'
Dalí once said in one of his less Delphic utterances. His riddle most certainly
has a key, as has been suggested so far, even if it only opens the first in a
dreamlike series of doors. This perfectly rational, if disguised, message reveals

its outlines in the same clues, stated over and over again, almost obsessively, as if the artist were being hounded by the weight of his inner experiences. In this respect the break with his father gave him access to a plethora of new material and perhaps he sensed, as soon as he began exploring the images of his waking fantasies, that it would be inevitable. To know that the break was final – as it seemed, when he was painting in the early 1930s – removed any remaining scruples. The doctrines of Freud turned such exploration almost into a virtuous act because, 'pleasures, even criminal ones, in contrast to the Gothic period when they could be glimpsed only in the half-light of oil-lamps, can today be turned inside out like a stocking', Dalí said of *Plaisirs Illuminés* some years later. He was unveiling the shameful, the hidden, the criminal even – by which he surely must have meant incestuous or half-incestuous – in his family history. Such testimonials, hung up on the walls of a museum in broad daylight, accused the perpetrators in perpetuity, and that was his revenge. Those who were foolhardy enough to probe for explanations would be spun around with conflicting and nonsensical statements until they were reeling, which would serve to further mystify and 'cretinize' the public, so that he had it all ways. Like the statements of the mad Lidia, the cunning widow of a sailor, whose logical illogic he so much admired, the paintings screamed their disclosures to uncomprehending ears. 'I also tell the truth, and I must be allowed to tell it.'

Dalí's symbolism may be based securely on his own obsessions, but it goes without saying that his works, and those of the Surrealists in general, were the honourable descendants of a long tradition. Henry Fuseli (1741–1825), a Swiss-born painter who lived in England and, as professor of painting at the Royal Academy, taught such important pupils as Etty, Constable, and Landseer, was a fantasist whose distortions and stylizations, most evident in his famous exploration of the irrational, *The Nightmare* (1782), gave him a permanent place in the Surrealist pantheon. Another was Arnold Böcklin (1827–1901), the major Swiss painter of the nineteenth century, whose landscapes of heightened imagery and menace were widely appreciated and imitated. His best-known work, *The Island of the Dead* (1874–85) is as haunting as a dream image and was to have an enormous influence on Dalí. He wrote an extended study of the work and made frequent references to the painting's surreal fountain and menacing cypresses in his own works.

Hieronymus Bosch, Pieter Bruegel and Francisco Goya are other obvious precursors of Surrealism, as are William Blake, Henri Rousseau and, especially, Gustave Moreau (1826–98). He was a leading Symbolist whose elaborate biblical and mythological compositions are painted with a richly encrusted sense of the magical and decadent. Simon Wilson, who wrote the preface for Dalí's retrospective exhibition at the Tate Gallery, London, in

1980, has pointed out that the particular contribution of the Surrealists was their wholehearted espousal of Freudian doctrine and their determination to 'tap the creative and imaginative forces of the mind at their source in the unconscious and, through the increase in self-knowledge achieved by confronting people with their real nature, to change society'. Surrealists leaned heavily on the idea of 'shock through paradox, the idea of giving such a jolt to surface consciousness that it is dislocated to reveal the hidden mysteries that affect it', the former *New York Times* art critic John Canaday wrote.

> In Surrealism these mysteries are usually morbid. Its immediate parallel outside the field of art is psychoanalysis, which probes the darkness of the pathological spirit to discover rational explanations for irrational conduct. There is a terrible rationality to Surrealism ... where everything is vividly real, yet where nothing is what it seems to be. The basic paradox of Surrealist painting is that every detail of every explicitly represented image ... undeniably exists – yet at the same time it cannot exist because it is outside the realm of possibility.

As a member of a group whose expressed purpose was to create an art that reflected the language of the unconscious divorced from any other considerations, whether aesthetic or moral, Dalí has to be considered exceptionally single-minded. It is a view he himself held. After he had finally broken with the Surrealists for good in 1940 he declared, 'The difference between me and the Surrealists is that I am a Surrealist.' 'This doctrine of an unaesthetic and amoral art ... was embraced and pursued more enthusiastically and more consistently by Dalí than by any other member of the Surrealist group, resulting in the production of a lifetime's output ... which in general visually reveals the unconscious with greater purity, intensity and conviction than any of the others,' Simon Wilson wrote. As for the subject-matter, it has already been suggested that Dalí was coolly prepared to wade into areas that the Surrealists, for all their idealistic manifestos, found distinctly repugnant: castration, putrefaction, voyeurism, onanism, coprophilia, and impotence among them. Where his art was concerned Dalí's stare was analytical and unflinching, and his ability to stomach such unpalatable subjects is all the more remarkable when one considers the pathetic fearfulness with which he confronted everyday life. There is a sense in which he saw it as an interesting intellectual exercise, but one requiring double vision. In his view the artist must become '[a] carnivorous fish ... swimming between two kinds of water, the cold water of art and the warm water of science'.

Like Duchamp, Picabia and Max Ernst, Dalí was in revolt against the doctrine espoused by Roger Fry and others of art for art's sake, i.e. that of

Abstractionism, that painting had to do with circles and straight lines and not with subject-matter. Perhaps in reaction to his brief flirtation with Cubism, the contention set Dalí's teeth on edge and he attacked it consistently throughout his career, most notably in his book on modern art in 1957. The titles of his paintings grew ever more abstruse and the anecdotal nature of their content more and more elaborate. To his belief in painting as a medium of illustration Dalí added a precise observation of form. One finds irresistible parallels between the child Dalí's grim determination to make his father acknowledge his uniqueness and the care and cunning he lavished on depicting his talismanic images. All of Dalí's fertile inventiveness – Picasso said Dalí's imagination reminded him of 'an outboard motor continually running' – was focused on persuading his audience of the absolute reality of his irrational obsessions. He insisted because it was the literal truth, as can be seen from his autobiography. He was living symbolically, a far richer, more complex, and dangerous life than anyone around him perceived except, perhaps, Lorca, Buñuel, and Gala Eluard.

This single-minded drive turned him, by general agreement, into a spectacularly skilled artist. John Canaday called *The Persistence of Memory* (1931) a jewel

> in its brilliant colour, its small size, its immaculate precision. It is in the technical tradition of early Flemish and early Venetian painting; also it is parasitic on their forms. The deep distance with its sea and its rocky promontories picked out in golden light is all but a steal from the early Venetian Giovanni Bellini, whose allegories would be Surrealist if their symbolism were morbid instead of poetic.

Dalí, who was as interested in theorizing as he was in painting, soon had a theory that was to provide him with one of his most often reiterated themes. He called it his 'paranoiac-critical method'. This method has been most cogently explained by Carlton Lake, one of Dalí's biographers: 'Basically, it involved setting down an obsessional idea suggested by the unconscious and then elaborating and reinforcing it by a perverse association of ideas and a seemingly irrefutable logic until it took on the conviction of inescapable truth.' In dreams or waking fantasies, Dalí recorded the first image he saw and then filled in the space with the images this suggested. 'Just as a true paranoiac is constantly seeing countless persecutory forms in whatever object is presented to his view, so Dalí claimed that any given image suggested endless other images to him because of his "paranoiac" sensitivity,' James Thrall Soby wrote. 'Applied to his painting, this theory meant that once his

subconscious had supplied an initial form, the task of elaboration could be entrusted to conscious paranoiac reasoning.'

His method was probably his greatest single contribution to Surrealist thought. One of the problems with which Surrealists had always wrestled was how to go about reaching the depths they wished to plumb. To adapt methods of psychoanalysis was the obvious step, and before the comparatively late appearance of Dalí, Breton and his group had used, and to some extent exhausted, the technique of free association, which they called 'automatism', the use of earliest memories and 'that royal road to the understanding of the unconscious', dream symbolism. As Dalí saw it, what made his own method an important departure from theirs was the role consciousness had to play at the right moment. The others seized the point. Just before he and Dalí had a major wrangle in 1934, Breton said in a lecture,

> Dalí has endowed Surrealism with an instrument of primary importance, the paranoiac-critical method, which has immediately shown itself capable of being applied equally to painting, poetry, the cinema, to the construction of typical Surrealist objects, to fashion, to sculpture, to the history of art and even, if necessary, to all manner of exegesis.

The Persistence of Memory, now at the Museum of Modern Art in New York, was painted in 1931. It is one of Dalí's most famous, most imitated, and most enigmatic works and what Dalí has to say about it gives few clues. He had eaten a very strong Camembert that evening, and while Gala went off to a movie he sat at the dinner table meditating on the issue of super-softness that the cheese seemed to exemplify. Then he went over to look at his work in progress, as he did every night before bed. He was painting a landscape near Port Lligat, deserted, forlorn, lit by a fading sun and with a leafless olive tree in the foreground. He knew it was the setting for an idea but he did not know what, and besides he had a headache. Suddenly, in a flash, he saw the solution. Two hours later he had added his famous soft watches.

The painting has been called 'one of the strangest statements in art of man's obsession with the nature of time'. While it is certainly that, it is obviously more. Perhaps these three flaccid and useless timepieces, which have stopped at three moments which could be six, ten minutes to seven, and half-past twelve, could bear some kind of relationship to the person in the picture. And there definitely is someone there, a pale profile with eyes closed, a nose and no mouth who is almost identical to the profile in *The Great Masturbator* of three years earlier. Here is the same blank where a mouth should be, an omission that was connected in Dalí's mind with anguish. In place of the horrible grasshopper that had been glued in place (in *The Great*

Masturbator), there are only a few rocks, a cluster of ants, and that forlorn tree with its one fork, more like a prop for the watch, or perhaps a crutch. It is also possible that since the word for watch in French (*montre*) also means a show, display, even a shop-window, or parade, the artist is putting something on display.

That the subject on parade is linked to feelings of impotence is a possibility. Another painting, *Premature Ossification of a Railway Station* (1930), is clearly meant to suggest impotence, and one of the objects in the foreground is a large melting clock that has stopped at ten minutes to seven. A further explanation for the painting is suggested by Dalí himself in a later passage in which he discussed the extent to which, as his 'favourite psychiatrist' Dr Roumeguère asserted, he had identified so closely with his dead brother that his inner image of his own body was that of 'a ... soft ... worm-ridden corpse ...'. His sexual obsessions centred around limp objects, cadaverous shapes, distended breasts and the crutch, which is 'not merely a support element, but its fork is a proof of my ambivalence'. He added that, before he met Gala, he 'existed only in a bag full of holes, limp and shapeless, always on the look out for a crutch'. The theme was clearly stated, he went on, in *Daddy Longlegs of the Evening ... Hope!* painted nine years after *The Persistence of Memory*. (The painting is now at St Petersburg, Florida.) A child with angelic wings, left foreground, watches in horror a slithering sexual drama in which a canon-penis gushes forth a raging horse on one side while, on the other, a forked tree supports the broken body of a woman whose head has slumped to the ground into the same dreamer's profile that one finds in *The Persistence of Memory*. Impotence and death as a punishment for having witnessed the primal scene? Male sexuality, seen in all its brutality, with woman as the broken victim? Dalí himself did not seem sure for once. 'All I can say is that the limpnesss, the ... gelatinousness do portray in my mind the vital feeling I long had of my body and of the life of my being.' *Daddy Longlegs of the Evening ... Hope!* may make the artist's intentions more explicit, but the painting has nothing like the haunting power of *The Persistence of Memory*, as perhaps Dalí himself knew. When Dalí was finally introduced to Freud in London in 1938, Freud told him that what seemed most mysterious, troubling, and interesting about such Old Masters as Leonardo or Ingres was 'the search for unconscious ideas, of an enigmatic order, hidden in the picture'. By contrast, Dalí's mystery was clearly stated and his painting was simply the pretext. 'It is not the unconscious I seek in your pictures, but the conscious.'

The Dream, another of the magnificent works which Dalí executed in the same period (1931), has the same enigmatic and haunting quality. The bust, that of a sleeping woman with flowing hair within a conch shell, is based on an Art Nouveau pin box that Dalí owned and also a monument in Barcelona

to Serafí Pitarra. One of the figure's peculiar features is its lack of a mouth, which refers back to one of the prominent aspects of *The Great Masturbator*. The terrifying grasshopper has been replaced by ants, which are always associated with decay in Dalí's lexicon. The image recalls a sequence in *un Chien Andalou*; a close-up of an actor's hand, trapped in a door, shows ants apparently crawling out of a hole in his palm. In a later sequence the same actor wipes his hand across a girl's face, apparently erasing her mouth, which then bristles with her own underarm hair. That the themes are interlinked is suggested by an ink study for *The Dream* in which the same profiled head is in the upper right-hand corner and the woman's head and hair are in bas relief on a font containing, one assumes, the waters of the unconscious. Figures in the left background, hardly stated in the original study, have become more intricate and developed. There is the same atmosphere of helplessness, despair and guilty sexuality, a kind of anguished grappling that stands in vivid contrast to the transfixed, gleaming, silent figure of the dreamer. If she has truths to tell, she has been rendered mute.

Along with *The Great Masturbator, The Dream, The Persistence of Memory* and *Illumined Pleasures*, one might add *The Spectre of Sex Appeal* (1934) as one of the great statements of Dalí's career. The painting shows the headless torso of a bony and broken figure propped up on a beach, with a rocky promontory behind it. The figure is almost ludicrously stuck together and padded out. A kind of cushion-shaped rock has been tied to its front to give it the semblance of curves and two potato sacks provide a buffoonish substitute for emphatically uplifted breasts. In contrast to this plainly fantastical object, there is the tiny figure of a boy in a sailor suit, very realistically, almost photographically, executed, in the right foreground. He has a hoop in one hand and an ossified bone in the other. Dalí wrote, 'The child Dalí is terrified by the giant specter of the eternal feminine, at the anguishing hour when the latter is bathing.' Much as one would like to accept Dalí's explanation at face value, it is not persuasive. The little boy looks on more in innocent surprise than fear at this symbol of flaunted sexuality. It is such a ludicrous and pathetic parody of itself that one could hardly call it menacing. Dalí added, 'The eternal … feminine is perhaps a phobia.'

The first small oil representing Dalí's relationship with his father, *The Feeling of Becoming*, was painted in 1930 and exhibited at the Museum of Modern Art in 1941. A youth is hiding behind a large tablecloth or sheet suspended somehow in another of Dalí's characteristically desolate landscapes. There is a shadow in the foreground, another favourite motif of that period, from which the young man appears to be hiding. It is the shadow of the bold and uncompromising figure of a lion. That same silhouette, which one might freely interpret as representing sexuality run rampant, shows up again in *The*

Old Age of William Tell, painted a year later. The sheet is back, the lion's shadow is dramatically projected against it, and two slathering nudes are doing unmentionable things to a grinning greybeard behind a sheet. In the background, Adam and Eve, their hands to their faces, are retreating, as if in horror at what they have witnessed. Robert Descharnes wrote in *Dali*: 'Here the father is chasing the couple Salvador-Gala,' but that hardly seems a sustainable interpretation, given the nature of the father's expression. Just to make sure no one mistakes the real message, a rose hangs against one of the pillars supporting the sheet and, in the background, what appears to be two grappling women are caught up in a similar drama of defloration.

In *The Birth of Liquid Desires* Dalí tackles the same triangle from a slightly different perspective. Here the same almost nude father figure clutches a woman in a white dress while a young male, nude save for one sock, is about to stoop through the entrance of a rock-shaped object that may be a womb. In the background another woman, this time deathly pale, eyes averted, seems to be pouring something from a jug (maternal milk?) into a bowl. The idea of a marriage is further suggested from the fact that the woman's whole head is a mass of flowers – Dalí had spent many hours watching his aunt, who was a milliner, sew flowers on brims – and a few broken petals lie at her feet.

Dalí's apparent intent was not only to make the clearest statement of his family drama that he dared, but also to turn the conventional image of heroic father defending his son on its head. He used the symbol of William Tell for his father, but instead of the legendary hero who was forced to shoot an apple on his little son's head at the order of a tyrannical Austrian bailiff, here is a William Tell surrounded by images of putrefaction and death, with a pair of scissors in his hand and a son in flight, his face buried. Speaking of one of the last of a series painted with this theme, Dalí wrote in 1974, '*The Enigma of William Tell* is perhaps one of the paintings which describe one of the most critical moments of my life. William Tell is my father; I am the tiny child he has in his arms and who, instead of an apple, has a raw cutlet. This is by way of saying that William Tell has some cannibalistic intentions: he wants to eat me.' Beside William Tell's foot is a miniscule nut containing a kind of cradle and this cradle contains Gala as a tiny infant. The least movement by the father and his sandalled foot will crush it. Dalí continued,

Sigmund Freud has defined the hero as he who revolts against paternal authority and ends by defeating it. *The Enigma of William Tell* was painted at the moment when the very young Dalí was in revolt against paternal authority, but whether he would be victor or vanquished hung in the balance. It is for this reason that the painting is ambivalent: it depicts the

psychological drama of the Surrealist revolt of the son against the father and at the moment of its execution it was quite possible that William Tell, that is to say my father, would end up devouring me voraciously like a cannibal and at the same time, with the smallest movement, he could have broken the little nut containing the fragile tiny body of my wife Gala, who, as everyone knows, is the being I love most in the world.

Similarly, when Dalí came to paint his feelings about his mother, he took the sentimental image, the *Angelus* (1857–9), the best-known work of Jean François Millet, which depicts two peasants in prayer after a day's work in the fields, and turned it on its ear. He insisted that there was nothing in the least pious about this painting. The bowed figure of the male is actually concealing an erection under his hat and the decorous figure of the female is actually 'the exhibitionistic eroticism of a virgin in waiting – the position before the act of aggression, such as that of the praying mantis'.

It would be entirely characteristic of Dalí to take a popular nineteenth-century painting reproduced on the walls of every household and insist upon its hidden erotic message. Even to suggest such a thing about the *Angelus* was to stupefy the bourgeoisie in the best tradition of *un Chien Andalou* and *l'Age d'Or*. It would also be entirely consistent with his declaration that he spat on his mother's portrait, coupled with an outline of the Sacred Heart. Again, he was ridiculing her pious adherence to the ritual and dogma of the Catholic church in the best anti-clerical anarchist tradition.

However, the fact that Dalí devoted many years of his life to this theme – he began to write about it in the early 1930s, lost the manuscript, rediscovered it decades later and published it in 1963 – demonstrates that more than just a desire to *épater les bourgeois* was involved. The image, he wrote, had haunted him ever since he first saw the painting in the corridor of the Marist brothers' school in Figueres. It was associated with the twilit moment when 'we heard the chiming of the Angelus, and the whole class ... would repeat in chorus the prayer recited with bowed head'. The image became bound up in his mind with these elegiac associations, 'the evensong of the locusts, the last daydreams at nightfall, the poetic declamations I recited at fourteen. What I might call the atavism of twilight, imbued with a feeling of the end of the world.'

Then, in 1932, the same image suddenly appeared to him with extraordinary vividness and although it was point for point exactly as he remembered it, the composition seemed charged with new significance. It became the most troubling, dense, and enigmatic painting in the world, full of rich unconscious associations. One does not have to explore his reasoning far to see that the message he found there was his own. Millet, he declared, actually

intended to paint two peasants praying over a grave. In fact, subsequent X-rays of the work showed a black shape in the foreground, later painted out, which Dalí took as a coffin in vindication of his thesis that the painting concerned the death of a son. One was dead and the other was the male figure standing opposite the woman, his mother. Her bowed head and hands clasped over her breast were, to him, exactly analogous to the attitude of a praying mantis, that terrible insect that ate the male after copulation. It was all associated with his original terror of the sexual act, which he thought of as animalistic, violent, and catastrophic. This fear had naturally surfaced with the advent of Gala into his life, reactivating all the old Oedipal terrors. He even had an early memory, perhaps a fantasy, in which his mother was sucking and devouring his penis. At the time of writing his book about the *Angelus*, he identified Gala and himself as the couple, 'Gala occupying in reality the place of my mother, to whom I owe my terror of the sexual act and the belief that it would bring about my total annihilation.'

Art historians have been reluctant to accept Dalí's insistent belief that the *Angelus* has this underlying theme. The discovery of the black shape in the foreground would seem to support his theory but it takes a considerable suspension of disbelief to accept the idea of cannibalistic intent in the gentle and submissive figure of the peasant woman, despite all the accompanying paraphernalia, such as fork and wheelbarrow, whch Dalí cites in support of his claim. As an art historical explanation it is flawed, but as a statement of the way Dalí felt about his mother and women in general it is extemely revealing. The dead son lying under the earth, before which two figures are bowed, the living son about to be devoured by his mother – it all fits into the tentative portrait one has of the woman who, having lost her first son, was ferociously determined to take possession of the second. Dalí also reveals in his book, as he does in the many paintings he executed on the *Angelus* theme, that Gala and his mother are images merged far too closely in his mind for comfort. Having become the sacrificial victim of his mother's obsessions, he now stood to repeat the role in Gala's life. Dalí, in short, is analysing in exquisite detail the extent to which his frantic attempts to extricate himself from emotional dependency on his mother have failed.

Dalí received a commission to make etchings on copper plates for the Comte de Lautréamont's *Les Chants de Maldoror* in 1933–4 and in them he makes repeated references to Millet's *Angelus* as well as the themes of cannibalism – objects suddenly attacking each other with butchers' knives – William Tell, cutlets, Gala, and other familiar obsessions. For the five or six years immediately after his acceptance as a Surrealist, Dalí was one of its chief theoreticians, even if he never came close to assuming the leadership he so confidently expected. He designed illustrations for Surrealist magazines, published poetry

and essays, took part in all the meetings, started the group off in a whole new direction (that of making objects), was one of the first to argue for the rediscovery of Art Nouveau and a staunch supporter of Gaudi. He had three well-received exhibitions at the Pierre Colle Gallery in 1931–3 and, in short, imbued the movement with all the vigour of his forceful personality.

Marcel Jean, author of the authoritative history of Surrealism, wrote, 'Dalí had much in common with those circus performers who, with an imperturbable seriousness, perform sketches based on themes as banal as climbing a ladder or playing a trumpet solo. He was a dazzling intellectual acrobat.... The most vulgar clichés were grist to his inventive mill.' He was in the habit of sending ludicrously funny missives to the group addressed to his 'dear friend Breton' and usually ending with assurances of his 'Surrealist unconditionality'. These would be read by Breton at meetings in gravely measured tones until the audience dissolved in laughter. Thirion, who greatly admired Dalí's brilliance, inventiveness, and courage, said that he had inter-jected so much new energy into the movement that a break was out of the question. Yet that Dalí and Surrealism were perhaps not meant for each other was clear from the very beginning. With the virtue of hindsight many pointed to the preface André Breton wrote for Dalí's first exhibition at the Galerie Goemans in 1929, which seemed to veer between admiration, a distaste for perversion, and a suspicion that Dalí might be more interested in sen-sationalism for its own sake than in furthering the movement. Indeed, before long it was obvious that Dalí was perfectly indifferent to their social and political aims and bent upon precisely the kind of commercial success they disdained.

When it seemed likely that the Surrealists would identify themselves com-pletely with the Communist Party, Thirion wrote, 'I could sense the emerging distrust: Dalí was about to shock all the petty-bourgeois [sic] minds in the Party with his painting, irritate the theoreticians with his references to psychoanalysis, and scandalize the militants with his lack of interest in social problems.' While believing that his group should not actually become Party members, since they would then have to subject themselves to the kind of doctrinal discipline he thought they should avoid, Breton was, nevertheless, a fervent supporter. Dalí, of course, could not resist this weak chink in Breton's armour and gave the main figure in *The Enigma of William Tell* the unmistakable features of Lenin. Since the gentleman in question was nude from the waist down and sported one grotesquely elongated buttock supported by a crutch, the joke was on Breton, as he immediately saw when the painting was hung at the Salon des Indépendants early in 1934. He denounced it as an 'antirevolutionary act' and lunged at it, but fortunately the painting was hung too high up to be damaged. That might have been the pretext, but

relations had been souring between Dalí and Breton for some time. Hitler's rise to power in Germany in 1933, and the political reactions of the left wing, were being discussed by the Surrealists in lengthy meetings. Dalí insisted on treating Hitler as an entrancing new addition to the ranks of de Lautréamont and the Marquis de Sade and could not see why the Surrealists did not agree.

Eluard, who was extremely close to Breton and in almost daily contact with Gala, tried to intercede. He would defend Dalí of course, but 'I shall not try to gloss over ... the almost insurmountable difficulties which this Hitlerian-paranoiac attitude of Dalí, if it persists, will entail', he wrote early in February 1934. '*He absolutely must* find another delirious subject. It is too important to us all that we do not separate. And this eulogy of Hitler ... is unacceptable and will bring about the ruin of Surrealism.' Gala might accuse the group of hating Dalí, of being jealous, and of lacking understanding, and no doubt it was all true, but such human emotions were a fact of life, Eluard asserted. There was one further reference to the affair in the next letter a few days later. Eluard wrote, 'Yes I know very well that he isn't a Hitlerite.' In evident irritation he underlined the words. The enquiry into Dalí's behaviour on the issue of his support of Hitler took place on 5 February 1934. Dalí showed up at André Breton's studio on the rue Fontaine pretending to have the flu. He declaimed with a thermometer in his mouth which he gravely examined at intervals. He kept pulling his socks up and, as the evening wore on, peeled off one garment after another until the floor was littered with them. Then he knelt at Breton's feet and, Marcel Jean wrote,

> began reading out a preposterous communication intended to demonstrate the Surrealist and Maldoror-like character of his admiration for Hitler. But he had gone too far. At the point in his speech where he reached the phrase: 'But, in my view, Hitler has four balls and six foreskins.' Breton interrupted him brutally with, 'Do you intend to bore us much longer with this damn nonsense about Hitler?' Dalí was so taken aback that he stopped.

As Jean saw it, Breton did not intend actually to expel Dalí but merely call him to account. For his part, Dalí argued that he had the right to dream up anything he liked, and since nothing was taboo in Surrealist theory, they had to accept it. He must have maintained then, as he did later, that 'Lenin's anamorphic buttock was not insulting, but the very proof of my fidelity to Surrealism'. His version is that he won the argument, with the concluding words, 'So André Breton, if tonight I dream I am screwing you, tomorrow morning I will paint all of our best fucking positions with the greatest wealth of detail.'

Although Dalí's association with the Surrealists was to continue for several

more years – and involve another confrontation – he was never as committed to the group after 1934. By 1941 Breton claimed that Dalí's work had stopped having any interest for them after 1936. In retrospect the break seemed only a matter of time. Dalí found the group's insistence on dogma and social purpose, its petit-bourgeois taboos and its humourlessness intolerable. One assumes that he would be bound to rebel eventually against Breton, if only because he had originally embraced him as his 'second father'. The issue went even further, as Dawn Ades has seen. What Breton was attempting when he condemned the narrowly rationalistic view of life was to make the public declare its 'allegiance to folly, to dreams, to the absurd, to the incoherent, to the hyperbolic – in a word –, to all that is contrary to the general appearance of reality', as the Surrealist poet and film-maker Georges Hugnet wrote. But the eventual goal of Surrealism was to resolve the apparent contradictions into an absolute super-reality. Once its social purposes were accomplished, Surrealism would encompass reality, not exclude it.

However, for Dalí, there was no goal larger than the exploration of his own psyche, the furtherance of his own ambitions, the discovery of his own meaning. What Dalí intended was to '*maintain* the opposition between reality and surreality, between the irrational and the rational': '. . . "things of reason" should be permanently discredited, and his world of imagination substituted for the real world.' While skirting the very edge of the precipice Dalí intended to avoid the fate foreshadowed by the mad Lidia. He would conquer the irrational in himself by sheer willpower. As he explained:

The secret lies in lucidly keeping a steady course between the waves of madness and the straight lines of logic. Genius consists of being able to live while going constantly from one frontier to another, grasping handfuls of the treasures of mystery that one then, like an athlete, holds at arm's length to make them shine.

CHAPTER TEN

Puzzle of Autumn

What good is honour on an empty stomach?
RUSSIAN PROVERB

In June 1931 Alfred H. Barr Jr, the director of New York's new Museum of Modern Art, and his wife wandered into a Paris art gallery in a side street off the rue la Boétie, the Pierre Colle Gallery at 29 rue Cambacérès, and found a one-man show in progress. Recent paintings by Salvador Dalí were hanging in unlikely juxtaposition with some worldly portraits by Jacques Émile Blanche; they began to inspect the exhibits intently. Margaret Scolari Barr has the impression that Dalí's masterpiece *The Great Masturbator* was on view. ('At the time I didn't know what the word meant.') Other works of the same period are known to have hung on the walls: *The Invisible Man, Dismal Sport, Accommodations of Desire, Portrait of Paul Eluard* and *Memory of the Child Woman.* Interestingly enough, in view of its eventual destination, another painting that had just been finished was also for sale: *The Persistence of Memory.*

Alfred Barr, who was to mount a large exhibition in New York five years later, which traced Dada and Surrealism back to their roots in the fifteenth and sixteenth centuries, was, when Dalí first met him, 'a nervous young man of cadaverous paleness, but fantastic plastic culture, a veritable radar of modern art, interested in every type of innovation'. He was the first to point out the connection between Surrealism and the trick images of Giuseppe Arcimboldi, a sixteenth-century Milanese artist whose fruit and flower arrangements turned into profiles and whose landscapes became eyes and noses. The Barrs were talking with the dealer when Dalí walked in. He rapidly took over the conversation – Mrs Barr decided that he was a '*M'as-tu vu?*' ('Have you seen my latest?') personality – and at a certain moment whipped out a postcard. He had found it as he was looking for an address in a pile of papers and was astounded to see a profile by Picasso that he did not know existed. Looking at the postcard from the right angle, however, he discovered an African village. Dalí was beginning to expound on the double-image theme when Mrs Barr noticed that he was wearing a raincoat with no jacket underneath. She realized that he must be very poor.

Everyone knew that the Dalís were short of money. When they needed to be in Paris they had, at first, made use of the apartment leased by Paul Eluard in the summer of 1929 at 7 rue Becquerel, in the 18ème *arrondissement*, which they appear to have appropriated. Dalí called it 'ours'; Eluard kept trying to get Gala to return there alone. When this did not happen, he bowed to the inevitable. They were divorced in January 1932 and, some six months afterwards, Dalí and Gala moved their possessions to a new location in Montrouge, not far from Montparnasse and the Parc de Montsouris, at 7 rue Gauguet. According to the art dealer Ted Schemp, who took over the same apartment later, it was on the top floor of a private house built in 1930 on a short, dead-end street and was above a high-ceilinged studio with excellent views on four sides. Dalí had painted every room and nook a different colour, Schemp supposed, to provide backgrounds for his art.

Dalí's first actual patron was not the Vicomte de Noailles but the Prince J. L. de Faucigny-Lucinge, a devoted admirer who met him through the poet René Crevel and quickly saw his merits, as well as the extent of his need. He recalled:

> They were very hard up. I remember their apartment very well. There was very little furniture and no attempt at a decor, although the rooms were scrupulously kept and you never saw a paintbrush hanging about. Eluard had no money at all and Dalí's only possible source of income was his paintings. So I tried to interest Prince Paul of Serbia and Robert de Rothschild in his work. I brought them to the apartment and they both found him appalling.

The Prince introduced them to the de Noailles and bought an early Dalí, now called *Vertigo* (1930), also known as *The Tower of Desire*, of a naked woman knifing a man on a terrace, with a blue ball in the foreground. He remembers very well the day that Gala came to see him to discuss their financial plight. 'If only we could find people to keep us going. Otherwise Dalí will have to commercialize his talent,' she said. So the Prince set about looking for twelve patrons who would agree to contribute the sizeable annual sum of 2,500 francs and, in return, would have the right to choose a large painting or a smaller one and two drawings every year. The ingenious arrangement was that the patrons would all come to the Dalís for dinner just before Christmas and draw lots for the month during which they could make their selection. Besides the de Faucigny-Lucinges and the de Noailleses, a number of other wealthy and influential people were thus cajoled into taking a benevolent interest in the future financial security of the Dalís. Among them were the Marquise Cuevas de Vera, the Comtesse de Pecci-Blunt, Caresse

Crosby, Robert de Saint-Jean, and René Laporte. Julian Green, who was born in Paris of American parents and later became an eminent *homme de lettres*, was among the first to draw lots in the 'Zodiac' group, which started in January 1933. On 28 February he went along to collect his picture and was offered the choice of 'an admirable landscape of rocks as a background, but with the foreground taken up by a sort of naked and whiskered Russian general, his head sorrowfully bent to show the shells and pearls that pepper his skull', or a small picture in delicate shades of grey and lilac. He chose the latter, and the artist 'carefully explained the meaning of my picture . . . which represents a horse turning into rock in the midst of a desert'.

Later that year Green went back to the Dalís' and was shown three tiny paintings about the size of postcards.

The most beautiful he showed us represents four people by the sea. Two men wearing grey are stretched out on a beach; beside them a nursemaid, seated and seen from the rear, and near her a little boy in blue with a cutlet on his head. This cutlet, the painter told me gravely, derives from the William Tell legend which he apparently translates as the father's suppressed desire to kill his child. One of the men on the beach is Lenin. The nursemaid wears a lilac dress, the folds of which are delineated in almost hallucinatory bas relief. One's final impression after looking at these figures is that they have been shrunken, not by the artist, but by the vastness of the distance, and that one is observing them through powerful opera-glasses.

David Gascoyne, the distinguished British Surrealist poet who made his first visit to Paris as a teenager, met Roland Penrose there and quickly became acquainted with the Dalís. He remembered that the flight of stairs to their apartment was short, and outside the door there was a work by Miró, a hank of rope covered with spots of tar, in a glass case. The apartment consisted of one big room with a dining recess at the end, a bedroom and kitchenette. The whole studio was full of Dalí's paintings and objects, dominated by *The Great Masturbator*. Gascoyne was writing a short survey of Surrealism, which was published in 1925, and Dalí asked him if he would be willing to translate into English his essay 'The Conquest of the Irrational'. Gascoyne agreed and was there for a week, observing their life at close quarters.

'They gave me a table to work on placed at such an angle that I could see everything happening from a mirror. I have watched Dalí at work with extremely fine brushes containing three or four hairs and with a magnifying glass screwed into his eye.' He was working on a painting based on the

African hut/Picasso head idea, which he called *Paranoiac Visage* and renamed a portrait of the Marquis de Sade, in honour of André Breton.

He was very agreeable and elegant and spoke French with a very strong Catalan accent which Gala would interpret. He didn't discuss his work very much; he was a secretive man. He had some nervous habits, which he cultivated, I think. For instance, there was this obsession with bread. The help [char] was being continually sent back to the local *boulangerie* because the bread wasn't long enough. [He was just beginning to make a fetish out of his moustache and to curl the waxed ends.] He wasn't a restful person to be with, unless he was concentrating.

Dalí had very few close friends. The gifted poet René Crevel was one of them and all the Surrealists were fond of him, though he was a *pédéraste* and the Surrealists had an obsession about this. Breton was puritanical. I used to go to meetings and parties with the poet Georges Hugnet and it was very respectable. There was lots of talk about orgies, but nothing ever happened, although I do remember one time when I was taken to a shed that had a stage on which a sex act was being performed. It was very dreary.

Gascoyne was a great admirer of Paul Eluard, whom he remembers visiting in his apartment above a shop in the rue Legendre near the Gare du Nord, where he was living with Nusch, surrounded by the remains of his famed art collection, sparse but choice. There Gascoyne would listen while Eluard declaimed his poems in a slightly husky voice, his hands trembling. About half-way through Gascoyne's week with the Dalís, Eluard came to lunch with his daughter Cécile, then about seventeen and exceptionally shy. He hardly understood a word she said. 'Right in the middle of lunch, Eluard said, "I have the most wonderful prose poem, 'Nuits partagées', ('Shared Nights') which you must hear." He then began to read it aloud. It was all about his love for Gala. Dalí went on crumbling his very long bread and saying nothing.'

By then 'they weren't exactly poor, but it was Gala's ambition to be rich as soon as possible'. He said, 'You know they used to call her Gala la Galle – it's a nasty skin disease, a play on words, a plague. I would have said they were quite a harmonious couple. She understood him, but in retrospect I think she wanted to exploit him. In her very reserved, occasionally grumpy Russian way she was quite gracious.' He remembered taking a long walk with her to deliver proofs and at the end of it Dalí presented him with a marvellous calligraphic drawing of the horsemen of death. Gascoyne seemed to remember that they lent him his fare to get back to London.

Bettina Bergery, née Shaw-Jones, American wife of the Radical-Socialist deputy Gaston Bergery, who appealed in the Chamber on behalf of *l'Age d'Or* (without success; it was banned on the grounds that it was an incitement to riot), became a close friend of the Dalís. She has vivid memories of Gala's cleverness and economy.

She would give you meals made of mysterious little things you have never had before. At the time it was unusual to eat raw mushrooms in salad. You would have a wonderful dinner and then she would proudly tell you how little it cost her. She was always thinking about two centimes and where she could buy the cheapest bread. I can still see the little scrunchy way she would wrinkle up her eyes when she was thinking about money.

The Prince de Faucigny-Lucinge said,

When I first knew them, they were very unsocial, but it was clear that they would become a great success. My wife liked them too and we used to invite them to stay with us in the South of France and lent them our house when we weren't there. Gala was a rather fascinating personality, not likeable but agreeable. She was a witch but an attractive one. She was someone, you know. A clever ambitious woman with a great deal of common sense who kept him at work. She was a hard woman, not an atom of sensibility of any kind. Hard and heartless.

The Dalís and Bergerys were friends of Roussy (Roussadana) and José-María Sert. Sert, five years Dalí's senior, was descended from a vastly wealthy Catalan textile manufacturing family, a friend of the Spanish royal family and, in Paris, of everyone who mattered – Colette, Chanel, Cocteau, Diaghilev, Gide. Roussy, a Georgian princess and sculptor, whose father had been an aide-de-camp to the Tsar, had moved into Sert's studio to work while he was married to the famous Misia, and took over his life. They entertained lavishly every summer at Mas Juny, a large property on the Spanish coast near Barcelona to which the Dalís and Bergerys were invited, along with 'the fashion world, the rich and the vaguely talented', wrote Misia's biographers, Arthur Gold and Robert Fizdale. Madame Bergery recalled that,

There were oven-shaped fireplaces, carpets of braided straw, mosquito nets, huge chairs slipcovered in thick white handspun linens, crystal lamps of thick glass, candelabra with dozens of branches from bazaars in Turkey, huge silver basins in the shape of shells, always magnolias in pots and tuberoses under the porches. You'd have coffee on the terrace with

cushions on a bench and be waited on by servants dressed as sailors. It was an absolute heaven of a house.

They spent their days in the water or on the beach and on lingering, extravagant meals.

Roussy came out of the golden age [Mme Bergery said]. Her brothers were Mohammedans, leaping fellows with laughing eyes who loved all the girls. Gala worshipped them. She loved Dalí and they were very close. She looked at him with love and awe.

As for Dalí, he was an angel. Very kind and as good as gold. One forgets how sweet Dalí was, how generous and anxious to help. He looked at everyone with affection. Even when he was doing his act he would look at you with a little smile to see if you agreed. With all the extravagant things he said he was very careful to tell the truth, but there are many ways of telling it. It was the difference between, 'Father, can I smoke while I am praying?' or, 'Father, can I pray while I am smoking?' And if you said, 'Dalí, this time you've gone too far', he would reply, 'It's the only place I ever wanted to go.'

Julian Green had a similar impression of Dalí. His gentleness and gravity were entrancing, he wrote in 1933, and de Faucigny-Lucinge said, 'In those young days he was full of charm and loved life.'

Dalí spoke in large, ambitious terms and was very generous. Bettina Bergery thought he must have been very much influenced by José-María Sert, the Catalan who dressed in a sombrero and cape, was partial to alcohol and morphine, lived as he pleased and with such panache that he got away with everything; he had a kind of aristocratic notoriety. Perhaps Dalí's way of speaking – exuberant comments, in tones of great seriousness, with a twinkle in the eye to see how much he could get away with – was in part modelled on Sert, who was born rich and was soon richer, since his talent for making money was prodigious. He had been commissioned by King Alfonso XIII to decorate the Cathedral of Vich near Barcelona with frescos, and this became his main task. He was soon also painting other frescos, for the ballrooms and pavilions of the rich: the Errazuriz in Argentina, the Rothschilds, Wendels and Polignacs in Paris, Sir Philip Sassoon in England, and the Mackays in America. The rich could not, it seemed, get enough of his 'elephants, camels, and mules, dwarfs and Herculean trees and parasols, popes, bishops, and cardinals, mythological and biblical scenes, lanterns and billowing curtains'. He decorated the grand ballroom of the Waldorf-Astoria, which was named

in his honour, for $150,000, the modern equivalent of over half a million dollars, the highest fee an artist had until then received for wall decorations. According to Bettina Bergery, Sert was the one who explained to Dalí how you went about presenting your paintings on red velvet to get such prices, explaining that 'a lack of money was simply a lack of imagination'. Besides admirers, Sert had his detractors. It was widely said that 'Sert paints with gold and *merde*'. No doubt Dalí heard the quip.

Dalí's work had been seen in America – surprisingly when he was still very young – in October–December 1928 at the 27th Carnegie International Exhibition held in the Museum of Art, Carnegie Institute, Pittsburgh. Three paintings were shown, his famous basket of bread, a painting of Ana María absorbed in sewing beside a window, and one titled *Young Seated Woman*, presumably also of his sister. Nothing more is known about the exhibition and since none of the works was painted in the style for which Dalí became famous, it is fair to say that the first significant exhibition of his work did not take place until November 1931, with the first Surrealist exhibition ever seen in the United States, at the Wadsworth Atheneum, Hartford, Connecticut.

The person responsible was an extraordinary museum director and half-forgotten figure, a man of multiple talents as aesthetician, museum organizer, energetic patron and educator. A. Everett (Chick) Austin, Jr, was born into a Boston Brahmin family. When he was three, his mother took him to Europe on the first of many voyages. He studied painting in Italy, took courses in architecture and museum management at Harvard and also taught a course in fresco painting there. A friend remembered him shovelling plaster into water, 'all in white, with white spattered on his hair and on his face, with an ambiguous smile, almost melancholy'. He had a kind of genius for recognizing innovation in all branches of the arts and, when he was appointed director of the Wadsworth Atheneum at the age of twenty-six, Austin set about turning it into a centre for the controversial and experimental, whether it was the Gertrude Stein/Virgil Thompson opera, *Four Saints in Three Acts*, with an all-black cast, or the young School of American Ballet being organized by George Balanchine and Lincoln Kirstein, or *Les Noces* by Stravinsky with a décor of mobiles by Alexander Calder. He showed a similarly unerring taste in terms of Matisse, Balthus, Ernst, Tanguy, Cornell, Miró and Arp and, at a time when the Louvre had barely opened its doors to the masters of Impressionism, he gave Picasso his first large retrospective exhibition in the US, in 1934. The set designer Eugene Berman, who knew them both, called him the American counterpart of Diaghilev for his daring sponsorship of the avant-garde. When Austin took on the uphill proposition of introducing the

Surrealists (Super-Realists, as they were called) to the residents of Connecticut, he prepared the ground with some care, explaining:

These pictures which you are going to see ... are chic. They are entertaining. They are for the moment. We do not have to take them too seriously to enjoy them. Many of them are humorous.... Some of them are sinister and terrifying; but so are the tabloids. It is much more satisfying aesthetically to be amused, to be frightened even, than to be bored by a pompous and empty art which has become enfeebled through the constant reiteration of outmoded formulae.

Austin was farsighted, indeed, but in the case of this particular exhibition he was not the only American to have spotted the trend. The collection of works he showed, by Picasso, André Masson, Max Ernst, Joan Miró and Salvador Dalí, had actually been put together by another young man of talent and a personal friend, Julien Levy. Levy was opening a gallery of contemporary art on Madison Avenue and planned to show the complete exhibition a month later. He agreed to allow Austin to have it first, 'to strengthen its impact, to lend it museum authority, but above all to do a favour for one of my best and most stimulating friends', he wrote later.

In 1931, when Levy first met Pierre Colle in Paris, the French dealer was arranging to have some Dalí paintings shipped from Spain and was most interested in cooperating on a Dalí exhibition in New York. Levy was intrigued but doubtful. He could not imagine how Dalí's scandalous images would get through US customs. Colle was reassuring: Mr Dalí was aware of the problem and promised to tone down some of his more graphic statements so that they could not possibly offend. Colle already had three paintings that were, as he explained it, *'sans ordure'*, yet original and dramatic enough to startle New York sensibilities. Two had already been sold to American collectors and the third was going begging. It was *The Persistence of Memory*. Levy bought it at the trade price of $250.

For his meeting with Levy, Dalí dressed up in a tight-waisted black pinstripe suit, a black shirt, a crimson tie and, Levy believed, orange shoes. Levy had expected that he might be 'slick or pandering' and found no trace of either.

He was disquieting to me ... not because of ambiguity but rather by his singleminded intensity and frankness. He fixed his piercing black eyes on me, he crowded against me, his restless hands alternately picking at my sleeve or suit lapel or fluttering emphatically as he described his very newest, his most revolutionary of all Dalinian theories, his most recent

work as yet unseen, perhaps as yet unaccomplished and now being enacted in his mind's eye.

Levy found his ear being bombarded with staccato French in a most unfamiliar accent. Every consonant became a 'b' and every 'r' was emphatically rolled; so that, instead of *'Cométons authentiques, vrais sculpture supérieur d'intérieure, frotté convulsivement'* ('authentic meteorites, a true superior sculpture of the interior, rubbed convulsively'), what Dalí indeed said was, *'Les comédons authentiques, les brais scubdur supériorre, d'andérriorr, brotté combisiffmong'*. These apparently meaningless phrases rolled off his tongue while his eyes rattled like 'frantic juggling balls' and his teeth gnawed at his lip until it was visibly sore. At the end of such an outburst Dalí would be likely to conclude that Levy simply must study his ideas in order to understand them, and pull out a sheaf of notes. Gala would add, 'Since Dalí tells you to read it, you must', in a most unexpectedly intimate way. She had 'a voice full of complicity, which I soon learned was a tone she used often and quite impersonally', Levy wrote in 'Memoir of an Art Gallery'.

The works shown at Hartford that had already been bought by Americans were *The Feeling of Becoming*, owned by Mrs Murray Crane, and *Au Bord de la Mer*, bought by A. Conger Goodyear, president of the Museum of Modern Art board of trustees, who also lent two drawings, whose titles he had to invent, since they had none. One might be called *Beach* or *Sea Shore*, he suggested, and the other *Andromeda* or *Sea and Sand*. He thought that an insurance of $250 ought to cover it, $200 for the painting and $25 each for the drawings. The others, *Fantaisies Diurnes*, *Le Lever du Jour*, *l'Homme Poisson*, *La Solitude*, *Paysage avec Chaussure*, and *Persistence of Memory*, all had price tags. The last was officially for sale at $400 (a figure of $350, presumably after museum discount, was pencilled in beside that), but Chick Austin's unfailing eye misled him there, or perhaps he thought that the painting titled *La Solitude* was a safer choice. It was, at any rate, cheaper ($300), and he purchased it for the museum and not *The Persistence of Memory*.

Interestingly enough, Levy decided to show only his own painting in his first Surrealist show because, he told Austin in November 1931, he did not think the other Dalís were good enough. What he actually punned in French was, *'Les toiles ne sont pas de* [sic] *première ordure.'* However, when he saw the success of the painting he owned – *The Persistence of Memory* was immediately bought by a Museum of Modern Art trustee, Mrs Stanley B. Resor of New York, for the collection (presumably for $350) – Levy must have begun to thaw. By about 1943, after having given Dalí numerous one-man shows, Levy was remarking, apropos of the work of another artist, that although his paintings were first-rate they did not have the instant eye-appeal of Dalí's.

Whatever one thought of the latter's canvases, whether one considered them hopelessly slick and vulgar, or poetic and hypnotic, collectors always responded in the same way, which was that they had to buy before somebody else did.

The appearance of Julien Levy and Alfred Barr in Dalí's life, that summer of 1931, confirmed his belief that his future lay in America. Barr told him, 'Come to the States. You'll be a lightning success', and his first New York reviews seemed to confirm this. They revealed 'a comprehension a hundred times more objective and better informed ... than most of the commentaries on my work that had appeared in Europe', he wrote. There, the critic in question judged the work in terms of his own prejudices. Defenders of Cubism and non-figurative art 'received me with [a] fiery barrage', while enthusiasts for 'pure and absolute automatism' were critical of Dalí's 'rigour and systematization'. No doubt he was feeling mellow because one of the first such reviews, in the winter of 1933, came from the august pen of Lewis Mumford in the *New Yorker*. Mumford said Dalí's paintings were as inexplicable as dreams: they could be meaningless or, on the other hand, full of hidden significance. In contrast to those sentimental painters who represented their dreams shrouded in a delicate mist, Dalí gave them a severely realistic appearance, but that was indeed the way dreams looked. His harsh, frozen nightmares would be unbearable if one did not suspect that this bleak vision were being tempered with an impudent wink, that of the precocious schoolboy who had just made a new addition to his repertoire of obscenities. This and similar comments would have fuelled Dalí's belief that, in America, writers weighed the relative merits of each newcomer and fairly decided who had made the biggest impression.

This fair appraisal would, of course, point to Dalí, but first he had to get there. Dalí's one-man show in the late autumn of 1933 at Julien Levy's should have been his signal to appear in New York, but he and Gala were not married and no doubt Levy cautioned them against making an appearance without a wedding ring. They were also being given sage advice from another quarter. Shortly after their divorce, Paul Eluard wrote on 8 February 1933 to ask Gala whether, as he assumed, the apartment at the rue Cauguet, along with their house in Port Lligat, were in Dalí's name. If so, he thought she ought to know that if Dalí died she would have nothing. (He included the phrase, 'or went mad', but crossed it out.) Dalí's father would have the legal right to take everything in his son's house and absolutely all of her paintings – those Eluard had bought, in other words. If it could be proved that she had removed the least thing, even her own clothes, she could be charged with theft. 'It would be too dreadful. It would seem that the father has disinherited the son, but his son cannot disinherit him, nor his sister,' Eluard concluded.

He advised her either to consult a lawyer and have her property legally labelled or to marry Dalí. After due consideration Gala and Dalí decided on the latter course and were married on 30 January 1934. Among the witnesses at the ceremony were their landlord and landlady at the rue Gauguet and Paul Eluard.

It has been widely stated that Dalí was not reconciled with his father until 1948, even though a close reading of his autobiography demonstrates that he was back on speaking terms by the start of the Second World War, and visited his family en route to Portugal and his escape to America. It has, however, been established that in October 1934 he went to Barcelona in connection with the opening of his one-man show there on the second of the month. Dalí used the opportunity to make an impassioned plea for a reconciliation to his father's younger brother Rafael, a successful Barcelona doctor and a sympathetic supporter of Dalí's artistic ambitions from the start. Rafael's only daughter remembered the occasion vividly. 'Dalí was devastated by the break with his father because he loved him,' Sra Montserrat Dalí de Bas recalled.

He really wanted a reconciliation and he went around to all his father's friends, but his father was so wounded he wouldn't hear of it. Anyone who tried to make such a suggestion was shown the door.

On the fourth of October, a date I shall never forget, he came to our house and said, 'I love papa and I want him to understand that I am through with the Surrealists, I have broken with all that.' He told my father, 'You are the only one who can help me', and so the three of us went to Cadaqués to make his father understand that he must pardon him.

The moment Dalí appeared in the doorway his father said, 'Out! Never!' So my father shoved him into his office and talked to him for a long time. When he came out, Dalí said, 'Please, please forgive me', and his father did. It was a very moving moment.

Because Dalí's dates are consistently unreliable, it is also believed, on the basis of his own writings, that he fled from the Civil War and barely escaped with his life. A flight from Spain took place, but the clear indication is that it happened two years before the actual outbreak of the war. The day after he was reconciled with his father in Cadaqués there was a political coup in Barcelona. It centred around the issue of Catalonian self-government and, specifically, its right to redress the third-class status of the *rabassaires*, Catalan sharecroppers who toiled in the vineyards and were fighting for some measure of economic security. They were given sympathetic support by the Esquerra, or Catalan left, headed by Lluís Companys. A moderate law was passed by

the Catalan government dealing even-handedly with tenants and landlords, but it was declared invalid in Madrid. At the same time that the government was breaking with the Catalans, they were quarrelling with the Basques over related issues and, on 1 October, after a vote of no confidence, the government resigned. On 5 October the Unión General de Trabajadores called a general strike and insurrections broke out simultaneously in Barcelona, Madrid, and the mining district of Asturias. That same night, an hour before Dalí was scheduled to give a lecture titled *The Surrealist and Phenomenal Mystery of the Table of Night* at the Llibreria Catalonia run by his old friend, Josep Dalmau, Companys proclaimed the independence of the Catalan state from the balcony of the Generalitat in Barcelona. Before dawn the fight was over. The bid for freedom had been an ignominious failure, but in the meantime a general strike was going on all over Spain and there was fighting in the streets of Madrid. That morning of 5 October the Dalís, who were staying with Dalmau, were awakened by their host, his hair on end, his beard unkempt, his face flushed, and his fly open. He looked as if he had just woken from a nightmare. They had to get out at once; civil war was about to start.

One has to believe that the journey to safety made as unforgettable an impression on Dalí as had his incarceration in a Catalan jail ten years earlier. It took him and Gala two hours to obtain a safe-conduct pass and half a day to find someone with a car willing to drive them to the border for any price. Everywhere there were drunken rioters and machine-guns at windows.

> I can still see the little village where we stopped for gasoline. The men are carrying ridiculous but lethal weapons, while under a big tent people are dancing to the tune of the 'Beautiful Blue Danube' ... and then I hear the voices of four men who ... are exchanging remarks about Gala's luggage, which seems ... offensive.... One of them looking me in the eye suggests we ought to be shot, there and then, as an example. I fall back on the car seat. I gasp for breath. My cock shrivels like a tiny earthworm before the vicious mouth of a pike. I can hear our driver's shouted swearwords ordering them to get out of our way.

The driver deposited them safely at a small hotel in the frontier town of Cerbère. He made it almost all the way back and then, in the suburbs of Barcelona, caught a spray of machine-gun bullets and died. Dalí called the experience 'the trap of that awful stupidity, civil war'.

The painting entitled *Puzzle of Autumn*, now at the Salvador Dalí Museum in St Petersburg, Florida, is one of three relatively large oils (40″ × 40″) that Dalí painted the following year. Against a landscape that seems to be an amalgam of the plain of Ampurdán and the rocks around Cadaqués an elderly

whiskered figure, framed by what may be a door, is looking at the bent and dangling body of a young man in tights. To the left a vintage automobile, seen from the rear, faces toward distant hills and some bare-breasted, distinctly nineteenth-century females in tutus strike attitudes. To the right is what has been described as a philosopher contemplating a grain of sand, sitting beside a pool. Above the central male figure is a post with a lion's head on top, typically Dalí's shorthand way of referring to his father. The theme of the prodigal's return is too evident to need much elaboration. Three shapes that look like jigsaw puzzle pieces strongly suggest a map of Spain. One surrounds the lion's head. Another, on end, provides the hole in the door through which the male figure can be seen and the third is attached to the back of the car like a piece of luggage. Invariably, certain symbols recur in canvases of the same period and the car in the landscape, fossilized, appears in several works of 1935–6. In one of them, *Paranoiac-Critical Solitude*, the shape of the car has been superimposed on a rocky barrier so as to suggest both a car and the map of Spain. As for the bare-breasted women, the symbolism may simply be elegiac, having to do with all that is quaint and vanished about the past, as is suggested by another work in which they appear, entitled *Forgotten Horizon*. Or it may also refer to Gala's fondness for cavorting on the beach bare-breasted. Finally, the figure reflected in a pool of water seems to foreshadow an image that would emerge full-blown a year later in Dalí's poetic, haunting and profoundly self-aware painting, *Metamorphosis of Narcissus*.

Dalí's second one-man show in New York that year, in November-December 1934, provided a new opportunity for a trip to the United States, but there was still a stumbling-block, this time financial. It seems from Eluard's letters that Gala and Dalí had continuing money problems throughout 1932, since he invariably advised her to sell something, along with the comment, 'Do not torment yourself with material cares, there is nothing tragic ... I am sure that things will work out.' They scraped along until the Zodiac group's regular stipend began to ease the way in 1933. Even so, there was barely room in their budget for a transatlantic expedition. After they had paid for two berths on the ss *Champlain* to New York, there was nothing left for expenses. Just three days before they sailed the Dalís were rushing around looking for an extra $500. They screwed up the courage to approach Picasso. As Dalí later described it, 'he broke Daddy's legendary piggy bank open for the benefit of the prodigal son'.

The new friend who most helped smooth their way to New York was a member of the Zodiac group, Caresse Crosby. She was the widow of Harry Crosby, a wealthy American expatriate known for his extravagant life-style, his famous friends and his courageous publishing house, Black Sun Press.

Crosby had committed suicide in 1929 and, when Dalí met his widow in the early 1930s, she was continuing his work and establishing a paperback publishing house that was far in advance of its times, printing works by Hemingway, Faulkner, Dorothy Parker, and many others. She was still living outside Paris in the marvellously romantic mill which she and her husband had taken on a twenty-year lease and extensively restored. Jean-Jacques Rousseau was purported to have lived there as well as the magician, mesmerist and alchemist Count Cagliostro. It was in Ermenonville, less than an hour's drive north of Paris and surrounded by a forest of evergreens, providing a background of filtered green shadows for its all-white décor. 'Dressed all in white, she drank milk, walked on white rugs, and everything possible from telephone to curtains was spotlessly white,' Dalí observed. The single exception, in deference to Harry Crosby, was a set of black china and a black tablecloth.

The further problem, one that seemed intractable, was Dalí himself. No matter how often he travelled in Gala's reassuring company, a train journey was a terrible ordeal. Julian Green noted, in late February 1933, 'He is going to Spain and speaks with terror of the customs formalities and the thousand petty annoyances of a trip by *ferrocarril* (railroad).' Such hurdles were minor, compared with the challenge of entering America, and presumably nothing would have come of the idea had it not been for the enthusiasm of Caresse Crosby, who swept objections aside. A section of her autobiography deals with the pathetic figure Dalí presented as he prepared for the ordeal. He was at the station hours ahead in terror of missing the train. He sat with all his canvases propped around him in the compartment, strings from each attached to his person, in case they should be stolen. He made the comment, no doubt with a straight face, that he had to sit near the engine so as to arrive sooner. His conduct on board ship was equally piteous. He spent his days in a champagne fog and went everywhere in a lifejacket. Photographs of him on deck after they docked in New York show him huddled against Gala, looking frozen, but there is an impish sparkle in his eyes that belies his panic. As was to become customary, he had spent most of the crossing stage-managing his press conference. He had persuaded the ship's baker to concoct the longest possible *baguette* – it was something like eight feet – and, when he found a mob of newspapermen waiting, he brandished it like a talisman. When the newsmen politely (he thought) forbore to mention the embarrassingly large object, he quickly shifted gear and began to declaim on a recent painting in which his wife appeared sporting a cutlet on her shoulder. The reasons for the presence of the cutlet, which had originally appeared on his own form to distract that ogre, William Tell, and had now gravitated to Gala's, would have been interesting indeed to explore. Dalí was much too smart for that. 'I

answered that I liked my wife, and I liked chops, and that I saw no reason why I should not paint them together.'

The press was most respectful in Hartford. Dalí braved the journey to give a conference in French – as yet he spoke no English – on his Super-Realist theories, illustrating his remarks with Picasso's paintings and his favourite postcard, the one of the African village. If indeed he did tell his audience, as is now believed, that the only difference between himself and a madman was that he was not mad – a statement that has achieved great fame – the *Hartford Courant* was too polite to say so. However, when he repeated the performance at the Museum of Modern Art on the occasion of its fifth anniversary, his upsetting ideas elicited a livelier response. One magazine reminded its readers that this was the artist who had painted *The Persistence of Memory*, a picture of watches melting over table edges, the branch of a tree 'and over something that looks like a fatigued walrus. It makes some people quite ill'. As for the lecture, the 'hall was full of tense, incredulous, baffled and appreciative faces.... Mr Dalí explained, while throwing on the canvas a picture which looks like a lady, a bird, a horse's head, and a bad Martini, that the difference between himself and a madman is that he is *not* mad.'

Lucius Beebe of the *New York Herald* was even more entertaining on the subject of this young Spanish artist, who had blown into town 'wearing a loaf of bread for a hat and displaying, among other nonpareils, a painting showing a chair with a running faucet on its side and tree growing in its seat from the branches of which a human arm is seen tossing brown omelets down a roller coaster. This work Mr Dalí considers somewhat academic.' These sprightly comments could be explained, Dalí wrote to a friend, by a pervasive American inferiority complex that ensured a 'hands-off' and 'giving-the-benefit-of-the-doubt' attitude, whereas, in Paris, critics always thought they had seen it all before and practically yawned in one's face. Even the measured rejection of his art by such critics as James Johnson Sweeney in the *New Republic*, who weighed Dalí against the solider, rounder outlines of Miró and found him wanting, could not deflate his enthusiasm. Americans saw him, he crowed, as 'the King of the Non-Sequitur, the clown, ... the *tummeler*; not one of them had divined the terrific pressure, the Nietzschean will pent up behind the appearances'. It was all that he could have hoped for.

It seems clear that Dalí had a ferocious aptitude for the art of self-promotion. He appeared tirelessly willing to hammer home the same message wherever he went, according to the most advanced advertising principles. That such an approach sold paintings was gratifyingly evident. In 1934 Dalí, who was after all barely thirty, had the amazing number of six one-man shows, two in Paris, one in Barcelona, one in London and two in New York (earlier in

the year, Levy showed his drawings and etchings for *Les Chants de Maldoror*).
That autumn in New York Dalí showed twenty-two paintings, a couple of
them already sold, and quickly sold eight more, three to museums. The
Wadsworth Atheneum bought a second, one of his best, entitled *Paranoiac
Astral Image*, as well as an Ingres-like pencil study drawing of various figures.
Dalí was without doubt the man of the moment, as Caresse Crosby, who liked
to spend her money wisely, instantly saw. To give him the proper send-off
she took over Le Coq Rouge, a fashionable rendezvous on East 56th Street,
for a Bal Onirique. Guests were invited to come as their dream and be wined
and dined from ten in the evening until question mark for only ten dollars a
couple. It was a tremendous success. 'Mad Dream Betrayal of New York
Society at the Astounding Party to Its Newest Idol', blared the *New York
Sunday Mirror*, adding 'All-Time High in Gotham Smart Set's Traditional
Pursuit of New Thrills, No Matter How Crazy, is the Latest Cock-Eyed Rage
for Salvador Dalí, the "Super-Realist" Who Paints His Nightmares Which
Critics Applaud While Mortals Grow Dizzy'.

Dalí naturally took some pains with his costume. Robert Descharnes wrote
that he came 'disguised as a shop window'. Dalí himself explained that he
had dressed himself as a necrotic corpse with a bandage around his head. In
the white shirt front of his tuxedo he had cut a square hole, lit from within,
which acted as a shadow box for a pair of tiny breasts, decorously enclosed
inside a bra. He then rolled his eyes. It was wonderful but it was only the
beginning. Pierre Matisse, who was showing Miró at his New York gallery,
recalled,

> Downstairs there was the carcase of a steer ready to be butchered, nice
> and clean, wide open, and in it sat one of the patrons of the exhibition at
> a table, having tea with her daughter, who was perhaps seventeen. The
> costumes were amazing. One woman had a crown of young tomatoes
> around her head. Another had cut his face, I don't know how, and had
> hat pins sticking to it with wax. Another lady, very well known, whose
> name I will not mention, wore a long grey silk dress and when she turned
> around there was nothing there. She was asked to go home and change.
> I went as Pierre Matisse.

Even Dalí was surprised at the macabre depths of the guests' imaginations:
'Eyes grew on cheeks, backs, underarms, like horrible tumours. A man in a
bloody nightshirt carried a bedside table balanced on his head, from which a
flock of multi-coloured hummingbirds flew out.'

Most shocking of all, in retrospect, was the outfit Gala wore. Exactly who
designed it is not clear, but by general agreement the object she was sporting

in the centre of an enormous black headdress was a baby's corpse. The doll had a wound on its forehead, carefully painted by her husband, that was filled with ants and its skull was being clutched by a lobster. A pair of gloves, acting as wings on either side, completed the macabre imagery. The similarity of lobster image to grasshopper theme would suggest that some private fears were being aired in public, and the fact that Gala would appear to be dreaming of a murdered baby, in view of her rejection of her own child, would conjure up some uncomfortable thoughts about her private opinions. The press came to conclusions of a different kind. A few months before, Bruno Richard Hauptmann had been tried and convicted of the kidnapping and murder of Charles and Anne Lindbergh's son, and the particularly revolting details of the event were fresh in everyone's mind. Were the Dalís capable of this kind of brutal symbolism? It suddenly seemed all too likely to those, in this case Matisse, who had heard them make such cynical comments as, 'You have to boil Americans right down to their bones.' That, Matisse said, was typical of Dalí beneath the charm. When they arrived back in Paris shortly afterwards, reporters bombarded them with questions; Dalí denied that any reference to the Lindbergh baby was intended. The Surrealists, he later said, filed a ridiculous lawsuit charging that to make such a headdress was a provocative act. It sounded like the final, final break and he was delighted.

Luis Buñuel told another version.

> Read the riot act by his agent, Dalí retreated, and in his best hermetico-psychoanalytic jargon he explained to the journalists that Gala's costume was a purely Freudian representation of the infamous X complex. . . . When he returned to Paris, however, he had to face trial, for his error had been serious – the public retraction of a Surrealist act. Breton reported to me that during the meeting Dalí fell to his knees, clasped his hands, and, his eyes filled with tears, swore that the press had lied, that he'd never denied the fact that the disguise was well and truly the Lindbergh baby.

If one can make the fairly safe assumption that the subjects of Dalí's paintings are, in broad outline, accurate indicators of his inner preoccupations, one can see a mood of submerged melancholy behind the façade of the controversial and much-quoted young artist he appeared to be in 1934–6. His bleak assessment of New York – he compared it to a landscape by Böcklin, evidently with the *Island of the Dead* canvas in mind – is one clue, and so are the ideas he dreamed up for Surrealist stunts that would add the right sparkle to the lectures he was giving in Europe and the US. He said,

> During those days I was very much impressed with a murder committed in Germany. On a bed and on top of a fur coat, a naked woman was

discovered, dead, and her fingernails had been violently pulled out and bent backwards. I set the actress up in my lecture with some artificial fingernails attached to some adhesive tapes which were flesh coloured and, underneath, subcutaneous red, and which came all the way up the arms and into her eyes. And at a certain moment in my talk, I took her hands with my teeth and bit her fingernails and pulled; the effect of tearing them was shocking and the audience screamed.

Whatever was horrific and sadistic terrified him and at the same time attracted him like a magnet. Another of his stunts had its origin in a transparently mean-minded desire to poke fun at an old woman he saw every day who trembled uncontrollably. He wanted to cut off her hair, dress her in a bullfighter's costume and cap and put a dripping omelet on her head so that, one assumes, her agitated movements would have an unpredictable, not to say comical, effect on the raw egg. Since the little old lady declined to be thus ridiculed, an actress was found for the part and the stunt took place. It is often cited by his friends as an example of Dalí's less lovable aspects.

It was his fate, at that period, to be surrounded by painful reminders of his own mortality. The poet René Crevel was seriously ill with tuberculosis, as a few people knew. Paul Eluard happened to be staying at a sanatorium in Passy when Crevel arrived there. Eluard was merely recuperating from a minor case of exhaustion, but Crevel was about to undergo a serious operation. Eluard begged Gala to pretend she knew nothing and, indeed, Crevel's friends were used to his periodic disappearances. He would always return in great good humour, well-dressed, his hair waved, ready for a new bout of Surrealist wrangling. There were late nights and self-destructive debauches, while he worked his way towards a new round of mental and physical exhaustion.

Crevel killed himself on 19 June 1935, the week David Gascoyne happened to be staying with the Dalís:

One morning I came to work and found both of them greatly distressed and Dalí putting on an overcoat, about to leave. Gala was saying, '*Et surtout ne l'embrasse pas,*' and it gave me a bit of a start, implying as it did some kind of homosexual relationship between them. Apparently they knew Crevel was ill, but did not know it was a suicide attempt. She thought he had been stricken by something contagious and wanted to make sure Dalí didn't catch it.

We learned later that he was found in the bathroom with the gas tap for the hot water heater turned on full. He had pinned a little note to

himself that said, 'Disgusted, disgusted'. When Dalí came back and told us, Gala was a hard woman but she had tears in her eyes and so did he.

That evening we went as usual to the Café de la Place Blanche. Breton presided, always in a green tweed suit and a pipe, the tables pushed together. ... Eluard, who almost never went, came that evening, with a white face, very shocked. He said, 'You know what's going to happen? They're going to give him a religious funeral!' They were religiously anti-religious. They wanted to go and have a demonstration, slash up all the chairs, but in the end they did nothing about it and all the Surrealists were very disappointed.

What seems to have most affected Dalí's mood was the thought that he had not actually touched Crevel. Once before, when Crevel had had a break-down near by – presumably when he was visiting them in Port Lligat – Dalí, feeling himself a victim of his irrational fear of contamination, could not bring himself to get anywhere near him. 'I acted as I should have, in a way that everyone considered the most devoted possible, but I could not bring myself to touch him.'

This pattern, of reacting first and feeling remorseful later, had a long history. It went back to the early days when he discovered the interesting fact that to pretend to have a fishbone lodged in his throat was the one thing his father could not bear. The stages by which this innocent game shifted in meaning for Dalí are important to explore and quite obvious. Edward James, who was to become Dalí's patron and close friend, reminisced at some length about Dalí's description of the death of his cousin Carolineta, a consumptive, frail, and poetic figure who always wore flowing gowns. Edward James said, 'She resembled one of those figures that were popular heroines of mid-nineteenth-century literature, post-Jane Austin and pseudo-Brontë ... [when] to be dying of tuberculosis was the most romantic thing a young heroine could do.'

One evening at supper, when Dalí was about twelve years old, the family was assembled as usual around the dining-room table when a messenger brought a telegram to the door: Carolineta had just died. Dalí's small grand-mother, who seemed not to be paying much attention, let out such a scream that the whole table was in an uproar. Everyone had already put down their knives and forks except Dalí.

Even though I knew very well that I shouldn't, I went on eating what was on my plate because it was very good. So my mouth was full, but I was fascinated by the very peculiar noise my grandmother had made and as I

155

turned my head to look at her I saw enormous crystal tears coursing down her wrinkled cheeks.

Dalí was suddenly seized by remorse and tried to swallow what was in his mouth, but 'the mouthful stuck in my throat like an elevator between two floors'.

The connection between guilty feelings, death and remorseful choking had become firmly cemented in his mind, as is clear from a later comment that,

> Ever since the days when I was a babe in arms, the moment anyone spoke to me about death as an inevitable event, I have always shouted 'Lies!' ... If I believed in death, in the traditional sense of the word, that is to say, in decay and nothingness ... anxiety would keep me from swallowing anything.

One of the worst crises of this kind appears to have come in the first half of 1936, just before the Civil War began in Spain. Dalí and Gala, exhausted, had returned to Port Lligat to find Lidia in a frightful state. She was in tears; her sons had been attacking her and she had blue marks all over her body. One of the boys was, in fact, severely ill with a manic-depressive psychosis and both were committed shortly afterwards to an insane asylum in Girona. Before they went, Dalí, who knew something about psychiatry, amused himself by aggravating the psychosis of the sicker son a little more every day with impersonal malice, if one can believe his memoir. Then, a few months later, when he learned that the boy had starved himself to death in the asylum, he panicked.

> We went back to the house. We sat down at table. Suddenly, Gala looked at me, 'But you are as red as a tomato! What is the matter with you? You are sweating! You are soaked!' I could no longer swallow. I tried an anchovy, some bread, oil. I chewed it and chewed it. At the final stage, totally impossible to swallow.

He was in despair, full of lacerating self-doubts and morbid imaginings. Dalí also said, 'You know I am a great coward and always afraid that things will come back to haunt me.' Soon after he met Gala, they had found a piece of driftwood among the rocks of Cap Creus which he carried everywhere in his pocket and would touch superstitiously. It provided him with a form of reassurance and Gala did the rest. 'You aren't responsible for his death,' she would say. 'Don't think you are at fault because you are not. But you are guilty of something much worse; you doubt yourself.' She knew that, at that

very moment, an inner voice would be telling him that he was finished as an artist. She would continue, 'You are obsessed by the idea of your artistic death, which is symbolized for you by this business of eating. Forget about dying, get up and set yourself to really drawing and painting, not just your fantasies of flight but the dictates of your talent, which is a great one.' Such was his belief in her powers of persuasion and the strength of her argument that, before he knew it, he would be eating normally. He could then conclude, 'I was probably punishing myself.'

He could always be sure of Gala, who could predict the future by reading cards. 'Gala ... is a true medium ... Gala is never, never ... wrong. She reads cards with a paralysing sureness. She predicted to my father the exact course of my life. ... She foretold the illness and suicide of René Crevel and the very day of the declaration of war on Germany.' With Gala's magic on his side, what did he need to fear from the dead, even if they did return? Yet Gala, for all her prescience, had not foretold the most terrible and haunting death of all.

Dalí and Federico García Lorca were reconciled some time in the summer of 1936, perhaps early June or July. How it came about has never been explained, but that they did is certain, because Dalí referred later to a three-day reunion with Lorca in Barcelona in the company of Dalí's English benefactor, Edward James, shortly before the Civil War. Gala, who had never met Lorca, was immediately smitten and so was the poet; for three days he could talk of no one else. As for Edward James, he was caught like a fly in amber by Lorca's seductive personality. James had just rented the Villa Cimbrone outside Amalfi, near which Wagner had supposedly been inspired to write *Parsifal*. James invited them all to join him there and stay as long as they liked. Lorca weighed the pros and cons for three days, changing his mind every quarter of an hour. His father, who lived in Granada, had a heart condition that might be serious. In the end Lorca decided to visit his father first and then go on to Italy. He never got there. He was kidnapped, captured and shot in Granada a month later. As he had once predicted in a poem, his body and grave were never found.

Dalí wrote, 'I hadn't insisted enough and dragged him out of Spain. If I really had wanted to, I could have taken him to Italy. But I was in the middle of writing a great lyric poem, "I eat Gala", and I felt myself, deep down, more or less consciously jealous of Lorca.' He had been jealous; now he was overcome by remorse and guilt, feeling responsible for Lorca's death. Privately, he insisted on it; publicly he was defiant. When he heard the news of Lorca's death, he shouted, 'Olé!'

How could he have said such a thing? The terrible reproach followed him for the rest of his life. 'That's what the Spanish say when a toreador executes a particularly well-performed movement before the blood-stained beast,' he

said later. He also admitted that he 'reacted like a villain'. Now there was another reason to reproach himself for his selfishness, his jealousy, his criminal culpability. He continued, 'I closed eyes and ears so as to know nothing about it, but the stories of the most terrifying atrocities still reached me and haunted me like nightmares.'

They lingered at the Villa Cimbrone before going on to Rome as guests of another important English collector, Lord Berners. There Dalí worked on a new canvas, *Impressions of Africa*, the result of a brief excursion to Sicily, and saw a few friends. There was terrible news from Cadaqués. The anarchists had shot about thirty people, all of whom the Dalís knew, including three fishermen who were their particular friends. 'Would I finally have to make up my mind to return to Spain, and share the fate of those who were close to me?' They were staying in the Italian Alps close to the Austrian frontier in a lonely hotel outside Cortina. Gala had business in Paris and he was alone for the next twelve days. The combined stresses of Crevel's death, of Lidia's two mad sons, of Lorca's death, of the news from Cadaqués, of his own guilty awareness that he was living in comfort while others bled and died, of his terror of launching himself into that conflict, were all too much for Dalí. He felt weighed down, persecuted, surrounded. 'All the upsets, the tragedies, murders, crises, troubles that rang out through the news reports translated themselves in me into one obsessive anxiety: germs.'

He began to inspect his stools with a terrible foreboding. They were fine. He worried about every minute speck that resulted from blowing his nose. He found his anxiety focusing on a piece of what looked like greenish snot stuck to the tiled wall opposite the toilet, and which caught his eye every time he sat down. One day he could stand it no longer; he took a piece of tissue and swooped down on the evil-looking lump. Instantly a fierce pain seared him; the lump had pierced his finger between nail and flesh and struck him right to the bone. His finger began to bleed and, he believed later, he genuinely went off his head. '... my imagination quickly informed me that soon my finger would doubtless have to be cut off, as might even the whole hand.... Tetanus had surely taken hold ... Would I be able to survive with a hand cut off? With a dead hand rotting underground? The very idea made me shiver. I fell to my knees.' At that moment his eyes were caught by a reflection at the base of the fatal lump and the truth dawned upon him. It was not snot, but a piece of hardened glue. Nothing to worry about! No germs! He pulled the sliver out of his wound. It was a clear reprieve. Needless to say, he did not go back to Spain.

The Metamorphosis of Narcissus

'I was lucky. I saw the last days of the true Dalí.'

DAVID GASCOYNE, OF HIS STAY IN PARIS IN 1935

When Julien Levy saw Dalí again in the late summer of 1936 he had moved, this time to an expensive-looking house in suburban Paris. He was markedly changed in appearance and manner. No longer the 'half-timid, half-malicious' foreigner, he seemed completely in control, very much in his element, and quite formidable. The Pierre Colle Gallery had closed and Dalí, taking on the business of promoting himself, had sent around a card bearing the outlines of a pearly coronet. It announced a one-day showing of his works.

Emilio Terry, the well-known architect who had been one of the twelve patrons of the Zodiac group, had helped remodel Dalí's new house, which was of white stucco, inside and out. Instead of the Surrealist interior he had been expecting, Levy found it soberly, even monastically simple, with Spanish provincial pieces ranged around the walls. Some excellent early de Chiricos, from his very best period (1916–17) were discreetly hung around the walls and a convex mirror had been positioned so as to reflect the whole room. A large studio, which took up the entire top floor, was devoted to Dalí's own works.

All the paintings had apparently already been sold, but this did not prevent crowds of extremely chic and well-known people from trooping up the stairs. Levy was impressed and discouraged, since he assumed his tenuous agreement with Dalí through Pierre Colle had now ended. Dalí was already, it seemed, too famous, too fashionable, and too busy to be bothered with ambitious young New York art dealers. Levy had brought with him a promising young star in the Surrealist movement, Léonor Fini, a gifted and youthful (she was eighteen) Argentinian who had grown up in Trieste, where she had showed her first paintings the year before. Levy was to give her her first one-woman show in New York three years later. He had hoped to impress her by the effect of his entrance on Dalí, but he could not attract the latter's attention. Dalí, it seemed, had lengthy comments for the idlest visitor but no time for Levy. Even Gala, who had once seemed so warm, was superficially polite but quite remote. Levy, although he did not know it, was feeling the full effects

of the technique the Dalís were to refine to an exquisite degree in their dealings with anyone who wanted something from them. Such tactics were only useful, however, for as long as the victim was willing to be dangled. Levy discovered, quite by accident, how to tip the scales. 'Come on, let's get out,' Léonor Fini remarked as she made for the door. She said it in rather a loud voice. Instantly the Dalís were at their side. Dalí kissed Levy on both cheeks and was ready to talk business – his next show in New York.

It is difficult to pinpoint the exact moment at which Dalí moved from young Surrealist and the darling of a small and extremely brilliant 'in' group to international figure whose 'slick-as-grease craftsmanship and even slicker press agentry' were synonymous, as *Time* magazine phrased it. It is clear, however, that despite Gala's impassioned plea to the Prince de Faucigny-Lucinge that Dalí must be relieved of financial pressures so as not to fall into the trap of commercialism, Dalí was actively trying to make the right business connections from the earliest days. He gives a poignant description of seeing Gala set off, day after day, with a case full of his designs under her arm – false fingernails made of tiny mirrors, streamlined automobiles, baroque bathtubs: there was no end to his phenomenal ingenuity, or their indifferent reception. But, in that halcyon period (roughly 1933–6) when he was introduced to the Parisian *haut monde* and taken up by the Zodiac group, and particularly following his American triumphs, his position changed markedly as far as the world of commerce was concerned. It would soon come to be said of him that his gifts as an artist had been put on display merely to attract lucrative commercial contracts. To think so would be wrong, but there is no doubt that he saw no conflict and, indeed, many others of his generation were grateful to pick up whatever extra money floated their way in the form of contracts to design anything from tea cosies to perfume bottles. And, at least in the beginning, if Dalí was willing to hire himself out, he did so at a very august level.

The great dress designer Elsa Schiaparelli is justly famous for the inspired collaborations she undertook with such dazzling figures as Jean Cocteau, Pablo Picasso, Christian Bérard, Pavel Tchelitchev, and others. Of all the *couturières* she has to be considered the most consistently daring, the most willing to treat the subject of apparel as an experimental art form and one of the most courageous, since she defended the results no matter how badly realized they might be. In the mid 1930s she turned to Surrealism and, by a happy coincidence, Dalí's good friend Bettina Bergery was working for Schiaparelli in her salon on the Place Vendôme as a public relations assistant, party-giver, window designer, 'and anything else I could think of', she said. Mme Bergery modestly refused to consider herself pretty enough to become a model – she is often confused with another Bettina, who was one – but she

was an excellent advertisement for her employer's creations, being svelte, impeccably turned out, and seen in the best circles. She credited herself with 'one gift, but a useful one, that of getting other people to do things for me'. She succeeded in channelling Dalí's playful imagination into designing, for Schiaparelli, such confections as buttons made from fake chocolate tidbits covered with bees, for instance. He invented a hat made from a high-heeled shoe turned upside down, a great sensation, worn with a tailored suit embroidered with lips. Another of his improbable ideas, which Schiaparelli faithfully translated into an outfit, was the cutlet or lamb chop theme, made into a hat and worn with a suit similarly embroidered. He made a handbag to look exactly like a telephone (in dark blue doeskin and brass), and a scarf of telephones turning into clouds. There were telephone buttons and earrings – perhaps Dalí's first attempt at a jewellery pun. He also designed a sofa in the form of Mae West's lips, which was made up in Paris by the fashionable interior decorator Jean-Michel Frank. The rumour is that Schiaparelli did not like it much, but Dalí did and later built a *trompe l'oeil* room around all of Mae West's features that is one of his enduring inventions. He then designed a flowing evening dress printed with lobsters that were seen cavorting among mayonnaise and parsley. Schiaparelli, who was willing to go to almost any lengths with Dalí, refused to allow him to spread real mayonnaise on the gowns. Dalí's ideas for clothes were, of course, devastatingly easy to ridicule. 'When Dalí depicts on a [magazine] cover a female figure in dull green with . . . a head composed of roses – well for all one knows women may next year be wearing heads of flowers,' the London magazine *Studio* commented. Any time now, on Bond Street, Fifth Avenue or the Champs Elysées, one would be bound to see 'ladies of fashion with hair gummed in thin vertical branches like those of a leafless tree, skilfully twirling their long trailing dresses through the loop of an indispensable skipping rope'.

At the same time that Dalí was being embraced by Schiaparelli the fashion world was pouncing on his other ideas. The first reference to the Dalínian dream landscape, which was to become a cliché of the 1940s and 1950s, appeared on page 37 of the New York *Vogue*'s issue for 15 January 1936. It showed a Dalí painting with 'that sense of the solitary human lost in space, wrapped in infinity', as *Vogue* put it, which was then put to use in the following pages to provide the background for some suitably pensive designs by Schiaparelli. In London that year, the enterprising photographer and designer Cecil Beaton was making use of the same imagery. Numerous photographers were also finding, in Dalí and Gala, patient and most malleable subjects. Brassaï had already made a series of studies of them in those already distant days when he was romantically Surrealist and she was definitely un-chic. Beaton gave Dalí a fencer's mask and pitted them against each other,

then posed them before two of Dalí's paintings, very Magritte in tone, that symbolized themselves. Man Ray tangled them up with strings, but not before Carl Van Vechten, whose photographer's and novelist's eye were on a par, had spotted Dalí as a celebrity in the making. He photographed Dalí and Man Ray together in 1934 and one sees, from his photograph, that Dalí's famous eye-rolling stare had begun.

Naturally Schiaparelli vied with other dress designers, including Chanel, who also knew the Dalís socially, for the chance to dress Gala. Her choice of clothes seems to have mirrored her changing fortunes in these years. From her First World War letters to Eluard it is evident that she was cultivating a *soignée* look at a young age. A year after she met Dalí, when they were living in a fisherman's cottage, she was running around the beach in shorts and the most unisex of shirts, when she bothered to wear one. Her hair was plastered boyishly against her head, sometimes under a sea captain's cap worn at a rakish angle, and there were saddle shoes on her feet. Once their fortunes began to rise in Paris, her taste in clothes shifted again. She was beginning to cultivate a look of refined distinction that alternated between Chanel's impeccable tastefulness and Schiaparelli's flamboyance, although never to the extent of upstaging her husband. She was self-effacing, shrewd and practical, and very much the power behind the throne. She was the one who paid the bills, arranged to have paintings transported and insured, negotiated the contracts, kept Dalí's household running smoothly and (it was rumoured) sent him into the world with a label tied to his clothes, his eventual destination written on it in large letters. She saw her role as indispensable assistant, interpreter, defender, and admirer, the tolerant and patient muse of a genius, and she played it to perfection. He wrote, 'She taught me how to dress, how to go down a stairway without falling thirty-six times, how not to be continually losing money ... how to eat ... how to recognize our enemies. ... She was the Angel of Equilibrium.'

In saving Dalí from himself, Gala was as vigilant as Dalí's mother had been in his father's case. She needed to be because people thought there was something really bizarre about Dalí's behaviour on occasion. It was said that when Dalí happened to arrive in Italy in the autumn of 1935 on the day when Mussolini invaded Abyssinia (3 October), and finding rioting in the streets, he told anyone who would listen that Il Duce had purposely held off his war until he got there. Someone saw him fly into a rage because, while watching a floor show in a Paris café, the dancers happened to come too close to his table. 'They just did it to scare me,' Dalí said tearfully, after he had fled. There was also the time when, having arrived at the outside door to Julien Levy's apartment, where he was expected for drinks, Dalí pushed the buzzer as signal for Levy to let him in, which Levy promptly did, then did

not appear. Levy went downstairs to investigate and was in time to see Dalí tearing off. When he had caught up with him, Levy demanded an explanation. 'The door, the door!' Dalí stammered. 'It *whispered* at me.'

Julien Levy described another occasion when the Dalís attended a private showing of Surrealist films by Joseph Cornell, the first American to be influenced by the new movement. In the middle of one of the films there was a loud crash. '*Salaud!*' came from Dalí. Levy yelled for lights. Gala was beside Dalí in a flash. '*Calme-toi!*' she begged.

'*Salaud et encore salaud!*' Dalí screamed, struggling to free himself and take Cornell by the throat. Dalí was launched on one more of his periodic rages, 'somewhat between the firebreathing, lightning-flashing rampage of a demon and the spoiled yielding to frustration that is a temper tantrum. One sensed whirling blades of sharpest steel flashing about him and ... tears of uncontrolled hysteria.' Cornell was horrified and Gala frantic as she tried to restrain Dalí until he had cooled off. The problem, it turned out, was that Dalí thought Cornell had stolen one of his ideas for a film, even though he had not actually written it yet. It was, he explained, 'as *if* he had stolen it'.

There was, however, one occasion on which Gala was not there to save Dalí at the right moment, an omission that might have had serious consequences. The incident took place during the first International Surrealist Exhibition, organized by David Gascoyne, Roland Penrose and a small group of scholars, poets and artists centring around Henry Moore, Herbert Read and the British Surrealist painters Eileen Agar and Paul Nash, which ran for almost a month at the New Burlington Galleries in London in the summer of 1936 (11 June–4 July). Dalí, although no longer in the inner circles of Surrealism, was deemed too important to be excluded and was represented by a few works (one was his famous *Aphrodisiac Dinner Jacket*, which was covered with dozens of tiny glasses of liqueur and dead flies), while reserving his choicest inventions for a one-man show being held at the Lefevre Gallery at the same time. The exhibition was a phenomenal success with the public, attracting record crowds, and helped by Dalí's unerring publicity instincts. One of his stunts was to dress up Sheila Legg, an extremely pretty member of the British Surrealist group, in a mask of red roses that covered her whole head, and send her out to feed the pigeons in Trafalgar Square. Another was to give a lecture at the Galleries, 'Some Authentic Paranoiac Phantoms', wearing a diving suit, the helmet of which was decorated with the radiator cap of a Mercedes Benz. He made his entry with two white Russian wolfhounds.

As Dalí launched into his discourse, Gala left, either to watch newsreels at a nearby cinema or to get a cup of coffee. The versions differ and Dalí does not mention it, but it seems that for once she was not there to adore him as he, by chance or design, talked exclusively of his love for her. However, the

old-fashioned suit, which had been efficiently bolted together by a workman who then left, was not only immobilizing – the shoes were so heavily weighted with lead that Dalí had to be helped onto the platform – but an effective sound barrier. Dalí buzzed away in French and the audience sat politely mystified. Dalí was soon more and more uncomfortable, partly because it had dawned on him that he could not be heard and also because, after spending ten minutes in his suit on a very hot day, he was perspiring profusely. He began to make elaborate gestures for the removal of his helmet, which struck everyone as a new development deserving of applause. The more he gesticulated the more they laughed and it took some time, during which Dalí thought he would faint dead away before, as David Gascoyne explained, 'we realized he was in some distress. Finally Roland Penrose said, "For heaven's sake go and get a spanner," and I found one somehow. It took us about five minutes to get him out of there.' By the time they freed him Dalí was almost prostrate but he gamely finished his lecture. He was complimented warmly on his realistic performance.

The British organizers of the movement had steeled themselves for a hostile press reception and, with one or two exceptions, were ridiculed for what was seen as an attack on all that was sacred and serious-minded about art. Dalí had been given the same treatment in 1934 when he had two shows at the Zwemmer Gallery in Litchfield Street. The enthusiastic response of David Gascoyne in the *New English Weekly*: 'Salvador Dalí is the most important living literary painter', had been followed by that of Herbert Read in an article in *The Listener* in which he discussed the similarities between the work of Dalí and Hieronymus Bosch. The aim of the latter, which was to combine the present life, the life to come, Paradise, and Hell into a super-reality, paralleled that of the Surrealists. They sought 'to break down the barriers ... between the conscious and the unconscious, between the inner and ... outer world, and to create a super-reality'. Read suggested that Bosch's enduring fame ought to act as a cautionary reminder to those tempted to dismiss Dalí and the movement.

His words fell on deaf ears. Clive Bell wrote in the *New Statesman and Nation*: 'These paintings are vulgar trash intended, I surmise, to take in the would-be smart and up to date', a sentiment echoed with more dignity by Anthony Blunt in the *Spectator*: '... many painters ... have condemned themselves to the second class by their refusal to take material reality as the foundation for their work.' The problem, as Roland Penrose saw it, for the movement as a whole, was to release the British from 'the constipation of logic which conventional public school mentality had brought upon them', but that proved difficult, especially when the immediate response of critics was to argue, as one did:

If as Dalí maintains, the common base of the human spirit is to be found in what he is pleased to call the visceral cosmos of the subconscious, by which perhaps he means the stomach and its corrupting influences, then no doubt we should all bark, gibber and turn somersaults like apes and be unable to comment rationally on this performance in formed sentences with . . . a modicum of grammar and a modicum of sense.

It was all, the writer concluded, 'irreverent', 'irresponsible' and 'not in good taste'.

Given the vehemence of the attacks (one letter writer to *The Times* complained that Surrealists had been the butt of so many feeble jokes it was a wonder the movement still existed) Dalí was let off rather lightly on the occasion of his Lefevre Gallery show in 1936. It may have had something to do with his stubborn success. Like it or not, any artist in those immediate post-Depression years who could sell twelve paintings by lunchtime on opening day for an average price of £200 ($1,000) was someone to be reckoned with. The critic of the *Daily Telegraph* contented himself with a mild reproof: 'These pictures from the subconscious reveal so skilled a craftsman that the artist's return to full consciousness may be awaited with interest.'

Among those British admirers of Salvador Dalí not afraid to gamble their money was Edward James. This notable English eccentric, who boasted that he was the illegitimate grandson of Edward VII, was born into a wealthy and stuffily conformist family, and made his escape at the earliest possible opportunity, throwing champagne parties at Oxford for the Sitwells, the future poet laureate John Betjeman, and Randolph Churchill. He painted, wrote poetry, bought his first Bruegel at the age of nineteen and, when he inherited £1 million at the age of twenty-one, spent it all on Surrealist works by Picasso, Magritte, Tchelitchev and others. Levy, who was tall, said that when he met James in 1936, 'I looked down at least a foot to perceive a pretty and well-proportioned, very miniature gentleman', but he was a mesmerizing conversationalist, speaking 'in precisely clipped, beautifully rounded phrases' reminiscent of Churchill at his peak. James spent a small fortune on Dalí and eventually owned between forty and fifty of his best works, all from the 1930s. They sold for record-breaking sums when they were auctioned at Christie's in 1981. James, who had married the Austrian singer Tilly Losch and then acrimoniously divorced her, shared Dalí's delight in the outrageous, in thought or deed.

Why not have a Surrealistic dinner party in which dwarfs stood on the table and held the candelabra? Why not a menu of oysters that appeared to be chilled in ice but were actually smoking hot? Why not fish-skins stuffed with steak, potato jackets containing pease pudding and carrots masquerading as

peas? (That particular menu seems not to have been executed.) Why should a house be what it seemed? James had inherited West Dean, an imposing mansion dating from the eleventh century, which had been 'Gothicized' by James Wyatt in about 1790, and which stood on 12,000 acres in Sussex. James lived there whenever he was not in his London house, in New York, Paris or Italy. By the end of 1935 he had decided West Dean was too big and embarked on the conversion of the family's shooting lodge, Monkton House, some distance away, a small country house designed by Sir Edwin Lutyens. James disliked its 'mousy good taste' and thought Dalí could brighten it up. One of the architects he engaged that year was just setting up in partnership over a shop on the Fulham Road; he was the now famous Sir Hugh Casson.

As Sir Hugh recalled:

James was an extremely elegant young man, dapper and small-boned, who wore shirts from Italy and ties from Paris; he was perfection. He and Dalí would come down to the office and discuss their ideas from the practical to the impossible. Nowadays you couldn't get away with redesigning Lutyens, but at that time it seemed acceptable, although we thought the ideas were dotty. Dalí wanted the chimney tops to have sculptured blankets thrown over them. That we did. In the centre of the chimneystack, Dalí wanted a great clock showing the days of the week. That was done using hand-painted glass, the colours mixed by Dalí. Then Dalí wanted plaster bedsheets hanging from the windows. That we could do. He then wanted the bamboo columns from a ballroom in a house in Regent's Park that was being pulled down to be used as downspouts, with leaves at the top. We did that. Then he wanted the roof stripped and green and black pantiles from Italy used. We did that.

The main problem was that Dalí wanted the drawing-room to feel like a dog's insides. He wanted its walls to expand and contract and, since the dog was not very healthy, he wanted an audible panting noise. We had thought up a way to do it, but the Munich crisis intervened and it was never finished. To be honest, I was rather disapproving. I was a young architect intent on building a new world and improving society, and this kind of conceit seemed perverse and even decadent. I don't remember trying to keep any of Dalí's drawings, for instance, if he did leave any in our office. I do remember him saying, 'It's very difficult to shock the world every twenty-four hours.'

Dalí and James were inseparable in the 1930s. George Melly, the British jazz singer, writer and art critic, who edited James's memoir entitled *Swans*

Reflecting Elephants, said James told him that he and Dalí went to bed together in Paris. The story was that Dalí wanted to spend the night with James, but had promised to telephone Gala. So he let the phone ring only once, then hung up, knowing she would not have time to answer. When he went back to the apartment next morning, he found her packing her suitcases. They had a terrific fight, which James watched in awe. At the end of it Dalí, with a meaningful look at James, told him to give Gala the beautiful jewel he had in his pocket, and James handed over an exquisite example of Art Nouveau. Gala stopped packing.

Another of James's friends recalled that James told endless tales about his and Dalí's fantastic escapades. If they were less close after the war, part of the problem was that James had supported Dalí from the end of 1937 for a year and felt he had not been properly recompensed. James later claimed that he had engaged his New York lawyer to draw up a legal agreement for that year, by which he gave Dalí a monthly stipend in exchange for all the paintings and drawings he finished during that time. James said his terms were generous: double the largest sum Dalí had ever received from all his dealers combined for the same number of pictures. James later claimed that Dalí painted thirty-two pictures that year, then dragged his feet and would not ship them to James in New York, and finally brought him only two at the beginning of the Second World War. The rest, James believed, were stored in Dalí's Paris apartment and were on their way to Germany in a final shipment of 'loot' a day after the actual liberation of Paris. James engaged the services of Gaston Bergery, who immediately recovered two more, but the rest were never found and were presumed stolen. One of those that James did recover, *Swans Reflecting Elephants*, had bullet-hole damage, the result of a pitched battle that raged when the train reached the German lines. James had it repaired so that the damage was virtually undetectable. He thought its scars added a touch of historical interest.

Dalí's *Aphrodisiac Dinner Jacket* was among the curiosities on view at an exhibition of Surrealist objects in Paris in the early summer of 1936. He and Gala were in New York that autumn for yet another one-man show at the Julien Levy Gallery, as well as the opening of the Museum of Modern Art's learned exhibition on Surrealism, Dada, and its fantastical precursors. The new and popular magazine, *Time*, published a lengthy article about the exhibition, choosing to place Dalí's photograph by Man Ray on its cover. Dalí had the edge because, *Time* explained, 'Surrealism would never have attracted its present attention in the US were it not for a handsome 32-year-old Catalan with a soft voice and a clipped cinemactor's moustache'. Dalí, disappointed by the magazine's deceptively small format, was unimpressed, but for those

Surrealists who wished to dissociate themselves from his popular allure, there were some embarrassing compromises to be made. To salve the collective conscience, Dalí was billed as a 'special adviser' to yet another international exhibition, this time at the Beaux-Arts Gallery in Paris in January 1938. As usual, Dalí stole the show with a preposterous taxicab crawling with 300 snails inside which it rained. The Surrealists were being invited everywhere; to Gloucester, London, Amsterdam, Pittsburgh and Hartford, and Dalí was being shown at them all. Annual one-man shows at Julien Levy's and at Renou et Colle's elegant gallery in the fashionable Faubourg Saint-Honoré were sandwiched between trips to Italy, substituting for Port Lligat during the Civil War, and a move to a larger and more elegant new apartment on the rue de l'Université. When the *Minotaure*, the slickest and most handsome of the avant-garde art reviews, was launched by the Paris publisher Albert Skira, financed in part by Edward James, Dalí was actively involved as artist and writer.

That he was at least as much of a theoretician as an artist can be gathered from these and other articles, which expound on his admiration for the Pre-Raphaelites, his reverence for the genius of Gaudí, his championship of that much-derided movement, Art Nouveau and, in particular, the architecture of Hector Guimard (who designed the entrances to the Paris Métro). In defence of Art Nouveau Dalí showed his willingness to flout conventional opinion and cling tenaciously to the evidence of his own eyes, championing what he felt to be enduring values.

No collective effort has succeeded in creating so pure and disturbing a dream-world as these *art nouveau* buildings which, on the fringe of architecture, constitute in themselves ... desires made concrete, in which the cruellest and most violent automatism painfully betrays a hatred of reality and a need for refuge in an ideal world. ... Here is something we can still love ... something worth opposing to the whole history of art.

Dalí's indefatigable travelling, painting, lecturing, writing and exhibiting appears to have left him sizeable chunks of leisure time, during which he was photographed with Beaton and Man Ray, or at a supper given in Monte Carlo by the Prince and Princesse de Faucigny-Lucinge with Alexandra Danilova on his right and Coco Chanel on his left. In those days he and Gala loved to dine in the very best restaurants on jugged hare, *canard à l'orange*, duck liver with raisins, garlic mushrooms and the very best Bordeaux wines. Meantime, on the pressing issue of the next world war, Gala kept a step ahead by reading the cards.

If Dalí believed that he had still not taken New York by storm, his opportunity to remedy that omission came about in the spring of 1939 in a most unexpected way. Dalí and Gala were there in connection with his latest one-man show, staying at the St Moritz – they had not yet gravitated to the St Regis – and anxious to dream up yet another publicity stunt. It was Julien Levy's idea that Dalí design some shop windows, and when Bonwit Teller of Fifth Avenue expressed an interest, and Dalí was shown their extensive workshops, he became so excited by the possibilities that he almost forgot to name his fee, according to Levy. (He was paid $1,000.) Dalí was given two windows and it was agreed that they would go on view the day his exhibition opened. The central feature of the window he called 'Day' was a bathtub lined with black astrakhan and filled with water, beside which stood an old-fashioned mannequin discovered in one of the store's storage rooms. She was decorated only with red hair and green feathers. In the window he called 'Night' another disreputable-looking mannequin was asleep on a black satin bed, the canopy of which was composed of a buffalo's head with a bloody pigeon in its mouth. She lay on a pillow of apparently live coals. Dalí and Gala worked all night on the windows, which were considerably more intricate than described above, then went to their hotel to sleep for several hours. By the time they returned at about 5 o'clock to judge the effect from the Fifth Avenue side, several complaints had been received that the windows were hideous and obscene. The management hastily removed the bed and replaced the horrible-looking mannequins with some inoffensive ones. Dalí stared at the results in outrage. Gala, recognizing the danger signals, suggested he go and talk to them. She urged him to be reasonable.

According to Dalí, she then left. He went inside to deliver a formal protest in French or Spanish – what language he used is not clear. Either restore his work or take his name off the window, he demanded. Bonwit Teller refused to do either. As Dalí tells it, he backed off politely. One newspaper claimed he was overheard muttering that he would destroy the whole display. No one seems to have accompanied him as he calmly made his way straight for the 'Day' window, stepped inside and took on the most obvious object, the bathtub.

'With the place inundated, they would certainly be forced to lower the shade and take everything out,' he reasoned. He took hold with both hands and attempted to lift it. It was much heavier than he expected. Before he could turn it on its side, it slipped against the window. With a supreme effort he succeeded in turning it over and it crashed against the plate glass, scattering thousands of splinters over the sidewalk. Miraculously, no one was hurt, not even Dalí. He coolly jumped out and had barely made his escape when an enormous piece of glass that had been hanging by a thread crashed to the ground behind him.

Julien Levy, who said he showed up two minutes after the accident, found Gala with Dalí, frantic and ready to scratch everyone's eyes out. Dalí had been arrested by a detective who happened to be passing on a bus and saw the whole drama. Dalí was whisked off to a police station and booked on a charge of malicious mischief, later reduced to disorderly conduct, sentence suspended, and the exhibition opening went off as planned. As the *New York Times* phrased it, 'Dalí surged into the south window and carved his name on the police blotter.' He also enlivened several front pages. 'Through the Window to Fame' was one of the comments. There were queues of people fighting their way into Julien Levy's. After two weeks, twenty-one of his works had been sold to private collectors for more than $25,000. *Life* magazine recorded that Dalí, at the age of not quite thirty-five, was now one of the richest young artists in the world.

His action, which was passed off as the understandable reaction of a hypersensitive artist defending his work, was an example of Dalí's quick-witted ability to twist events to his own advantage. That he had, with obvious calculation, set out to inflict major damage on an expensive exhibit and might have endangered several people's lives in the resulting chaos, appeared not to have occurred to anyone. He had gone after the headlines in that most hospitable of all cities for self-promoters, and escaped unscathed, something that seemed to strike everyone as particularly clever. As a result he was instantly famous. He had rightly observed on his first visit that New Yorkers would count it a lack of imagination on their parts if they could not fathom the meaning of works with such titles as *Debris of an Automobile Giving Birth to a Blind Horse Biting a Telephone*. Those who visited Dalí's exhibition at Levy's gallery and asked for enlightenment would then be answered with such sly comments as, 'the telephone represents the blackened bones of my father passing between the male and female figures in Millet's *Angelus*'. Dalí would then nudge Levy so he would not miss the way the questioner's expression of thanks slowly changed to bafflement as he or she left the room.

The exhibition, Robert M. Coates observed in the *New Yorker*, was as imaginative, erratic, and baffling as anything Dalí had shown. Among the items on view was a charming nineteenth-century bust of a lady 'which Dalí has apparently picked up somewhere and thoughtfully decorated with tin spoons, a broken egg, and the jawbones of an animal'. In short, the reviewer considered this side of his art great fun, 'a kind of slapstick commentary on life in general and particularly on aesthetic tradition'. He thought that many of Dalí's canvases could and should be taken in the same light. '... Dalí's work is neither so portentous nor so outrageous as it has been made out to be. It is simply a form of social satire, more oblique than most and frequently cluttered and obscure in manner, but presented with ... suavity and skill.' It

was only a matter of time before the humorists went to work on the designs for something called *Dalí's Dream of Venus*, an extravaganza that Dalí, with the assistance of Levy, James, and others, produced for the 1939 World's Fair in New York. Observing that the plans called for the reconstruction of the foetal experience and that mermaids in a tank of water would be swimming through rubber trees, past long tendrils hung with typewriters, a writer observed, 'I don't recall anything like it, and my grandmother says she doesn't either. We may be a conventional family of course, but I seriously question whether this sort of thing goes on in even the wildest womb.' As for Dalí's sketches in the 1 June issue of *Vogue*, the same writer noted that they included the figure of a girl skipping that frankly gave him the willies.

> This creature's head is a brownish bulb with long roots standing up from it – a clever conceit for a younger person, I suppose, except that the roots, located as shown, could only produce flowers growing *down* into the lady's neck instead of springing *up*.... Moreover, the rope-skipper has a terribly mature figure for a girl still in the root stage.

Such comments were well deserved for an exhibit that, in its early stages, was to have been called Dalí's *Bottoms of the Sea*. However, as it happened, there was nothing punnish about one of the Dalínian motifs at issue, that of the girl in a long white dress with a skipping-rope. Like many other images in Dalí's *oeuvre*, this one is repeatedly found in a group of paintings of similar dates, 1934–6. In *Nostalgic Echo* (1935), one sees the girl, her hair flying, running in front of a bell tower which duplicates her silhouette thanks to the *trompe l'oeil* skill of the artist. In *Suburbs of a Paranoiac-Critical Town: Afternoon on the Outskirts of European History* (1936), she appears again as a central motif; again in *Morphological Echo* (1934–6), and once more in *Bread on the Head of the Prodigal Son* (1936).

She appears to greatest effect in a triptych of the same period once owned by Edward James. Here is the same sweetly nostalgic figure, leaning into the momentum of her solitary, wind-whipped flight across a deserted plain, with only a few silhouettes visible on the distant horizon, a walled city and the echoing bell tower. Her shadow is enormously elongated since, in Dalí's inner world, it is always late afternoon. There is something dreamlike about her self-absorption as she floats across that phantasmal scene with its deep, hallucinatory perspective. And indeed she is a mirage, the shadow of his dead cousin Carolineta. As if in anguished atonement, Dalí painted her over and over again either skipping or, in two similar studies, as an actual ghost in white drifting towards a tree that has unaccountably sprouted on the middle of the beach and no doubt is a direct reference to the cedars in *Island of the*

Dead by Böcklin. Her symbolic significance for him is stated most clearly in *Bread on the Head of the Prodigal Son,* another version of *Puzzle of Autumn,* one which takes the same theme a step further. The figure of the prodigal son, crawling on his hands and knees, is seen in the centre. On one side of him several impassive male figures watch his progress, while behind him are two rocklike shapes that recall Millet's *Angelus.* There is a mother and child, and also a hint of vague guilty couplings of figures in shadow. Then, on a platform in the sunlight, by herself and unconnected with the painful symbolism, is the figure of Carolineta. She seemed associated in his mind not only with the dreamlike innocence of childhood but with all that was poetic and forever vanished.

That he was in an elegiac mood is evident from *Suburbs of a Paranoiac-Critical Town.* There is the beckoning central figure of Gala proffering grapes. To her left one sees the classical, columned façade of a building that recalls de Chirico; to her right, a narrow street with distant perspectives. There are the huddled figures of Angelus, an open drawer, a key, other objects, the whole scene spread out against a threatening sky. Whatever was violent, anguished, and tormented about his canvases was gone forever. In its place was a group of idyllic land and seascapes, which make one suddenly aware of the delicate intensity of feeling, romanticism even, concealed behind his front of ironic detachment. In a world that was on the brink of disaster, what Dalí wanted to remember was unspoiled, beautiful, haunted, and silent, perhaps the purest expression of his landscape of fantasy that he would ever evoke.

The image was disappearing. That actually was the title (*The Image Disappears*) of one of the paintings he showed at Julien Levy's in 1939, the profile of a girl reading a letter in the manner of a Vermeer, which, with the blink of an eye, turned into a trick portrait of a bearded man. On all kinds of levels one's very existence was being threatened and the ephemerality of the real was now too obvious to belabour. How much of this shift in style was calculated, how much a subterranean response to yet another period of upheaval in his not-very-stable inner world, it is impossible to say. Dalí was launched on another adventure, the systematic exploration of interlocking and shifting images, one that had intrigued him for years. His essay, *The Stinking Ass,* written in 1932, contained a long description of the ways in which the outward appearance of things could be challenged and discredited by deliberately turning that image into something else. That second image would then replace the dominant one, turning the viewer's world inside out, like Alice's looking-glass, and forcing the viewer to question exactly what most people took for granted: the world as it seemed. The goal of this systematic attempt at disorientation, he wrote, was to transform the modern

sensibility, sending it off on the proper path, that is to say in search of an ideal.

Dalí had already put these quasi-philosophical speculations to work on a self portrait, *The Invisible Man*, for which he made numerous studies in about 1929 and which he finally left unfinished. A seated male stretches the length of the canvas, completely constructed from a landscape of ruins and arcaded buildings, his hair a miragelike cloud, his shoulder and upper arm the bent nude torso of a woman. Despite the elaborate care with which *The Invisible Man* has been constructed, the deceptive forms do not quite knit themselves together; but as a statement of the hidden thought behind the outward façade of bits and pieces of broken rubble, it was a clear comment on Dalí's self-image. Exactly how Dalí came upon the brilliant idea for his second self-portrait, as *The Metamorphosis of Narcissus* certainly is, is not known. The pose for a related image in *Puzzle of Autumn* is not the same and, in contrast to so many of Dalí's paintings, it was never used again.

If, as Kenneth Clark has written, 'all artists have an obsessive central experience round which their work takes shape', then what was as the waves to Turner, the sky to Constable, or the sun to Van Gogh was surely, in Dalí's case, the omnipresent theme of the sea or, more precisely, reflection. Just as Narcissus drowned himself while amorously attempting to embrace his own image, so Dalí, who had constructed a grandiose self to compensate for the freak he secretly believed himself to be, was expressing some deep truths about his state of mind in this perfectly realized, extraordinary painting. The bent shape of Narcissus, half-immersed in his pool of endless self-absorption, has, by a transmutation of genius, become the limestone sculpture of a hand. However, since everything about this particular work can be taken literally, one can place some emphasis on the fact that Dalí was known to be right-handed and the hand shown here is the right. Between thumb and first finger this mirror-image holds something delicate, infinitely fragile and beautiful: an egg, through which has metamorphosed a narcissus flower.

The importance Dalí placed on this painting can be deduced from the fact that he wrote an elaborate poem to accompany it. In it he quotes a Port Lligat fisherman: 'What's wrong with that chap, glaring at himself all day long in his looking glass?' Another answers, 'If you really want to know, he has a bulb in his head.' Dalí explained that this Catalan phrase meant an illness, a complex. He concluded, 'If a man has a bulb in his head, it might break into flower at any moment, Narcissus!'

In other words, not only had Dalí become two distinctly different people — he was perfectly aware of the inner fragmentation. The two sides of his personality are not twinned here, as one might expect from a man who liked to discuss himself and his brother as Castor and Pollux, two peas in a pod.

The man lost in helpless exploration of the waters of his subconscious, still bent under the weight of his inner load, was nevertheless flesh and blood, whereas that other half, the one he would refer to in the third person, that poor specimen carved out of rock, was the one that held the miraculous egg. 'I had lost the image of my being that had been stolen from me,' he said. The spurious self that had replaced it had, nevertheless, performed the alchemical miracle of turning *merde* into gold. His images had made him famous, become his stock in trade, his moneymakers. His worthwhileness lay in the extent to which he had exploited them, and the process of reinventing himself, he believed, emancipated him from his parents' expectations to compensate them for their loss and become the first Salvador. It was the only way he knew to obliterate the 'rival false king', as he called him. But even if he had wanted to rid himself of his obsessions, to do so would put him at the risk of losing something he valued even more: his *raison d'être* as a creator. No artist ever saw his imprisonment more clearly or painted it with more power, insight and poignance. No wonder he believed that '... nothing is more important to Me than Me'. Otherwise, he continued, 'I cease to be ...'

The Thinking Machine

'I'm in a constant interrogation: where does the deep
and philosophically valid Dalí begin, and where does
the looney and preposterous Dalí end?'

SALVADOR DALÍ

As war approached, Dalí and Gala went off to the Grand Hotel in Font Romeu
in the Pyrenees, close to the Spanish frontier, for a short vacation. That night
Gala read the cards and predicted the exact date of the declaration of war.
They still had a little time to make plans for the future. That they intended
to sail to America is clear, since Caresse Crosby wrote in May 1940 to ask
for further details of their plans to spend that summer in New York and
inviting them to her country place in Bowling Green, Virginia. She sent her
letter of 14 May to 131 boulevard de la Plage, Arcachon, the spot Dalí and
Gala had chosen, he wrote, because it was close to the Spanish border and
their exit route via Lisbon, and not far from Bordeaux, where the food was
marvellous.

By chance the villa they rented was next door to one occupied by the young
Surrealist painter Léonor Fini, who had also left Paris as war was declared.
She recalled, 'Gala was very practical-minded. She was delighted to see me
because I had a large car and she saw this as a way of getting to the two
restaurants in Bordeaux that they loved, the Château Trompette and the
Chapon Fin.' Not only did they eat very expensively, but in those days Dalí
drank a great quantity of Bordeaux and anything else he could get his
hands on, whisky, cognac, champagne.... Léonor was as enchanted by his
personality as was almost everyone else. He was so adorable, intelligent and
diverting. His point of view was always original and one could forgive him
his rather blatant interest in life's luxuries as well as his snobbish preference
for the titled – his ability to choose his friends on the basis of their aristocratic
blood being quite marked, even in those days. Although they never discussed
politics, Dalí was absolutely terrified of Hitler, frightened to death, Léonor
said. He was building a bomb shelter in his garden and wanted to buy a suit
of armour. It was passed off with a laugh but she did not think he was really
joking. The truth was that Dalí was extremely timid, even cowardly. If Gala

was in Paris and she invited Dalí to dinner alone, he would insist on being walked back to his own front door even though it was only a few yards away. When Gala went to the station, Léonor would have to accompany them. Dalí would stand on the platform as the train pulled out, and as Gala waved goodbye, he looked as bereft as a baby, absolutely abandoned.

Léonor Fini knew Dalí disapproved of women painting – he was a true Spaniard in that respect – although he was too polite to say so in her presence. From time to time Gala would come by while she was working, asking, 'How do you do this? How do you do that?' Gala was completely devoted to him and did everything for him.

She had a very well-modelled face. You couldn't call her beautiful, but she knew how to dress, wearing just the right jewels, and she had all the practical virtues that he lacked. What I didn't like about either of them was their lack of feeling where animals were concerned. While we were at Arcachon I lost a grey cat and I happened to tell Gala about it. She had seen a grey cat in someone else's house, so she calmly picked it up, put it in her skirts and brought it to me. 'Here's your cat,' she said. Meanwhile, my own cat had come home. Gala had a pet rabbit for a long time. One day she killed it, cooked it and ate it. They both liked to say they had tortured animals, whether it were true, or to shock me, because I loved them, I don't know. Gala was very cold. For instance, if you were to say that someone had a good heart, Gala would answer, 'Then he must be made to eat it.'

One day in July 1940 the Dalís were visited by the Paris interior decorator with whom Dali had frequently collaborated, Jean-Michel Frank. He was highly gifted, successful and, it seemed, ill-starred. His mother had gone insane; his two older brothers had died in the First World War and his despairing father had jumped out of a window to his death. Frank's life was to end in New York in a similar manner. Perhaps Frank, who was Jewish, knew the truth about Gala's background. At any rate he had come to tell them they were fools to stay. He was on his way out of France because, 'the Germans are going to kill us all'. Dalí and Gala left that very afternoon, Léonor Fini said, in the clothes they were wearing. Their furniture went later. It was an example of how easily one could frighten Dalí. 'There was nothing to panic about,' she said.

Gala went directly to Lisbon to tackle the painstaking task of making arrangements for their departure to America. Dalí went to Catalonia. He had sworn to stay clear of the Civil War and had succeeded. The fighting was over; Franco was in power. Dalí reached Cadaqués at two in the morning,

after crossing 'ten ruined villages, the ghostly walls of which stood out in the
moonlight like drawings of "Goya's horrors", and my heart tightened at
going through this maze of the miseries of war'. He knocked at his father's
door and it seemed an age before there was an answering call. He was
welcomed with kisses and embraces. His father, still a formidable figure
although now in his seventies, sat opposite him, his eyes never leaving his
face. They showed him where the balcony had been knocked off by a bomb,
the blackened place on the tiled floor of the dining-room where the anarchists
had built fires to cook their meals. Once in his own room, he was astonished
to find that everything was the same: the same stain on the curtain, a rusty
key, the same ivory rabbit on his dresser and a few old buttons in the back
of a drawer, where they had been since his childhood. All the killing had
been for nothing. His sister's sufferings – she had been tortured by the CIM,
a military intelligence committee, and almost lost her mind – had benefited
none of her tormentors. His family was back again under the same roof.

Next day he went to Port Lligat. The house was completely destroyed, the
shutters askew, the doors off their hinges. Of the furnishings, the beds, tables,
chairs, china, silverware, there was no trace.

Everywhere, on the walls, graffiti . . . recorded each passage of rival armed
troops. . . . I could follow the progression of the war as on a general-staff
map. Anarchists pushed out by Communists, return of the Trotskyists, the
Separatists, the Republicans, and finally the Francoites with their 'Arriba
España!' covering a whole panel.

He talked to the fishermen of Port Lligat. The period when the anarchists
ruled was 'worse than anything: stealing, murdering. . . . Now things are once
more the way they've always been: you go home, and you're your own
master!'

Sir Henry Channon, the British socialite and MP otherwise known as 'Chips',
noted in his diary for 17 February 1938 that he had gone from Paris to Italy
by train in the company of a 'dark, sinister, Bloomsbury-looking man' who
had turned out to be Salvador Dalí. They had an amusing conversation over
dinner and Dalí told him that the anarchists had burned his house. Chips
Channon noted that 'he seemed to be pro-Franco'.

In *Homage to Catalonia* George Orwell noted that, when he arrived in
Barcelona late in 1936, the anarchists were in power and the streets full, it
seemed, of workers and no one else. On the train going into Spain a French
travelling salesman had urged him to take off his collar and tie or they would
be torn off him, the man said, once he arrived. However, when Orwell left
some six months later, the bourgeoisie was back in power and the overalls

had disappeared from the streets. It was a revealing lesson. In those days, when the temporary ascendancy of the Stalinists meant that every Trotskyist had to go into hiding, with the violent settlings of old scores taking place on every street corner, the need to adopt a protective coloration was a fact of life. 'It was as though some huge evil intelligence was brooding over the town.... And it was queer how everyone expressed it in almost the same words: "The atmosphere of this place – it's horrible. Like being in a lunatic asylum," ' Orwell wrote.

In a madhouse, to feign madness is the only sane recourse, and Dalí was no fool. It is clear from the detailed way he described his return to Cadaqués and his sentimental journey from room to room, the embraces and the tears, that his reconciliation with his family was now fully established. The discovery of the old buttons at the back of the drawer was not just a symbol, as he described it, of life's tenacious hold on itself, but the tenacity of the past's hold on him. He was not only planted in that ground but it would never have occurred to him to uproot himself. Like any Catalan he would know that, once the firing stopped, one simply adopted a protective coloration, gathered one's forces and waited for the next wave. Here, however, was the rub, since if he proposed to live in Spain he would have to be pro-Franco, or make a convincing display of it, and therefore aligned with everything he once detested: the entrenched power structure, the aristocrats, the Army and the Church. If Dalí had been a Communist in his youth, he had long since refused to follow the Surrealists in that direction. He was, however, to judge from his statements, a lifelong anarchist, and therefore pro-worker. How could he reconcile this with his support of a dictator? First of all he needed to be reassured, and the Port Lligat fishermen seemed to offer that assurance. Their lives were much more secure now that a strong man was in power. Second, there was a kind of precedent for his point of view. One leader of a conservative Catalan nationalist faction, Prat de la Riba, argued in the 1920s that Catalanism prospered under dictators since only they had the power to halt class struggle and enable their culture to develop peacefully. Finally, one has to remember that he and his half-Jewish wife were fleeing in terror from what looked like a certain Nazi victory. Their only hope must have seemed to lie, in the short and long term, in cultivating Franco's good graces. Dalí's defence of Franco always had an uneasy ring and from then on he tried to avoid being tackled in argument by saying that men of genius, artists, ought to be above politics. But Dalí had reckoned without the particular tenacity of the Catalan nationalist cause, not to mention his own special position as a figurehead. By seeming to sanction a detested strong man he was managing to overlook the fact that Franco was no blessing for Catalonia, since the dictator banned its languages, literature and culture. Those old friends who

had fought and bled in vain while he slept in comfortable beds would never forgive him.

In common with his Surrealist colleagues, Max Ernst was violently anti-Franco and added Dalí's politics to his own list of reasons for detesting him. Jimmy Ernst recalled that he and his father came face to face with Dalí on the sidewalk in New York during the Second World War. Dalí was offering his hand to his former friend in a gesture of reconciliation. He stood there, his hand still stretched out, 'as Max, hissing *"ce chien couchant"*, pulled me with him to the opposite sidewalk'.

Various rumours circulated. One was that the Dalís had been arrested in Spain, which was contradicted by another rumour, in a London magazine, that Dalí was on his way there to paint Franco's portrait. Others were that he had fled to Mexico and his latest works had been confiscated. In fact, the sixteen he painted in Arcachon had all been shipped safely to New York and were shown at Julien Levy's in April of the following year, at the Arts Club of Chicago, and elsewhere. Dalí was by then living at Caresse Crosby's Virginia mansion, Hampton Manor, where he painted half a dozen more canvases. The Dalís had landed in New York on 16 August 1940 for an exile that would last for eight years. He was wearing a sedate double-breasted pin-stripe suit and there were circles under his eyes. Gala Dalí was, as usual, impeccably elegant. Her burnished brown eyes, in an expressionless face, reminded one writer 'of those inedible nuts called buckeyes'.

The writer and famous diarist Anaïs Nin happened to be one of the guests at Hampton Manor the night the Dalís arrived. She met them for the first time at breakfast.

Both small in stature, they sat close together. Both were unremarkable in appearance, she all in moderate tones, a little faded, and he drawn with charcoal like a child's drawing of a Spaniard ... except for the incredible length of his moustache. They turned towards each other as if for protection, reassurance, not open, trusting or at ease.... Was Dalí truly mad? Was it a pose? ...

They wanted me to solve this riddle because I could speak Spanish, but they had not foreseen the organizational powers of Mrs Dalí. Before we were even conscious of it, the household was functioning for the well-being of Dalí. We were not allowed to enter the library because he was going to work there. Would ... [one of the guests] mind driving to Richmond and trying to find odds and ends which Dalí needed for his painting? Would I mind translating an article for him? Would Caresse invite *Life* magazine to come and visit?

So we each fulfilled our appointed tasks. Mrs Dalí never raised her voice, never seduced or charmed. Quietly she assumed we were all there to serve Dalí, the great, indisputable genius.

Dalí arose at 7.30 each morning, donning dark trousers, a red waistcoat and a black velvet jacket. He usually started painting at eight and took an hour or so off for lunch and a game of chess, which he played with Gala. He always lost. He then either painted or worked until midnight at his newest book, his autobiography. In the evenings a charming group might be found in the library bent to the task of furthering Dalí's monumental literary ambitions. Mrs Dalí, seated left, collated notes; Dalí, centre, hair tousled, stared fiercely at more pages; Mrs Crosby, on the floor at right, edited and typed. There *Life* magazine found them in the company of a tethered cow. Mrs Crosby, when questioned, said agreeably that it was not difficult to put a cow in the library. As for hoisting a piano into one of her trees, another of Dalí's magical ideas, she found it much easier to do than finding a fourth for bridge.

Dalí always painted with the help of a powerful electric light, even during the day, and rarely left the house except to have coffee on the steps. He did not venture into the long grass, because grasshoppers frightened him. He always had a radio going and pestered Mrs Crosby with questions about a radio personality named Wollowa Beckstein. It eventually transpired that he was referring to Bulova Watch Time.

When Anaïs Nin returned, some months later, she found her hostess temporarily absent and the atmosphere distinctly sour. The Dalís insisted on the use of French at mealtimes, which made the other guests restive, but the main problem was that Mrs Dalí was beginning to get on everyone's nerves with her imperious demands. Some were becoming sarcastic and others were balking at the very name of Dalí. Anaïs Nin rather liked him. 'He was full of inventions and wild fantasies ... Dalí ... lost his shyness when I came. He showed me his work.'

Dalí and Gala made occasional forays into the hinterland and were the principal stars at a tea given by the Arts Club of Chicago in connection with an exhibition of his paintings. Everyone was assembled by four p.m., but the principal guests did not arrive until five, by which time, according to the *Chicago Daily News*, the group was in a dither. The reporter continued,

Except for his moustache waxed to pinpoints and his narrow sideburns that point in toward his face instead of straight down, the great Surrealist did not look as different as many expected him to. He is of medium height, very straight and very dark, and yesterday he wore a conventional navy

blue pin-striped suite, white shirt and deep red tie.... Mrs Dalí is a Russian, also dark complexioned. She wore a dress of fine black net yesterday that caused something of a sensation because of its long sleeves that were tight and sheer and its back which was likewise from the waist up.

Mrs Dalí usually translated for her husband and interpreted his paintings. She was once caught out, confessing, of a piano that was descending from a cliff by parachute, that it did not really mean anything. 'Just imaginative!' On his first visit to New York some five or six years before, Dalí had gurgled a message about Surrealism that he wrote out for himself phonetically, beginning, 'Aye av ei horror uv joks/Surrealism is not ei jok/Surrealism is ei strangue poisun ...' Exactly when Dalí did begin to learn English is unclear, but he could follow it years before he would admit to understanding a word. One magazine noted in 1939 that, whenever the conversation turned to Dalí, his face lit up with a gleam of instant comprehension. Occasionally he was caught red-handed. At an exhibition in 1952, he explained that one of the paintings was not yet hung because,

'The sheep she is losing the anchor not like Old World shrimp boats.'
'Yes of course,' said the reporter, 'but when will it arrive?'
'It comes from Spain, like the all,' Dalí replied. 'Only a few touches, and she will be complete.'
'Oh, the picture is here but not finished?'
'I am working on it, sir,' Dalí responded in perfect English, 'and when it is completed you will be informed.'

It was a great game, of course. Dalí said that he had invented his English by rolling his r's as in Spanish, exaggerating his French pronunciation, and throwing in a few Catalan vowels. Thus, instead of saying 'butterfly', he would pronounce 'booterrrrrflaaaaaaaeeeeee'. Usually no American or English audience could understand a word, but if they did the result was deafening applause. The act was to struggle along gamely, then lapse into rapid French, shrug, and apologize. He would entwine his legs once more and arch his eyebrows as a signal for Gala to take over.

Caresse Crosby, who had married a handsome Westerner, Selbert Young, in 1937, was in the middle of divorce proceedings by the time the Dalís came to stay in 1940. One night Young, who was known for his spectacular drinking bouts, arrived on the scene. One story was that he 'saddled a horse and rode wildly around the house in which he used to live, firing a pistol ... in the air'. Anaïs Nin was told that he entered the house, turned on all the lights and opened all the doors.

Alas, there was no orgy! He found Mr and Mrs Dalí asleep in one room, Caresse asleep in another.... He ordered everyone to leave, but as no one paid any attention to him, he rushed down the stairs, shouting that he would destroy all of Dalí's paintings. At this the Dalís became alarmed, they dressed, ran downstairs, packed all the paintings, and drove away.

Dalí's autobiography, *The Secret Life of Salvador Dalí*, was finished at Hampton Manor and published in the autumn of 1942 after being translated from the French. In it there are few references to his brother, the first Salvador; it is evident that, when Dalí wrote the book at the age of thirty-seven, the significance of his early upbringing was not apparent to him. There are, of course, endless references to his budding genius. There is no question that the book is one of the most curious examples of the deliberate construction of a false persona ever written. It bears more than a passing resemblance to the subject of A. J. A. Symons' famous biography, Baron Corvo, whose ambition to become a prince of the church was thwarted in real life. Corvo's bitter frustration led him to write his novel, *Hadrian the Seventh*, in which a scorned and spurned priest shows the world what stuff he is made of by being elected Pope. One finds, in the writings of both Corvo and Dalí, the same pedantic use of overblown literary expressions, the same tendency to linger over irrelevant detail, the same arbitrary blurring of outline between fantasy and the real world. There is a similar tiresome compulsion to shock at all costs, the same braggadocio, the same insistence on obfuscatory explanations, the same refusal to conceive of themselves in any terms short of genius.

As reading matter, Dalí's *Secret Life* was a very deceptive book since it seemed to confirm the world's image of Dalí as a monomaniac. One reader called the book 'perhaps the greatest feat of willed obscurantism of the times'. Clifton Fadiman wrote, 'Dalí speaks of his megalomania somewhat as if it were an interesting special talent, like ambidexterity or exceptional vision. Indeed, he takes it so for granted that one might almost say he is modest about it.' What was particularly grating was 'the frank admission ... that ... he determined to capitalize on the stupidity of people and, in effect, make them pay for his living', the *New York Times* critic wrote. Many critics threw up their hands, metaphorically speaking, contenting themselves with a summary of the more outrageous statements, i.e. the youthful dreamer of dreams bites a sick bat, kisses a dead horse, goes into manhood hoping that he will one day eat a roasted but still living turkey, and covers himself with goat dung so that he may give off the true and noble odour of the ram. The temptation to comment was too much to resist for one of the great humorists of the age, who promptly published an essay titled *The Secret Life of James Thurber*. He measured his own childhood against that of Dalí and found it

hopelessly wanting. Part of the problem was that Dalí had been brought up in a land of magic and mystery, whereas he was 'brought up in Ohio, a region steeped in the tradition of Coxey's Army, the Anti-Saloon League, and William Howard Taft'.

Thurber could not help wondering why Dalí thought he was the only kid who lived somewhere between fantasy and reality, as if this distinguished him from

Harry Spencer, Charlie Doakes, I. Feinberg, J. J. McNaboe, Willie Faulkner, Herbie Hoover, and me. What Salvie had that the rest of us kids didn't was the perfect scenery, characters, and costumes for his desperate little rebellion against the clean, the conventional, and the comfortable. He put perfume in his hair (which would have cost him his life in, say, Bayonne, N. J., or Youngstown, Ohio), he owned a lizard with two tails, he wore silver buttons on his shoes, and he knew, or imagined he knew, little girls named Galuchka and Dullita. Thus he was born half-way along the road to paranoia, ... the melting Oz of his oblations, the capital, to put it so that you can see what I am trying to say, of his heart's desire. Or so, anyway, it must seem to a native of Columbus, Ohio, who, as a youngster, bought his twelve-dollar suits at the F. & R. Lazarus Co., had his hair washed out with Ivory Soap, owned a bull terrier with only one tail, and played ... with little girls named Irma and Betty and Ruby.

Most critics took the lurid writing style as the natural expressive medium of this particular personality. Since it was consistent with everything else Dalí had published as a young man they were fully justified. There had, however, to be some explanation for the reader's feeling that the writing was 'stillborn ... without emotion, and really without personality'. There was: it was deliberately concocted. The most cursory comparison with his month-long diary of 1920 makes the false tone of *The Secret Life* glaringly evident. When the early diary was privately printed by the Reynolds Morse Foundation in 1962, a note in the front of the book informed the reader that the artist termed the publication 'a disaster – a calamity', and asked that the entire edition be suppressed and destroyed. Reynolds Morse noted that permission had originally been given but was withdrawn by the artist once the booklet was in print. No doubt Dalí realized that the early diary gave a very different impression: it showed a human being.

All this to one side, what is remarkable about Dalí's *Secret Life* is that, given its single-minded goal, it is nevertheless a revealing book. It might be no more than an occasional adjective, adverb or phrase, but Dalí does indeed often disclose the state of mind hidden beneath the layers of hyperbole. He was

making a veiled but unmistakable allusion to genuine inner concerns while avoiding large areas: incidents and aspects of relationships that were too delicate or too painful to deal with, or would have aroused the wrath of those close to him. For all his seemingly compulsive boasting and self-advertisement Dalí, for instance, diplomatically avoided all mention of his father's remarriage or the eventual fate of his stepmother. He never discussed the cause of his mother's death. He never talked about what was obviously an extremely close relationship with his sister. He did not, in this book, describe the actual incident that caused the break with his father, much less the reconciliation itself, a particularly puzzling omission. As for his marriage, if there were any tensions, one cannot find the slightest hint. Gala was perfection; she made his life; she was his all. He says this over and over again with such clamour one wonders why he protested so much. There is a puzzlingly abstract quality to the love so vaunted, as there is a distinct coldness at the very core of the book, a kind of chilly detachment, as if he were observing himself observing himself in an infinity of mirrors. Just occasionally, one critic wrote, one caught 'a glimpse of the terror of his early life, of the fear and timidity, the loneliness and guilt, that all but consumed him'.

Having, so to speak, dispensed with his self-analysis, Dalí tore into his first and only novel, *Hidden Faces*, which was written at top speed in Franconia, New Hampshire, and which concerned a group of elegant, languorous, and decadent French aristocrats confronted by the Second World War. Bettina Bergery believed that the heroine, Solange de Cléda, was a mixture of Roussy Sert and herself; the hero, the Comte de Grandsailles, was really the aristocrat who has been called the Diaghilev of costume balls, Comte Étienne de Beaumont, and that Gala came into the plot in a minor way as a young student of the Latin Quarter. Reviewers could not agree whether the ferociously complicated plot and labyrinthine style revealed, or showed the absence of, innate novelistic gifts. They were, however, generally agreed that, as Edmund Wilson observed, the properties, figures, and posturing of the later and gamier phases of French romantic writing had been disinterred in a modern setting, making the whole seem to verge on parody.

Wilson wrote, 'On Dalí's side, one finds ... none of the qualities that are good in his pictures, which are certainly not deficient in craftsmanship: there is no clarity, no sharp-focused vividness, no delicacy or firmness of line ... Dalí's literary models have been bad ones.' Wilson seemed to share Marcel Jean's view of Dalí's writing style: 'a burlesque-flavoured sauce'.

If Dalí was disconcerted by these negative notices, he was moving too fast to be put off his stride. He was hard at work on the book, sets, and costumes for his ballet *Labyrinth*, a retelling of the Theseus and Ariadne legend, performed by the Ballet Russe de Monte Carlo at the Metropolitan Opera House

in New York to the choreography of Léonide Massine. It was as successful as his earlier ballet had been for the Ballet Russe, *Bacchanale* (1939), based on the Venusberg scene in Richard Wagner's *Tannhäuser*. He also created *Mad Tristan*, a less successful venture in which the hero imagines himself devoured by Isolde's Chimera – its creator contemplated calling this ballet *The Praying Mantis* – which received mixed notices when it was performed in New York by the Ballet International in 1944. It was, one critic kindly observed, 'a masquerade that only a genius could invent'.

Whenever Dalí was in New York through the war and afterwards he took refuge in the St Regis where he set himself up in the extremely lucrative business of painting the portraits of society ladies. One source thought his fees were as high as $25,000, and while this seems to have been an exaggeration there is no doubt that he was well paid. It was, after all, a genre that he had already mastered from the long and patient study of his sister, father, and friends like Luis Buñuel, and in his fanciful portrait of Marie Laure de Noailles (1932) he seemed to have found exactly the right flattering formula. In the early 1940s he had a similar success with his portraits of Lady Mountbatten, Mrs Harrison Williams, once called the best-dressed woman in the world, whom he portrayed barefoot wearing a ragged Grecian tunic, Mrs Charles Swift of Chicago, the former Polish opera prima donna Claire Dux, Mrs Dorothy Spreckles, heir to a San Francisco sugar fortune, and Princess Gourielli, otherwise known as Helena Rubinstein. He portrayed that redoubtable lady as if hewn out of a rocky cliff. It was a view of herself, the Princess told a magazine, with which she felt entirely comfortable.

Since Dalí's reaction to his sitters' personalities was unpredictable and his symbolism over their heads, it was astonishing that he managed to please so many of them. He was, of course, capable on occasion of parodying his subjects but he did it with such a deft brush – as in the case of the art collector Chester Dale, depicted showing a solemn and unmistakable resemblance to his poodle – that one gathers the barb went unnoticed. Even when his painting disappointed the sitter's expectations, as in the case of another subject, who originally thought that Dalí made him look much too fat and his face much too smooth, 'like a baby's behind', time made him revise his judgement. Now in his eighties, he wishes he still looked that way. There were, however, at least two cases in which the sitter's disappointment was marked. Ann Woodward, socialite wife of the banker and race horse owner William Woodward, took one look at the finished result and turned her back on it. She later explained that she had wanted something suitable for her sons, William III, aged ten, and James, aged seven, and Dalí's version was definitely not it. Dalí was obliged to sue for payment and recovered $7,000.

Perhaps the most extraordinary incident, however, involved Marie-Thérèse

Nichols, French-born wife of William I. Nichols, former editor of *This Week Magazine*, the syndicated Sunday magazine with, at one time, a circulation of 15 million, making it the biggest in the world. William Nichols, now retired and living in Paris, recalled that he first saw Dalí's work in an art gallery on 57th Street in the middle or late 1940s. His eye was caught by one of the most charming paintings he had ever seen, a loaf of bread.

> Leonard Lyons [of The Lyons Den] was there and said to me, 'Bill, why don't you publish this piece of bread on the cover of your magazine?' Well, that was in the days when we put autumn foliage or football heroes on our covers and the very idea of using a painting was radical. We did, however, print it and it was the beginning of our friendship with Dalí. It may have had a formative effect on his career, since he'd always been with *Vogue* or *Vanity Fair* and this was his first mass audience. He acquired a kind of awe of me, since I sat at the controls of a great big magazine. For my part, I was trying to lift Sunday journalism out of the rut of sex sensation and bring in people of stature and quality.

Dalí and Gala, who had a studio in Carmel, California, in the early 1940s, would arrive in New York every year on Thanksgiving Day and a round of dinners and party invitations would follow. Mr and Mrs Nichols admired him and believed in his work, but, at the same time, thought him opportunistic and a terrible snob. 'He was always too elegant and polite, almost obsequious,' Mrs Nichols said. As for his relationship with his wife, it resembled, to a remarkable degree, that between the Duke and Duchess of Windsor. Mrs Nichols said, 'I have never seen a man so much in the thrall of a woman. In the middle of a dinner one would see him consulting notes on bits of paper that she had given him. Or he would turn to her and ask, 'What do I say? What do I say?' When they decided to commission Dalí to do her portrait – it would have to be a sketch, since they could not afford a painting – Gala did all the bargaining. 'She had a way of jabbing her finger at you. She said, "We will give you a special price", but she wanted cash on the line.'

The portrait took about three years of spasmodic sittings. When it eventually arrived, 'It was awful,' Nichols said. 'I had never seen her look so hideous. He made her elderly and ugly, which was unfair because she was, and is, a beautiful woman. Nobody recognized her.' They could not bear to look at it, so it was not even framed but put in a closet.

Some time later they decided to give it to charity, without thinking that the store was not far from the St Regis and that Dalí was in town. One day Mrs Nichols was lunching at the Caravelle on 55th Street, when she suddenly heard a voice hissing '*Cocu!*' It was Dalí. 'Somebody so stupid as to give away

a Dalí has to be a cuckold!' Everyone in the restaurant stood up to look. She was so astounded that she could not say a word. That was not the end of it, either. The Nichols had the misfortune to meet the Dalís shortly afterwards at a Park Avenue dinner party. Dalí told them, 'I just want you to know that I bought the portrait. I keep it and I am sticking pins into it. Because, you see, I have magic and do you know where I am going to stick pins? Into your eyes.' Mrs Nichols tried to shrug off the incident.

I knew he was being abominable, bad in his heart, and so I said, 'Poof'. But I have a feeling for the supernatural and he had something supernaturally evil about him. When he talked about people not being good for his career, his face would change; and if you had a bit of an Achilles' heel he would know it and exploit it. I could not think of him without a shudder for years. I was afraid, you know, that I would go blind.

Paul Eluard was the first to say of Gala, and Dalí often repeated it, that she had a gaze that could pierce walls. (An English wit amended that to bank vaults.) There was indeed something irrational about the absolute belief that both had in her magical powers. They needed that reassurance, since Gala lived with the conviction that catastrophe lurked behind the most harmless of exteriors and the most routine daily experiences; as she became increasingly suspicious and mistrustful, so did he. Their persistent preoccupations about their health, in particular, exactly matched. An interviewer, meeting them both for dinner in the 1940s, made the mistake of politely enquiring after Dalí's health.

There followed an almost explosive commotion. Up went the tablecloth and up went the bread. Gala frantically knocked on the table's surface. It was metal. Back went the chair and up jumped Gala. Finally, she found a wooden strip around the seat of the chair and gave it a bullish poke. 'Ah,' she sighed.

There was no doubting their desperation. Fortunately, Dalí explained, he was protected. Gala stood guard; Gala believed in him. The same writer asked Dalí who he thought was the greatest artist alive and Dalí, plainly ill at ease, named Picasso first and Giorgio de Chirico second. Then Gala was asked to assess her husband's position. 'He is the very first, the greatest of all,' she declared. 'I agree,' Dalí snapped.

He absolutely needed her fanatical belief in him and her ceaseless ministrations. One has to think that she, who never had the kind of automatic

cial status given a child of respectably married parents, had a lifelong need be paid court to and honoured, not for her own achievements but in terms of the exalted name she carried. From that point of view her marriage to Dalí assuaged old wounds. And he idealized her, wrote poems about her, painted her unwearyingly, gave her all the credit, even signed her name with his. They made a pact to be all things to each other and, after fifteen or twenty years of marriage, were closer than ever. One has to doubt, however, that their physical relationship was ever very satisfactory. When he was in his seventies Dalí gave lurid details of their sexual couplings but it sounds like an old man's boasting, and other evidence contradicts this. As a fair indicator of his reactions one can refer to Gala's many portraits, painted at intervals during their marriage. The first, an oil on a postcard painted in 1931, gives the clear message that Dalí found Gala terrifying; in its malevolence it almost rivals Munch. With the passage of years, Gala's image lost much of its harshness, although the tenderest portraits are not without that hint of a formidable jawline that would become pronounced in old age. At least until 1947 Dalí depicts Gala as licentious, triumphant, even insatiable – in one of his most famous, her breast is bared –, his mirror image in reverse. A revealing aspect of *Hidden Faces* is the game of sex that its author has invented. The hero, the Comte de Grandsailles, tells the luckless Solange de Cléda that they are to reach orgasm without ever touching. The subtle sadism of the concept was not lost on Dalí. In fact, he seemed proud of having invented 'Clédalism' and would, in years to come, have a pronounced, open aversion to close contact. Why Gala, however, with her particular need for sexual reassurance, picked the one man incapable of giving it to her, is an unanswerable question. One assumes that, for similarly obscure reasons, she denied it to herself. One only knows that, while married to Dalí, she had been looking for consolation elsewhere for years and that, like Eluard, Dalí may well have appreciated the voyeuristic possibilities.

She was very discreet indeed about it but very seductive and persistent. Max Ernst's son tells a fascinating story about meeting Gala when he was a young man in New York and coming up against the cool, smiling face of the woman who had caused the break between his parents. He was not particularly angry with her but very curious and did not protest too much when the Dalís pressed him to accompany them on a shopping trip. On the day of the outing Gala appeared alone. Dalí was indisposed; he did not mind being left behind. They spent an aimless day jumping in and out of taxis, Gala continually asking, 'Where shall we go now?' They ended up finally at the Russian Tea Room and he became aware, as he put it, of 'a constant encounter of knees, thighs and shins'. Finally the time came to part. Dalí was surely asleep, Gala said. Why not come back to the hotel with her? Ernst suddenly

realized how afraid he was, stood up and left. When he next saw Gala, she walked up to him and snarled, *'Tu es la merde . . . monstre!'*

Reynolds Morse recalled that 'in 1942 she tried to tackle me. She took me upstairs and showed me a great many beautiful erotic drawings and I bought a couple of them'. He paused uncomfortably. 'Of course I said no. She was old enough to be my mother.'

Dalí's determination to diversify – into ballet, opera, the novel, portraiture and film – was channelled increasingly toward commercial art. By 1947 he was being paid up to $2,500 for an ad, $5,000 for book illustrations and $600 for a magazine cover. His dismembered arms, limp watches, ruined columns, pieces of driftwood, tables with women's legs, crutches and ants were helping to advertise Gunther's furs, Ford cars, Wrigley's chewing gum, Schiaparelli perfume, Gruen watches, the products of the Abbott Laboratories and of the Container Corporation of America. They were being reproduced in shop windows up and down Fifth Avenue. They inspired a Broadway show, *Lady in the Dark*, as well as a Hitchcock film, *Spellbound*, and an experimental collaboration with Walt Disney. The symbiotic relationship between Dalí's private nightmares and their profitable capitalization was becoming so marked that, for instance, one could be sure Dalí was about to sign a perfume contract when Gala, without the hint of a smile, was photographed applying perfumed pads to his eyes, the better to inspire his dreams. In fact, the prominent role Gala played in all of these contracts was general knowledge. Noting that Dalí had been undertaking numerous book illustrations that included Shakespeare's *Macbeth* and Cervantes' *Don Quixote*, a columnist described negotiations for the latter project as particularly delicate at one point.

> The overall price had been settled, but the publisher suddenly asked, 'How many full-page color illustrations do you intend to supply?' Dalí, who speaks no English – at least during business hours – held up five fingers. The publisher picked up his hat and coat and said, 'Anyhow, it's been a lot of fun.' Mrs Dalí, who acts as her husband's agent, saved the day by hurriedly explaining, 'When Dalí says "five", he means "ten".'

Dalí was, it was noted, slightly heavier and distinctly prosperous-looking the day he swung into Brentanos to autograph copies of his *Secret Life*, fingering his moustache, which had attained 'the luxuriant droop once affected by river-boat sharpers', and making bold, page-long signatures. It was raining and few people were in the store. One man with a briefcase came over to ask who the author was. 'Anyone I should know?' he said. In the

background Mrs Dalí was explaining how much her husband liked the St Regis for its limpid crystal light, a remark that was perceived as a 'commercial'. Dalí was, it was stated, now a social phenomenon, the only painter whose advertising techniques were being mistaken for serious modern art.

Dalí would, of course, have hotly contested this. His attitude towards commercial art was quite consistent down through the decades. He was willing to tackle any kind of advertising project, not seeming to care how banal or trumped-up, if it paid well enough. There were projects, such as book illustration, that fell between two stools, primarily money-making but, at least at first, approached with sensitivity and considerable art. There were prints, again in the early days money-making ventures to which he nevertheless gave his meticulous attention, as a long correspondence with the Cleveland Print Club over the issue of his *St George and the Dragon*, 1947, shows. Last, there was his serious painting, the standard by which he expected to be judged; he would defend this against all comers. In that respect he would have felt particularly secure in the winter of 1941. He was awarded the signal honour of his first retrospective exhibition by a major American museum, one of only three such exhibitions he was ever to receive in the United States. A retrospective of Miró was held concurrently and it must have been particularly gratifying now to be considered on equal terms with the older painter, whose protégé he had been only a decade before. Salvador Dalí, the critics wrote, was a painter of major importance, not just for his astonishingly inventive imaginative gifts but for his spectacular technical accomplishments. More than any other painter he had demonstrated the shock value, sometimes the delicate poetry, to be discovered in visual illogic. His best works were particularly compelling. For all their strangeness, 'they seem in an odd way familiar because somewhere within them there is a real grain of truth', a critic observed. Even those who grumbled that there was too much manner and not enough matter, had to concede that Dalí was 'adept at communicating ideas in terms of a minutely articulated, trance-clear image'. For sheer painting his work revealed 'an absolute mastery of the craft that is equalled by no other artist alive today'.

Whether Dalí discarded Surrealism before it abandoned him is a moot point, since the two events appear to have occurred more or less simultaneously. A 1941 article in the Surrealist magazine *View* attacked Dalí for having abandoned revolutionary values, espoused Franco, penitence, Catholicism and classicism, more or less as Dalí himself was making the same declaration. In these chaotic times, when 'the warmed over vermicelli of romanticism serves as daily food for the sordid dreams of all the gutter rats of art and literature, Dalí himself, I repeat, finds the unique attitude towards his destiny: TO BECOME CLASSIC!'. James Thrall Soby wrote that Dalí's three extended visits to Italy

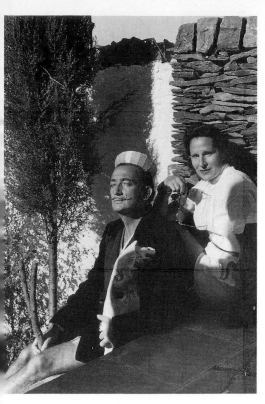

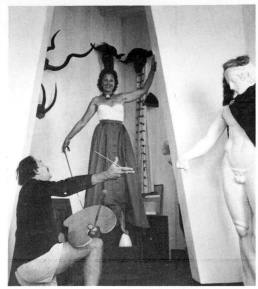

At Port Lligat

At work in Vincennes Zoo, 1955

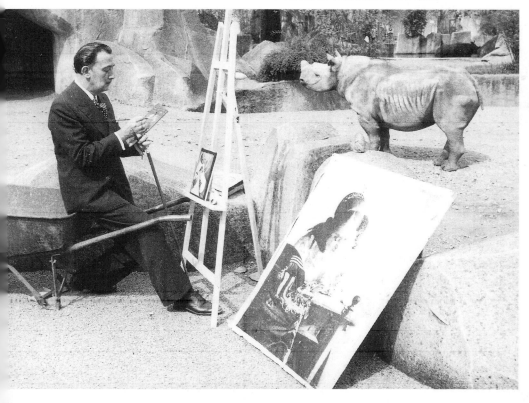

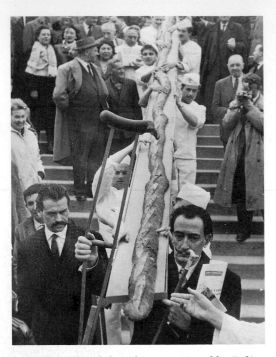

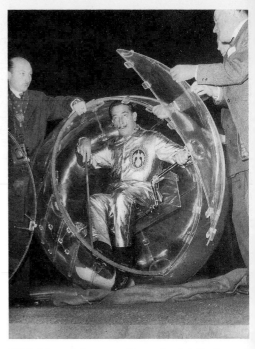

A fifty-foot **French** bread commissioned by Dalí to illustrate **a** lecture in Paris, 1958

With his pedal-powered 'ovocipede', Paris, 1959

The inhabitants of Figueres staged a bull fight in Dalí's honour in 1961

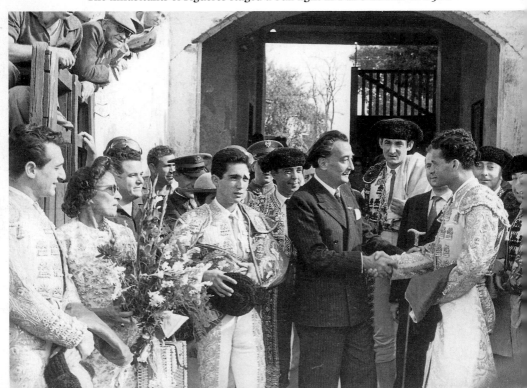

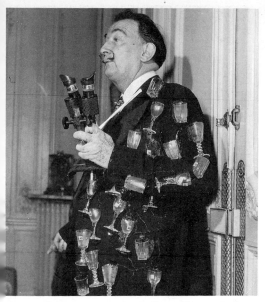

At an exhibition in 1964, Dalí said he needed the microscope to see his work in oils on tiny honeycomb-like metal cells

Publicizing an exhibition of lithographs in Paris in 1971

Making a spectacle of himself in Barcelona in 1966

Huntington Hartford, Gala, Dalí and a friend beside *The Discovery of America by Christopher Columbus*, which Dalí painted for Hartford's Gallery of Modern Art in New York

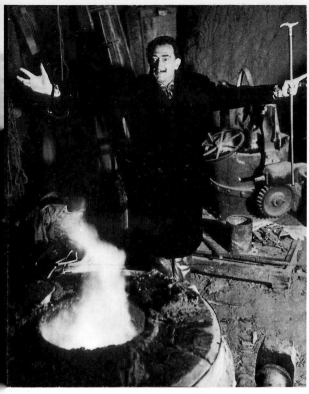

In the foundry casting the
bronze cover for the unique
copy of his book, *The
Apocalypse*

At the Meter Monument,
Sals-Narbonne, France,
1974

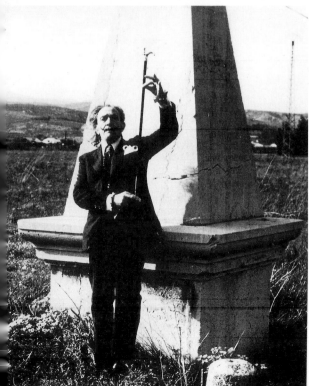

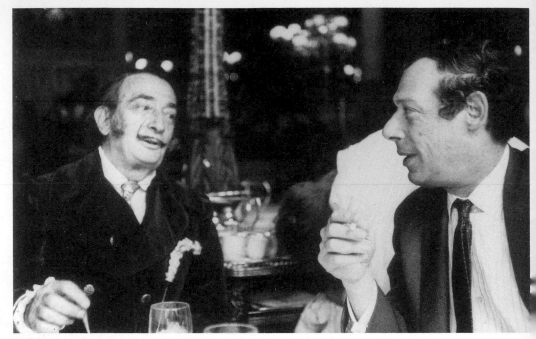

Dining in Paris in 1970 with art historian
Thomas B. Hess, one of Dalí's few American
supporters at the time

Dalí's Teatro Museo in Figueres

The Torre Galatea, an annexe of Dalí's museum
in Figueres, newly decorated with simulated
bread rolls

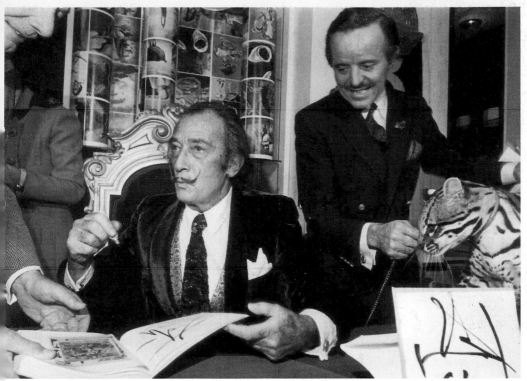

Autographing *Dalí by Dalí* in a Paris store in 1970, with Peter Moore and his favourite ocelot

Gala's castle in Pubol

Enrique Sabater (*left*) and Dalí leaving the Pompidou arts centre in Paris, after striking employees refused him admission to his own retrospective exhibition, December 1979

Accompanied by nurses and his close friend Antonio Pitxot (*far left*), Dalí leaves the Pilar Clinic in Barcelona, having recovered from burns received in the fire at Pubol castle, 1984

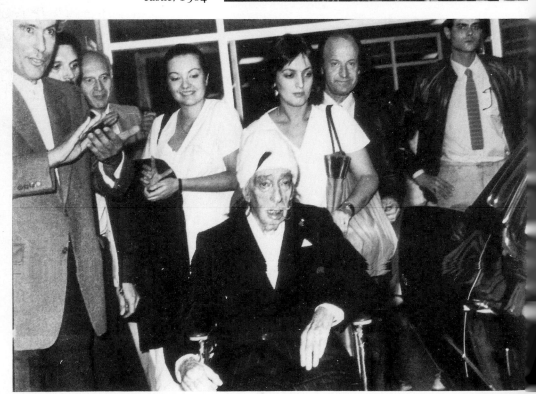

just before the war were the factors that brought about his appreciation for the great Italian tradition, specifically the works of Botticelli, Piero di Cosimo, and Raphael. He also developed a new appreciation for Uccello, 'long since hailed as a precursor of Surrealism by André Breton himself', Soby wrote. This close familiarity 'still further moderated his disdain for established aesthetic standards', Soby's delicate way of referring to the volte-face opinions Dalí was now espousing. The more the rest of the art world veered towards abstractionism, the more clearly Dalí saw his opportunity for continued provocation and mystification. This new stance did, however, put him in the peculiar position of being revolutionary for an espousal of traditional values: a revolutionist against revolution, as it were, a paradox that Dalí would have been the first to appreciate.

Even if he had not already arrived at this conclusion, that his public expected more of him than the same old bag of tricks was made painfully evident during a one-man show in New York in the winter of 1945 at the Bignou Gallery. Edward Alden Jewell did not actually say that Dalí was turning into a reactionary, but he almost implied it. Such canvases as Dalí's portrait of his wife's back, echoed in outline by a pair of stairs, some columns, sky and architecture were, Jewell wrote, cosily familiar. Dalí had now humanized the unconscious, and his work seemed 'as comfortable as a pair of scuffed old-fashioned slippers. Some of the thrice-familiar symbology goes on crutches, and all of it is a little down-at-heel from persistent wear and tear. . . . He has put Surrealism in curl papers for the night and given it a glass of milk.'

It was a bitter taunt: enough, one would think, to bring about an upheaval. However, Dalí's announced return to classicism four years before had already ushered in his next stage of development. It is clear from his autobiography that, as war started, he was almost desperate to shift styles again and absolutely obsessed by the necessity of constructing a comprehensive philosophy that would, in the spirit of Leonardo, integrate 'all metaphysics, all philosophy and all science' into a single, coherent vision. It is fascinating to see how this passionate interest in coherence and integration in his work occurred at the very moment when he had come to accept the fact of a permanent psychic split. That he was consciously attempting to compensate for this feeling of being torn in two directions seems beyond doubt. Gala, as his idealized other half, presented certain thematic possibilities; Catholicism, reinterpreted in the light of the latest theories of Einstein and nuclear physics, was another. By sublimation he would not need to resolve his inner contradictions; he could surmount them, he thought. To become a great religious painter answered yet other emotional needs; leading towards ever-more-grandiose visions of the perfected Dalí. He would anoint himself the saviour –

his name, of course, providing the perfect pretext – and save modern painting from itself. 'I, Dalí, by restoring currency to Spanish mysticism, will prove the unity of the universe.' Spirituality, unity – these were his themes, suddenly the only ones he could talk about.

Dalí seems to have toyed with the idea of sanctifying Gala on and off through the later 1940s – his first attempt at etherealizing her features seems to have come in 1945 – and presents her at an interesting transitional point in 1947–8 as Leda, accompanied by her swan. In painting this myth, Dalí seems to have depicted the traditional version, which is that Zeus, masquerading as a swan, copulates with Leda and that she in due course lays an egg from which are hatched Helen, Castor, and Pollux. From his comments Dalí makes it clear that he has not only elevated Gala to the realm of mythology, but that, since his private shorthand for himself is Castor and Pollux, the twins, she has become the vehicle for his divine birth. Leda, in other words, is seen here in terms of the role she has assumed in his life rather than for her erotic symbolism. And indeed there is something very antiseptic and chaste about the whole undertaking. To make sure nobody misses the point, Dalí very much underlines it. Nothing touches anything. Leda seated on her pillar floats a good inch above it, her foot almost resting on what could be a learned tome does not touch it, and the hand caressing the swan's face hovers in the air, as does the enamoured swan itself. Even the sea is depicted as levitating above the shore. Dalí called it 'the key painting of our lives', and one can see why, since when Gala appears a year or so later she has become the Madonna herself. The very fact that she was, in his eyes, transformed from a bold adventuress into a goddess and a saint, can only mean, if one accepts the mirror-image theory, that another shift had taken place in Dalí's psyche. Just as she, in real life on the prowl, was from now on to be put on a pedestal as the Virgin Mary, so he, who had spent so many years trying to come to terms with male–female sexuality, had settled into his role as voyeur and given up. There is a further point to be made about the use of a swan image, which is often hermaphroditic in meaning. If Dalí had felt sexually fragmented up to this point, it is certainly possible that, in fixing on the symbol of the swan, he was falling back on the solution of his adolescence and the only one he felt safe with, that of being enough to himself.

In 1949 and 1950 Dalí painted two versions of Gala as Madonna, the first a smaller work, 19″ × 14″, an early study of which he presented to Pope Pius XII when he was granted an audience on 23 November 1949, and the second the biggest work he had attempted so far, 3′ × 5′; both paintings were called *The Madonna of Port Lligat*. The fact that, as in *Leda*, nothing touched anything else, was explained by Dalí as symbolizing 'dematerialization which is the

equivalent in physics, in this atomic age, of divine gravitation'. After being received by the Pope, Dalí, aged forty-four, announced that he was converting to Catholic ideals and classical Renaissance art. The Pope, he said later, 'was very pleased and commended me for my change of heart'.

One would like to place some stress on the fact that Dalí's father, late in life, became as vehemently pro-Catholic as he had once been most emphatically anti-Catholic. Josep Pla recorded with some humour a conversation that took place with Salvador Dalí senior at the end of the Civil War,

> when he told me with great hopefulness and with many gestures, standing among the broccoli and the lettuces that he grew with such pride, 'My friend, this broccoli, these lettuces, don't they support the unquestionable existence of a first cause, of an omnipotent, eternal and universal God? If it is not clear to you, either you've got something in your eye or you're lacking in grace!'

However, whether Dalí senior influenced his son is unknown; it may be a genuine coincidence. In fact, exactly how often they saw each other before he died in 1952 is difficult to establish. There seems no explanation for the fact that Dalí waited until the summer of 1948 to make his return to Europe. One would have assumed he was impatient to rebuild the house at Port Lligat, which meant more to him than anywhere else on earth.

As best one can piece the story together, the major problem seemed to be that of having Gala accepted by the family circle, since Dalí was sincerely set on building cordial relationships with his father and sister. So many bitter things had been said in years past. It is known, for instance, that when Dalí's father discovered his son's intentions of marrying Gala in a French civil court, he wrote a letter to the court protesting against the marriage on the grounds that Gala was a whore. This was bad enough, but Ana María Dalí, on what evidence is not known, always believed that Gala Dalí had denounced her during the Civil War. Apparently it would have been enough to give her the wrong political label at the right moment; this, she believed, is why she was tortured.

It is also believed that when the Dalís finally did make the trip to Port Lligat in the summer of 1948, Gala was opposed to the reconciliation and hid in the street, watching from a discreet vantage point while her husband knocked on the door of his father's house. Just when a delicate bridge seemed established between all of them, Ana María Dalí published her reminiscence, *Salvador Dalí Seen by his Sister* (1949), and it became a new bone of contention. Dalí was absolutely furious. His sister had painted him as an ordinary human being; she had 'destroyed the myth of Dalí', he raged when he saw Reynolds

and Eleanor Morse in New York in 1950. He was almost pathetic about it, they said. Dalí added, 'Don't forget that when I left Spain all I took with me were my memories of my childhood. That was everything I had to offer; the only thing I had to sell.' She was, in other words, threatening the very basis of his fame. There could be no real reconciliation as long as the two camps were so at odds over the past and had solidified their positions in print. Everyone knew and thought that the estrangement between father and son was sad.

'Tío Ben', Benjamín Castillo, a small, highly gregarious lawyer, manager of office buildings in Figueres, recalled the endless times he had met Dalí's father in the Casino, more or less a club and meeting place for all the professional men in the town. One day Dalí's father suggested that they have their usual cup of coffee, but this time he did not want to go to the Casino. 'He suggested we go to another bar, the Express, that faced the Rambla. He wanted to see, without being observed, his famous son walking up and down the Rambla twirling his moustache and swinging his cane.'

CHAPTER THIRTEEN
Avida Dollars

'Very few people know who I really am.'
DALÍ

When the Prince de Faucigny-Lucinge paid his first visit to New York after the war, he sent word to the Dalís and was invited to join the artist for a night on the town. Gala, it seemed, would not come – she seldom went out at night with Dalí any more – but Dalí was in full regalia. 'It gave me a bit of a shock,' the Prince said with a smile. 'He had developed those enormous moustaches and a cane. I thought to myself, "How can I walk around with this figure of fun?" I almost cancelled. But I found that I couldn't have been more wrong. He was instantly recognized and received everywhere.'

By the time Dalí reached his mid forties his showmanship had become ingrained, reflexive. He had no incentive to abandon it and every incentive to become more flamboyant and outrageous or, as he sometimes said, 'more and more Dalí'. As a writer observed in 1970, 'forty years after his soft watches drooping over a barren landscape made him famous, Dalí is still Everyman's idea of the mad genius of modern art, and mad genius sells like nothing else'. Every professional entertainer knows the importance of the image, but few artists ever reached the stage in which their particular artistic signatures were so instantly recognizable by the masses that their name was not necessary. Dalí, by dint of native wit and cunning, was at the peak of his fame, and every object he touched appeared transformed into gold.

By 1970 Dalí was earning half a million dollars a year at least, after taxes, and had an estimated fortune of $10 million. He was selling portraits for $50,000 each and paintings to such multimillionaires as H. J. Heinz II, Huntington Hartford, heir to the A & P grocery fortune; the New England Merchants National Bank of Boston, and the French entrepreneur and art lover Paul Ricard. The latter reportedly arrived by yacht in Cadaqués to buy a couple of watercolours and ended up paying $280,000 for a mammoth, 11' by 14' painting, *Tuna Fishing* (1966–7). Such major works provided the lesser part of Dalí's income. He designed, among other things, shirts, fabrics, ties, cognac bottles, calendars, ashtrays for Air India, stamps for Guyana, bathing suits and gilded oyster knives. 'At any given moment there may be

hundreds of people working on Dalí artifacts,' *Life* magazine reported. Several dozen women at the Aubusson factory might be weaving gold threads into Dalí-designed tapestries. Glass heads and tableware would occupy some thirty glassblowers in Nancy, and elsewhere the same number of workmen might be making bronze heads and tableware. A handful of highly skilled jewellers might be fashioning flowerlike Dalí designs or other *objets d'art*, small, exquisite and most expensive. At the Paris mint, craftsmen would be at work on medals designed by Dalí and so beloved by the French as additions to their watch chains or insurance against hard times. Elsewhere, printers and bookbinders by the score might be designing lavish publications, priced at from $35 to $15,000 a copy, for which Dalí had created the illustrations: new editions of the *Divine Comedy* or *Alice in Wonderland* or the Bible ... It was a far cry from the days when Gala would trudge around Paris all day long trying to sell Dalí's creations. She once declared she would believe that Dalí had really succeeded when you could buy one of his works at Woolworth's. When Dalí, in 1965, unveiled his original work of art, called *The Mystical Rose Madonna*, which he had painted for the Vincent Price Art Collection at Sears-Roebuck, she must have felt that her dream had come true. Or true enough.

Whenever Dalí was in town, the lobbies of the St Regis in New York or the Hotel Meurice on the rue de Rivoli in Paris would be full of anonymous-looking businessmen with attaché cases and absorbed expressions. Several hundred contracts would be proposed in any one particular year and of these about fifty would come to fruition. They included, in 1970, a fifteen-second commercial on French television during which Dalí rolled his eyes roguishly and said, 'I am mad, I am completely mad ... over Lanvin chocolates.' He was paid $10,000. The previous year he received the same amount for a spot television appearance in which he extolled the merits of Braniff Airways although, as was well known, he had never flown in a plane and declared he never would. Such contracts would have been, until the 1960s, negotiated by Gala once her husband had agreed in principle, and there were few propositions to which he did not agree. One of these involved an American businessman who proposed buying the second letter of Dalí's name so that he could open a chain of stores called Dalicatessens. Dalí called him crazy and threw him out.

After years of practice the Dalís were absolute masters of the art of keeping dealers and businessmen on their toes, and anyone else who wanted anything out of them. Joseph Foret, an ambitious Parisian publisher who finally persuaded Dalí to make lithographs for his 1957 limited edition of *Don Quixote* (197 copies), has never forgotten the patience that was required when he went to Dalí with a new idea:

I had done two books with Utrillo while he was alive, and collaborated with Picasso and also Cocteau, and I had the idea of commissioning Dalí to illustrate *Don Quixote*. It seemed a wonderful idea to me but I didn't know Dalí at all. People told me he was in Spain, so I told my wife we were going. She said, 'He won't see you', but I was stubborn. I got the address and we drove there. I rang the bell, with what kind of emotion you can imagine – I think it was about four in the afternoon – and a Spanish woman appeared. She spoke no French. I gave her my card although I knew my name would not mean anything to Dalí. Anyway, I was ushered into the salon and the Dalís were there talking to some friends. He was in the middle of a conversation. I just stood there. He: 'Who are you?' I told him. They went on talking and I went on standing. Finally, Mrs Dalí and his friends left, and he said, 'What did you say?' I repeated that I wanted him to illustrate one of my books. He replied, 'Come back tomorrow at six.' The next day I returned. More people were there. A repetition of the day before; he talked to them and said nothing to me. After about an hour: 'Come back tomorrow.' The third day, the same thing happened. Always talking to his friends around and past me, as if I didn't exist. This went on for almost a week and at the end of it, Dalí told everyone, 'This is the most patient man I have ever met', and I knew I had won. I found that my experience was typical. All the trips I have taken for nothing! But I persevered because I knew that it was the Spanish way and one dared not push him.

Whatever the business occasion, the Dalís had practical ways of dealing with it. Lionel Poilâne, owner of a famous Paris bakery, who collaborated with Dalí on several sculptures made out of bread, had received no payment for his services. Finally, Dalí presented him with one of his paintings. When Gala heard of that, she said, 'Yes, I know he gave it to you, but give it back to me', so he did, to his eternal regret. Cocteau told the story that, when one of his boyfriends decamped with a valuable Dalí, Dalí said, 'Never mind, we will give you another one', and Gala added, 'Yes, we will give you another one for only the price we would charge a dealer.' The former head of M. Knoedler & Co., Roland Balaÿ, who had known Dalí since the late 1920s and acted as his dealer in New York for a time, recalled Gala saying, after Dalí bought her a house of her own (the castle of Pubol), 'Roland, after all the years we have been together, you owe us a present.' He continued,

One day when I was in Paris there was a phone call. It was one of the big furniture firms, 'Will you come and see the sconces you have ordered?' So I went to see them. 'There is a mistake. I didn't order these.' 'Oh but

Madame Dalí said you would be very interested in buying them.' So I went to the Knoedler firm and said, 'We will have to give these two candelabra to the Dalís.' They were eighteenth-century originals and cost $7–8,000. And do you know what? She never thanked me.

If necessary Dalí could sell his own paintings with a flair reminiscent of that other incorrigible showman of the art world, Joseph Duveen. For instance, after painting one of his monumental post-war canvases, *The Battle of Tetuan* (1965), this one 10′ × 13′, and having a particular collector in mind, Huntington Hartford, Dalí arrived at Knoedler's a day ahead to orchestrate the presentation. He wanted the whole painting to be covered by a curtain and specified the exact colour. A staff member was dispatched to Bloomingdale's to find just the right fabric and someone else hired to make the enormous curtain required at a few hours' notice. Dalí then took Balaÿ step-by-step through the proceedings. Two chairs were to face the painting. Dalí would sit in one, Hartford in another. Balaÿ was to stand. They would face the curtained painting without a word for as long as it took for the collector to react. At the moment he did, Dalí would say grandly, 'Roland, go and stand next to the picture.' Then, 'Roland, pull the curtain.' Balaÿ continued, 'It sold the picture.' Forever afterwards Dalí called Roland Balaÿ '*Le baron de la ficelle*' – the master of stage tricks.

At one point in 1970 Dalí announced that, from now on, he was going to charge a fee whenever he was invited to appear. His minimum tariff for a minute of film, for instance, would be $10,000. Three Mexican film-makers had already discovered this. In the 1960s they went to get Dalí's permission to film him entering the bar of the St Regis, walking a baby panther on a golden chain. Mrs Dalí sat them all down and asked, 'Do you like steak? Good steak? Cut thick? Very tender?' Thinking they were being invited for lunch, they all nodded. 'Well,' Gala continued, 'so does Dalí. Do you know what a good steak costs?' They left in a hurry.

One of the most amusing incidents concerns a delegation of American congressmen who wangled an invitation to the Dalís' suite at the Hotel Meurice while they were visiting Paris in 1975. When the conversation seemed to lag one of the wives suggested jokingly that Dalí might want to contribute his services and paint a mural in celebration of the American Bicentennial. Dalí considered the proposal with great seriousness, seeming oblivious to her attempts to back away from the idea once she discovered his point of view. 'You pay. I paint,' the great man said. As they left, Enrique Sabater, his secretary, was at the door. He tapped the woman on the shoulder and said, 'I'll be waiting to hear from you.'

The unprecedented scale of Dalí's success had something monstrous about

it. The fact that Michelangelo designed uniforms for the Pope's Swiss Guard, that Titian ran a painting factory, that Picasso designed pottery and scenery as well as painted and sculpted, that Jean Cocteau's name will forever be associated with theatre and film – none of these historical precedents seemed to approach, in scale, the unmitigated, flamboyant gall of this erstwhile revolutionary who, it seemed, went from strength to strength as he raked in banknotes by the cartload. Reynolds and Eleanor Morse were among the few who remembered the early days. They met the Dalís at the St Regis in December of 1942 and bought their first painting the following March, the recently completed *Daddy Longlegs of the Evening ... Hope*. Reynolds Morse recalled that the cost of the frame, $1,800, was more than the painting, which was acquired for the modest sum of $1,200. The often repeated story that Morse told Dalí to send him another picture whenever he needed another thousand dollars is colourful but quite untrue, according to the Morses. The bulk of their ninety-odd paintings, part of a collection of over 400 works, came from collectors and dealers, and perhaps thirty from the artist himself. Morse said that Dalí's transactions were always in cash. As the paintings grew in size and price, suitcases were needed. Peter Moore, who was to become one of Dalí's secretaries, told the story that one day the manager of the Hotel Meurice complained that Dalí's possessions were taking up an inordinate amount of space in the hotel strong-room and asked if he would be good enough to examine them. Moore and Dalí descended into the vaults. Box after box was stuffed with cash and at least half of the banknotes were no longer valid.

Avida Dollars – the cutting anagram André Breton coined from Dalí's name in 1942 – was picked up far and wide. As the original indictment went, 'The rustle of paper money, illuminated by the light of the moon and the setting sun, has led the squeaking patent-leather shoes along the corridors of Palladio into that soft-lit territory of Neo-Romanticism and the Waldorf Astoria. There in the expensive atmosphere of "Town and Country" that megalomania, so long passed off as a *paranoiac intellect*, can puff up and hunt its sensational publicity in the blackness of the headlines and the stupidity of the cocktail lounges.'

Dalí's financial backing depended on the continuance of the symbiotic relationship existing between himself and the world of press, television and radio. Reporters knew that Dalí could be counted on to say something shocking and outrageous, and would always ask for an interview, thus nudging him further along his chosen path, a circular progression in which everyone won. Dalí was, of course, a past master of the art. As he also said, astonishing the world every half hour was no joke, and since he had managed to keep the world amused for a quarter of a century he ought to be given a

medal. In particular Dalí continued his technique of hammering home the same tireless message. Morse explained,

> If Dalí was in New York you only needed to see him once because he always had a single theme. He had a set of theories that he would tell over and over again in connection with the prop of the year, whether it was an arquebus or a rhinoceros horn or a cage with a little man in it. He was a man of few ideas but he worked them inexhaustibly.

One of the lodes Dalí liked to mine was the link between semen and gold. 'I am looking for the vision which gives me direct access to a divine orgasm, bringing with it the certainty that ... my sperm, like my gold, are the products of the transformation of matter.' Money was to be transformed by the alchemist, Dalí, from base metal into a spiritual substance and therefore the more he acquired the more there would be to convert from the sordid material sphere into the mystical. Money was somehow mixed up with sexual frustration and, as everyone knew from reading Freud, accumulated frustration was desirable if one was an artist, because it led to the process of sublimation and creation. All that astonishing creativity, in other words, came about because Dalí had been miserly with his own precious substances; therefore to be miserly was, *ipso facto*, good. 'For the Divine Dalí, if one drop of jism leaves him, he immediately needs a huge cheque to compensate for the expenditure.' Money as magical compensation, money as alchemical raw material, the transformation of *merde* into gold – there was no end to the ingenious explanations Dalí could dream up at a moment's notice. They always varied slightly, they were always slippery, and, if pushed far enough, they contradicted one another. But that, too, was typically '*Dalínien*', to use a phrase he himself invented. It reminded him of that joke about Raimu.

> As Raimu always said, 'In every lie, there is a grain of truth.' One day at a café, he had said, 'When I was twenty-two years old, I made love twenty-five times in a single night.' The people in the café all shrugged their shoulders and changed the subject. At that point Raimu punched the table and said, 'Even in this there is a basis of truth. It wasn't me, it was my sister. She was a streetwalker.' Even when one is playing games [Dalí continued] there is always a shred of more or less bitter truth.

Deciding where the truth began and ended was not, of course, his problem. Most journalists were content to ask the routine questions and write down the same frivolous answers, but if they ventured to challenge him, they were told to report what he said and shut up. This they usually did but occasionally

Dalí would come up against someone who was really trying to get beneath the mask. Such a questioner had to have all his wits about him, since no one could twist and turn faster than Dalí. He evaded every hook.

Questioner at the Hotel Meurice, in front of about fifteen people, including a hairdresser trying wigs on Dalí: 'Why do you take such pleasure in constantly mystifying and provoking people?'

Dalí: 'The one thing I really like is to *"crétiniser"*, stupefy the people around me, you above all, if I could.'

Questioner: 'How do you propose to do that?'

Dalí: 'By making them drool. [The word also implies, make them talk nonsense.] Haven't you noticed that people who are in love drool, those who are frightened do too, and so do people in a trance state, they make a film along the edge of their mouths that becomes a bead, it turns into a fly and when the fly comes here (he indicates the corner of his mouth) I close my mouth and bzz, I let the fly go and at the end of a moment, bzz – the fly comes back. Have you got the idea? (His audience is suddenly silent.) Idiocy is the thing to cultivate.'

. . .

Questioner: 'All right, since you insist, why are you trying on wigs?'

Dalí: 'At last! Well then, it's simply because I am going bald. You didn't expect that, right?'

Questioner: 'Well played. It sometimes occurs to you to tell the simple truth.'

Dalí: 'Yes, when it's a surprise, whenever it helps to stupefy.'

. . .

Questioner: 'But when the Civil War began to heat up in your country, in Spain, you were off to Italy walking in Stendhal's footsteps, you wrote . . .'

Dalí: 'Oh me, I am off right away. I like unhappiness for others. When there is a real catastrophe the first thing I try to be is not in the same spot! . . . And when I hear the word Hiroshima, and all those things, and I am in the Hotel Meurice, very comfortable and in the process of eating an ortolan for example, that ortolan tastes even better, if I know that there is a great world catastrophe, than if there is a mundane life going on around me.'

Questioner: 'I need hardly tell you that what you are saying is so monstrous that one cannot believe a single word.'

Dalí: 'That's for you to say! I am here to confuse and cloud the issue, you to put matters straight. Perhaps I am only trying to provoke you into thinking, "Dalí is really a sentimentalist at heart, he only loves poor people,

because as soon as he leaves the Meurice he gives alms at every street corner" ' ...

Questioner: 'I don't believe that either.'

Dalí: 'So much the worse, so much the better! That's your business.'

One could observe Dalí climbing on board the *France* or the *United States* or the *Queen Elizabeth* on his way to New York in November and descending the gangplank the following April on his way back to Spain, with the usual stopover in either direction at the Hotel Meurice. In fact he was hard to miss since he was, in those years, accompanied by a retinue that included one or two ocelots, declawed and with their teeth filed down, supposedly belonging to him but actually owned by his British *homme d'affaires*, Peter Moore. Moore had taken over more and more of the daily business details involved in running the Dalí empire and was later replaced by the Catalan Enrique Sabater, who took over still more of them. Once in Paris other members of the Dalí entourage would appear such as Jean-Claude DuBarry, an amiable personage who said that was his real name and that Dalí had nicknamed him Verité (Truth), whereas people said it was the other way around. A handsome former model, DuBarry was owner of a model agency in Barcelona when he first met Dalí in November 1969. One might also find Nanita Kalachnikoff of Park Avenue and Marbella, a highly discreet and, people said, learned socialite, who was always hovering somewhere in the background, whom Dalí had named Louis XIV after her supposed resemblance to that monarch. There was also Robert Descharnes, with whom Dalí was cooperating on books and films, and who was among the regular visitors to Room 108 on the rue de Rivoli side of the hotel, overlooking the Tuileries. This was called the royal suite since Alfonso XIII of Spain had lived there in 1907 when he was twenty years old, and had returned there a quarter of a century later, when forced into exile. As a further fillip to the royal image Dalí liked to say that he had obliged the Meurice to restore the royal toilet seat for his personal use. He invariably wore a jewelled pin in his richly embroidered tie that once belonged to Alfonso XIII.

There was a revolving assortment of spectators, 'starlets in Cardin breeches; and hippies in goatskins and fringed potato sacks; and bullfighters, music-hall stars, artists, living corpses from the Living Theater'. Among them was Carlos Lozano, now owner of an art gallery in Cadaqués, a young Colombian who had grown up in New York, California, Paris and Spain and, when he met Dalí in 1969, was relatively poor and stage-struck:

I was taken to the hotel by a pop singer for one of his famous high teas at five o'clock. It was fireworks. One never knew what would happen. There

was the strangest group of people; Dalí always had very extraordinary tastes. I was in complete awe and admiration of him. He had wonderful energy and explosiveness. He would grab you by the arm when he talked to you. He was very flattering and gave me a lot of compliments. I posed for a gouache and a sculpture. The sculpture doesn't look anything like me but in the gouache you can tell it's me.

I used to see him in Port Lligat as well. I stayed across the street and would watch him painting – he never talked when he worked, but would whistle when he got excited – and saw him every night. In those days he was mad about Hippyism and said I was the first one in Cadaqués. He used to call me La Violetera. There is a famous *zarzuela* [operetta] about a woman who sold violets at the turn of the century and sang at the same time. He introduced me to the producer of *Hair* and I got a part in it. If he liked you, he could be very helpful but you did not dare ask him for anything because he was the essence of contradiction. And I was very pure with him. I think this is why the relationship lasted for many years, because he could also be sadistic.

For instance when he first gets you, he puts you on a silver platter, but then he drops you. At night, he will look around and point to certain people to go out to dinner with him, 'You, you, you and you, but not you.' It's a court and you are not on the list any more. He is tired of you; you don't count. They were both like that and I have to admit I was badly hurt.

Despite this, Lozano stayed on the scene, doing minor secretarial work for which he was never paid. 'I was screening people and briefing him about them. Then also in a base sense I was procuring for him. Soliciting beautiful and famous people. He'd say, "Can you bring me a man who speaks Russian tonight?" Or he would want beautiful girls, because he was so voyeuristic.'

Jean-Claude DuBarry said:

I always liked him. I saw him as a figure out of the Italian Renaissance. He wanted to be surrounded by scientists, philosophers or beautiful people, actors and models. As Teilhard de Chardin tried to make the connection between science and religion, Dalí was looking for the connection between science and aesthetics. I used to organize the dinners, I'd bring girls and help him put on a show. My importance is that it was my models who inspired him. After a year I understood what kind of girl Dalí wanted. Above all, he wanted perfectly beautiful girls, tall and blond with long legs and very regular features.

DuBarry leafed through his files of former models and then books of Dalí's art to demonstrate the paintings for which his girls had posed, most of them nudes seen from the rear. He stepped back and clicked his fingers appreciatively. 'He was a little bit voyeur but for a painter that is normal,' he said.

Gala was not so easy to understand. According to DuBarry she had a lot of class and although reserved, could be frank to the point of boorishness: 'Why do you have such a big nose?' or 'You look like a homosexual to me,' she would remark. Lozano had similar comments about her direct approach. 'I have seen Gala once burn a boy in Barcelona. She put out her cigarette on his arm. She poured a vodka over me. She was jealous. It was done to make a point. I had to be passed by her; she had to give the green light.'

Paula Pelosi, who was working for Peter Moore, called her ageless. 'When I was there she was in her eighties and she looked like a young woman from the back; she had this sprightly walk and straight back.' Chanel had apparently given her the idea that she should wear a black bow on top of her head and wherever she went Gala wore her Alice-in-Wonderland bow.

This little perky person had an enormous presence but not a particularly appealing one. I have not heard of especially generous gestures on Dalí's part, but I never saw him be mean. Gala really was mean. None of the stories I heard about her are nice. I always thought he was much more down-to-earth than anyone around him and that she was really the crazy one.

DuBarry recalled that he got on well with Gala because, 'I am from Gascony and we speak our minds. They called me Verité for that reason.' As for Gala, 'The way to treat her was with humour; she liked that.' Besides, she liked being surrounded by handsome young men. DuBarry said, with a professional's interest, 'the Alain Delon type when he was young, that kind of boy. I think she needed the energy of young men. She liked men and I like that.'

One has to remember, Lozano said, that Dalí and Gala really loved each other. They held hands in public. They always called each other in the morning, if she was in Pubol. They were 'mon petit' and 'ma petite' to each other. 'At the same time Gala was tiring of her role. One day she called me and said, "I can't take it any longer. I want to leave him. His role is to be charming and mine to infuriate people."'

For Catherine Perrot-Moore, the wife of Peter Moore, Gala was a complex figure for other reasons. 'She had a fantastic life. She had a lot to tell the new generation but she did not accept that. Whenever a young man came along she would start to flirt like a girl. You'd see her with all the airs and graces

of a young woman, sitting on one leg.' Both DuBarry and Catherine Perrot-Moore believed that the Dalís understood and tolerated each other's sexual peccadilloes. DuBarry said, 'Maybe Dalí was living sexually through Gala; he was very cerebral you know. What people will tell you about orgies is not true,' he added in the same breath. 'Sometimes I would arrange to have a couple making love, but he never took part.' He said proudly, 'He never touched my models. He wasn't impotent, but he didn't like the contact.'

John Peter Moore, an imposing member of the Dalí entourage, is another colourful personality. Described as a man of polish, charm and wit, Moore was born in London of Irish parents on 1 March 1919, educated in France, Belgium and England, and joined the 61st Teleprint Operating Unit of the First Army Royal Corps of Signals in Canterbury, Kent, in 1939. Moore was evacuated at Dunkirk and later served in Africa, Italy, Austria, and France as a captain in the Psychological Warfare Branch of Allied headquarters. His wife said that he had been deputy mayor of Venice, and a lawyer, who had known him for fifteen years, believed he had been a captain in the Irish Guards and also a Swiss Guard at the Vatican. In the years immediately following, he is believed to have worked in Rome and Vienna for London Films and British Lion as Sir Alexander Korda's representative. Moore was reported to have been involved in the filming of *The Third Man*. Mrs Moore said that her husband met Dalí in 1951, when he was setting up an internal television circuit at the Vatican, and that he was instrumental in arranging for Dalí's audience with the Pope. This version is disputed by Robert Descharnes and a friend of Mme Kalachnikoff's, who believed that she had introduced Moore to Dalí in the bar of the Plaza Hotel in New York. It is known that Peter Moore's tenure as *homme d'affaires* began in 1962 and ended around 1976. Dalí always referred to him as Captain Moore and called him 'my military attaché'. While working for Dalí, Moore amassed numerous real-estate properties worth, by his own estimate, $10 million, including houses close to Dalí's in Port Lligat and Pubol, and a sizeable collection of Dalí's works, many of them graphics, which are on permanent exhibition in the Museum Perrot-Moore run by his wife in Cadaqués. For Russell Harty, the British television personality, he was the man standing between Dalí and the outside world when they met in 1973. He was, Harty wrote, 'curt, organized and formal'.

While in Paris Dalí would be interviewed widely. He might be making a film and signing copies of his latest books, and also offering what might be called photo opportunities. In the case of Foret's undertaking in particular, Dalí announced that he, in the company of Don Quixote and Sancho Panza, would storm the Moulin de la Galette for the benefit of newspaper and television

cameramen, all of whom dutifully appeared. On his agenda for the autumn of 1966 there was a conference at the École Polytechnique, an exhibition of his medals, a visit to the Eiffel Tower, participation in a judging of children's drawings, and other engagements. In 1955 he made an unforgettable appearance in an amphitheatre of the Sorbonne, at which he lectured on 'The Phenomenological Aspect of the Paranoiac-Critical Method'. Arriving in a magnificent yellow-and-black Rolls Royce full of fresh cauliflowers, Dalí was met by a wild crowd of students. Those in the amphitheatre greeted him with cockcrows and a deluge of paper darts, while hundreds of others milled around outside, trying to get in, or climbed the Sorbonne walls to peer in through the windows. Janet Flanner wrote in the *New Yorker*,

> Dalí, modestly got up in a dark suit and matching handle-bar moustaches, used as his main theme Vermeer's picture, *The Lacemaker*, which, if all of us there heard rightly, can no longer be thought to have been based on the theory of the morphic something-or-other of cauliflowers, as Dalí had earlier supposed; instead, it derives from the something-or-other else of rhinoceros horns, which, he claimed, is his latest discovery.

At the end Dalí gave away the cauliflowers, which were not, however, autographed.

As one might expect, the schedule in New York varied only slightly from this successful formula. Dalí might, for instance, arrive at the Quo Vadis as guests gathered for lunch, placing an enormous rhinoceros horn on the table reserved for a beautiful and wealthy socialite, then disappear, returning some time later to chat with the lady, collect his trophy, and leave. He might be found in the depths of a new sewer as a prelude to his appearance, in the 1960s, at a real 'Happening', explaining, as he stamped around in the primeval muck wearing a golden space-suit, with a reporter at his elbow, that, 'Dalí likes to show the fusion of creativity – the hidden reality of our time.' He might be dressed up as a stoic-looking Santa Claus, signing books in the window of Brentano's. He might be photographed accepting the world's largest chunk (forty pounds) of pink bubblegum ('What mean booble gum?' he is said to have asked). He might be soaking a mink-wrapped girl from head to foot in black paint. Or he might be pelting another girl, who seems to have become somewhat hysterical, and no wonder, with 400 pounds of popcorn hosed down with chocolate syrup. One of his most publicized exploits involved taking over *The Morning Show* on CBS-TV, involving more copies of Vermeer's *The Lacemaker*, juxtaposed against fresh mounds of cauliflowers, preferably exploding, as outlined in a book bearing the following misspelled label:

HISTOIRE PRODIGIESSE DE LA DENTELIERE ET DU RINOCEROS, EXTRAI DU JURNAL DUN JENIE in Dalí's characteristically erratic scrawl. Dalí was delighted with this. '*Bravo! C'est magnifique!* The wrinkles of that rhinoceros – they are *parfaits!* . . . Confusion is best. Accidents make creativity. Order makes boredom.'

Naomi Sims, who met Dalí when she was a model in New York, often went on Sunday nights to his dinners at Trader Vic's, at which any number of bizarre people might appear.

He was very articulate, very dramatic and he enjoyed the props, i.e. the setting and his guests. I found him not to be pretentious at all, and very astute. His eyes had a glazed expression but he would notice things. He was very polite and also very generous; if it were your birthday you'd get flowers, and once he gave me a crystal egg with his astrological sign, Taurus, on it. He had a habit of never completing a sentence, although you always knew what he meant, and gesticulating. . . . There was lots and lots in his eyes, though he was never self-pitying. I would say he was not easy to get to know.

Dalí presided over the scene from a fan-backed wicker chair, often in the company of Andy Warhol's star Ultra Violet, who helped with the English-French conversation, and occasionally in the presence of Gala, who sat quite apart from the revels. 'All this is invisible to me,' she told a reporter. 'I come no more to these dinners. Too many monsters.' She spent one evening talking to one young man, Jeff Fenholt, who played the title role in *Jesus Christ Superstar*, and was now composing music. 'I am the source of God,' the young man said, 'and I have the talent of the masters.'

He got to know the Dalís, Jeff Fenholt said, when he was the star of the Broadway show. He had been performing eight times a week for several years and drinking too much. He was emaciated, down to 122 pounds, and one evening when he was singing he broke an artery in his stomach and almost died. The Dalís came to the hospital to visit him and afterwards Gala came every day, sat and held his hand. During one crisis, when the nurse did not react fast enough, Gala stabbed her with a hat pin. After Fenholt came out of hospital he became a frequent visitor at Port Lligat, six months of the year for several years. Gala detested Dalí's public performances, but she could not bear to be alone in her castle, so Fenholt used to stay with her. They became close friends, 'real tight' is the way he described it. Fenholt knew about certain aspects of Gala's early life that she had told no one and agreed to talk further, but when next contacted had been advised by his lawyer not to comment.

'I've been having doubts,' he said. 'Maybe I shouldn't be so open. The bottom line is that I loved Gala very much.'

Everyone knew that Gala responded to an emergency and, if she had made up her mind to defend one, she was implacable. Fenholt described the time when he was involved in a lawsuit with his management. All his assets were frozen and he was ill at the same time. The Dalís very generously helped him out. When Dalí eventually decided to fly back to Paris from New York, since he was irrationally convinced that someone would put a bomb on the plane if he were known to be a passenger, they swore everyone to secrecy. However, the pharmacist at the St Regis Hotel happened to hear about it and, when he next saw Gala, said innocently, 'Oh good morning Madame, I am so sorry to hear you are leaving tomorrow.' To his absolute astonishment she spat in his face.

If one were acting in the capacity of dealer one would need to take that aspect of her temperament into account. John Richardson, the art historian and biographer of Picasso, who was director of Knoedler from 1972 to 1976 when Dalí was exhibiting there, had endless business meetings with them:

My feeling about him was that he was a burnt-out case, a clever old conjurer who had totally had it, a very tough businessman, shrewd as anything, being manipulated by Gala but also manipulating her. It is an axiom of the art world that the creator appear as an unworldly, free spirit and that the wife be fiendish, but Gala really was. What is unforgettable about her is that she would hit you all the time. She would belabour you physically if you didn't give her what she wanted; she went at you with her fists.

Richardson wanted to think of Dalí as he had been in the 1930s, a great magical painter, and not what he became, 'destroyed by this terrible woman, Gala – because I think Gala was only interested in power, money and luxury'.

Port Lligat is a small, sheltered, barren cove, very well protected from the sea and without distinction. It has a grey pebble beach surrounded by some semi-arid grasses, small stubble, leaves, jagged rocks and no trees. A few boats are pulled up on the beach. The dominant colours are slate, mud, olive green; even the beach is grey and brown; the sky is pale and the sea silverish. Dalí's house of white walls and terracotta tiled roofs is a series of structures climbing unevenly up the side of the hill. It is surrounded by gardens which, for all their openness to the sky, sea, and road below, have been ingeniously planned so as to be out of sight. It is all on a much smaller scale than one imagines from photographs and, for all its prominence in that tiny hamlet, closed off

and secretive. Numerous visitors, who have pulled up in cars and campers, walk about in a desultory way to the sound of dogs barking, wandering past 'Sangria' scrawled in chalk on a blackboard and the equally crude pointers to a snack bar-boutique, food, and rooms, and on past the 'No Camping' signs. The blinds of Dalí's house are drawn.

Dalí liked to point out that the name, Port Lligat, meant 'tied port' and for him it was the equivalent of a jail cell since it left him alone with himself, at least in the early days. It provided 'a life of asceticism, of isolation. It was there that I learned to impoverish myself.... A life that was hard, without metaphor or wine, a life with the light of eternity.' It might seem charmless by day under the clouds of an October sky, but at night, when the ragged edges of the rocks were blurred and the barrenness masked, one could endow it with a certain evocative charm, as Josep Pla did after he arrived there by boat one night.

At the mouth of the cove the sea seemed dead.... Far off, and almost lost in the immensity of it all, one could hear the soft, floating rumour of the undercurrent on the cliffs of the coast.... As this rumour gradually decreased, there came – across the warm night air – the monotonous chant of the crickets in the olive trees, and near by, the stifled sighs made by the ropes of the anchored boats.

From the original two rooms the house had gradually become a rabbit warren of interconnecting levels, flights of steps, ingenious doors, and large windows facing the sea, or terraces planted with herbs and flowers. As with most fishermen's cottages in that area, rooms were low-ceilinged, tile-floored, painted white, and invariably contained fireplaces, since winters are cold. Everything was meticulously neat and clean – Dalí insisted on that, even in his studio, no doubt a vestige of his tidy mother's influence – and the décor was an interesting combination of his more eccentric props, like the dyed polar bear at the entrance that had been given to him by Edward James, now a receptacle for scarves and umbrellas, and Gala's more predictable tastes, such as a damask-covered Louis xv chair. Dalí designed the handsome fireplace wall in the living-room, and beside it Gala placed a Russian samovar, iridescent silk pillows, some comfortable banquettes, books, chairs, candlesticks, and vases of flowers. When Dalí was there he was always working. 'He worked twelve to fifteen hours a day when I first met him ten years ago,' said Jean-François Fogel, a French journalist for Libération and Le Point, now a member of Dalí's Foundation. 'He was always working except on Sunday. Painting and writing, making sketches, looking for ideas for a new book.' In Paris or New York, Dalí ate expensively. In Port Lligat it was the simplest

food possible, fresh fish, shrimp, or anchovies with salads of tomato and lettuce. The days of drinking too much, or very much at all, had long gone. Although he served pink champagne to his guests, he would hardly touch half a glass and often drank tea at the cocktail hour. Those who visited him expecting to see him in full regalia might be in for a shock. Moustache ends were unwaxed, there might be no sign of the cane, and their host would be wearing a simple, open-necked shirt and a pair of slacks.

Edwin Mullins, a British art critic, novelist, and writer of television films, was an art critic for the *Daily Telegraph* when he first met Dalí in the mid 1960s. 'I leapt at the chance, but actually I was terrified,' he said. 'I don't think I had ever interviewed anyone before. It was like going to Bluebeard's Castle. There was this really weird house. I remember ringing the bell and shaking in my shoes. I didn't know what kind of a monster would appear.'

Gala received him. She was neat and beautifully groomed, charming in a rather formal, efficient-secretary sort of way. She seemed to be the absolute figure of authority in the house and very protective of her husband. He remembered her saying, in a touching way, that she hoped he was going to be nice to Dalí. As for the house, it was oddly comfortable despite its Surrealist mannerisms and the carefully calculated visual effect. He was conducted to a completely circular room, surrounded by a padded banquette, called the egg living-room and asked to wait. 'Dalí will be with you.' He waited and nothing happened. The room, he found, had as many echoes as the whispering gallery at St Paul's Cathedral. Then he began to hear the sounds of an approach, footsteps and deep breathing, but there was still no sign of Dalí: 'I thought he'd never appear.' Suddenly there he was. 'He had dressed up for me as a clown, a harlequin, a fool, wearing a clown's bobble nose, a glittering, sequinned robe, and a hat. In his right hand he carried a cane with a death's head and in his left a tiny flag, the Stars and Stripes, which he was waving about.'

Mullins immediately relaxed and began to enjoy himself.

I got the feeling he was sending himself up as well as living up to expectations. He was laughing at himself, just a little bit. He would strike attitudes, then look at me as if to say, 'How am I doing?'

I found him a man of very great intelligence and knowledge. I got him talking about early photographs and daguerreotypes and he knew all sorts of things about them. He was very entertaining to talk to and among all the craziness of his views on art it was clear that, in certain areas, he was deeply serious, despite the exhibitionism.

That is not to say they always agreed. Dalí's much advertised opinion that

Turner was the worst painter in the world was quickly challenged. Dalí's defence of that notion was that 'the green English countryside was hopeless for painting and that Turner's late canvases reminded him of nicotine-stained fingers'. Dalí's insistence that every recent development in painting had been anticipated by himself was tiresome, his accusation of 'masochism' against Le Corbusier curious, and his obsession with Picasso, who had never acknowledged his adulation or replied to his taunts, pathetic.

They continued their discussions in Dalí's swimming-pool – Mullins would have to keep dashing out to write things down – and later at a barbecue in the nearby foothills. Quantities of rabbits were served, washed down with wine, and countless pretty girls and young boys milled around. Again, Dalí was completely at his ease, even ordinary, and that was rather nice. Mullins would always think of him at the end of the table, drinking tiny amounts of wine, joking and laughing.

The castle of Pubol, which was in ruins when Dalí bought it for Gala in 1967–8, was on three floors. She restored two and left the third untouched. Catherine Perrot-Moore recalled:

They were big rooms, painted white and decorated very soberly. No particular style; there were wooden chairs, white slipcovers, and her bedroom had beautiful baldaquin curtains in front of the door. She lived on the first floor. There was a big reception room, dining-room, two bedrooms, and a terrace, Persian carpets, candelabra, tapestries. Gala wanted Dalí to hide the ugly radiators, so he had covers built and decorated them himself, with meticulous renderings of radiators. Some of the doors were painted in trompe l'oeil so that if you were not very awake, you could walk right into them.

One had to consider the house a symbol, if not of their marital separation, certainly as evidence of their divergent tastes. Gala was heartily bored by the charades because, some thought, she was jealous of all the attention showered on Dalí. Jacqueline Goddard (a friend of Julie Man Ray, widow of the famous photographer), a photographer who spent several weeks photographing the Dalís, once asked Gala, 'How does it feel to be immortalized?' and was astonished at how angry she became. Descharnes had a different explanation. Gala had supported Dalí for years, worked for him, protected him, defended him, and deserved some time off. She loved Italy with passion and longed for a castle in Tuscany. Dalí was always promising her one – signed and sealed with his own blood, as it were – but somehow it never happened. Fogel said, 'Dalí has been extremely tough and harsh with her. They always did what

he wanted to do, not what Gala wanted.' What he wanted was the same old yearly round shuttling between Paris, New York, and Port Lligat, with the occasional appearance in London, where his work was not as well received and the press more exacting than effusive. Gala deserved her own backdrop, something that proclaimed her difference and uniqueness. She told Dalí that he would not be welcome at the castle without a written invitation, and it seemed to strike him as a genuinely interesting idea. He painted the castle as if it were a vision out of Alain-Fournier's *Le Grand Meaulnes* – enchanted, inaccessible, and dreamlike.

The castle of Pubol was one of the locations to which Russell Harty was introduced when he set out to make a film on Dalí for ITV's programme *Aquarius* in 1973. The project came about in an unconventional way. Meeting Dalí in Paris, Harty launched the idea. 'Will it be a considered treatment of my life's work as an artist?' Dalí wanted to know. 'Absolutely,' Harty replied. 'Then No! No! No! No! No! No!' Dalí said. 'Goodbye. Thank you. I want you to go away now. Our conversation is finished.' Harty hastily added, 'Well, when I say "Absolutely", I mean, can I point some cameras at you and see what happens?' Dalí would be delighted to cooperate; a date was set. Harty and his crew duly appeared and were invited to join the crowd around Dalí's swimming-pool, that included five or six hippies, three extremely elegant Greeks from a yacht anchored in the bay, the Mayor of Figueres and a great many servants with trays of pink champagne. Gala, 'a Russian lady of aristocratic mien, sharp, intelligent, difficult', was lounging against a large red cushion. The swimming-pool was 'the shape of an erect penis at one end with two round cosy corners at the other'. Dalí had an endless stream of stunts to suggest, some more promising than others. Gala was being wayward. Having had a tour of Pubol, Harty ingenuously asked how long Gala intended to remain in that idyllic setting. 'Why?' 'Well, I just wondered.' 'Why do you ask such questions? Why do you look for precise answers? ... Next you will ask me how long are my legs and how much money Dalí has in the bank!' She absolutely would not be photographed. She would consent to only one shot as she opened her castle door, peered out, and then closed it. A day or so later, back at Port Lligat, Gala had had a change of heart. She would allow one further shot of herself, to be taken on the roof at the end of the garden. 'How will you get on the roof?' Harty asked. 'Why do you ask such precise questions?' retorted Gala. Harty continued,

I called over the camera unit and we lined up. Standing in line were the director, the cameraman, the sound man, me, and Dalí watching Gala being lifted on to the roof by her chauffeur. When she was in position and the limelight fully on her, came the time for Dalí to distract us all. I noticed

him on my right taking off his trousers and shirt and begin to lower himself into the pool. The director whispered to me, 'Get your trousers off and follow him.' I whispered back, 'I don't have any swimming-trunks.' He said, 'I do. I'll take my trousers off and give the trunks to you.' Out of the corner of his mouth he murmured to the cameraman, 'Get your trousers off and follow them in the pool.' Gala, on the rooftop, caught sight of four pairs of hastily dropped trousers and decided that she couldn't cope with it all, so she got herself lifted down.

Harty concluded, 'I may not have been to the front lines, but by God, I've had to deal with the oddest emergencies.'

Dalí was painting far less in later years, perhaps a single major canvas a year, but his experimentation with styles was, if anything, even more energetic than before. Forays into Pop Art, optically illusionistic painting, photographic hyper-realism, stereoscopy and holography, among others, were presented in his meticulously realistic style and all had the same goal, that is to say, the construction of a new metaphysic. He explained in 1976,

The progress of the sciences has been colossal.... But from the spiritual point of view, we live in the lowest period of civilization. A divorce has come about between physics and metaphysics. We are living through an almost monstrous progress of specialization, without any synthesis.

That Dalí's experiments might be worth attention, and certainly were deeply considered, even audacious, were attributes no critic seemed willing to concede. This may well have been because Dalí, in their eyes, was perversely intent on couching his ideas in a thoroughly discredited language. American painting, which had travelled ever further in the direction of total abstraction since the war, seemed to have swept all before it. Dalí looked like an anachronism, old, tired, superficial, cynically pandering to a debased popular taste. One heard music critics thundering against melody in much the same terms at the same period. Dalí, of course, took on all of modern art and thundered back.

Dalí's work was up for reappraisal almost as soon as the war ended. Robert M. Coates wrote of one of Dalí's exhibitions in 1947 that it showed, as always, the expertness of his technique, but one had to wonder whether matter and manner were not perpetually at odds and whether the artist were striving for greater and greater skill simply because he did not have much to say. Elsewhere the same critic wrote charitably, 'I think the trouble is that everyone took him too seriously in the first place, and it is as wrong to be

disappointed in him now for not living up to expectation as it was to get angry at his antics and theatricality earlier.' That was the best to be said for him. In 1951 in London, for instance, Osbert Lancaster, never exactly a fan, was merciless about Dalí's religious paintings, which he thought might just be worthy of a minor master of the Victorian Academy, by implication deriding his championing of Meissonier and Bouguereau and even the Italian Renaissance painters. John Canaday was just as indignant:

> I suppose that no man has the right to say of another that his stated conversion to religion is an opportunistic pose. But certainly one has the right to say what one thinks when faced by Dalí's intrusive and embarrassing holy pictures, the crucifixion in the Metropolitan Museum and the Last Supper in the National Gallery in Washington.... They seem to me to be blatant expressions of morbid eroticism, in which the artist has abused the right of sanctuary to the point of sacrilege.

Hilton Kramer's review of Dalí's work appeared under the headline, 'Hoax to Unknowing Public'. It was 'complete rubbish', he wrote. 'The ostentatious display of "old master" ambition has degenerated into the purest Kitsch. The puerile fantasy, with its aggressive self-importance and operatic rhetoric, is no longer even amusing.' Dalí's latest show, Robert Hughes wrote in 1972, 'is a lugubrious event'. Dalí was undoubtedly the last of the great dandies, but no one accepted his own belief 'that he is the last of the great artists, heir to Vermeer and Velasquez'.

That is not to say that Dalí did not have his defenders. Chester Dale, the great American collector of Impressionists and modern French paintings, was 'bowled over' by Dalí's *Corpus Hypercubus* when he saw it at the Carstairs Gallery in 1955 and immediately bought it for the Metropolitan Museum of Art. Dale said, 'I can't explain it except in one way – when it hits me, it hits me hard. It's a very honest picture, very great.' Reynolds and Eleanor Morse, equally convinced of Dalí's greatness, continued to buy his work and began to publish books about him. Morse said that his book, *Dali, A Study of His Life and Work* (1958), was the first art historical study since Soby's own monograph sixteen years earlier. The biographies began to appear: Fleur Cowles's *The Case of Salvador Dali* (1959), Robert Descharnes' *The World of Salvador Dali* (1962), and Carlton Lake's *In Quest of Dali* (1969). Fleur Cowles, editor of the bold, experimental, Surrealist-influenced magazine *Flair*, and a good friend of Dalí's, approached the artist in terms of his many facets – as designer, author, poet, inventor, sculptor, jeweller, painter and exhibitionist. She had the benefit of numerous interviews with her subject, who eventually initialled every page, so that her biography may be said to have been authorized, and

Dalí evidently approved of the main thrust of her enquiry, which was to determine his sanity. There was, and still is, no question in this author's mind that Dalí was extremely eccentric if not actually insane, although reviewers did not necessarily agree. One writer observed, 'Whatever may have been the origins of Dalí's fantasies and moods, they have been professionalized through and through – and they work. Isn't that what we mean today by sanity?'

Carlton Lake, for many years Paris art critic of the *Christian Science Monitor*, was less interested in Dalí's normalcy, or lack of it, than in the public spectacle he presented, and painted a *New Yorker* style chronicle of Dalí's on-stage appearances in Paris and New York. Lake said afterwards that for anyone who could talk to Dalí in French or Spanish, it was a rare experience to meet someone with such mental agility and intellectual originality; unfortunately in English Dalí's fluency deserted him. As luck would have it, Françoise Gilot's autobiography, *My Life with Picasso*, written with Carlton Lake, appeared as he was interviewing Dalí. Dalí was horrified that Gilot should make what seemed to him to be unflattering revelations about Picasso. That Lake should cooperate on such a study, without getting the artist's permission, seemed a gross betrayal to him. Lake observed later that, although Dalí claimed to be indifferent to whatever was said or written about him, the reverse was the case. Dalí eventually became so hostile that he threatened Lake with obscene penalties if the author did not submit his manuscript for approval before publication. Lake refused and that was the end of their association. Robert Descharnes' *The World of Salvador Dali* and later studies have the benefit of his wide knowledge of the artist's life and *oeuvre* and his own photographic skills. His books are written with the close cooperation of the artist.

As has been noted, Huntington Hartford was another admirer. That multi-millionaire, who built his Gallery of Modern Art on Manhattan's Columbus Circle in 1964, bought Dalí's monumental canvas, *The Discovery of America by Christopher Columbus*, in 1960, for a reported $250,000. Hartford said the work 'exceeded my greatest expectations'. A year later he arranged for a retrospective exhibition of Dalí's work. Almost a thousand people came to the opening including, of course, Gala, posed beside paintings of herself, and Dalí, accompanied by cane, growling ocelot, and crowds of friends speaking only French. Dalí called the opening of the museum a historic event, a vindication of the Dalínian prophecy of art. 'Dalí', added Dalí, 'has never been presented better.' There were some fine passages, the critics agreed, but these were swamped beneath 'the dozens of polished absurdities that have for so long been Dalí's substitute for the talent that he killed by abuse'. If Dalí had lost his critical and intellectual following that had to be, in large measure, because of his stubborn role of the wise fool, the court jester out of Velázquez. No one took him seriously. 'Even the best work suffers by magnification of its weak-

ness since it cannot be dissociated from the Freudian clown that Dalí has chosen to project as his public image over the decades.'

Dalí was becoming an embarrassment to some serious-minded critics, art historians and museum directors. When the Glasgow Art Gallery bought Dalí's *Christ of St John of the Cross* in 1952, the crucifixion seen from above, based on a vision of Christ that St John of the Cross drew after a trance, the reaction was almost completely hostile and, in fact, the painting was slashed by an enraged visitor some time after it went on exhibit. At least half the outcry centred around the sensational price, £8,200. Six years later the gallery smugly reported that income from entry fees and royalties had amounted to £4,377 and profit from the sale of reproductions to £3,644. In other words, the painting had paid for itself in six years, making it indeed a most prudent investment. Another of Dalí's religious paintings, *The Last Supper*, was just as much of a success with the public, but less of a critical one. Some influential voices were raised in horror when it went on exhibit at the National Gallery of Art in Washington. (The painting was bought by Chester Dale and has been part of the permanent collection since 1959.) The distinguished American theologian Paul Tillich, then professor of philosophy at the Harvard School of Theology, was outraged by the painting. He called it a symbol of all the worst elements in what was termed the religious revival, sentimental and trite. As for the central portrait of Jesus, that might be a 'very good athlete on an American baseball team'. That the central figure had a distinctly modern look was unquestionable but the face was not, Dalí said, in response to Reynolds Morse's query, modelled after Gala's features; he had employed a male model. Congressman Frank Thompson Jr was among those who urged that the painting be removed from its prominent position – at that point it had a room of its own. Subsequently Sherman Lee, former director of the Cleveland Museum of Art, called it 'the most overrated individual work' in an American museum. None of this, of course, affected the painting's enormous popular success, which appeared undimmed even though the painting was quietly moved to progressively less prominent display areas. It was finally quite inconspicuous. Responding to a protest about that in 1984, Sidney Freedburg, chief curator, replied that the work's demotion had begun several years before his arrival but that he shared the view of most critics of twentieth-century art that *The Last Supper* was one of Dalí's less admirable canvases.

A great many other American and European art museums added Dalís to their collections with no protests from anyone. The Museum Boymans-van Beuningen in Rotterdam acquired some major works, many of them formerly in the Edward James collection, that included *A Couple with Their Heads Full of Clouds* (1936), *Spain* (1938), *The Great Paranoiac* (1936), *The Face of War*

(1940), and some valuable drawings. Yale University bought *The Phantom Cart* (1933). The Staatliche Museen in Berlin acquired Dalí's *Portrait of Frau Isabel Styler-Tas* (1945). The Art Institute of Chicago acquired one of the many versions of Dalí's portrait of Mae West, this one in gouache, collage and photograph, as well as a major canvas, *Inventions of the Monsters* (1937). The Albright-Knox in Buffalo acquired *The Transparent Simulacrum of the Feigned Image* (1938). The Museum of Modern Art added *Portrait of Gala* (1935) and *Imperial Violets* (1938) to its collection. The Munson-Williams-Proctor Institute of Utica, New York, bought *Cardinal, Cardinal!* (1954). The Musées Royaux des Beaux-Arts de Belgique acquired the *Temptation of St Anthony* (1946). The Philadelphia Museum of Art chose *Agnostic Symbol* and *Soft Construction with Boiled Beans: Premonition of Civil War* (both 1936). When the Edward James collection was sold, the Tate Gallery, London, acquired the *Metamorphosis of Narcissus* to add to *Forgotten Horizon* (1936). Finally, the Morse collection, now in a museum of its own, rivals Dalí's collection, on view in Figueres, for its comprehensiveness and quality. It is the largest array of Dalí's work in North America, if not in the world.

As Carlton Lake had, interviewers who attempted to surmount Dalí's formidable defenses found it an almost impossible task. One of them, writing in *l'Express*, asked Dalí whether he still had any great living enemies. He replied, 'None I believe. But I'd like the whole world to be my enemy. Those who are against me are often extremely intelligent, admirable really. What is so awful is the people who defend me, the sub-Dalínians. They're the real idiots.' One could not tell from the text whether or not this remark was delivered with any hint of a roguish twinkle. The interviewer for *Le Point* found the same barriers when he asked Dalí whether or not his provocative stance were not his way of concealing his true feelings. Far from being caught off guard, Dalí moved briskly to the attack:

'Exactly, I advance masked, that's stated at the very beginning of my novel. I've even put it in Latin.'

Q: 'Isn't there going to come a time when you will have to take the mask off?'

Dalí: 'Ah! You're not the one I'm going to tell!'

Q: 'I don't expect you to either. But, finally, you will admit that such a time must come?'

Dalí: 'I don't personally think so. Because at the moment of my death I think that I have already decided to make use of ways to be even better masked than ever. I have already thought about hibernation. That is the most impenetrable of all masks, because no one knows whether you are dead, or not.'

CHAPTER FOURTEEN

Masked Faces

'If we knew beforehand where we were going to fall, we could lay down a carpet.'

RUSSIAN PROVERB

Buying prints of an artist's work has always been a game for experts since almost any statement that can be made about what constitutes a genuine print versus a fraudulent one can be challenged. If for instance one examines the guidelines dealing with the issue that were published by the Print Council of America in 1967, one will find that 'the artist alone has created the master image in or upon the plate, stone, woodblock or other material, for the purpose of creating a print'. However, this straightforward, unambiguous language was only meant to apply to works made after 1930, since everyone knew that earlier printmakers routinely employed specialists to do the work for them. Even Dürer did not make all his own woodblocks.

Similarly, in general terms a buyer would be advised to buy a print from a limited edition since the usual argument was that the rarer it was, the greater its value. Even that general statement had many exceptions. In 1904, for instance, Picasso authorized a limited edition of twenty-nine to thirty for *Le Repas Frugal*, now one of the most famous of all his prints. One would expect it to be much more valuable nowadays than a reissue of that same print in 1912 by the French art dealer Ambroise Vollard in a larger edition of 250 copies, and it is. Yet even the cheaper Vollard copy of *Le Repas Frugal* is worth more than other, less admired Picasso prints, issued in much smaller editions. The respected New York authority Martin Gordon explained, 'If something is good, 250 throughout the world is a small amount. If it's miserable, five is too many.'

In 1967 the Print Council also made a statement about the photo-mechanical methods of making prints that were then coming into use. Such prints could not be called originals, it ruled. They were simply reproductions. Here again the Print Council set out to make a clear distinction between what was genuine, authentic and desirable about a print and what was cheap, commercial and undesirable. It could not, however, prevent artists from making use of the new technology, which they began to do at once, signing

them and calling the results original prints. As one painter said, 'Every time you set boundaries, the artist is going to work against that.'

The danger of the photomechanical reproduction is, however, that it makes it very easy for dealers to pass off their wares as 'fine' prints, lithographs, etchings and so on, when what they are selling is a cheap and eye-fooling copy. At one time, photomechanical reproductions could be identified fairly easily by the amateur; a magnifying glass would reveal the small halftone dots that are seen in a newspaper photo, for instance. Modern techniques, however, are now so sophisticated that an image can be produced without dots and screens and can deceive all but the most highly trained eye. The New York art dealer Sylvan Cole said, 'Yes, you can tell the difference, because certain images cannot be done by hand except in certain cases, i.e. by a chromiste, a technician. Very few artists have that kind of technical training.' In other words, it takes an expert to establish that there is an intent to defraud. He alone knows that what he is being asked to pay for is not an original print, was not made by the artist in question, is not in a limited edition and, last of all, bears a fake signature. Now that prints are a multimillion dollar business in the United States and elsewhere, such intents to defraud are flagrant. Cole said, 'It is high time someone exposed the entire hoax.'

Until the 1960s Dalí had produced very few prints. He had, of course, made his famous illustrations for *Les Chants de Maldoror*, originally issued in a limited edition of fifty-two watercolours by Éditions Albert Skira that had become collectors' items. He had designed book jackets, catalogues, and posters since he was young and had made numerous drawings, many of them studies for larger works, which he sold by the piece as he did his paintings. The remuneration for such studies was, in any event, not large. Even when Dalí had achieved an international reputation and was being highly paid for commercial work, it was considered perfectly proper to offer him a fee of $500 for an etching that would be reproduced 250 times, then considered a fairly large edition, as the Cleveland Print Club did in 1945. Henry Sayles Francis, curator of Prints and Drawings for the Cleveland Museum of Art, and secretary of the Print Club, conducted the negotiations and arranged that the artist would be supplied with a copper plate on which to etch the drawing agreed on, that of *St George and the Dragon*. The Print Club would be responsible for the printing, and the results would be forwarded to the artist for his approval and signature. Once the edition was complete the plate would be scored so that it could not be reused, a common practice. The Print Club, which had previously commissioned such artists as Henri Matisse, Rockwell Kent, Camille Pissarro, Thomas H. Benton and others, was a distinguished institution and Dalí was obviously delighted to be asked.

Dalí's determination to start etching the copper plate was continually being

announced by Gala, only to be delayed by the pressure of earlier commitments. When Dalí was finally ready, it seemed to Francis that he was asking that someone do a good deal of the actual etching for him. Francis wrote to John Taylor Arms, a distinguished printmaker, for advice. Arms replied in evident disapproval saying that, in such a case, the print ought to be jointly signed by the artist and the man who had drawn it freehand onto the copper plate and that the latter ought to receive the same fee as the artist had. He did not think, however, that this was what Dalí had in mind. Finally in January 1947 Francis managed to arrange for the use of a New York studio in which the work could be carried out. Gala's telegram to Francis in February 1947 announced that Dalí had completed the etching. The owner of the studio he used, Atelier 17, subsequently sent a bill for use of the studio and equipment to Dalí, all of which supports the assumption that Dalí did the work personally. There are several extant versions of Dalí's *St George and the Dragon* but the Cleveland Print Club print is either the most expensive Dalí fine print in existence or one of the most expensive. A copy sold at auction in 1981 for $3,850.

The *St George and the Dragon* print is an excellent example of the way Dalí began making prints, since it followed all the guidelines that are considered desirable by reputable dealers. That is to say, it was actually prepared by the artist himself, it was approved by him, signed by him, and most important, once the work was done the original plate was destroyed. Almost all of these factors would eventually be absent from prints sold as by Dalí.

Dalí's biggest venture into printmaking came about early in 1965 when, at the urging of his new business manager, Peter Moore, he entered into an exclusive contract with Sidney Z. Lucas, head of the Phyllis Lucas Gallery in New York, granting him the right to be his exclusive North American publisher of hand-signed graphics. During that association, which lasted until 1971, Mr and Mrs Lucas published limited editions (100 to 300) beginning with *The Fishermen* (January 1965) and *Departure of the Fishermen*, of the same date, and continuing with other Dalí works that have since become well known: *The Three Graces, Spring Explosive*, the *Bullfight Series, Fantastic Voyage, Lucky Number of Dalí* and so on. When the original works from which the prints were made went on exhibition at the Dalí Museum in St Petersburg, Florida, in January 1985, photographs also on view showed Dalí transcribing the image of *The Three Graces* onto a lithographic stone and examining lithographic proofs of *Studio of Dalí* (1965) and *Fantastic Voyage* (1965). According to the Lucases, the master saw trial proofs in each case which he then marked '*bon-à-tirer*', meaning approved. Each print was hand-signed. In his preface to the Lucas exhibition Reynolds Morse noted that the Lucas Gallery was one of the few publishers of editions for which the claim 'limited'

could fairly be made and that the artist's signature had been personally witnessed by Mrs Lucas. None of the prints has been reissued. A few are still for sale at between $5,000 and $6,000.

The first two drawings Dalí sold to the Lucases, of fishing boats, went for $10,000 each, a substantial advance in price since the Cleveland Print Club days. It seemed like a very good business deal to the artist and Peter Moore. Instead of the painstaking easel painting that required much advance thought and months of effort, here was something that paid extremely well and took hardly any effort, especially when such a drawing could be tossed off in half an hour. And there was a long list of customers. Dalí wrote later, in describing his daily round, that Peter Moore would bring him two projects each morning after breakfast. 'I like to start the day by earning twenty thousand dollars.' Assuming that Dalí were willing to execute ten such commissions a week, that was a weekly income of $100,000 and it must have been much more. Peter Moore, who was on duty seven days a week, was expected to pay all his own expenses at the Hotel Meurice (during the month or six weeks that Dalí might be there), and the same at the St Regis (four or five months a year). All of this he did without salary but, he is said to have confided, for a commission of ten per cent on sales, which exceeded $35 million. 'Thanks to Dalí, I've made a fortune,' Moore said.

The sizes of Dalí's print editions are nowadays their most derisible aspect. What publishers like to tell their prospective buyers is that they are limited – to 350 or 500 or 1,000 – but what they frequently fail to add is that each country has its own edition of that size. Thus the German edition will have an A after it, the Italian edition an I, the French an F, the Japanese a J – with such a system in operation a supposedly limited edition can run into tens of thousands. Another of the markings often used, E/A, *Épreuve d'artist* (artist's proof) is yet one more way of magically increasing the numbers.

The more successful Dalí's prints became, the more developed became the market for the resale of his earlier works. A case in point was an aquatint *Place des Vosges* (1958), one of a series of views of Paris. It was preceded by a large drawing that was heightened with wash and went through three stages before the copper plate was cut to size and bevelled. The run of 125 copies was printed on special paper with Dalí's watermark, but the plate was not destroyed, making it a simple matter to reprint a larger edition. However, even if the master plate has been scratched, punctured, or otherwise defaced to prevent its reuse, there are ways around this. 'These plates have often found their way into the hands of publishers who issue new editions, either with the cancellation marks in place or with the scratches and holes filled in or masked as much as possible.' There is only one drawback: such reissues have almost no resale value. But this has not prevented innumerable restrikes

from being offered for sale. One of the examples on file in the Dalí Museum in St Petersburg, a suite of twelve designs called *Song of Songs*, was published by Jacques David in France in 1970. The original etching and mixed media engraving on copper was in an edition of 300 (each). According to the publisher's information, numbers 1–6 were in Roman numerals on parchment, 7–50 in Roman numerals on Japon paper, and the remaining 51–250 on Arches paper; the final product was dusted with a gold glitter. In a 1980 restrike the size of the impression was identical, supporting the view that the same plate was used, but the paper was smaller and the glitter looked distinctly different. There was no information about the size of the edition, which can be presumed to be vast.

No one now denies that Dalí is the world's best-selling living artist and that the market for his prints, in particular, is enormous: the US, Canada, Latin America, Hawaii, Israel and France in particular. His best paintings sell for up to $1 million each, his original drawings for $40,000–$110,000, his best watercolours for up to $300,000 and his prints – generally conceded to be his worst work – are being put on the market for as much as $25,000. Almost no one disagrees that the prices for his prints are wildly inflated and that a preponderant number are fakes.

Michael Ward Stout, the attorney who represents Dalí in New York, is aware of over 100 fraudulent Dalí titles circulating in the United States. Assuming, for the sake of argument, that each fake is printed in editions of a minimum of 1,250 prints, that each title sells at between $1,000 and $5,000 retail, and that the works are not as represented but invariably cheap photomechanical reproductions worth from $5–10, Stout believes that counterfeiters may have easily sold $1 billion worth of Dalí prints in the last few years. According to a California detective the usual technique is that a salesman with no experience in art sets up a 'boiler room operation', buying his wares wholesale in the US, France and elsewhere. Advertisements are then placed in professional journals. Doctors and dentists are particularly marked out as targets, since they have money, are often interested in art as an investment, and are likely to know almost nothing about art or the wiles of the art world. The so-called gallery may be no more than six or eight salesmen working above a garage, posing as 'curators' or 'artistic advisers', and skilled in high-pressure tactics. The conversation might go as it did when this author contacted one of the galleries advertising Dalí graphics.

Salesman: 'How did you find out about us?'
Author: 'I don't remember.'
S: 'Well, we like to know. Most of our business comes from referrals by

satisfied clients and we like to know who he is, so that we can give him a little extra bonus. We will do the same for you.'

A: 'I am not a client yet.'

S: 'No, of course, but we hope you will be.'

A: 'Can you send me some information?'

S: 'Yes, I was coming to that. We carry a lot of other artists, but Dalí is our featured artist, because he is so famous and so ill as you know. [He then implied that prices were bound to go up.] We have acquired all rights to this material and are offering it in editions of 1,000, all of which we own. Tell me, do you know anything about Dalí?'

A: 'A little.'

S: 'What Dalís do you own?'

A: 'Look, I'm only vaguely interested and if I have to go through a questionnaire, forget it.'

S: 'We'll send this material out right away. Do we have your full address? We usually send by overnight mail.'

A: 'Just send this by ordinary mail. The address you have is adequate.'

S: 'May I call you again in a few days?'

A: 'I'll call you if I'm interested.'

In other words, the business in question will attempt to sell to the customer before he has even seen the work. If obliged to use the mails, the lavishly illustrated leaflets sent will contain the maximum of superlatives and the minimum of precise information. There seems to be a great reluctance to commit facts to paper.

The buyer may be offered the further apparent incentive of a guaranteed investment plan. The buyer is given up to three years to pay for, say, four pieces for $6,000 and signs a contract with the dealer guaranteeing that, at the end of this time, if he wishes to get his money back the dealer will pay him more than the original sales price. Detective Craig Frizzell of the Newport Beach, California, police department said that one such buyer who came into his office had bought three copies of *Lincoln in Dalivision*, a popular image, for $1,800 each with this kind of guarantee. At the end of the agreed period he wanted his money back but the gallery was not to be found. It had completely vanished. Detective Frizzell also reported that a couple of doctors in the Mid-West answered the advertisement of an art gallery on the West Coast placed in a medical journal. Limited edition, hand-coloured etchings were being offered. One doctor bought one of these signed and numbered prints – the numbering being, say 100/500 – and sent for another copy a few weeks later. The second copy bore the identical numbering. At that point the doctor contacted his lawyer, who got in touch with the detective. The

detective asked for further information and heard nothing more. No doubt the lawyer had advised his client that his legal recourse was slim. In California, for instance, the law protects the dealer. He only has to plead that he thought the work genuine when he bought it to be absolved of all crime. Similarly, in New York State the burden of proving that a work of art is falsely labelled rests with the buyer. This is an almost certain guarantee of an expensive lawsuit that proves nothing. To attempt to argue one's technical points before the average, uninformed jury can have the undesirable effect of merely confusing them and bringing about 'a plague on both your houses' attitude. Furthermore, the buyer seeking legal redress may have difficulty finding an expert who is willing to stand up and be counted. Such experts have been sued by sellers.

Even when the artist himself attempts to intervene and halt the traffic of shoddy goods being conducted in his name, he cannot be sure of winning his suit. Miró's dealer, Pierre Matisse, recalled that at one time an exhibition of Miró's paintings went on view in New York that was patently not by Miró. The Art Dealers Association brought Miró to America to denounce them. In the course of the pre-trial examination, Miró was grilled mercilessly for a whole day. 'How can you prove this is a fake?' he was asked. Miró replied, 'It's not my signature.' The lawyer: 'How can you prove these are not your signatures?' Miró: 'I know they aren't.' The lawyers kept asking for proof and at the end of the day Miró, who was not the kind of person to defend himself vigorously, 'sat there like a stone. Poor man,' Matisse said, 'he was so bewildered.' As for Dalí, everyone believed he was too tired and ill to press charges and even if he did, the suit might be ruinously expensive and the outcome uncertain. Robert Descharnes, on whom the burden has fallen, said, 'There is a lot of money involved. I never feel much like approaching the problem.' He even feared for his life. 'It is too easy to put a gun in the hand of a man for $3,000.'

The situation has reached the point at which, according to Martin Gordon, 'There is not a great chance of getting a genuine Dalí and if it were genuine, very few people could tell and I probably could not either.' If it were by some chance genuine, the price might be somewhere between $250 and $5,000, he said. Jennifer Josselson, expert in prints at Christie's in New York, likewise believed that a top price for the best Dalí print would be around $3,000. These modest figures, when matched against those quoted in mail catalogues or over the telephone, demonstrate how little a small, informed clientele in New York thinks of Dalí's work and how ready to believe inflated claims are those outside the metropolis who only know the artist by name. Ronald Rolly of the Rolly-Michaux Gallery in New York, referring to an advertisement for a *Lincoln in Dalivision* print that was being offered for $3,000 by an art gallery

in Hawaii, referred to the same phenomenon when he quipped, 'Prices seem to rise the further west the works travel. It must be the customs duty in Mississippi.' With the exception of Phyllis Lucas, very few reputable print dealers in New York will have anything to do with Dalís. Gordon said that, apart from Dalí's acknowledged master works, the *Chants de Maldoror* etchings, of which he has never seen a complete set, 'nothing else is worth a damn'. He added, 'In essence I don't deal in most of Dalí's prints because he didn't do most of them, so what's the point? I don't need it.' He called the Dalí business a 'big can of worms', and said, 'There's a whole idiot fringe out there thinking the more they spend on a Dalí print the more they're going to get.' He gave the example of someone on vacation in Hawaii who buys a print priced from $2,000 to $8,000. 'A guy's got to know he is being taken, but as long as it is presented as a bargain he is satisfied. That's why there is this price spread. If you have been involved in the trade you know that dealers are continually "taking" new people all the time.' Gordon said he had seen portfolios of six prints at the Arcades series of auctions at Sotheby's, New York, sell for about $400 the lot and full pairs for $200. 'The average value of this material is zero,' he said. A spokesman for Sotheby's said that the company dealt with Dalí's graphics primarily by avoidance. They sold only in portfolio, when it was possible to have some idea by whom they were published and when. He pointed out, as did other dealers asked, that the sellers usually managed to operate within the law by being careful about what was actually guaranteed. For instance, a certificate accompanying purchase might say, 'Signed: Dalí', not 'Signed by Dalí'. Sometimes the question of signature was not on the certificate at all. One gallery which was selling a 'mixed media lithograph' of Dalí's painting, *The Battle of Tetuan*, for $8,000 in February 1985, sent promotional literature stating that the image was hand-signed by the artist. However, when a copy of its certificate of authenticity was requested and received, it was found to state only that the artist was Salvador Dalí. There was no reference to authenticity of signature, which has raised a further point. Michael Stout said, 'Dalí became ill in New York on 15 February 1980 and I am absolutely certain that he has signed nothing since.' In the summer of 1985 Dalí authorized a statement that, 'all the documents signed "Dalí" that are with reproductions which are put up for sale to the public cannot be attributed to me without reservations, and I reiterate, in particular, that after my arrival in Paris on the 23rd of December 1980, I stopped signing series of sheets for plates already printed or not'.

That short phrase, 'plates already printed or not', is equally loaded with implications. For years before the scandal broke, Dalí was known by publishers as being hard to find when the moment to complete his print editions was at hand. The problem, Peter Moore explained, was that, since Dalí was painting

three months in Spain, three months in Paris and five months in America, it was physically impossible for him to deliver an edition unless he left behind him enough signed paper so that the edition could be published. He said, 'When they buy an engraving, people like to think the artist sweated all night waiting for the print, and then signed it. That's nonsense.' That Dalí was willing to smooth the path in this fashion no doubt added to the attractiveness of his contracts.

At some point in the mid 1960s it was suggested to Dalí, or he hit on the idea himself, that his signature alone was worth money. Why bother to create an image? All he had to do was sign a sheet of paper to receive $40. An eye witness described the way it was done. One aide slid the paper under his pencil and another pulled it away, for the greatest possible efficiency, meaning that the artist could sign one every two seconds. Assuming he could keep it up for an hour, Dalí was $72,000 richer – the easiest way to make money yet. The floodgates to blatant fraud had been opened.

No one knows how many blanks the artist signed. His lawyer, Michael Stout, doubted that it was more than 40,000. Peter Moore has been quoted as stating that there may be as many as 350,000. In other words, somewhere in the world there are 40,000 to 350,000 genuine Dalí signatures on blank pieces of paper. Leaving to one side the question of whether the prints were or were not photomechanical reproductions tricked up to look like the real thing, any dealer would assume that the handsome stacks of signed blanks on wholesalers' shelves were genuine; the greater the number supposedly at large, the more reassured he would be. The forger would be left at liberty to make ever freer use of Dalí's images or, in plain language, fake them himself. No one will ever know the truth. Peter Moore has helped underscore this point with his book, *The 678 Signatures of Dalí* (1984), published in Vienna, a compendium which, just to complicate matters a little more, identifies all the ways this artist had of signing his name. For a forger, of course, it is a very handy blueprint.

Moore has stated that he believes blank sheets with fake Dalí signatures are now on the market, but states that this problem did not begin until after he had left Dalí in 1978. Morse and Descharnes have stated that they have evidence that such signatures are now written to order. Morse engaged a detective to go to a Paris wholesaler's and offer to buy prints. 'How many are there?' the detective enquired, indicating a stack of sheets. He was told there were 12,000. 'They are not signed yet, but come back tomorrow and they will be,' he was told. Similarly, Descharnes stated that he discovered some 20,000 sheets of blank lithograph paper bearing forged Dalí signatures in a Geneva warehouse. The pile, which he said belonged to an American gallery, was to be made into supposedly authentic Dalí lithographs. Morse also said

that if such shenanigans had been taking place on the stock-market, 'the whole thing would have blown up by now'.

Meanwhile, news of the Dalí signed blanks and the ambiguities surrounding them has had the effect of depressing the retail market to some extent. In the autumn of 1985, Detective Frizzell said that wholesale prices had dropped to $30 for a signed blank and $100 for a print. 'Business is not so good,' he said. Apart from taking the limited step of disclaiming responsibility for late signatures, Dalí, who has certainly reaped enormous profits, has taken a detached attitude. If there is a proliferation of such editions, that is society's problem. 'I cannot be held responsible for the evolution of the art market,' he explains, according to Descharnes. It is ironic, to say the least, that the son of a man who had only one thing to sell – the probity of his signature – should have set in motion a chain of events which has cheapened, if not made valueless, an important part of his *oeuvre*.

Reproduction rights to paintings in private or museum collections around the world present yet another complication affecting a whole area of Dalí graphics. Laws governing these copyrights are complex and often mutually contradictory, when the countries involved are not signatories to international copyright conventions as is the case, in this specific instance, with the United States. In France an artist can almost never lose his copyright, i.e. his right to income garnered from sales of reproductions. However, in the US before 1976 the legal presumption was that these rights went with ownership. A collector or a museum buying the work might assume that copyright rights had also been bought. To ensure such copyright status, however, notice of copyright was also required on all works published. A work might be said to have lapsed into the public domain if it was published without such notice of copyright and not challenged.

Such loopholes seemed to invite lengthy and inconclusive court cases over who owned what might, in many cases, be an extremely lucrative asset. So in 1976 the presumption was reversed. As of all works produced or sold after 1 January 1978, the ownership of copyright was not transferred in a sale, unless expressly stated. Since most Dalí sales were made before that time, US copyright ownership was not greatly affected. One has to conclude that either the Dalís were not given a full explanation of the complicated American situation or they chose to ignore it when, in 1981, they accepted the contract presented them by a consortium of business people offering $4 million for the copyright reproduction rights to 100 Dalí paintings. By then the Dalís had engaged the Société de la Propriété Artistique des Dessins et Modèles. (SPADEM), an organization that administers rights of artists such as Monet, Renoir, Degas, Matisse, Rodin, Rouault, Utrillo, Max Ernst and Picasso, to

draw up the contract on their behalf. Since Dalí owned his own copyright under French law, and also under the new American laws, SPADEM's lawyers took the view that he had the right to sell them under any and all circumstances. This position is contested by the Dalí Museum in St Petersburg, Florida, which owns eight of the paintings cited in the agreement. The Metropolitan Museum of Art similarly takes the view that copyright ownership of Dalí's *Corpus Hypercubus* belongs to the museum, since the old copyright laws were then in effect. Dalí's lawyer agrees. He said, 'This is a real problem. A Spanish subject, selling property in America in the 1960s, cannot pass through Paris and invoke French law just because he wants to make several million dollars.'

That legal suits can become unpleasantly complicated is demonstrated by an imbroglio in which the Wadsworth Atheneum found itself in 1984, as a result of its ownership of *Apparition of Face and Fruit Dish on a Beach* (1938), which it acquired in 1939. SPADEM was in dispute with Magui Publications, SA, over copyright ownership. Both lawyers appealed to the museum hoping to enlist it on their side, according to the registrar, David Parris. SPADEM claimed absolute right to copyright ownership. For its part, Magui Publications wanted the museum to prove it had bought the copyright along with the painting in 1939, so that Magui could then argue that this right had gone by default, because copyright notices had not been affixed to museum publications of the work. In such a case the painting would, presumably, have fallen into the public domain, and Magui Publications would be legally free to reproduce it.

The museum itself appeared not to have thought much about the issue until battle was joined. Both sides were duly informed through its lawyers that the museum had successfully defended its copyright with respect to the same painting a few years before, and probably would continue to do so.

Meantime, publishers with perfectly valid SPADEM contracts were offering these works for sale. One of them placed advertisements for *Corpus Hypercubus* in 'hand-signed limited edition original lithographs' in an issue of *ARTnews*. Another stated that it had contracts to sell reproductions of this same painting. A third was, in January 1985, offering prints of *The Last Supper*, the painting in the National Gallery of Art in Washington, for prices ranging from $1,950 to $2,250 and of the painting *The Christ of St John of the Cross*, now in Glasgow, for $1,950 to $2,350. The April 1984 price list of yet another publisher listed the Tate's *Metamorphosis of Narcissus* for $750, the National Gallery's *Last Supper* for $4,000, the *Corpus Hypercubus* for $3,000, the *Christ of St John of the Cross* for $3,200 and the Dalí Museum's *Christopher Columbus Discovers America* for $1,200. Still another publisher offered the Museum of Modern Art's *The Persistence of Memory* for $2,700 and the Dalí Museum's

Three Young Surrealist Women with Heads of Flowers for $1,600. All of these prices were considerably higher than the cost of the same prints at their respective museums.

In many of these cases, the image is not exact. In 1984 one gallery in New York was offering what it called an original lithograph with embossing in limited editions of a thousand copies of a work painted by Dalí in 1930 to which he gave the title *Invisible Sleeping Woman, Horse, Lion*. The painting had been renamed the *IV Apocalyptic Apparitions of Caesar in Dalivision*, priced at $4,200. An examination of the dimensions of the print, 30" wide by 22" deep, compared with the painting's dimensions of $27\frac{1}{2}$" wide by $23\frac{5}{8}$" deep, revealed that the work was now somehow $2\frac{1}{2}$" wider than the artist had painted it, but $1\frac{5}{8}$" shorter. Something similar happened to another early painting offered by the same gallery, *Ossification Prematurée d'Une Gare* (1930), which was blown up from its original dimensions of $10\frac{5}{8}$" wide by $12\frac{3}{8}$" deep (the copy is 28" wide by 32" deep) in a peculiar way. The print was either proportionately wider than it should have been or had been cropped at the bottom. This trick of adjusting the image is, apparently, technically feasible and commonly done so as to fit the picture to the pre-cut paper rather than the other way around, but one would think that a buyer paying such hefty prices would be entitled to an exact rendering. Obviously the museums are in no way concerned in all this.

Such alterations are even more dramatically evident in the catalogues of a Paris publisher, which show the *Metamorphosis of Narcissus* so cropped on the right-hand side that the dog its creator depicted has lost its head. The work also appears to have been cropped on the left-hand side and the colours are very different from those of the original. As for Dalí's *The Invisible Man*, this work has been even more drastically dealt with; the painting has been cut in half and the bottom part discarded. *The Dream* (1931) presents a special case. The face of the central figure is the same but the painting has been radically reworked on the right-hand side so that instead of the black ground the artist painted, there is now what looks like an infinity of sand and blue sky. When the same firm had one of its many exhibitions in a New York hotel in the winter of 1984–5, the author paid a visit and saw a copy of this print for sale for $800. Another very popular image, to judge from the number of times it appears for sale, is *Vertigo* (1930), in the collection of the Prince de Faucigny-Lucinge, sold by various art dealerships and published by a French publisher. In August 1985 this print, which had been transformed from a rectangle to a square and dusted over with gold spangles, was for sale at Tot Art, no doubt in good faith, for 60,000 pesetas or about $400. Tot Art, at No. 3 Maria Angels Vayreda, is an art shop in Figueres run by Mariá Luisa Thomas who was, until very recently, director of Dalí's own museum there.

What makes the whole affair so interesting is that her store lies in the very shadow of the building inside which the artist lay bedridden, and opposite his very museum.

The issue of Dalí's sculptures presents a similarly confusing and ambiguous picture. So far as can be ascertained, Dalí only executed forty-three small figurines that can fairly be considered to be entirely his. He modelled them himself in a soft wax and they were afterwards cast in precious or semi-precious metals. His contract to create these figurines was made with Isidro Clot Fuentes, a Madrid businessman, in 1975, and Dali subsequently modelled the group in sizes ranging from two or three to eighteen inches high. There are monsters, horseback riders, bishops, Madonnas, depictions of Gala at a window, the Christ of St John of the Cross, and so on. The figurines are now in the permanent collection of the Dalí Museum in St Petersburg and went on exhibition in January 1985.

Dalí's name appears on many other sculptural objects but these are believed to be collaborations, sometimes called 'transformations', the result of a commission from Dalí to a sculptor or sculptors to prepare the work for him. When it was in roughly final form, Dalí would add the finishing touches, usually Surrealistic. Such examples are to be found on sale for prices ranging between $4,500 and $10,000.

The most famous example of this kind of collaboration led to a lawsuit that Dalí lost. The sculpture in question is his Head of Dante, a copy of which is in the collection of the Wilhelm-Lehmbruck-Museum der Stadt Duisburg near Düsseldorf in West Germany. Cast in bronze and painted green, the head is garlanded with a halo of silver spoons; Dalí's signature, 1964, is also prominent. Herein lies the nub of the issue since Forani, a Belgian woman sculptor, said that since she had sculpted the head herself (to Dalí's specifications), it ought to bear her name. She took the case to court in Brussels in 1969 under a provision of Belgian law, similar to French law, that allows the artist a *droit moral*, or moral right, going beyond copyright, protecting his or her work. Forani made her claim and Dalí's lawyers counterclaimed that, since the head had been commissioned, and Dalí had then made his own alterations to it, he had clear claim to it. The arguments were heard in Belgian civil proceedings and dragged on until 1980 when the Solomon-like decision was made that the sculpture must be exhibited as their joint work, i.e. by Dalí and Forani. However, by a curious twist of fate, Forani never lived to see her position vindicated. Shortly after the decision was rendered she was killed in a car accident in Bangkok and her heirs never took the legal steps necessary to enforce the judgment. Hence, the Head of Dante is always attributed to Dalí alone.

Straightforward fakes are in a class by themselves. In 1983 *The Times* of

London reported that at least eight fake Dalí watercolours had appeared in London in the past two months, each accompanied by a fraudulent artist's certificate and signature. The works were spotted by Michel Jules Strauss, head of Sotheby's modern painting department. Occasionally, however, even the auction houses make mistakes. An oil, *À Travers le Mur*, was accepted for a Christie's (London) sale catalogue for 30 March 1982, signed on the left as by Dalí and with a certificate of authenticity from Albert Field of New York, a long-standing associate of the artist's, who has been compiling a *catalogue raisonné* for decades. It was withdrawn before the sale when Robert Descharnes raised the question of its authenticity. The problem, as a spokesman for drawings and watercolours at Sotheby's, New York, explained, is that, apart from the early work, no one wants to deal in Dalís because there are too many intangibles and too many fakes, not to mention a number of Dalís that might be genuine but are not very good. A respected New York dealer who only deals in Dalí paintings of the 1930s made the same point in a slightly different way. 'Before 1930 he had not found himself and after that decade he was just repeating himself and became a commercial artist.' One had the impression that this dealer turned away would-be sellers of other than 1930s paintings at the door. The Sotheby's spokesman did not actually go this far, but said, 'Every time someone walks in with a Dalí I cringe.'

Many examples of suits involving Dalí copyright infringement can be found in Europe. One of the cases involved the French publisher Pierre Argillet, Dalí's old associate. He happened to be walking along the Via Condotti in Rome when he discovered some prints for sale in the Ca' d'Oro Gallery of a series on *Hippies* for which he had exclusive reproduction rights. He sued for damages and another Paris dealer, Pierre Marquand, was convicted of the offence by the Tribunale di Roma in the spring of 1984. Marquand received a prison term of a year and four months, along with a fine of 2 million lire plus the cost of the trial. However, the sentence was suspended. It could not, in any case, be enforced because the culprit was not in Italy.

Another interesting case that does, indirectly, affect the print collector involves an offer that was made to American Express cardholders in 1984. They could buy four 'original lithographs' by Salvador Dalí, each bearing the artist's 'personal signature in pencil' of his drawings for *Alice in Wonderland*, for $975 each or $3,900 the set. This initiatory offer of what was to become part of a larger sale stood to gross almost $5 million for American Express.

However, the company and others associated with the offer, including Collectors' Guild Ltd, were sued by a publishing firm in Liechtenstein, Werbungs und Commerz Union Anstalt, which claimed to own the copyrights to the *Alice* prints. The suit in the US District Court, Southern District of New

York, claimed breach of contract and infringement of copyright. $10 million was sought in damages.

The legal issue is strictly limited to ownership of copyright, but has ramifications directly affecting buyers, for the case encapsulates all the issues that now surround the Dalí print market. In other words, are the images really those of Dalí, are the prints actually drawn from Dalí plates, as opposed to being simply photomechanical reproductions, and are the signatures actually Dalí's? On the issue of copyright infringement, Max Munn, president of Collectors' Guild, which initiated the offer, says that the charges are completely without foundation. Munn said that the 1968 copyright on the works was made with Maecenas Press Ltd, a subsidiary of his organization. The Dalí paper used for the American Express series came with certificates of authenticity from the printer and maker, Munn stated. He conceded that Dalí did not actually make the plates himself, but 'from Salvador Dalí's original master a chromiste [copyist] prepared the many individual colour plates'. Michael Stout stated that 'the artist never touched or approved the prints'. Did Dalí actually sign them himself? Again, Max Munn stated that he had purchased the Dalí signed blanks through intermediaries and that the signatures were genuine Dalís of the 1970s. Michael Stout, Robert Descharnes and Jean-Paul Oberthür, SPADEM's representative, all challenge this statement. According to them, an analysis of the paper used has been made. It shows that it was manufactured in mid-1981, in other words, at least six months after Dalí's own assertion that he had stopped signing anything. Finally, what are such works really worth? Laurence Casper, a former president of the Appraisers' Association of America, who certified them, stated that they were worth significantly more than $975. However, Aldis Browne, a member of the Art Dealers' Association's print committee, contended, 'These are lithographs by some artisan who has copied them from Dalí. Unframed, they are worth maybe $5 to $20.' The value of the signature, if genuine, would add another $75 to $100.

Two other legal suits, both pending in New York state, raise similar issues. In the spring of 1985 the US Postal Service was given permission to search the Barclay Gallery Ltd offices at 801 Madison Avenue, New York. The affidavit filed by Robert G. DeMuro, United States postal inspector, on 22 April 1985, cited the New York State Arts and Cultural Affairs law, article 15, dealing with the sale of prints. According to that law, in order to be considered a limited edition, original fine art print and advertised as such in New York, the artist must conceive or create the master image, and it must be signed by his own hand after the print has been produced and not before. The affidavit brought charges of infringement of these laws before Barclay Gallery.

A year later, in the spring of 1986, Robert Abrams, Attorney General for

the State of New York, brought suit against seven people, charging them with having sold photomechanical reproductions, reproduced from slides of Dalí's paintings, and misrepresenting them as hand-signed original lithographs. Seven people, representing two galleries – the Carol Convertine Galleries, Inc., and the Caravan Galleries, Inc. – were arrested and charged with conspiracy in the fifth degree, schemes to defraud, grand larceny and securities fraud and issuing false certificates of authenticity. If convicted, the defendants would face up to seven years in prison and fines of up to $5,000. It was, according to a spokesman, the first time the state of New York had moved against the flourishing Dalí market. One of the companies, it was claimed, had sold roughly $500,000 in art works over a two-year period.

Felicie Balaÿ, owner of the Gallery Felicie in New York and a former associate of Peter Moore's, recalled, 'One day in New York I got a phone call from a man who hardly spoke English. It was Sabater.' She invited him to her apartment and then to dinner at a very chic restaurant Dalí and Gala frequented in New York, Laurent. It was ironic, she thought in retrospect, since Sabater eventually ate there every day. At the time he was compiling a book of artists' drawings and wanted one by Leroy Neiman, an artist Mrs Balaÿ knew well, since she had published the first book about him. She took him to Neiman's studio and Sabater declared that this marvellous artist should have an article written about him in Spain, and, 'hey presto, one day there was, arranged for and written by Enrique. He could write, he took pictures, he flew planes; whatever you wanted, Enrique could do.'

Enrique Sabater, a Catalan now aged about fifty, had married the daughter of a hotel owner. He had worked in dozens of jobs before he met the Dalís, as waiter, chauffeur, salesman for a real-estate development concern, and sporadic journalist, writing for a small local paper, *Los Sitios*, of Girona. He had also been a semi-professional football player and travel agent. Despite his lack of a single *métier*, he had a great deal of charm and the knack of being in the right place at the right time. The story is told that he went to Dalí asking for an interview for *Los Sitios*. Dalí wanted a fee of $5,000, which Sabater could not pay, so Dalí relented to the extent of allowing Sabater to take his photograph. By a lucky chance, one of the pictures Sabater took was of Dalí with a fly perched on the end of his nose. It was widely reproduced and much admired, almost in the same league as the brilliant series of photographs taken by Philippe Halsmann over a long period and under much better conditions. For thirty years Halsmann photographed Dalí in every conceivable position and juxtaposition. Dalí nude in the womb, curled up in a foetal position, Dalí breaking into a grin, half of which was Picasso's, Dalí's face melting like one of his famous watches, Dalí's moustache on the Mona

Lisa, or its pointed ends piercing a newspaper that he was reading, eyes crossed; Dalí's moustache in every kind of trick photograph – Halsmann eventually ended up doing a whole book about that appendage. The collaboration between the two men was as ingenious as it was successful. Dalí seemed to see Sabater as potentially worthy of joining the Halsmann and Descharnes ranks; in any event, he quickly joined the circle of intimates.

Sabater seems to have ceased being on the fringe of the Dalí circle and become the kingpin in about 1975, replacing Peter Moore. Relations between the Dalís and the Moores seemed to have declined throughout the early 1970s. Reynolds Morse believed that, after about five years as Dalí's chief business negotiator, Moore and Gala Dalí were involved in increasingly acrimonious confrontations, whether over the contracts themselves or Moore's increasingly affluent life-style is not known. Other observers believed it would be entirely like Gala to suspect someone on slender evidence and that she became irrationally mistrustful in the final years of her life. She had a way, one said, of pushing a handsome ashtray towards you and saying, 'Why don't you steal it?' Then, if someone did, Gala would say, 'You see, people are always stealing.' Reynolds and Eleanor Morse acknowledged wearily that this had been a problem during the length of their forty-year friendship with her. Morse said, 'I was the only person who dared stand up to her.' He recalled that, in about 1968, Air India signed a $250,000 contract with the Dalís to use publicity shots of them for promotional purposes and the Morses happened to arrive in Port Lligat just as the photographs were being taken.

Gala opened the door and said, 'You've just come to get free publicity' and tore into me and I didn't even know what was going on. So I said, 'the hell with her' and went back to our hotel and packed. As we were preparing to leave Dalí was making repeated telephone calls, trying to smooth things over. Things always began that way. We'd have to have what we called a kiss and make-up session.

Others close to the scene thought Gala had a positive genius for pitting Moore and Sabater against each other. One of them said,

Peter Moore was very social, very elegant and very good for the Dalís in the 1960s. Sabater was less sophisticated. He spoke the language of the concierge and since they were getting older, they needed that kind of help, someone to drive them around, open doors and provide an arm when they needed it.... They seemed to enjoy corrupting people. They liked to see these very simple people adopting all the pretensions of the rich. They selected people of great ambition and limited means and threw them into the arena. It amused them, but it was rather ugly to watch.

Felicie Balaÿ recalled that on one occasion, when she was in Paris with Peter Moore, Dalí gave her a Spanish cat for a Christmas present and Sabater took a whole group of photographs of the event at the Hotel Meurice. She was continually being promised copies, but somehow never received any, so the following summer, when she went to Cadaqués, she called him up to ask about it. He seemed to be going to great lengths to arrange a secret meeting, so when they met she asked him why. Sabater explained, 'Peter Moore doesn't want you to see me.' Some time later she was in a taxi with Peter Moore in New York and he stated that she was, under no circumstances, to talk to Sabater.

The continuing affair of signed blank pages must have been a cause of embarrassment for Dalí long before it became general knowledge. In 1974 an estate car going from Andorra into France was stopped by French customs officials. It was found to contain 40,000 blank sheets signed by Dalí. The driver of the car, connected with an art publishing house in Paris, successfully argued that transporting such signed blanks was not illegal and was allowed to proceed into France. No doubt the driver stated the source of his material, which must have raised a storm at Port Lligat as well as Peter Moore's unannounced arrival at the house one night. There he found his employer signing great quantities of blank sheets. *El Pais* reported, 'Dalí was doing it without informing his secretary so as not to pay the usual commission.'

Another constant irritation had to do with Gala's tightfistedness. Left to himself, Dalí would certainly have rewarded services rendered one way or another, but Gala clung tenaciously to the illogical conviction that, if someone worked for them without a salary, that proved his or her honesty. Conversely, if that person were making money from a business arrangement, he must be dishonest. Furthermore, there is no doubt that the artist and his business manager were competing in an area that was, for Dalí, even more important than money: his immortality. Establishing a museum to his art in his home town of Figueres had been a dream of Dalí's for years. It was finally opened in 1974 and plans for it were no doubt constantly discussed while Moore was in the Dalí circle. At the same time Moore was amassing his personal collection of Dalí's works, worth $10 million by his estimate. Once he announced his intention of establishing his own museum in Dalí's native Cadaqués, and bought an old hotel in a prominent position, relations must have further cooled. However, Dalí did make an appearance at the opening. Even after the two severed business relations, they were on speaking terms, apparently, until the summer of 1982 when Peter Moore showed some 400 items from his collection in a palace in Perpignan. Dalí claimed that eighty of them were fakes.

Dalí's main concern was a painting with the title *Cosmic Metaphysic* which bore his signature in the lower left corner and which was in the undated catalogue Moore had published in connection with the travelling exhibition of his works. Before arriving in Perpignan in July 1982, the collection had also been exhibited at the Auersperg Palace in Vienna and the Royal Palace in Munich. The painting shows a typical Dalínian horizon and a few objects that bear a slight resemblance to his Surrealist period. Peter Moore said that he had bought it from Xavier Cugat and that in the past fifteen years some 150 experts had seen it and not one had expressed the slightest doubt as to its authenticity. Nevertheless, the figures in the foreground were most un-Dalínian and, indeed, the painting turned out not to be by Dalí but by an American artist, Karin Van Leyden, who lived in Switzerland until her death. She had given it the title of *Brave New World* (1946) and had signed 'Karin' in the lower right-hand corner. Since an enterprising journalist had turned up a photograph of her in the act of painting the picture, which was given wide coverage, there was no questioning Dalí's assertion, but exactly when its attribution changed could not be discovered. Peter Moore said that Dalí's signature was there when he bought it.

For all his lack of interest in fake multiples, Dalí demonstrated that he could be most energetic in challenging a work in the medium he took seriously, oil painting. He filed suit in August and early in October some sixty drawings and sketches on view were seized. Peter Moore countered with his own suit claiming that Dalí had signed works he had not painted, offering two examples in proof of this position, and asking for handsome damages. The deadlock was resolved with a lengthy agreement signed by both parties the following summer (3 July 1983). *Brave New World* having by then been returned to its previous owner, Xavier Cugat, it was agreed that Dalí's signature should be removed from it. Two works titled *Amanda and the Hippie* were not by the artist, it was stated, and his signatures were to be erased before the works were returned to their owner. The signature on another work, *The Young Girl and the Sailor*, supposedly dated 1925, was also to be removed. Dalí further stated that he was doubtful about the authenticity of a sketch called *Freud* and wished to examine it further. If he decided that the work was not his, it would be destroyed. Numerous further details involved the correction of misspellings and dates. The agreement required that the Moores submit to the artist a detailed inventory of all their holdings, together with dimensions, title and date. A recent catalogue of the Perrot-Moore collection, when compared with that published in connection with the Auersperg Palace opening in Vienna, reveals that the *Cosmic Metaphysic* is no longer depicted and neither are fifty-two other items, most of them drawings.

As for Sabater, observers of the Dalí circle thought he was a strange

choice to represent such a sophisticated artist. This did not prevent him from appearing to the Dalís as the man who could do everything.

According to newspaper accounts, Sabater began in the usual way by taking a certain percentage from the sales of Dalí's paintings, jewellery and reproductions. His lawyer for the management of his business affairs was Michael Ward Stout, who began working for Dalí in 1975 and quickly won his confidence. (Stout has never ceased being Dalí's American lawyer and also represents the Dalí Museum in St Petersburg.)

According to Morse, Stout protested that he could represent Dalí or Sabater, but not both. He did so against his better judgement when Dalí insisted on the grounds that, in this way, he would have a better control over his secretary's affairs. About a year after Sabater had begun to negotiate for Dalí, on 31 May 1976, Dalí set up a company jointly with him in Girona called Dasa Ediciones, combining the two first syllables of both names, to publish posters, postcards and a monthly museum newsletter. Very shortly thereafter, according to Alfons Quinta, a former bureau chief for El País, who has been a lawyer and a policeman, and is now a judge and the main force responsible for uncovering the details of Sabater's business involvement with Dalí, two more companies naming Sabater were created in the Dutch Antilles. One was called Dalart Naamloze Venootschap or Dalart NV (established 18 June 1976) and the other was called Dasa NV. At about the same time, the US Internal Revenue Service instituted an enquiry into one of Dalí's income tax returns. The Dalís successfully defended their case, according to Stout, and the federal government subsequently refunded the artist some $200,000 for the years 1972, 1973 and 1974. Then, in November 1976, the Dalís voluntarily relinquished their permanent residence visas at the US Consulate in Paris and formally considered themselves legal residents of Spain.

The existence of the three companies, two of them, Dasa Ediciones and Dasa NV, with almost identical names but with one in a tax haven was, according to Stout, part of a sophisticated and entirely 'correct' plan designed to allow the artist to minimize the amount of taxes he would be obligated to pay on his American royalties. Unlike the reciprocal agreements in effect between the US and some foreign countries, there is none for Spain, making any royalties earned in the US by a Spanish national subject to an automatic tax of thirty per cent. The appearance of Sabater's name in the records of Dalart NV and Dasa NV, according to Stout, was part of the income tax strategy. 'The Dalís benefited substantially' from Dalart whilst he himself was overseeing its operations, Stout stated, implying that he was no longer doing so. Sabater also benefited substantially. Whenever a painting that had commercial potential was sold by Dalí through Sabater's auspices, the name of one of the three companies was in the contract as the owner of the repro-

duction rights. Dasa Ediciones was seldom cited, but Dasa NV and Dalart NV often were, according to reports by Quinta. Consequently, whenever Sabater negotiated a sale for Dalí, he received direct commissions and indirect ones as well, since he owned the companies holding the reproduction rights.

By the time the complex plan was being put into operation, Gala Dalí appears to have taken a minimal interest in the fine details. As for Dalí, he seemed persuaded of the tax advantages and willing to allow Sabater a remarkable amount of latitude in representing him. That things later went awry from the artist's point of view is conceded by Stout: 'Nobody intended Dalart to become the monster it did,' he said. Dalí sold his interest in the one company in which his name appeared, Dasa Ediciones of Geneva, to Sabater on 6 June 1979.

Estimates of just how short a time it took Sabater to become a multi-millionaire vary, but Quinta and other observers agree that the process was swift. By the time Quinta's articles began appearing in *El País* in 1980 and 1981, Sabater had become proud owner of two mansions, one of them equipped with close-circuit television, a year-round swimming-pool and a lobster pond, among other gadgets. He owned a number of expensive cars with Monte Carlo licence plates, a yacht on the bay at Llafranch, an hour's drive from Port Lligat, and lived on a sumptuous scale whenever he travelled. Stout commented, with some amusement, 'Sabater started out in a single room at the St Regis and ended up with a bigger suite than the Dalís, so they were bound to notice the visual repercussions.' It is not known how many copyrights – for prints, statuary, jewels and many other items – were owned by Sabater's three companies, but the number is substantial. Some observers believe that Sabater's yearly income far surpassed that of his employer. Of course, it was all perfectly legal.

Until 1975 Dalí was in remarkably good shape for a man in his early seventies. He travelled as usual, ate with gusto, followed an extremely demanding social schedule in New York and Paris and, at Port Lligat, worked for twelve to fourteen hours a day. He was in full command of his astonishing intellectual faculties. Jean-François Fogel, writer for *Le Point* and *Libération*, who spent thirty hours in conversations with Dalí, said, 'He was exhausting. I had the feeling whenever I talked to him that I was a fruit being squeezed dry.' He considered him to be completely egotistical. 'The power to create so much implies the power not to lose. Everything was grist for his mill. He could not afford to make a gift; he had to use everything. I do not see him as a humanist; he has nothing to do with mankind. He is concerned only with himself.'

As has been noted, Dalí and Gala took exceptional care of their health. Gala in particular seemed obsessed by the battle against old age. She had

several plastic surgery operations, at least one of them with a well-known surgeon, Dr Maxwell Malz of New York. The scars were imperceptible and, apart from some tiny lines around the mouth, she never looked her age. The surgery did, however, have the effect of drawing her skin back so tightly that her chin became sharper and more angular and her features took on a rigid, almost mask-like, look. She also paid visits to La Prairie, the Paul Niehans clinic in Clarens, near Vevey, Switzerland, for cellular therapy. According to Somerset Maugham and his secretary Alan Searle, who both had the same injections, the result was to make one feel extremely sexually stimulated. The Morses recalled that, despite her youthful appearance, Gala began to reveal her age by always wanting to sit down when they went out. They thought that one of the reasons why she disliked Dalí's large dinner parties for thirty close friends was that, in a noisy restaurant atmosphere, she could no longer distinguish different voices. As has also been noted, when not performing, Dalí lived a sober and abstemious life and kept regular hours. His only doctors' prescriptions appear to have been regular doses of gamma globulin and, according to Descharnes, of anti-depressants that he had been taking for about twenty years.

However, 1975 marked the no doubt traumatic battles between Peter Moore and Sabater as the latter slowly took control. Dalí, in later years, called himself apolitical, although Morse could think of endless occasions when Dalí was all too ready to air his political convictions at exhausting length. That his admiration for Franco, who had brought 'clarity, truth and order', into Spanish life, never wavered, is evident. That same year also marked a terrifying event in his life. On 17 September 1975 the ailing Franco ordered the execution of five Basque terrorists, pardoning six others, and Dalí sent a telegram of congratulations. He compounded the error, when interviewed by French radio, by saying that Franco ought to have executed them all. Dalí later explained that all he meant was that the death of a few people was preferable to another civil war, but it was too late. There was a storm of protest. According to the Morses, there were innumerable threatening phone calls and, according to the press, scrawled graffiti messages in Port Lligat. Then, in an obviously symbolic gesture, the chair on which Dalí habitually sat at his favourite restaurant, the Via Veneto in Barcelona, was blown up.

Dalí was naturally terrified but it did not take much to petrify him. One such occasion took place while he was being photographed by Jacqueline Goddard and her husband. 'I really would have liked to take some unposed photographs of him, while he was talking, but as soon as he even smelled a camera it was hopeless,' she said. However, during the same session she had the good fortune to catch an unforgettable glimpse of the man behind the mask. Dalí was arranging for some kind of Happening involving himself, a

goat's skull, some stones and several buckets of water. The stones, water and goat's skull were thrown up into the air simultaneously and, suddenly, 'there was Dalí running for dear life and looking a hundred years old. I never could bring myself to sell that picture.' That he was genuinely afraid someone would assassinate him one day is evident from the memoir of Maurice Béjart, who collaborated with Dalí on a ballet and opera performance in Venice in 1961. The day before Béjart's planned arrival in Port Lligat Dalí was on Spanish television and performed magnificently. Next evening Béjart arrived at Dalí's door a little ahead of time and knocked. Dalí opened it, gave a cry and pointed a finger at him. 'You have come to assassinate me!' He was trembling all over. 'But I am Béjart!' his hapless visitor said. Dalí said, 'I was sure you had come to assassinate me', and explained, in a cracked voice, that he had spent a sleepless night being terrorized by thoughts of death.

In a panic over the Basque incident, Dalí made his first plane flight and flew to New York in mid October. A month later, on 20 November, Franco died and it was another catastrophic blow. According to Descharnes, 'He began to look awful. He had something the matter with his shoulder and left leg, perhaps the result of a mini-stroke.' He had already had a prostate operation; now he began to tremble uncontrollably, and began to show similar symptoms to those of the disease that killed his father, Parkinson's. Eleanor Morse recalled that she would sit beside him and hold his hand to stop it from trembling.

Under these circumstances, a return of the old fears and suspicions was almost inevitable. Before long the inventor of the 'paranoiac-critical' method was insisting that his food be tasted in advance by his chauffeur, when he would consent to eat at all. As he withdrew into himself, his old friends began to discover that he was unreachable by letter or telephone. One of them recalled, 'Whenever I telephoned, I would have to leave a message.' Another old friend, Jaume Miravitlles, a writer who had known Dalí since childhood, also tried to reach him in vain. A maid told him to 'call back in a month'. Shortly thereafter Miravitlles wrote an 'open letter' to Gala which was published in La Vanguardia of Barcelona. 'You should know, Gala, that several news agencies, two of them international, have asked me to write Dalí's obituary. So far, I have resisted,' Miravitlles wrote. 'Are you sure I shouldn't see him?' Ana María Dalí, who had received the same treatment, began to call for a public enquiry: 'Even his family and his most intimate friends cannot see him. This will be fatal, for his health and for his spirit.'

The Dalís left the United States for the last time in the spring of 1980. They had both been given influenza shots and came down with a bad case of flu in February at the St Regis Hotel. Stout recalled that he was pressed into service. 'They were very difficult people. They had no idea of Christmas or

Sunday. She was particularly demanding; to her, a lawyer was like a maid. You used them both to clean house!' Their food was being sent up by Laurent, since they did not trust hotel food, and Stout would serve it. 'Sabater was so rich and multinational by then that he was never there.' Finally they seemed a little better so he left them in the care of Mme Kalachnikoff and went on holiday in Acapulco. Two days later he was called back to New York. There had been another crisis and, he said, 'Dalí has never had a healthy day since.'

To help them convalesce Sabater took them to the Incasol clinic, a fancy health spa in Marbella on the Costa del Sol, which was, according to Stout and Morse, exactly the wrong place. They returned to Port Lligat enfeebled and confused. By May Gala had fired the cook and the servants had not been paid. There was no heating oil in the house, there were unpaid bills and Gala was claiming they had no money. 'By then Gala was a glutton for medication,' a friend said. 'She had suitcases full of drugs and was giving them to Dalí, all the wrong things at the wrong times.' Dalí was hardly rational, in large part because of the conflicting effects of the drugs, as Morse and Stout found when they made an emergency trip to Port Lligat. Gala seemed genuinely demented. She kicked out Dalí's long-standing doctor in Cadaqués, Dr Viguerra, with the comment, 'You are not curing Dalí. You are no good.' Meanwhile she attacked anyone who dared to raise a word of criticism. 'Dalí is an indestructible rock,' she stated. 'Few people, apart from myself, have been able to rise to his heights. His sensitivity and aesthetic sense made him a perfect being.' It took Morse and Stout ten days to persuade Dalí to enter the famous Barcelona clinic run by Dr Antonio Puigvert. Puigvert subsequently prescribed psychiatric consultations with Dalí's old friend Joan Obiols, professor of psychiatry at the University of Barcelona. Obiols saw him for about six weeks. Then one evening that summer Obiols, who had just completed his weekly consultation with Dalí, was sitting talking quietly with Gala when he suffered a massive heart attack and died. The servants summoned Antonio Pitxot, Dalí's close friend who lived a few minutes away. Pitxot said, 'You can imagine what a surreal scene it was, dragging the half-dead body of the psychiatrist through Dalí's house, which is the most surreal setting itself, with all those stuffed animals. Gala was screaming, but Dalí was in another part of the house and didn't know that Obiols had died.' There was a bizarre sequel. When another Catalan psychiatrist, Ramon Vidal Teixidor, was summoned to replace Obiols, he broke his leg.

Puigvert believed that Dalí had a slowly developing case of arteriosclerosis and a Barcelona neurologist, Dr Manuel Subirana, who also examined Dalí, noted that Dalí complained of trembling in his right hand and arm and difficulty in walking and swallowing. Subirana prescribed an 'intense anti-

depressive treatment' and Dalí's condition seemed to improve. Dalí was melancholic and depressed, the doctor stated, and suggested that he might be something of a hypochondriac. Meanwhile, Dalí was still insisting that his chauffeur taste his food before he would eat it.

On Dalí's return from the Puigvert clinic in the summer of 1980 he began to eat the local fish and pigeons prepared by Paquita, the cook. According to Dalí, when he was interviewed in the autumn of that year, he had begun to paint again, was working for four or five hours every day, and devoted the rest of his time reading Spinoza and Leibniz. Meantime, Morse had made public his concern for his old friend, along with his determination to form an informal group, which he called Friends to Save Dalí. He wrote, 'We have proved pretty well that under Gala's untender care ... Dalí has been reduced to a shell of his former self.' Morse continued to make trips to Port Lligat and arranged for an international triumvirate of specialists in New York, Paris, and Barcelona who agreed on a diagnosis of Parkinson's along with the use of a new medication, which, if faithfully administered, would alleviate the symptoms if not arrest the disease. 'But Gala ... is difficult. She gives Dalí tranquilizers which, along with the emotional turmoil, are contra-indicated for Parkinson's,' Morse said. 'She once even forbade the nurses in Barcelona to give Dalí the proper medication.' Meanwhile the Generalitat, the governing body of Catalonia, began making enquiries of its own into Dalí's financial affairs and a friend began to receive despairing phone calls from Dalí: 'All my life I have made fun of everything. I have painted my fair share of wheelbarrows. Now I am the one who is going to be taken out in a wheelbarrow.'

Bit by bit the era of Sabater was coming to an end. According to the *New York Times*, Jean-Claude DuBarry visited the Dalís in Port Lligat in the summer of 1980 and, after hearing of their emotional distress and financial worries, agreed to negotiate some fast business contracts, to the sum of $1.3 million. Some months afterwards Sabater began to discuss the possibility of retiring as Dalí's secretary and was quoted by *La Vanguardia*, the Barcelona newspaper, as saying, 'My friendship with Salvador Dalí and his wife, Gala, will continue, because it is a genuine friendship, and a friendship like that is not easily broken. It will last as long as I live.' Through the intercession of Descharnes, the safeguarding of Dalí's copyright interests was transferred to SPADEM at the end of January 1981. (Morse and Stout were strenuously opposed to the move because they thought SPADEM's fees were too high.) There was a brief interregnum by DuBarry of about a month (December 1980 to January 1981). Then, through the intercession of Morse and Stout, Robert Descharnes, who had been *persona non grata* during the Sabater era, was returned to the Dalís good graces and eventually became their new business manager. That

same spring, on 18 March 1981, Dalí issued a statement to Agence France-Presse, the French news agency, that 'I declare that for several years, and above all since my sickness, my confidence has been abused in many ways, my will was not respected. That is why I am doing everything to clarify this situation, and Gala and I are once again resuming our freedom.' Alfons Quinta recalled that, shortly after Sabater's resignation, he was invited to Port Lligat and most cordially received.

In the spring of 1981 Dalí was, as usual, at the Meurice while being treated by Dr François Lermitte, head of the neuropsychiatric unit of the La Pitié-Salpetrière hospital, for Parkinson's. The astounding rumour was circulating that Gala wanted a divorce. It was said that she was accusing Dalí of impotence and telling him he was finished, washed up. A friend witnessed one of their battles. Gala cracked him on the forehead using her rings, to the friend's horror, drawing blood. When he asked her why she would do such a thing, she said, 'I wanted him to know he's been hit.' The cause of the battle was Jeff Fenholt; Gala wanted them to go back to New York so that she could see him and Dalí emphatically did not want to go. Friends said that Gala had also given Dalí a black eye. For his part, he had pushed her out of bed. Gala was admitted to the American hospital in Neuilly in February 1981 suffering from one or two fractured ribs and a minor arm lesion.

The Morses paid another visit to the Dalís in January 1981 and found them, at the Meurice, in the middle of another crisis. Dalí had received a sizeable contract from a German doctor – the down payment alone was $60,000 – to execute a watercolour of an orchid of a certain specified dimension, with the word 'orchid' in letters not less than an inch high across the top. Dalí had made a start but seemed incapable of going on and was falling apart under the stress. He was not wearing pants and urinating in the fireplace out of sheer panic. Descharnes persuaded him to do some more painting. Between them, they came up with an orchid. Morse said, 'It wasn't a bad orchid, but it wasn't a good one either.' However, it met the specifications. Dalí seemed terribly emaciated. Reynolds Morse recalled hugging him and finding that he was skin and bone. Dalí had never been tall but Morse was horrified to discover that Dalí was now so shrunken that his head was under Morse's chin.

The problem, Dr Roumeguère the French psychiatrist believed, was that Dalí no longer wanted to live. He was suicidal because Gala no longer loved him.

She is eighty-six, only two or three hours of lucidity are left to her every day and she spends them thinking about Jeff ... whom she also calls

Salvador ... and [so] she brutalizes, bullies and injures Dalí as much as she can. So his whole world is falling apart. You have certainly heard of babies who, brutally cut off from their mother, by war or illness, let themselves die of despair. For Dalí it's the same thing.

CHAPTER FIFTEEN

The Labyrinth

'The soul divines that which it seeks, and traces
obscurely the footsteps of its obscure desire.'

PLATO

Robert Descharnes, Dalí's principal spokesman, and I had our third meeting
in the spring of 1985 over lunch at the Hotel Meridien in New York. He
had telephoned from Paris to make the appointment, saying that he would
probably be staying at this hotel, although he did not yet have a reservation.
I arrived there ahead of time and asked to be announced, only to find that
he was not registered at the hotel. When he finally arrived late, he was in
the company of the chief lawyer for SPADEM, Jean-Paul Oberthür. Descharnes
looked fatigued and preoccupied by numerous concerns that included a last-
minute change of plans, because his flight to Paris had just been cancelled.
He said that he was trying to avoid meeting someone from CBS-TV who
wanted him to do a programme on art fakes. It was one thing to discuss fakes
in print, something else entirely to put them on a television screen. He
mentioned another appointment for two o'clock, and as the time drew near
I reminded him of it, but he said it was not important. We parted after about
three hours of conversation, at about 2.45 p.m.

It was my first real chance to clarify some of the questions raised by the
fire seven or eight months before, as well as press my suit for an interview
with Dalí. An American magazine had asked me to write an article about his
museum in Figueres, but insisted that I see the great man. After months of
silence Dalí had met a reporter from *El País* and had just given a long interview
to The *New York Times* that spring. He was obviously in better health and
spirits. If he had once been mentally deranged, or at least muddled and
confused, it was clear from his comments that his mind was working with
its old verve and clarity. Descharnes was guardedly optimistic and willing to
help. He thought it might be possible to see Dalí within the next few months.
He warned, however, that Dalí would not talk about what I wanted but only
what he wanted. He certainly would not discuss his family or childhood and
would not talk at all if he thought I was writing a biography because, 'he is
always sure someone will make money at his expense'. I did not know how

much weight to place on this opinion but decided to take it at face value. Descharnes discussed at some length Dalí's circle of acquaintances after wanting to know who I had contacted. While assuring me that 'I am not in the role of saying his collaborators abused him', Descharnes appeared to have reservations about them all. Peter Moore, Luis Romero, Dalí's old friend who has written a great deal about him, Reynolds Morse, the Spanish art historian Rafael Santos Torroella, even Ana María Dalí – all of them were described as prejudiced witnesses, for one reason or another. The only person Descharnes seemed to approve of was Enrique Sabater, whom he thought had been unfairly treated. He was described as most agreeable and helpful. Descharnes has a deadpan sense of humour in that he waits for his listener's reaction before breaking into a laugh that often ends in a cough. He alluded briefly to his own intention to write a book about Dalí, but one that would not be published until after the artist's death. He seemed amiably willing to help my project but said he would not tell me 'all'.

We turned to the subject of the fire of 30 August 1984, and the verdict of the Spanish court investigating it, which had been handed down early in February 1985. Its origin, the court declared, was completely accidental and there was therefore no question of criminal intent. Descharnes was most willing to go over the old ground once more. He explained that Dalí's bell push had originally been connected to a buzzer, and later changed to a system of lights. When pushed it activated a light over his bed, another in the kitchen, and a third in the nurses' room. The bell push was attached to his right sleeve with four clips. On that fateful morning Dalí pushed it once more at about five o'clock. A plastic part, worn out through continued use, gave way, causing a short circuit. A fire started in the wall and smoke began pouring out. Descharnes drew a diagram on the back of a napkin to demonstrate that Dalí's bed was at one end of a large salon and the door to the nurses' room on the opposite wall. The direction of the smoke into the salon was away from the nurses' door, which explained why they had not smelled it. However, this was the case for only a few moments, he said. A nurse and a Guardia Civil discovered what was happening and rushed into the room, but were driven back by dense smoke. Descharnes was already awake listening to a radio broadcast. He heard a nurse running by his room shouting, ran into Dalí's room, and tried to open the heavy wooden shutters, but could not. Just as he, too, was overcome by smoke, he caught site of Dalí in the light of the flames. The artist had thrown himself off the bed and was lying on the floor near the door, and not on his hands and knees, as had been reported. Descharnes, the nurse, and policeman carried him to safety.

Descharnes said that he first met Dalí in 1950 through a good friend who was public relations director for the European office of US Lines, the shipping

company. One day his friend took him to one of their transatlantic liners to meet Dalí, who was setting out for Southampton or New York, he could not remember which. Descharnes took his first photographs of Dalí on board, ones he still had. 'I was very much impressed,' Descharnes said. 'He was very charming.' Descharnes particularly admired Dalí's talent for showmanship: 'I was young, after all.' Dalí suggested an artistic collaboration; Descharnes found just the right Dior model for him, and a long friendship began. He and his wife often met the Dalís for lunch or joint trips to the movies.

Descharnes denied that relations had ever been strained. There were periods when he was cut off from Dalí because of 'the idiots', and when this happened he went on with his life, because he did have another life apart from Dalí, but they were never on bad terms. He recalled that, in the summer of 1980, he had tried to alert Dalí to the dangers in an article published in *Le Figaro* in which he stated that the artist was no longer the man he had known. He likened him to a tight-rope walker surrounded by a chorus of sycophants. Very few people had stayed 'stable', that is to say, firm, steady and well balanced, around Dalí. Descharnes implied he was one of the few because he had never been involved in Dalí's business affairs. Now rumours were being circulated about him, ones that he denied. It was not true, he stated, that he had persuaded Dalí to join SPADEM, the non-profit organization to which he himself had belonged for some years. He merely suggested it as a possibility during the period when Dalí was very upset by Sabater. It was equally not true that he held power of attorney and that his signature appeared on the cheques. He, Pitxot, and Domènech decided which bills should be paid and gave instructions to Dalí's bank, which issued the cheques. The only person with power of attorney was a former mayor of Cadaqués, an old friend of Dalí's, who had handled his Spanish affairs since 1940. This was the substance of Descharnes' comments to questions about his business affairs. Elsewhere he was quoted as saying that he made his living as a Dalí archivist, author and appraiser: '... he admits continuing the hard sell of Dalí – the kind of marketing that has produced Dalí ashtrays, T-shirts, and tarot cards as well as an awesome array of coffee-table books and leather-bound "limited edition" tomes', wrote the *Wall Street Journal*.

The article continued,

Recently, for instance, Mr Descharnes was listed as the author of a hard-bound, full-colour book promoting 5,000 numbered bottles of Le Parfum Salvador Dalí at about $3,000 a bottle. The perfume, Mr Descharnes writes in the promotional literature, is 'a unique fragrance, composed like a work of art, like a painting, with its drawing, its colors and its delicate touches; an epic struggle of rare essences!'

In other interviews later in the year Descharnes discussed a legal suit which he had successfully brought against the French weekly newspaper *L'Express* for casting aspersions on his competence in authenticating Dalí works. He thought this judgement more significant than that handed down in another lawsuit he had just lost. In it, he had attempted to prove that he had been defamed by an article in the *Journal du Dimanche* that previous autumn, September 1984, in which Dalí was described as being sequestered by his 'Troika' or 'Politburo'. After hearing testimony from his old Spanish and French friends, the French judge declined to find for Descharnes. However, by the time the verdict was handed down in the summer of 1985, the artist himself was making public denials of the rumours that he was being sequestered. Speaking on the Catalan radio in July 1985, Dalí said he was old and tired and asked his friends to respect his privacy. It made the explanations of Guardiola (the former Mayor of Figueres) and others, that Dalí's vanity was at the root of his unwillingness to be seen, very plausible. Reynolds and Eleanor Morse finally came to the same conclusion. The root of the problem was not that Dalí was being sequestered but that he was turning away old friends who had known him at the height of his masquerade and in full regalia, preferring to risk hurting their feelings rather than face the humiliation of their pitying looks.

Descharnes said that dealing with Dalí was a constant uphill fight because he automatically resisted every suggestion, whether to receive an old friend, give an interview, or just sign a cheque. 'Gala would have to put her foot down,' Descharnes said. 'Dalí has infinite ways of putting people off.' He recalled that, on one occasion when there were cheques to sign, he brought them to Dalí and warned him that he simply had to leave for Paris the next day. 'So Dalí sent a nurse out carrying a pen. His message was that I must guard it very carefully because he intended using it the next day to sign his cheques. It was his way of keeping me there.'

Dalí was still being fed through a tube as well as with vitamin supplements. The tube continued to make talking an effort, but he evidently found this preferable to the ordeal of swallowing. Descharnes' explanation, that the problem was psychological, had not changed. 'He tells me he is dying of hunger but it's his own fault.' I was not able to determine, from questioning, that there was any real understanding of Dalí's past history, or of the feelings of guilt and remorse that had apparently been reactivated by the death of Gala. Now there was no longer a Gala to exhort and seduce him into wanting to care for himself. For all his lucid awareness of his problems, Dalí seemed helpless and so did those around him. Psychiatrists, Descharnes claimed, had been of no use. They seemed paralyzed by the strength of Dalí's personality. He was devilishly stubborn and, more and more often nowadays, used silence as a weapon. Descharnes said, 'If I asked him why he was starting to eat

again, just before the fire, and why he has not eaten since, he refuses to answer.' Whenever the subject of Dalí's gifts and qualities of heart and mind were raised, Descharnes was likely to counter with an anecdote demonstrating how difficult he was to deal with at close quarters. He even called him *'malin'*, that is to say, malicious and spiteful, and said Dalí was convinced that everyone was out to take advantage of him, including his doctors. One day Descharnes had had enough. *'Foutons le camp'*, he told Dalí, *'en Amérique.'* My dictionary stated that *'foutre'* was not in polite use, but freely translated, the phrase meant, 'Then let's hop it to America.' Dalí did not take up the suggestion. Descharnes said he never knew, when he went in to see Dalí every morning, what kind of mood he would be in, but that it was frequently despairing. He was quite likely to demand that Pitxot be summoned immediately because he was about to die. One day Descharnes replied, 'If you intend to die, don't do it until tonight because I have too much to do today.' Dalí answered, 'You are making fun of me.' Descharnes said, 'Not at all, but you do not realize how much I have to do on your behalf.' In the battles that took place between Dalí and Gala it was clear where his sympathies lay. 'It's quite something to carry Dalí on one's back.'

Dalí's decision to turn his back on the castle of Pubol, connected as it was with so many painful memories, and take up residence beside the museum he had created seemed, nevertheless, a positive step. His museum and its future well-being had preoccupied him ever since the moment when, having no child of his own, he had decided to make provision for the continuation of his name and fame. That it had opened at all was a triumph, involving years of delicate negotiation and at least one visit to El Caudillo, General Franco, in 1968. Dalí's project was greatly assisted by the indefatigable efforts of Ramón Guardiola, who managed to persuade the recalcitrant state and local authorities to accept a gift of works by Spain's most famous living artist (since the death of Picasso), and then allow him to establish his museum. The choice Dalí made, of the town's former municipal theatre, in ruins since the Civil War – it had even been used as a fish market – was as judicious as the many other pivotal decisions of a long life. Besides having served as the site of his first exhibition, it was right beside the church, San Pedro de Figueres, in which he had been baptized. It was centrally located and had been a stage, making the transition to his concept of a Teatro Museo most felicitous. He told an interviewer, 'It's the sort of luck that only I could have. Just to think that, at the end of the Civil War, a bomb should fall on the Municipal Theatre, turning it into what Marcel Duchamp called a "ready-made".' He also called it a 'kinetic Sainte Chapelle', and said, 'Since everything about me is theatrical I couldn't make a better choice.'

The exterior of the museum, built in the nineteenth century in the Italian manner, with neo-Palladian detailing, has survived largely intact but the interior, almost gutted by bombs, was remodelled so as to transform it into a museum. Tiers of exhibition galleries now circle its walls, with dramatic views over what was formerly the amphitheatre that now provides a multi-storey exhibition space. A geodesic dome covers what was once the stage. Among the museum's assortment of oddities is a *Cybernetic Princess* (1974), inspired by ancient Chinese sculpture, and fashioned from computer circuits, a chair on legs with a clock for a face in the best Surrealist tradition, a bathtub from a brothel once (supposedly) frequented by Edward VII, a room that, when viewed from a certain perspective, becomes the face of Mae West, a taxi inside which it will rain once five pesetas is fed into a slot, and all manner of bizarrely juxtaposed objects, kinetic sculptures, and *trompe l'oeil* effects. The museum also houses a small but distinguished group of paintings from Dalí's own collection. Some of the most notable works on view are *The Spectre of Sex Appeal* (1934), *Ghosts of Two Automobiles* (1929), *The Great Masturbator* (1929), *Soft Self-Portrait with Grilled Bacon* (1941), and one of his most glowing portraits of his wife, called *Galarina*, painted in 1945. The juxtapositions of such 'serious' work beside the kind of objects one might have found on a seaside pier in England before the Second World War have led critics to deride the museum as a Temple of Kitsch. This has not affected its enormous popularity in the slightest. In 1984, for instance, 300,000 people went through its doors, some 67,000 in August alone. It is the second most visited museum in Spain. Only the Prado attracts greater crowds.

Dalí's Teatro Museo, not surprisingly, has outgrown its limited quarters. This has led to the acquisition of an adjoining building, which will eventually triple the available exhibition space, linked to the museum by a series of interconnecting walls and gardens. At least one wall of the Torre Galatea, as it is now called, comprises the ancient ramparts of Figueres, made of stuccoed stone two feet thick. On one corner of the wall there is, indeed, a handsome circular tower of medieval origin. The building's interior, however, dates from about 1850. Although some demolition and restoration was in progress when I visited the Torre in the summer of 1985, it was then being used solely as the artist's residence.

One entered a main doorway constantly attended by a Guardia Civil into an inner courtyard, and mounted a stone staircase leading up to the main floor. What had been the principal salon, a room of handsome proportions with French doors leading out to a terrace, had been refurbished as the invalid's bedroom. Night tables and a bed, some chairs and a few pieces of furniture were arranged around walls painted with *trompe l'oeil* panelling and fake marble and carpets laid on a floor tiled in black and white squares.

A nurses' office guarded the entrance, to one side of an interior hallway. There were another fourteen or fifteen rooms on this floor and thirty in all. Descharnes, who took me on a tour, was using another of the formal rooms as an office, sparsely furnished with a large table and two chairs; there was an ornate fireplace of French stone and faded wallpaper. Elsewhere one found the same *mélange* of faded paper patterns in, for instance, Toile de Jouy, along with odd stencilled borders still bright after the passage of half a century, high ceilings and many stone floors and fireplaces. There was an old kitchen, its walls patched with successive waves of tile in inharmonious juxtapositions. The windows, of dark wood, all had shutters closed against the sun, and the resonant echoes put one in mind of a monastery. Near the nurses' station a television set had been installed and invariably showed a soccer match. Two nurses were always on duty. Four doctors in the town had been equipped with bleepers so that they could respond the instant they might be needed. Dalí's staff included a cook and a maid, plus two or three downstairs guards, and a personable young secretary, Maria Teresa Brugués, who had been engaged as a temporary assistant by Descharnes and had become indispensable. She, like so many young Catalans, spoke idiomatic French and seemed to have the right brisk, noncommittal, nurse's touch.

Since Descharnes commuted between the Torre and his Left Bank Paris apartment, where he lived with his wife and two sons, and also travelled a great deal, there were often times when he was not in residence. The constant presence in Dalí's life, the man who came every evening at seven, was Antonio Pitxot. A tall, handsome man with an olive complexion, greying hair, a clear, open expression and finely formed, youthful hands, Pitxot has an air of calm reasonableness which has undoubtedly been enormously beneficial to Dalí during his late, difficult years. Pitxot recalled that 'there was never a time when I didn't know Dalí', but their adult friendship dated from about 1971– 2. Dalí paid him the compliment of a visit to Cadaqués to view his work, with the object of helping to advance the younger man's career. Subsequently Pitxot was invited to take over the second-floor galleries in Dalí's museum, the only other artist on permanent exhibit there. He played an important role in the design and installation of the museum, worked on sculptures for its amphitheatre, and is involved in the day-to-day details of its operation and future expansion. His artistic expertise, his sympathetic personality, and the link of their century-old family connections have given Pitxot a special place in Dalí's life. When Dalí was in the United States he would call him every day to sing a song at long distance or ask what flowers of the countryside had begun to bloom. When he came out of his skin-graft operation following the fire, 'the first thing he said was, "Put Pitxot in a mask so that I can hear his voice"'. Dalí would take his evening meal some time between seven and nine

p.m. and Pitxot was not allowed to leave until he felt ready to go to sleep. Pitxot said, 'When Gala died everyone thought Dalí would never paint again. I am the one who persuaded him to do so, bit by bit. I told him he must be like Gaudí and live for his last work [a reference to the Sagrada Familia, the cathedral in Barcelona on which Gaudí was working when he died]. Nowadays he thinks only of his museum. It is his sole remaining stimulus.'

Thanks to the details provided by Pitxot and Descharnes, a pattern of Dalí's days and nights was emerging. He could walk but would not. He moved between his bed and an armchair. He did not sleep well at night, so that he often napped in the morning. Descharnes said that, apart from the feeding problem, Dalí's general health was good: heart sound, digestion excellent, urine normal. His doctors had discarded an earlier diagnosis of Parkinson's disease. His eyesight was remarkable and his hearing acute. Maria Teresa said that he instantly recognized people outside his room by their voices. Indeed, I was asked to tiptoe past it, despite the television set. Noise bothered him. He refused, for instance, to have an air conditioner installed despite the intense heat, because of the sound it would make. There was no evidence to suggest that he did much staring out of his French windows, but if he had, he would have surveyed a small, pretty garden, replanted to his detailed instructions. It was considered a mark of great improvement that he no longer insisted on being in the dark night and day, as he had at Pubol. He complained, however, of hallucinations. Descharnes thought these were probably nightmares. He could hold a pen with difficulty and spoke on the telephone. There were long periods of silence.

Dalí liked to say that the best mask was the latest one he had thought of. In 1979, at the time of his great retrospective exhibition organized in Paris by the Centre Pompidou, it was cryogenics. One of his enduring jokes was the stir he was going to make in Figueres once it was discovered by his old crowd of the Sport Figuerense, that perennial gathering-place for the sharpest minds in the town, that he was not really dead. 'Once more, Dalí is not like the rest,' they would declare, according to him. 'He's had himself hibernated!' It was Dalí's last laugh, like the other joke he loved to make about Jean Carbona, the man who was not going to die. It was in keeping with the flip remark he liked to make at dinner parties, that 'I intend to die of an excess of autosatisfaction', and similar outrageous statements designed to scandalize and 'cretinize'. But since, as he also said, behind every lie there was a germ of truth, and since he also went on to describe in elaborate detail how the best specialist in the field of cryogenics proposed, in 1976, to deep-freeze bodies for $10,000, it was clear that at some level he was seriously considering it. He really did intend to set Figueres on its ear. He really was still, pathetically,

trying to court the opinion of that unprepossessing, provincial town. He, who had never been certain he was alive, was preparing to live for ever.

Some idea of the enduring hold the question of death had on his imagination could be gained from the frequency with which the subject was broached in interviews as he approached old age. Before Gala's demise he seemed endlessly prepared to speculate on death in all of its fascinating ramifications, quoting from his favourite writers, such as the Catalan philosopher Francesc Pujols (1882–1962), to whom he was dedicating a whole room in his new wing, and to whose enduring fame he had already erected a monument outside his museum, or Ramon Llull (1232–1316), Catalan poet, storyteller, mystic and philosopher. He was sometimes argumentative, sometimes paradoxical, sometimes self-congratulatory. He had recovered, he was convinced, from the terrors of his youth and could face death with dispassion, even benevolence. He lived more intensely and fully just by being so aware of it. Every time he took a bite of food he could say to himself, 'I am not dead, I am living, I live!' He made arclike associations between gold and angels, with a little alchemical excrement thrown in. He compared himself to saints and mystics and, in 1960, even said he was one. 'I am ... the reincarnation of one of the greatest of all Spanish mystics, St John of the Cross. I can remember vividly my life as St John, of experiencing divine union, of undergoing the dark night of the soul of which he writes with so much feeling. I can remember the monastery.' Thanks to the sheer dazzling inventiveness of his imagination he had every weapon a man facing death could want except one. In 1940 he wrote, 'At this moment I do not yet have faith' and, thirty years later, he was still talking about that. 'Since I am not possessed of faith, which is a God-given grace, I rely on my studies, my cosmogony, and all that the special sciences of my era bring me.' He even joked about his lack of faith. Like St Augustine, he prayed to God to send him the gift but, since his life was so full of pleasures, he felt bound to add, 'Yes, give me faith, my God, but just wait five or six days more!' However, seeing death at close quarters, as he claimed to have done in 1980, and finding it a joyful, even hilarious experience – 'I discovered that God is not immensely grand, as is believed, but infinitely small' – had not succeeded in inspiring in him 'the grace which is faith'. Since, as he had predicted, he was now trembling like a leaf and too terrified to swallow, it was clear that behind his confident assertions there was still a terrible fear that the end lay in decay and oblivion. Death was no longer a subject for brilliant philosophical speculations; it had entered his house and destroyed the foundation of his life. Gala's recurring fear of the effect of her death on him had been well founded. What no doubt added to his anguish was the fact that the end of her life had been marked by such bitter feeling on both sides and so many actual battles. Early in March of

1982 Gala underwent another operation, this one for a fractured thighbone. How it was caused, no one would say. That was followed shortly afterwards by further surgery, this time for a urinary tract infection. Gala, the very model of indomitable determination and with seemingly endless physical reserves, was losing her will to live. A friend spoke to Gala on the phone a few days before her death. There was more bad news about Dalí. He trembled ever more violently, was refusing to eat, and continued to lose weight. She herself was exhausted and despairing. Gala went into a coma on the evening of Wednesday 9 June, and died the following afternoon without regaining consciousness. That she had died at Port Lligat caused an immediate crisis, since Dalí was determined to carry out to the letter her wish to be buried in Pubol, but to transport her corpse the necessary distance without the permission of each municipality through which it would pass contravened an old law dating from the days of the plagues. In great secrecy, Gala was wrapped in a blanket and placed in the back of a Cadillac; Dalí followed in another. The blinds were drawn at Port Lligat and Dalí never returned.

Until the Paris retrospective exhibition of 1979–80, the most comprehensive exhibition of Dalí's art had taken place in Rotterdam (November 1970–January 1971) at the Museum Boymans-Van Beuningen. It was organized by the then director of the museum, Renilde Hammacher-Van Den Brande, whose specialty is Surrealistic art. She knew Magritte well and had organized a number of previous exhibitions of notable Surrealists. To contemplate such a showing of eighty-eight paintings, ninety-seven watercolours, gouaches, and drawings, fifteen sculptures, and thirty-six jewellery designs, was daring to say the least. Dalí's critical reputation was at its absolute nadir; how the introspective Dutch would react was another problem and there were immediate practical difficulties involved in preparing for such an enormous undertaking. Mme Hammacher pursued the elusive Edward James until he consented to lend his Dalís, with such success that some of them went on indefinite loan and were eventually purchased by the museum. James was utterly charming but gave conflicting versions about when he had bought which painting. As for their titles, that kind of information did not interest him in the slightest, so that to discover them was a major accomplishment in itself. Similar obstacles confronted her when she approached the artist himself with a view to borrowing some of the works he owned. Descharnes acted as intermediary to arrange a meeting at the Hotel Meurice. Mme Hammacher was kept waiting for half an hour, a short period by Dalí's standards. When she was eventually ushered into the great man's suite she found him seated on a couch, wearing a purple suit, with his famous cane in one hand and surrounded by young men of indeterminate sexuality. At

the other end of the room sat Gala, similarly encircled. One young man was on his knees before her, stroking her hand.

Mme Hammacher said, '*Maître*, I am preparing a show of your work in Holland.' Dalí replied that the news did not interest him. Elsewhere, in fact, he observed that he always tried to sabotage museum exhibitions, but they gave them just the same. He gave the impression that he was not particularly anxious to be roundly dismissed as an artist – perhaps the New York experience, five years before, was still a painful memory. Mme Hammacher used every argument she could think of, to no avail. Finally she reproved him for his negative attitude. The whole point of the exhibition was to honour his accomplishments, she pointed out. Flourishing his cane, Dalí responded, 'That means nothing to me, but you can be very honoured that you sat for two hours next to "Il Divino".' Despite this rebuff, Mme Hammacher sent the great man an invitation as the opening drew near. Descharnes was sure the artist would not come. On the other hand, Dalí had stated that it would be interesting for him to see a group of his paintings of the 1930s. On the day of the opening, Descharnes called to tell her that he thought the Dalís might appear. Mme Hammacher then rang Dalí's Paris hotel and was told that the great man and his wife had left – for Holland. They were a sensational success and mobbed wherever they went. In fact, the exhibition attracted 200,000 visitors during its six-week run, with long queues stretching for blocks around the museum. In Rotterdam books about Dalí appeared in all the shops and posters of his art on every wall, bus stop, and movie hoarding. Such a phenomenal success appeared to startle art critics who, for the most part, argued that the popular acclaim rather confirmed the absence of talent demonstrated by the work and not the reverse.

Similar judgements appeared a decade later, when the Musée National d'Art Moderne held its own retrospective at the Centre Georges Pompidou (18 December 1979–21 April 1980). A similar group of 300 paintings, drawings, and Surrealist 'objects' borrowed from international collections but not from that of Reynolds and Eleanor Morse, who no longer lent works, attracted so many people that the flow into the museum had, at times, to be halted. Between 8,000 and 12,000 came every day, bringing the total Paris count close to a million by the time the show ended. In the early summer of 1980 the same exhibition went to the Tate Gallery in London and the identical phenomenon was observed: a total of 251,000 visitors, the largest number ever attending an exhibition at that museum since such records began to be kept in the 1940s.

The only reason for the crowd, some commentators said, was the publicity caused by the fact that the artist had been refused admission to his own exhibition. On the day of the official opening the museum's employees went

on strike for increased salary and other benefits. Subsequently photographs appeared in all the papers of the artist arriving in a Rolls Royce wearing a leopard-skin coat, his moustache ends waxed to rapier points, and being stopped at the door. It was said that coupled with Dalí's enduring gift for keeping himself in the public eye was his readiness to pander to the lowest common denominator of public taste, of which the Pompidou exhibition provided numerous examples, such as a walk-in sculpture, designed for the show, of shocking-pink cement some 20' high, overhung with plastic sausages. One critic, Robert Hughes of *Time* magazine, called the exhibition 'the triumph of packaging over contents', and Bernard Levin, writing in *The Times* made similar comments. Dalí was a vastly overrated artist, whose work was empty, repetitive, and ugly and who had made lifelessness his stock-in-trade. Numbers of other distinguished English, French, and American critics offered involved and sometimes mutually conflicting explanations for their arguments that Dalí had just missed greatness, even at his greatest period, generally agreed to be between 1927 and 1940.

The problem, John McEwen wrote in *The Spectator*, was that ever since Dalí became unashamedly right-wing in his political beliefs and disgustingly rich to boot, he had not been popular with the intelligentsia. 'Thus the critical consensus has slowly ossified into the pronouncement that he is a minor artist, who painted some acceptable but derivative pictures on his first contact with Surrealism in the late 1920s, but who soon vulgarized the ideas of Freud ... to his own flagrantly commercial advantage.' This critic, however, considered that Dalí, of all twentieth-century painters, had most concerned himself with the preservation of the values of traditional painting, opposing the creed of novelty at whatever cost. '... Modern art in its self-destructive decadence and Russian Communism in its tyrannical mechanization he considers the scourges of our age.' He was the polar opposite of Picasso. 'Picasso consumed succeeding artistic fashions till the day he died, giving the overall impression of someone with the monstrous ambition of wanting to bring art to a close. Dalí, for all his self-publicity, is much less egocentric in his earnest endeavours to find a way forward for painting.' Dalí's later paintings, i.e. his attempts to incorporate into his art the discoveries of holography and nuclear physics with the aid of stereoscopic viewers, while not answers in themselves, were certainly fascinating forays into new possibilities. McEwen considered Dalí almost as phenomenal as his compatriot, Picasso, in terms of his fanatical energy and dedication, his spirit, and the heroic scale of his work.

Apart from Dalí's commercialized graphics, perhaps the most controversial part of his *oeuvre* are his ninety-two late paintings which, it is claimed, were painted between July 1981 and April 1983. A French reporter wrote that Dalí had been stimulated to paint again in the summer of 1981 when he

learned that yet another retrospective exhibition was being organized, this time in his native land. (It took place in Madrid in April 1983.) Dalí went to work at a great rate and soon turned out fifty paintings, the report claimed. He had even refused the help of his long-time assistant, the Barcelona artist Isidor Bea, who for years had prepared canvases and had worked on subsidiary details. Although his hand sometimes trembled Dalí worked as in the old days while Gala, a fragile eighty-eight-year-old, read to him in a loud voice, as she had always done. After the shock of her death, he returned once more to his canvases, according to the same report. However, even Descharnes, who insisted that the works were from Dalí's hand, conceded that he was helped on many of them, presumably the last forty-two, by Bea. Other reports were that more than one assistant was involved, as the bewildᴗring diversity of styles would suggest, and that Dalí did little more than outline his idea, apply a few brush strokes and finally affix his signature, the most valuable addition of all. Michael Findlay, director of fine arts for Christie's in New York, thought that if Dalí had claimed the works as his own then they would have to be considered by him, no matter how many other artists were involved. 'Whether they are good is another matter entirely.' A fairly compelling piece of evidence against the likelihood that Dalí was capable physically of painting so many works in such a state of mind, was provided by the Madrid exhibition itself. On display were twenty-nine manuscript pages of scrawls Dalí made six months after the death of Gala, in October 1982: jagged, faltering, and pathetic. He called them *Escritura Catastroifome*, meaning, presumably, *Catastrophic Writings*.

Although Dalí's late paintings are unlikely to add much lustre to his critical renown in the United States, *ARTnews* commented of Dalí in 1983 that 'the recent return to figuration and the accompanying revolution in taste are reversing many critical verdicts'. There seemed, in particular, to be an increasing appreciation of his pre-war works. As one art historian put it, 'Only a lunatic would deny the great qualities of the 1930s. They are kinds of masterpieces, there is no getting away from it.' In the same vein the director of the Guggenheim, Thomas Messer, called Dalí a great figure of twentieth-century art and said that his pre-war paintings were among his greatest contributions. Other kindlier verdicts would, no doubt, await a retrospective exhibition chosen with considerable discrimination to show the artist at the height of his powers, rather than the all-inclusive, historical perspective of Paris, London, and Madrid. Outside of the few works in museums, Dalí's 1927–40 paintings have not been seen in New York for twenty years. A public grown accustomed to innocuous drawings of whirling Don Quixote shapes and butterflies masquerading as flowers, or the faultless, emotionally sanitized compositions of his religious period, or such vacuous, *trompe l'oeil*

exercises as the painting of Gala's back which, at the right distance, became a portrait of Abraham Lincoln (1976), might be disconcerted to discover quite another Dalí: the artist of *The Dream*, *Illumined Pleasures* and the *Metamorphosis of Narcissus*. So far, no such reassessment has been proposed.

It was said that the theme of the labyrinth intrigued Dalí because he had been lost in a park in Barcelona when he was a boy. In 1941, as has been noted, one of his most successful ballets, for which he wrote the scenario, made use of the Theseus and Ariadne legend and the original backdrop now took pride of place on his museum's former stage. It depicted the naked torso of a man, bald head bent so that his features were indistinguishable, and displaying a hairline crack, reminiscent of the egg from which the flower had blossomed in the *Metamorphosis of Narcissus*, painted a few years before. A doorway had been cut into the man's chest, suggesting a descent into the nether world. Behind him there was, on the left, an almost identical group of sombre cypresses like those Böcklin had used in *Island of the Dead* and, on the right, jagged cliffs against a dark blue sea. According to Greek legend the labyrinth had been invented by Daedalus so as to have endless winding passages, rather like a meandering river with serpentine twists and turns, but without beginning or end. If, however, Dalí had been rescued with the help of an Ariadne and her thread, there was no hint of it in this particular painting. The only implication that might be intended centred around the crack in the skull, and that made one think of 'a bulb in the head', the Catalan description of a complex, which had, however, nourished a creative daemon in this instance. Spherical forms recurred in the design for an actual labyrinth that Dalí was drawing a few days before the fire of 30 August 1984. They were to be multicoloured and affixed to the tops of a forest of tall (six to nine feet) flexible wooden poles. The point of this exercise, as explained by Descharnes, was that the visitor would be confronted by an impenetrable jungle of identical shapes that he might, or might not, discover could be parted like a sea of grass to reveal his whereabouts. That one could feel lost in a menacing and terrible world, yet that the means to extricate oneself was at hand, seemed to be the message, if, as seemed likely, there was a message. The detailed instructions Dalí had given for the renovation of the exterior of the Torre Galatea, most of which had been completed by the summer of 1985, certainly seemed designed with symbolic intent. The now familiar outlines of an egg cropped up again along the building's roofline, where a row had been fixed in place. The building's stucco walls had been freshly painted in Phoenician Red and hundreds of ochre-coloured cement objects decorated its façade row on row. These turned out to be triangularly-shaped rolls of bread, a motif that may have been inspired by one of Pujols' profound sayings, that

Dalí often quoted: 'Before filling one's system up with ideas, one stuffs it like a pudding with the meat of raw reality.' At any rate, the simulated rolls of bread looked well stuffed and solidly down to earth and, from a distance, gave the right Surrealistic jauntiness to the somewhat austere façade. Dalí had one or two further finishing touches in mind. He wanted a display of flags of all nations, with a particular emphasis on the Russian flag, out of respect for Gala. He also wanted an inscription emblazoned across the façade, *'Prohibido a todos los que no sean héroes'* (Prohibited to all those who are not heroes).

Two or three days after my arrival, on Monday 22 July, I was given a date for a rendezvous with Dalí at the usual evening hour at which he received visitors, seven o'clock. People who had known Dalí for decades, such as his old friend 'Tío Ben', Benjamín Castillo, or Luis Romero, who had a house in Cadaqués, and the well-known hotelier Jaime Subiros, owner of the Hotel Ampurdán in which I was staying, were sure I would not see him. The pattern seemed to be that visitors were promised an appointment but that it was repeatedly postponed. One of the few men who had seen Dalí recently was the reporter who had interviewed him for Radio Catalana. He made the jovial comment that Dalí would, on the one hand, insist he wanted to see no one but, on the other hand, if he did receive, he would beg the visitor not to leave him. The former Mayor, Ramon Guardiola, casually mentioned that he saw Dalí all the time. Later the Morses gave me a possible reason: Guardiola, they thought, was one of the few people who knew the actual terms of Dalí's will. The artist had apparently made two, one of them disinheriting his sister, but whether this was the first or second will, no one knew. As for Ana María Dalí, she refused to be interviewed despite the personal intervention of Eleanor Morse. Guardiola, then, was a key figure, and most interested in my project. He suggested that, when I finally saw Dalí, I let him set the pace. Sometimes he had a prepared statement he wanted to make, so that if he refused to answer my questions, I would have something to fall back on. It did not sound promising and I was not too surprised when Maria Teresa, Dalí's secretary, came back to the small reception room where I was waiting to say that Dalí was indisposed. I had brought a small gift and asked her to take it to him. This she did. It was returned with the message that I could present it personally in two days' time, Wednesday 24 July, at the same hour.

That Wednesday afternoon I had another conversation with Descharnes. Spain, which had repeatedly honoured Dalí of recent years – the King and Queen visited him in Port Lligat in 1981 and then conferred on him the highest decoration of the Spanish government, the Gran Cruz de la Orden de Carlos III, as well as giving him the title (in 1982) of Marqués de Pubol, had yet another honour in store. An avenue and also a square in Madrid were to be renamed for him and Dalí was being asked to design his own monument.

Five government officials and an architect were coming to discuss details that weekend. Dalí did not want to see me that evening. Instead he suggested that I sit in on the weekend meetings. Since, however, I was committed to leaving Figueres that Sunday I wanted an earlier appointment and Descharnes was trying to arrange one. An hour later Descharnes reported that Dalí's plans had changed again. He was now insisting that the group from Madrid come the next day, Thursday 25 July. This was going to be difficult since it was a public holiday and all the flights were booked. 'Dalí is now making everybody's life as difficult as possible,' said Descharnes, who was having stomach pains at the very thought. He seemed to veer between amused admiration for Dalí's outrageousness and heavy irony. He showed me a sketch he said Dalí had made for this monument, which was to be an enormous dolmen some sixty to seventy feet high. Even with modern technology to move a single piece of stone of these dimensions into place would be no small undertaking. That same day, Descharnes told Verges that a Dalí painting of a horseman, dating from the mid 1930s, had been given to Gala's daughter Cécile in part settlement for her claim against her mother's estate, and subsequently offered to him for sale. Descharnes said that the price was reasonable as the painting was not a major one, was on a black ground, and in a poor state of repair. So he acquired it. He made a hand movement suggestive of raking in the gambling chips. He had since had the work professionally restored and, he said triumphantly, it was now worth six or eight times as much.

The vexed question of Cécile's inheritance was not raised, but elsewhere I learned that she had threatened to bring plans for the Madrid exhibition to a halt by laying claim to Dalí's paintings on deposit in Geneva and New York, which would have prevented them from being exhibited. She received, in settlement of her suit, some paintings, an icon, her mother's clothes and furs, jewellery and other personal possessions, and between $2 and $3 million. It was known that Gala, while on her deathbed, had turned her daughter away at the door. Those who sympathized with Cécile felt it was appalling that her mother should have carried her antagonism to the bitter end in refusing to see her and attempting to disinherit her. Those supporting Dalí's position argued that the artist was not really rich at all and that paying such a handsome settlement had helped impoverish him, relatively speaking. According to a reliable source, Dalí was left with very little cash in the bank by October 1985, something like $5 million. His business affairs were still in an incredible muddle and seemed likely to remain so. Dalí's American lawyer believed that Dalí's Foundation, established in 1974 as a public body in order to administer his museum and estate, was changed to a private body a decade later in 1984. Exactly what the foundation was designed to do seemed imprecise. To add to the débâcle, on a visit to Spain in the autumn of 1985

Dalí's Spanish lawyer, Miguel Domènech, had refused to see Stout and had fallen out with another member of the 'Troika'. Nothing had been done about the blatant fakes or seemed likely to be done, because a lawsuit could bankrupt the artist. In the meantime, Robert Descharnes made steady additions to his bulging files of photographs of prints on which Dalí had drawn a cross with the word *'faux'* beside them. Descharnes said, 'Dalí must now be the most forged artist in history.'

Even though I received a phone call from Antonio Pitxot on Wednesday evening asking me, with great cordiality, what time I would like to come next evening to interview Dalí, which really seemed to mean that I would meet him at last, as I went to the Torre Galatea I could not suppress a mounting panic. Was he going to turn me away again at the eleventh hour? Would I have made the trip for nothing and have to leave empty-handed? Conversely, if he did see me, how was I to deal with him, since his friends said one never knew what mood he would be in? What kinds of questions should I ask? The issues I most wanted discussed were all those that had lain in the background for decades and to raise them would, most probably, meet with resistance. To see him and somehow antagonize him would be worse than not seeing him at all. I had decided speak French, even though Dalí understood English, because I knew he was more comfortable in that language, and Pitxot, who had kindly agreed to clarify Dalí's statements, if necessary, also spoke it well. However, I knew it would place me at a further disadvantage. A few moments after I had been ushered into the now familiar waiting-room, I saw several men coming along the corridor, no doubt the bureaucrats from Madrid, who had obeyed the imperial summons and spent the afternoon talking with Dalí. Then Maria Teresa appeared to announce that the great man wished to rest for half an hour before seeing me. I used the time to memorize a flowery piece of French in which I said he was doing me too much honour by receiving me. I really meant it, but the more I repeated it, so as not to forget a crucial word in the flurry of meeting him, the more insincere it sounded. By the time Dalí was ready to receive me I was in no state to meet him.

He sat in his elegant, airy, light room, in a bedside chair covered in white. He was dressed in something white and flowing, white socks, and sandals, his feet resting on a low footstool and his elbows on white slipcovers. He was at one end; I entered at the other, and although the distance was probably short, crossing the room seemed to take a long time. I was greeted by Pitxot and Descharnes, wearing a wide smile, who then left, and waved to a seat on Dalí's right. I registered confused impressions of the famous moustache, once so elaborately clipped and waxed, now drooping and misshapen, white hair untidily pushed back and with straggling ends, his large, limp left hand

resting against an almost grotesquely distended stomach and his right hand on the arm of the chair. A tube of horrible thickness jutted up into his left nostril. Perhaps it was flexible but the rigid way in which it stood out, away from his body, conjured up nightmares about the process of inserting it. Yet still more disquieting was the suspicion that even to have it in place was a kind of martyrdom. Something about the stillness of that figure in the chair telegraphed the impression that the only thing that gave him strength to continue was his extraordinary willpower. Or was the tube, perhaps, umbilical? It was difficult to decide because I was, in effect, looking at a profile that betrayed not a flicker of emotion. As for his eyes, they stared straight ahead. It almost seemed as if he were no longer alive. Or rather, he had died and, through some supernatural means, at the cost of heaven knows what suffering, his brain had survived.

I managed to stammer out my little speech, which was received without comment and not so much as a ghost of a smile. I wondered if he had heard me. Then I decided he had treated that piece of gaucherie with the contempt it deserved. This was most discouraging, but I persevered, handing him my little gift, a tiny, perfect bird's nest, containing two miniature eggs. Even that seemed inappropriate now, so I was not too disappointed when, in answer to Pitxot's question, Dalí indicated with a marginal nod that he would open it later. Pitxot, evidently realizing that I was ill at ease, did his best to start the conversation. He talked about the Spanish national holiday of Santiago being celebrated that day, and that led him to Dalí's painting of 1957, *Santiago El Grande*, in which a dominant motif was the scallop shell. This led him to a reference to Botticelli's *Venus* and Aphrodite's birth in Crete and the symbolisms implied. So many learned references would surely elicit a reaction? Nothing. I then brought up the subject of the dolmen monument. When I had mentioned to Descharnes that my maiden name derived from this ancient Celtic word, he thought Dalí would be intrigued. Again, there was no shred of interest. A third subject, that of the art historian Kenneth Clark, whom Dalí met in the 1930s, was proposed, and still left him silent. I was suddenly all too aware of Guardiola's offhand comment, 'if he doesn't answer your questions...'. There was not even a prepared statement. Whatever was I to do?

I plunged into some innocuous questions. At last he began to speak, slowly, as if he were gargling; I understood about every third word. The museum, he said, should be seen as a single, immense Surrealist object that, despite its apparent meaninglessness, contained a hidden message. He alluded to Stefan Lupasco, a contemporary Romanian philosopher whose writings he much admired and who believed that extremes would meet in *'le logique de la contradiction'*. He made a brief reference to future plans for expansion. He was

still working on the design for his labyrinth. He referred to himself in the third person. His answers were extremely brief. If he were asked a detailed question, designed to elicit more than the usual stock answer, ones I almost knew by heart, he did not respond. His mind ran along the familiar tracks and exhausted itself. I realized, by the way he banged the arm of the chair as he tried to concentrate, how very tired he was. The effort to put on one more performance was just too much.

Other questions drew the usual blank and I was ready to concede defeat when he suddenly volunteered a statement. 'You know,' he said, 'I am a better writer than I am a painter.' I was so relieved that I was ready to agree to anything and, for the first time, he actually stole a sidelong glance in my direction. I was absurdly pleased. I had brought with me a borrowed copy of the poem he had written to accompany the *Metamorphosis of Narcissus* in 1937, published by Julien Levy in New York. There was a photograph of Gala on the cover by Cecil Beaton, posed in front of two of Dalí's Magritte-inspired canvases, one in the shape of a male head and shoulders and the other of a female. Gala was seated, looking towards her right shoulder, one hand up to her forehead, her delicate wrist encircled by an exquisite bracelet, wearing a low-cut evening gown, the bodice of which seemed covered with tiny sea-shells. She looked pensive and the graceful lift of her chin and expressiveness of her raised arm made one aware of her in a way that was difficult to describe; while remote, she seemed somehow very vulnerable. Pitxot held the book at some distance from Dalí and he looked at it without comment. Pitxot told me afterwards that it had been painful for Dalí to see Gala again. It seemed reminiscent of the time when, during his last venture into the outside world, Pitxot had pointed out a handsome orange tree, laden with exquisitely ripe fruit. Dalí replied, shaking his head, 'Do not show me things that I have loved so much and that hurt me so much because I know that I have to leave them soon.' I had hoped to make a human contact, and had only succeeded in arousing painful memories. Unwittingly, I had done absolutely the wrong thing.

As I left Dalí kissed my hand, 'a kiss in the air', as one of his courtiers would say, and I walked towards the door. But I suddenly thought of the gift I had taken so much trouble to deliver, and wondered whether it might be overlooked. So I turned to say, 'Don't forget my present.' At that moment I saw what I had despaired of seeing. His face was utterly changed. It was full, almost overwhelmed with emotion and the appeal in his eyes was agonized.

Source Notes

The following abbreviations have been used in the notes:

Ades Dawn Ades, *Dalí and Surrealism.*

AM Ana María Dalí, *Salvador Dalí vu par sa soeur.*

BOS Alain Bosquet, *Conversations with Dali.*

Brenan Gerald Brenan, *The Spanish Labyrinth.*

Cowles Fleur Cowles, *The Case of Salvador Dali.*

DEL Manuel Del Arco, *Dali in the Nude.*

Ernst Jimmy Ernst, *A Not-So-Still Life.*

Jean Marcel Jean, *The History of Surrealist Painting.*

L à G Paul Eluard, *Lettres à Gala.*

Lake Carlton Lake, *In Quest of Dali.*

Levy Julien Levy, *Memoir of an Art Gallery.*

PAR André Parinaud (as told to), *The Unspeakable Confessions of Salvador Dali.*

PAU Louis Pauwels, with Salvador Dalí, *The Passions According to Dali.*

SL Salvador Dalí, *The Secret Life of Salvador Dali.*

Page	**Chapter 1: The Dalí Affair**
9	He had been badly treated: letter from A. Reynolds Morse to author, 16 December 1984.
10	A former Spanish prime minister: Leopoldo Calvo Sotelo.
10	The master refused all requests for interviews: Dianne Klein, UPI, 16 January 1984, and Brian Mooney, Reuters, 19 December 1983.
10	Antonio Pitxot Soler now uses the Catalan spelling of his name professionally. His family still uses the Spanish spelling of Pitchot.
10	A reporter from Reuters ... saw the master tackling an omelette: *Sunday Telegraph*, Australia, 13 May 1984.
10	'I want to see my gallery.' *Times*, London, and *Daily Telegraph*, London, 16 July 1984.
11	Regarded by the Spanish as their greatest living painter: *Times*, London, 7 September 1984.
11	There was a short-circuit in his bedside electric bell: *Le Figaro*, Paris, 13 September 1984.
12	Ignoring Dalí was good for him: *Sunday Times*, London, 16 September 1984.
12	'a profoundly disagreeable mystery': *Australian*, 10 September 1984.
12	'everything concerning the Dalí affair': *Sunday Times*, London, 9 September 1984.

13 The nurses' salary a sore point: *Le Monde*, Paris, 24 September 1984.

13 Dalí on the road to Calvary: *Le Figaro*, Paris, 7 September 1984.

13 'an old clown': *ibid.*

14 Eventual disposition of Dalí's private collection: *Observer*, London, 14 October 1984.

14 'too much money surrounding a lonely old man': *Sunday Times*, London, 9 September 1984.

14 he had forged drawings, watercolours and oils with the full blessing of Dalí: *Sunday Times*, 16 September 1984.

14 Tens of thousands of signed blanks: *l'Express*, Paris, 12 October 1984.

14 The two men came to blows: *Times*, London and *La Vanguardia*, Barcelona, 10 September 1984.

15 Dalí's own reasons for his inability to swallow: *Paris Match*, 2 November 1984.

16 Comments by Sr Verges: Interview, 17 October 1984.

17 One painting a month his maximum output: *Observer*, London, 14 October 1984.

17 'You see ... Well, look now.' *New York Times Magazine*, 12 December 1981.

17 'It is a little rotten,' *New York Times*, idem.

17 Not in full possession of his faculties: *La Vanguardia*, 10 September 1984.

17 One coherent phrase in two years: *l'Express*, 12 October 1984 and *Sunday Telegraph*, 16 September 1984.

18 Allowing the curtains to be opened: *International Herald Tribune*, Paris, 16 November 1984.

18 Dalí was sad and disconsolate: UPI, 13 November 1984.

18 'have ended by dominating him': Dr Antonio Puigvert, *Le Figaro*, Paris, September 1984.

Chapter 2: 'Myself Alone'

20 'It was during ... is therefore essential': PAR, p. 37.

20 As if its author had never lived: H. P. Lazarus, *Nation*, 6 February 1943.

20 Records of his birth had been destroyed: to Jean-Michel Royer, *l'Actualité*, December 1969.

20 Carrer is the Catalan spelling.

21 A power of personality a child less than two years old could not have displayed: SL, p. 2.

21 'never able to get over it': *Les Informations*, 6 November 1972.

21 Brother died of meningitis: SL, p. 2.

21 Had seen a child with water on the brain: *Acta Neurologica et Psychiatrica Belgica*, Special No. December 1957, Les Editions 'Acta Medica Belgica'.

22 Dalí family tree: Josep Pla, *Homenots*, p. 201.

23 The first son of this union, Salvador, born in 1862: In giving this
 year of birth I am following the information given on the birth
 certificates of Dalí and his elder brother rather than that given by
 Pla in *Homenots*, p. 201.

23 Everyone was a doctor of laws: S. L. Bensusan, *Home Life in Spain*,
 (New York: Macmillan, 1910), ch. XXIII.

23 'The separation of powers ... at the word of the Civil Governor':
 Brenan, p. 8.

23 Everyone called him 'the money doctor': PAR, p. 22.

24 'He jumped on ... but also in the period when he did': *Homenots*,
 p. 163–4.

24 'He was a difficult man ... so wild, that I had to leave': Interviews,
 October 1984.

24 'He grabbed ... held its breath': PAR, p. 24.

25 High rates of infant mortality: *Home Life in Spain*, p. 17.

25 The precociously gifted child is most at risk: Alice Miller, *Prisoners
 of Childhood*, p. 5.

25 'They made comparisons ... the source of all his problems': Inter-
 views, October 1984.

25 'We would be walking ... he was and the like': *Sunday Times*, 19
 May 1980.

25 'Take a muffler ... of meningitis': Quoted in *Dali by Dali*, p. v.

25 The inevitable *bufunda*: C. E. Armstrong, *Life in Spain To-Day* (Edin-
 burgh: Blackwood, 1930), p. 148.

25 An early version of himself: SL, p. 2.

25 'I was much less intelligent': idem.

26 'finally ... I was my brother': *Redbook Magazine*, February 1965,
 p. 93.

26 'He had the idea ... alive or dead': Interview, 1 November 1984.

26 Thoughts of putrefaction and death: *Sunday Times*, 19 May 1980.

26 'I managed ... inside the coffin': BOS, p. 33.

26 'The thought ... anguished by it': *Sunday Times*, 19 May 1980.

26 Exasperating pressures: DEL, p. 69.

26 'My soul ... like a bludgeon': *Les Informations*, 6 November 1972.

27 Aspects of Catalan history: Victor Alba, *Catalonia*.

27 'Spanish pride ... of the Low Countries': Brenan, p. 11.

27 'the Catalans ... much prostituted name of liberty ...': *Catalonia*,
 p. 8.

28 Language origins: Encyclopaedia Britannica, vol. 5, 1957, p. 19.

28 'Do as ... the Catalans': *Catalonia*, p. 3.

28 The building in which they were born, No. 2 Carrer Monturiol, is
 now No. 6. There is a commemorative plaque to the right of the
 main door.

28 The street dances: AM, p. 18–19.

29 Their mother feeding her birds: AM, p. 28.

29 Sailing ships at anchor until the First World War: Interview with
 Luis Romero.

29 'I think of ... bathe in the moon': Federico García Lorca, *Selected Letters*, p. 59.

30 'Only the ... effaced by thistles': SL, p. 128.

30 'miraculously beautiful': idem, pp. 127–8.

30 'all the accumulated ... and sentimental life': SL, p. 126.

30 The way his grandmother looked: Dalí, as recorded by Edward James, unpublished memoir, Museum of Modern Art, p. 1.

31 'She was a ... mouth that was always smiling': AM, p. 25.

31 'I pressed ... beaches of Cadaqués': SL, p. 51.

31 The image vanished: SL, p. 222.

31 'who is the ... kind of thing': idem.

32 Pale and upset: idem.

32 'I've got you!' and 'Then I heard ... step by step': SL, pp. 346–7.

32 Listening to his favourite opera: AM, p. 18.

32 *'Era en ma vida'*: One time in my life, the night was still slumbering/My soul was sleeping without dreaming;/I longed for a glance to awaken me/So as to see the sun in my confusion. (translation by Jane Eliot).

32–3 'Snick, snick ... amazingly minute silhouette': Edward James, op. cit., p. 5.

33 Their mother's gift for drawing: SL, p. 48.

33 As soon as he could hold a pencil: *New Yorker*, 1 July 1939.

33 Hallucinatory colours: AM, pp. 14–15.

33 The spelling of Ramon Pitchot's name: always used by older members of this family.

33 Her postcard the inspiration for his blouse: Luis Romero, *Dali*, p. 340.

34 'as one looked ... and see it "impressionistically" ': SL, p. 81.

35 He did not need drawing lessons: SL, p. 86.

35 'I have already ... and left': SL, p. 84.

35 His extraordinary ambitions: SL, p. 1.

36 Would not be like the other: *l'Express* magazine, 8 December 1979, p. 59.

36 Lovable but stubborn: AM, p. 21.

37 Dalí's temper tantrum, and 'We did not know ... about something else': AM, pp. 25–6.

37 'He's always got ... too easy for him!'; 'See how capricious ... any more': SL, p. 44.

37 'Do you know ... till the tears rolled': SL, p. 82.

37 Warned not to get hurt: SL, p. 43.

37 'My mother ... start crying again': AM, p. 20.

37 'capable of remaining locked ... dying of suffocation ...': SL, p. 38.

38 'the anguish of menacing doubts': SL, p. 82.

38 'Each day ... pee on the sheets': PAR, pp. 27–8.

38 'On another occasion ... my father's reaction': SL, p. 12.

38 'It was only necessary ... Myself alone!' SL, p. 116.

Chapter 3: The Boy from Tona

39	'I alone wore . . . the slightest scratch': SL, pp. 36–7.
39–40	'At the age of six . . . wanted to be Napoleon': SL, p. 1.
40	'tragical sequence of exhibitionism': Cowles, p. 32.
40	A photograph in his autobiography: facing p. 86.
40	Trayter: not spelled 'Traite' as in autobiography; Dalí's spelling was uncertain in any language.
40	Conjuring up a world on the ceiling: SL, pp. 45–6.
41	'Still tonight . . . shoot through my back': SL, p. 129.
41	'In school my fear . . . the horrible insect'; 'as if all of a sudden . . . no matter where – on me!': SL, p. 130.
41	'I've got you!': SL, p. 346.
42	Moved when Dali was ten: AM, p. 27.
42	'the cruellest ruses'; 'at a given moment . . . a deep black'; SL, p. 63.
42	'Now we're about . . . must be mauve': SL, p. 65.
42	'I did not want . . . within my head': SL, p. 64.
42	'I still wrote nonchalantly . . . do it well': SL, p. 66.
43	'finally the superiors . . . to teach me anything': SL, idem.
43	Won the jumping championships: SL, p. 92.
43	Jumped down steps to gain father's attention: Dalí, as told to Alexander Eliot, interview with author.
43	Began jumping before age of ten. Fleur Cowles says age nine: Cowles, p. 32.
43	'How many times . . . into the void': SL, p. 92.
43	'the almost invincible attraction': SL, pp. 73–4.
43	'leap into the void': SL, p. 14.
43	Hardly felt the bruises: idem.
44	'I shall always remember . . . changed places with a god': idem.
44	'the slightest attention . . . spent my time hiding': SL, p. 15; BOS, p. 70.
44	'When I saw . . . an immense success': SL, p. 131.
44	The right winks and blinks: SL, p. 72.
45	'Looking out on the street . . . went into . . . convulsions': SL, p. 132.
45	'The invariable subject . . . "What if I don't die?" ': PAR, pp. 277–8.
46	'Have you ever thought . . . "think the sun was mad" ': Interviews with Ramón Guardiola, July 1985.
46	'scattered grapes . . . warble of canaries': SL, p. 1.
46	'snatch a piece . . . would nearly choke': idem.
46	'I am hungry now': Interviews cited.
47	Their mother's selfless passion: AM, p. 41.
47	Watching silent films: AM, pp. 41–2.
48	Dalí's drawing of himself in his sister's arms: reproduced by Luís Romero in Dali, p. 22.

48 'Within three hours ... perfect outline': Josep Pla, *Guide to the Costa Brava*, cited in Romero, op. cit., p. 327.

48 Correcting what she sees as his mythical version, published in 1942.

48 He never kicked her in the head as described in SL, p. 12.

48 He never did any of the other disgraceful crazy things: Ana María Dalí, in an interview with the *New York Daily News*, 27 July 1958.

48 'The following year ... basis of their noble temperaments': AM, p. 45.

48 Salvador jealous of his baby sister: A. Reynolds and Eleanor Morse, interview, 4 March 1985.

49 Sister also taught astronomy: AM, p. 35.

49 Knowing names of the winds: A. Reynolds and Eleanor Morse, *Salvador Dali: A Panorama of His Art*, p. 126.

49 Read his father's library in two years: SL, p. 60.

49 His age at the time: DEL, p. 57.

49 'a violent necessity ...': SL, p. 142.

49 Weeps on reading a definition of identity: SL, idem.

49 'Educate him ... make him practical': Victor Alba, *Catalonia*, p. 76.

49 Ferrer's eventual execution, in 1909: *Catalonia*, p. 87.

49–50 Characteristics of Spanish anarchist movement: Brenan, p. 131.

50 Agitation for federalist status constant: Temma Kaplan, 'Civic rituals', *Hobsbawm*, p. 173.

50 'since I observed ... only women's business': DEL, p. 57.

50 'I am, and ... against the bourgeoisie': *l'Actualité*, December 1969.

50 Feared an artistic future: SL, p. 140.

51 'I came to know ... history of art': SL, p. 71.

51 'books, all kinds of ... a ... fugitive caprice': SL, p. 140.

51 The first time he was given a palette: Robert Descharnes, *Salvador Dali, The Work, The Man*, p. 11.

51 'the inventor of anecdotal colourism': James Thrall Soby, *Salvador Dali*, p. 9.

51 His instinctive interest in story telling: idem.

51–2 'One year ... my father ... on the terrace': AM, pp. 62–3.

52 Enrolled with the Marist friars and the Municipal School of Drawing at the same time: AM, p. 59.

52 'This good friend ... of the art of drawing': AM, pp. 59–60.

52 'the mysteries of chiaroscuro ... full of Rembrandt': SL, p. 140.

52 'The man who feels ... will attain fame': Interview, 11 January 1919.

52–3 'He had a marvellous ... and nervous hands': Salvador Dali, 'Summer Afternoon', 1919–1920, as quoted in Descharnes, *Salvador Dali, The Work, The Man*, p. 15.

53 'The fact is ... never has a good time!'; 'I still had ... on the Prologue!': SL, p. 152.

53 Took place after the death of Dalí's mother in 1921: *Salvador Dali, The Work, The Man*, p. 11.

53–4 'My father conceived ... perfect to my brother': AM, p. 63.

54 They fought every day: DEL, p. 72.

54 'When, during one ... guile and outright lies': AM, p. 61.

54 'my taste for mystification': PAR, p. 46.

54 'violence to end all violence': Brenan, p. 148.

54 He was sent to the circus armed with a knife: Interviews with Guardiola.

55 'The pain was so great ... as long as I never die!' BOS, p. 62.

55 The grasshopper was his father: *New York Times* magazine, 12 March 1930.

55 Beaten for walking out of a movie: DEL, p. 72.

55 'Dali was gone ... to do it': Luis Buñuel, *My Last Sigh*, p. 184.

56 'I have kept my word ... is a modest one': SL, p. 155.

56 Giving them ten-*céntimo* pieces for every five *céntimos*: SL, p. 119.

56 The 'money doctor' paid all the bills: DEL, p. 72.

56 'I began now ... each day more "visible"': SL, p. 122.

56 The Catalan jester: Romero, *Dali*, p. 118.

57 'a singular woman ... I must be allowed to tell it': idem, p. 310.

Chapter 4: The Voyeur

58 'A dream can be told literally': Salvador Dalí, as quoted by Robert Descharnes in *The World of Salvador Dali*, p. 159.

58 Too much of a baby: AM, p. 44.

58 'One day our parents ... in all seriousness': idem, p. 45.

58 'I was terror-stricken': BOS, p. 62; PAU, p. 57.

59 Near-universality of masturbation: Anthony Storr, *Sexual Deviation* (Harmondsworth: Penguin Books, 1964), p. 11.

59 The culprit would be impotent: Peter Gay, *The Bourgeois Experience, Victoria to Freud: Education of the Senses* (New York: Oxford University Press, 1984), p. 300.

59 'It is often stated ... a developing insanity': Christopher Cerf and Victor Navasky, *The Experts Speak* (New York: Pantheon Books, 1984), p. 17.

59 'With rare exceptions ... in a brothel or in marriage': Luis Buñuel, *My Last Sigh*, p. 49.

61 They went to the Xirau's: Juan Xirau was one of his closest friends. He painted his portrait on the beach in 1924.

63 'Considering the circumstances ... a revolutionary': quoted in Brenan, p. 57.

64 'Soon we won't ... a show of every time': SL, p. 159.

64 'My father was ... actually becoming serious': SL, p. 156.

65 'Now you have only ... should not have erased it!': SL, p. 157.

65 'This was worse ... erased it completely': idem.

66 'If you don't pass ... My sister wept ...': SL, p. 158.

66 'But suddenly I ... than the first one': SL, p. 159.

66 The techniques he wished to learn: PAR, p. 52.

66–7 'Perhaps you see ... pair of scales': SL, p. 16.

67 Dalmau's exhibition of Cubists described by James Thrall Soby, *Joan Miró*, p. 14.

68 She died in 1921 of cancer at the age of forty-seven: Márius Carol Pañella *et al.*, *El Último Dalí*, p. 20.

68 Licentious behaviour alone the cause: *The Experts Speak*, p. 33.

69 Enthusing over Beethoven: *A Dali Journal. Impressions and Private Memoirs of Salvador Dali* (Cleveland: The Reynolds Morse Foundation, 1962), p. 48.

69 'how desperate I was': idem, p. 54.

69 'the ... cedar of Lebanon of vengeance': SL, p. 153.

69 'I had to achieve ... death of my mother': *The World of Salvador Dali*, p. 18.

Chapter 5: 'I Advance Hidden'

70 'I advance hidden': Salvador Dalí, *l'Express*, 8–16 December 1979.

70 '*Pero ante todo*': 'But above all else I sing a common thought/That makes us one in dark and golden hours/It is not Art the light that blinds our eyes/It is love first, friendship or fencing match.' Engl. Trans.: Carl W. Cobb, *Federico García Lorca* (New York: Twayne Publishers, 1967), p. 27.

70 'I was told ... the first Paris years': Ades, p. 21.

70 'He gave you ... with absolute clarity': Ades, p. 63.

70–71 'a gentle ... medical student': Luis Buñuel, *My Last Sigh*, p. 61.

71 Two very fine Cubist paintings: SL, p. 174.

71 'the Czechoslovakian painter': *My Last Sigh*, p. 64.

71 Biographical details of Federico García Lorca, in an introduction by David Gershator to *Selected Letters*, pp. viii, ix.

71 'Sometimes an author ... sometimes disputed': *My Last Sigh*, p. 59.

71 'more beautiful than the "Winged Victory of Samothrace"': Peter and Linda Murray, *The Penguin Dictionary of Art and Artists* (Harmondsworth, Penguin Books, 1983), p. 149.

71–2 'His enthusiasm ... shuns the emotional': Ades, p. 43.

72 'His face, with ... with extraordinary intensity': Ades, p. 63.

72 'with the age-vivid ... pavement of time': SL, p. 179.

72 'the aesthetics of my attitude'; 'dandyism of my mind': SL, p. 202.

72 'a little black mass ... covered with sores': SL, p. 204.

73 'a growing uneasiness'; 'why had I done this?': SL, p. 166.

73 'discredit ... the world of reality': Salvador Dalí, *The Stinking Ass*, This Quarter 1932, p. 348.

73 'crazy as a goat!': SL, p. 183.

74 'the thousand injustices ... history is woven': SL, p. 197.

74 A round-up of all known anarchists in May 1924: Temma Kaplan, 'Civic rituals', *Eric Hobsbawm*, p. 187.

75 Nine days in solitary confinement in Figueres and a further

twenty-six days in Girona: Encyclopedia Universal Illustrada de Europa 1931, vol. Americana, Appendix vol. 3, p. 1403.

75 Jailed shortly before 31 May and released by 1 June: established from information provided by Robert Descharnes, *Salvador Dali, The Work, The Man*, p. 34. There is a discrepancy between the year given in the text (1923) and that given in the accompanying illustrative material (1924). I am following Temma Kaplan's reconstruction of events and the illustrative documentation provided in *Salvador Dali, The Work, The Man*.

75 'In my cell ... most out of their ... ideas': BOS, p. 65.

75 A timid young man in bizarre clothes: *My Last Sigh*, p. 64.

75 'Is it true you're a *maricón*?': idem, p. 62.

75 'nothing effeminate or affected': idem.

76 Lorca was enamoured of Ana María Dalí: Antonina Rodrigo.

76 'quite a grand passion': *My Last Sigh*, p. 64.

76 'He was homosexual ... Divine Dalí's asshole': BOS, p. 36.

76 He was not a homosexual: SL, p. 170.

76 'real and eternal'; 'Lucky you, Ana María ... niece of the sea!': *Selected Letters*, p. 66.

76 'I sing of ... perfect direction of your arrows': author's translation.

76 'He was his own ... like a flame': *My Last Sigh*, p. 158.

76 'the personality of ... viscous and sublime': SL, p. 176.

76–7 Date of their friendship 1922–3: Antonina Rodrigo, in *Salvador Dali Retrospective 1920–1980*, Centre Georges Pompidou catalogue, p. 23.

77 Arms crossed and a smouldering look: photograph captioned 'The painter in Cadaqués in 1927', in *Salvador Dali, The Work, The Man*, p. 55.

77 Dali posed as Nefertiti: photograph captioned 'Salvador Dalí disguised as Nefertiti, in his studio in Figueres' Antonina Rodrigo, *Lorca–Dalí, Una amistad traicionada*, facing page 28.

77 'pushed my sexual parts ... like a girl': SL, p. 70.

77 'Every day I kill ... and with dandyism': BOS, p. 32.

77 'I was he ... rival false king': SL, p. 173.

77 Was reading Freud: SL, p. 167.

77 'The absence of ... "like a beautiful woman" ': SL, pp. 169–70.

78 The male transvestite described: Storr, *Sexual Deviation*, pp. 63–5.

78 Transvestism and homosexuality separate phenomena: *Sexual Deviation*, p. 64.

78 Pen and ink sketch of Lorca by Dalí: *Salvador Dali, The Work, The Man*, p. 66.

79 'Close attention to ... one finds a romantic': *La Publicitat*, 20 November 1925, author's translation.

79 'He is very serious ... is cold as ice': SL, p. 162.

79–80 'He had an ... poets have always loved': BOS, p. 35.

80 'I remember the ... purely intellectual sentiments': quoted by Luis Romero in *Dali*, pp. 323–4.

80	'the virginal originality': SL, p. 203.
80	'typically Spanish behaviour': *My Last Sigh*, p. 65.
80	'So we composed . . . sent it off': BOS, p. 37.
80	'cruellest act of my life': idem.
80–81	'he is, I think . . . South-American gracefulness': Antonina Rodrigo, '*Le poete García Lorca et le peintre Dalí*', in *Salvador Dali rétrospective 1920–1980*, Centre Georges Pompidou catalogue, p. 31.
81	'retrogressive . . . and conformist': *Selected Letters*, p. xi.
81	'In this way . . . not be closed'; 'detestable disorganization'; 'for if it should happen . . . completely erroneous': SL, pp. 154–6.
82	Sequence of events of the official proceedings, as translated by author: *La vie publique de Salvador Dali*, Centre Georges Pompidou catalogue, pp. 15-16.
82	'thunderstruck by the catastrophe': SL, p. 204.
82	'In the expression of . . . produced on him': idem.

Chapter 6: Blood Is Sweeter than Honey

83	'that familiar solitary pleasure': SL, p. 221.
83	'a bellwether for the . . . vanguard': Soby, *Joan Miró*, p. 14.
83	'just stepped out of a painting': SL, p. 205.
83	'in my bag with one sweep': idem.
83	'on the path of consenting'; 'your son's future will be brilliant!'; 'wait for the development': idem.
83	Taking his hand as he crossed the street: Luis Buñuel, *My Last Sigh*, p. 184.
84–5	'As soon as . . . never seemed so beautiful'; 'Each of us . . . understanding and defiance': *l'Express*, 10–16 December 1973, author's translation.
85–6	'The scuola metafisica . . . retreat to the dream': Soby, *Salvador Dali*, pp. 10–11.
86	'aggressive assault'; 'Born into a world . . . transgressed boundaries': Malcolm Haslam, *The Real World of the Surrealists*, p. 6.
86	The first Surrealist exhibition just held: in November 1925.
86	'a man of few words . . . people who asked for them': André Thirion, *Revolutionaries Without Revolution*, pp. 90–91.
87	'Tanguy's "*Il faisait ce qu'il voulait*" . . . ghostly configurations': Ades, p. 45.
87	'the general tonality . . . "Mama, Papa is wounded!" of 1927': *Salvador Dali*, p. 17.
87	'Yves Tanguy did not . . . on a (particular) deaf ear': *Yves Tanguy Rétrospective, 1925–1955*, Centre Georges Pompidou catalogue, p. 53, author's translation.
87	'The abstract forms . . . into Dalí's vocabulary': Interview with Pierre Matisse.
87	'I've snitched everything': Interview with Agnes Tanguy.
88	'I would awake . . . in my imagination': SL, p. 220.

88 'the profile of ... all the colours in the world': SL, p. 219.

88 'Federico, I am ... paint them honestly': Ades, p. 38.

89 'I am blood ... are running after honey': SL. p. 298.

89 'that one could not fail ... upon the outer': SL. p. 266.

89 'just try to sell ... finger in her mouth!': SL, p. 267.

90 'his sex life ... ran after women': *My Last Sigh*, p. 184.

90 Rejected on aesthetic grounds: SL, p. 208.

90 'the rhythmic and solitary ... thighs of feminine beds': SL, p. 216.

90 'Once more I wrenched ... cried my soul': SL, p. 221.

Chapter 7: The Little Russian Girl

91 'I have never loved anyone but Gala
 If I repulse other women it is to affirm this
 That I have never found a woman apart from Gala
 Who gave me something of a mind to live
 And very much the desire to kill myself.'
 'Song for Gala', Paul Eluard, L à G, p. 337 (author's translation)

91 'Don't call me *mam ère*': as quoted by A. Reynolds Morse, interview view with author.

91 In love with Gala then: Margaret Case Harriman, *New Yorker*, 1 July 1939.

91 'The secret of all my secrets': as told to Michael Ward Stout, interview with author.

92 Father the administrator of a Russian prince: Obituary in *Le Figaro*, 11 June 1982.

92 'No one has the right ... father is unhappy': L à G, p. 397. (This and subsequent extracts: author's translation.)

92 Family history as told by Gala's sister: related by Robert Descharnes, interview.

92 'I was very tired ... "sadness" of my parents': L à G, p. 397.

92–3 'Gala's secret and my secret': SL. p. 315.

93 Jeff Fenholt's version: Interview with author.

93 'Her look would penetrate ... movements of her mouth': Luis Romero, *Dali*, p. 340.

93 'a girl from nowhere': Interview with Mme Davidova.

93 'You must not forget ... beside myself': L à G, p. 387.

93 'vicious', '*putainesque*', 'whorish': idem, p. 374.

93 'I am so bad that': idem, p. 381.

93 'One evening Gala ... painful convulsions': SL, p. 241.

94 Sent to Switzerland to convalesce: Jean-Charles Gateau, *Paul Eluard et la peinture surréaliste*, p. 11.

94 'Eluard was a man of ... he looked like *someone*': André Thirion, *Revolutionaries Without Revolution*, p. 180.

94 'Perhaps if one ... by his personality': Jack Lindsay, *Meetings with Poets* (London: Frederick Muller, 1968), p. 207.

94 'an aura of beauty': interview with Diane Deriaz.

94–5 A complex personality: Jean Duval, 'Autour d'Eluard', in *Paul Eluard, 1895–1952*, Mairie de Saint-Denis, 1952, p. 29.

95 'his sensuous eyes ... a feminine figure': PAR, p. 84.

95 'And it is always ... never the same woman': José Pierre, *An Illustrated Dictionary of Surrealism* (Woodbury, NY: Barron's Educational Series, 1979), p. 62.

95 'Two in the bed is enough': interview with Diane Deriaz.

95 'conjuring up fantasies ... to notice him': *Meetings with Poets*, p. 206.

96 'My father said ... to a doctor': L à G, p. 383.

96 Gala 'aged' so as to leave Moscow: letter from to author.

96 'I detest housework ... not even you': L à G, pp. 382–3.

97 'My dear and dorogóí maltchik': idem, p. 381.

97 'very spoiled boy': idem, p. 387.

97 'My husband and my own': idem, p. 388.

97 'My absolutely unique boy': idem, p. 393.

97 She was his mother, sister, wife: idem, p. 395.

97 She went nowhere: idem, p. 378.

97 'If I lose you': idem, p. 376.

97 'It seems to me ... bottle will be full': idem, p. 392.

97 Moving to Paris proved her love: idem, p. 380.

97 'I buy your obedience': idem, p. 379.

97 He must be hers alone: idem, p. 388.

97 'some pretty ones ... in the métro': idem, p. 399.

97 'Your mother is really': idem, p. 377.

97 'Do not ask me ... everything is right': idem, p. 378.

97 'it revealed a marvellous body': *Revolutionaries Without Revolution*, p. 180.

97 Cécile's date of birth: 11 May 1918.

98 Eluard's dedication to Surrealism: Malcolm Haslam, *The Real World of the Surrealists*, p. 97.

98 'Crevel began ... brandishing a knife': idem, p. 98.

98 Eluard managed to stay on good terms with everyone: *Revolutionaries Without Revolution*, p. 181.

99 'the very salt of Paris': PAR, pp. 89–90.

99 Span of Eluard's letters to Gala: 1924–48.

99 '... to give you some pleasure': interview with Diane Deriaz.

99 'Children are the death of love': idem.

100 She tried to become an extension of him: Ernst, p. 18.

100 'this almost silent ... one of a panther': idem, p. 20.

100 The trio's movements chronicled: in L à G, pp. 403–4.

101 Dalí would make more money: interview with Diane Deriaz.

101 The past history of Nusch: Whitney Chadwick, *Women Artists and the Surrealist Movement*, p. 241.

101 'Dressed in a harum-scarum ... warmed his heart': *Revolutionaries Without Revolution*, p. 182.

101 They had decided to live apart: *Paul Eluard et la peinture surréaliste*, p. 156.
101 'Gala, my sister ... I embrace you terribly': L à G, pp. 89–90.
101–2 'Gala, if the thought ... are you coming back?': idem, p. 95.
102 Such a 'small, almost skeletal apparition': Ernst, p. 37.
102 'I hope she doesn't tear him': idem.

Chapter 8: 'Paris is Mine!'

103 'Paris is mine!' PAR, p. 75.
103 'Slowly the pawns of fate': idem, p. 84.
103 The dealer's 'grocery shop': idem, p. 76.
103 His compliments a good start: idem, p. 83.
103 'I could see Breton's blue eyes': idem, p. 84.
103 He was going to make a bid: SL, p. 250.
103 Isidore Ducasse: 1846–70.
104 'a very shy young man': Maxime Alexandre, *Mémoires d'un surréaliste* (Paris: La Jeune Parque, 1968), p. 181.
104 Dalí was a genius: Luis Buñuel, *My Last Sigh*, p. 183.
104 'desperately anxious to please': *Life* magazine, 22 September 1945.
104 'a small, dark, darting ... has stopped breathing': *New Yorker*, 1 July 1939.
104 'slender, shy, phlegmatic'; 'which his natural humour ... howl with laughter': *Revolutionaries Without Revolution*, pp. 194–5.
104 'He couldn't even ... several times a day': idem, p. 195.
104 A little piece of driftwood: *Life* magazine, 29 September 1945.
105 Laughed in terror: SL, p. 210.
105 'When he announced ... nobody got off?': idem.
105 'Reaching the surface ... a great initiation': PAR, p. 82.
105 He tried to go mad: SL, p. 222.
106 'cataclysm, abyss and terror': SL, p. 232.
106 The messenger of his fame: PAR, p. 76.
106 'my genius and Buñuel's talent': idem.
106 Buñuel's version: *My Last Sigh*, p. 104.
106 'Our only rule ... and absolutely necessary'; 'no one quite knew what he was doing'; idem.
107 'Scorning the technical ... stupefying experience': Jean, p. 206.
107 'It seemed to me ... poetic weaknesses': SL, p. 215.
107 He was keeping Goemans in suspense: PAR, p. 83.
107 'What's going on? ... a skeletal rosebush': SL, p. 224.
107 He 'rubbed his hands': PAR, p. 84.
109 'And her sublime ... roundness of the buttocks': PAR, p. 89.
109 His 'bachelor-girl' costume: idem
109 'hideous and superb': idem.
110 'a regular savage': SL, p. 229.
110 'the strength and dazzle of life': PAR, p. 89.
110 'attentive as a dog': PAR, p. 90.
110 'a child of genius': PAR, p. 91.

111 'The pictures in general ... of the subconscious': James Thrall Soby, *Salvador Dali*, p. 16.

111 'It has to be said ... distaste and repulsion': idem.

112 'even more interesting': SL, p. 231.

112 'If those "things" ... loathsome to me': idem.

112 'We shall never leave': SL, p. 233.

112 'she was going to do me harm': idem.

112 'I had read ... break like a melon': PAU, p. 33.

112 'I took revenge ... my upstretched cock': PAR, p. 93.

113 'as soon as ... love and fear': idem.

113 'How can you ... I let go ...': *My Last Sigh*, p. 96.

113 'Tell it to me obscenely': PAR, p. 94.

113 'with the ... precision of a director': idem.

114 'a real Renaissance': *Elle* magazine, 26 January 1981, author's translation.

114 'Gala drove the forces ... the love she gave me': PAR, p. 91.

114 'You know, Gala is ... his wife, his lover: *Elle*, idem.

114 'She cured me ... took over my madness': PAR, p. 97.

115 'my beacon, my double': idem, p. 95.

115 'the asker, the inciter': idem, p. 92.

116 *The Butterfly Chase* was exhibited at the Galerie François Petit, Paris, in 1965.

116 'At first, all ... perfectly understandable': *My Last Sigh*, p. 115.

116 He had become a drug dealer: PAR, p. 99.

117 Sodomizing his dying father: idem, p. 15.

117 'I do not know ... is giving us': Dr Christopher Maurer, in *Poesia*, No. 27, Madrid, 1986.

118 'The destructive ideas ... bad luck to join': AM, p. 95.

118 'all right-thinking people': PAR, p. 103.

119 'completely nude ... I gently masturbate': L à G, p. 139.

119 'My Gala, I really ... to your affairs'; 'No my little girl ... lots of it': idem, p. 131.

120 Tearful and depressed: PAR, pp. 104–5.

120 He wept for a week: SL, p. 23.

120 'Little darling Gala ... Write to us': L à G, p. 307.

120 The Vicomte gave a million: PAR, p. 99.

120 The third film with a soundtrack: *My Last Sigh*, p. 116.

120 'all the violence of love': SL, p. 252.

121 A frenzied and doomed love affair: *My Last Sigh*, p. 117.

121 'a blind man being ill-treated ... guise of Jesus Christ': Jean, p. 214.

121 Dalí's paintings destroyed: Jean, p. 215.

121 His anti-clericalism was too clear: *My Last Sigh*, p. 183.

121 'Buñuel betrayed me': PAR, p. 108.

121 'The mill won't run': *My Last Sigh*, p. 186.

121 'I don't want to forgive him': interview with Juan Luis Buñuel.

122 'The cheque assumed ... giddy with gold': PAR, p. 101.

122 'only what I wished': SL, p. 268.
122 'a psychoanalytical value': DEL, p. 78.
122 'It's not true at all': interview with Reynolds and Eleanor Morse.
123 'the story about Samson': SL, p. 178.
123 'I lost faith in myself': idem.
123 He did not turn to look: SL, p. 254.

Chapter 9: The Conquest of the Irrational

124 'to tell our life': *The World of Salvador Dali*, p. 157.
125 'pleasures, even criminal ... inside out like a stocking': idem, p. 155.
125 'I also tell the truth': Luis Romero, *Dali*, p. 310.
125 'tap the creative ... to change society': 'Salvador Dali', Tate Gallery catalogue, 1980.
126 'In Surrealism these ... realm of possibility': John Canaday, *Mainstreams of Modern Art* (New York: Holt, Rinehart & Winston, 1966), p. 521.
126 'This doctrine ... any of the others': Tate Gallery catalogue, p. 10.
126 '[a] carnivorous fish ...': James Thrall Soby, *Salvador Dali*, p. 14.
127 'an outboard motor': idem.
127 'in its brilliant colour ... instead of poetic': *Mainstreams of Modern Art*, p. 523.
127 'Basically it involved ... inescapable truth': Lake, pp. 68–9.
127 'Just as a true ... "paranoiac" sensitivity': *Salvador Dali*, p. 14.
128 The link between Camembert and watches: SL, pp. 317–18.
128 'one of the strangest statements': Tate Gallery catalogue, p. 16.
129 A play on the word '*montre*': Jean, p. 218.
129 'a ... soft ... worm-ridden': PAR, p. 242.
129 'a bag full of holes': idem, p. 243.
129 'the ... gelatinousness': idem.
130 'The child Dalí is terrified': *The World of Salvador Dali*, p. 51.
130 'perhaps a phobia': idem.
131 'Here the father is chasing': *Salvador Dali, The Work, The Man*, p. 108.
131 '*The Enigma of William Tell* ... being I love most in the world': 'L'enigme de Salvador Dalí,' *XXe siècle*, December 1974.
132 'the exhibitionistic eroticism ... praying mantis': PAR, pp. 154–5.
132 Haunted him since school days: SL, p. 64.
132 'we heard the chiming ... with bowed head': idem, p. 63.
132 'the evening of locusts ... end of the world': PAR, p. 154.
133 'Gala occupying in reality ... my total annihilation': Salvador Dalí, *Le Mythe Tragique de l'Angelus de Millet*, pp. 92–3.
134 'Dalí had much ... to his inventive mill': Jean, p. 208.
134 his 'Surrealist unconditionality': idem, p. 209.
134 A break was out of the question: *Revolutionaries Without Revolution*, p. 197.

134 Sensationalism for its own sake: Ades, p. 85.

134 'I could sense the ... in social problems': *Revolutionaries Without Revolution*, p. 197.

134 When the painting was hung: on 2 February 1934.

135 *'He absolutely must* ... ruin of Surrealism': L à G, p. 229.

135 Such emotions a fact of life: idem, p. 230.

135 'he isn't a Hitlerite': idem, p. 233.

135 Date of the enquiry: idem.

135 'began reading ... that he stopped': Jean, p. 220.

135 'Lenin's anamorphic buttock ...'; 'So André Breton ... wealth of detail': PAR, p. 126.

136 His 'second father': idem, p. 112.

136 Resolving the apparent contradictions: Museum of Modern Art bulletin, November–December 1936.

136 *'maintain* the opposition ... the real world': Ades, pp. 98, 100.

136 'The secret lies ... make them shine': PAR, pp. 134–5.

Chapter 10: Puzzle of Autumn

137 'a nervous young man of cadaverous paleness': PAR, p. 175.

137 He must be very poor: interview with Mrs Alfred Barr.

139 'an admirable landscape ... midst of a desert': Julian Green, *Diary 1928–1957* (New York: Carroll & Graf, 1985), p. 36.

139 'The most beautiful ... through powerful opera-glasses': Julien Green, *Oeuvres complètes, p.* 264.

140 The poem 'Shared Nights': Dalí contributed two drawings for the collection of poetry, published in 1935.

140 His fare to get back to London: inteview with David Gascoyne.

141 the rich and the vaguely talented': Arthur Gold and Robert Fizdale in *Misia* (New York: Morrow Quill Paperbacks, 1981), p. 271.

142 Gentleness and gravity entrancing: *Oeuvres complètes*, p. 267.

142 'elephants, camels, and ... billowing curtains': *Misia*, p. 218.

143 The highest fee then: idem, p. 220.

143 'gold and *merde*': idem, p. 219.

143 'all in white ... almost melancholy': Levy, p. 135.

144 'These pictures ... outmoded formulae': *Hartford Times*, 7 November 1931.

144 'to strengthen its ... most stimulating friends': Levy, p. 80.

145 '*comédons authentiques*': Levy, p. 72.

145 'Since Dalí tells you'; 'a voice full of complicity': idem, p. 74.

145 A. Conger Goodyear's painting, *Au Bord de la Mer*, is now in the Salvador Dalí Museum at St Petersburg, Florida.

145 He thought an insurance of $250 should cover it: Letter in archives at Wadsworth Atheneum, 19 October 1931.

145 Early buyers of Dalí works: Among them were Sidney and Harriet Janis, who quickly bought *Illuminated Pleasures* (1929), and later gave the painting to the Museum of Modern Art. They also gave

the Museum Dalí's pen, ink and watercolour drawing, *Frontispiece for Second Surrealist Manifesto*, 1930.

146 They had to buy it first: undated letter in Archives of Wadsworth Atheneum.

146 'Come to the States': PAR, p. 175.

146 '[a] fiery barrage': SL, p. 324.

146 'pure and absolute automatism': idem, p. 325.

146 A fair verdict in America: idem.

147 Eluard was a witness: interview with Ted Schemp.

147 Dalí's reconciliation with his father: described in interview with Sra Dalí de Bas.

148 'I can still ... get out of our way': PAR, pp. 137–8.

148 Was machine-gunned and died: SL, p. 357.

148 'that awful stupidity': PAR, p. 137.

149 *Forgotten Horizon*: painted in 1936, now at the Tate Gallery, London.

149 'Do not torment ... things will work out': L à G, p. 170

149 'Daddy's legendary piggy bank': PAR, p. 177.

150 'Dressed all in white ... spotlessly white': PAR, p. 174.

150 'He is going ... by *ferrocarril* (railroad)': *Diary 1928–1957*, p. 36.

150–51 'I liked my wife, and I liked chops': Sl, p. 330.

151 What he told his audience in Hartford: based on information provided in 'La vie publique de Salvador Dalí', Centre Georges Pompidou catalogue, p. 42.

151 Not in *Hartford Courant* account: of 19 December 1934.

151 'and over something ... people quite ill'; 'hall was full ... he is *not* mad': *Arts & Decoration*, New York, March 1935.

151 'wearing a loaf of bread ... somewhat academic': *New York Herald*, 7 December 1934.

151 Practically yawned in one's face: 'La vie publique de Salvador Dalí', 'Letter to a friend, 4 December 1934', p. 42.

151 Weighed and found wanting by James Johnson Sweeney: in the *New Republic*, 6 February 1935.

151 'the King of the Non-Sequitur': PAR, p. 179.

152 'Mad Dream Betrayal'; 'All-Time High': *New York Sunday Mirror*, 24 February 1935.

152 'disguised as a shop window': *Salvador Dali, The Work, The Man*, p. 154.

152 Dalí described his costume: DEL, pp. 135–6.

152 Pierre Matisse's recollections: Interview with author.

152 'Eyes grew on cheeks ... humming birds flew out': SL, p. 338.

153 Hauptmann tried and convicted: 19 September 1934.

153 He denied any reference intended: DEL, p. 136.

153 The Surrealists' lawsuit: PAR, p. 181.

153 'Read the riot act ... the Lindbergh baby': *My Last Sigh*, p. 183.

153 He compared it to a Böcklin landscape: 'La vie publique de Salvador Dalí', 'Letter to a friend, 4 December 1934', p. 42.

153–4 'During those days ... and the audience screamed': DEL, p. 135.

154 Begged her to pretend she knew nothing: L à G, p. 187.

155 'the Surrealists were very disappointed': interview with David Gascoyne.

155 'I could not ... touch him': PAR, p. 215.

155 One thing his father could not bear: SL, p. 12.

155 'She resembled ... young heroine could do'; 'Even though I knew '... between two floors': From an unpublished memoir by Edward James, Museum of Modern Art Archives.

155–6 'Ever since ... from swallowing anything': BOS, p. 30.

156 She had blue marks: SL, pp. 347–8.

156 'We went back ... impossible to swallow': PAU, pp. 58–60.

156 'I am a great coward': idem.

156 'You aren't responsible ... punishing myself': idem.

157 'Gala ... is a true medium ... war on Germany': SL, p. 370.

157 Kidnapped, captured, and shot: 19 August 1936.

157 'I hadn't insisted ... jealous of Lorca': 'Les Morts et Moi', *La Parisienne*, May 1954, author's translation.

157 'That's what the ... like a villain': BOS, p. 35.

157 'I closed eyes ... like nightmares': PAR, p. 138.

158 'Would I finally ... close to me?': SL. p. 365.

158 'All the upsets ... anxiety: germs': PAR, p. 184.

158 'my imagination ... fell to my knees': idem.

Chapter 11: The Metamorphosis of Narcissus

159 David Gascoyne's comment: interview with author.

159 Dali opening described: Levy, pp. 173–5.

160 'slick-as-grease craftsmanship': *Time* magazine, 26 August 1946.

160 Gala's attempts to sell his ideas: PAR, p. 109.

161 The Mae West sofa: A copy of the same sofa was made for Edward James by the London interior decorator John Hill.

161 Would not allow real mayonnaise: Jean, p. 279.

161 'When Dali depicts ... skipping rope': William Gaunt, *Studio*, September 1939.

162 Start of the eye-rolling stare: photograph is dated 16 June 1934.

162 His eventual destination on a label: *Life* magazine, 24 September 1945.

162 'the Angel of Equilibrium': SL, pp. 316–17.

163 'The door, the door!': *New Yorker*, 1 July 1939.

163 'somewhat between ... of uncontrolled hysteria': Levy, p. 231.

164 The Dalí diving suit incident: reconstructed from newspaper clippings, interviews with Eileen Agar and David Gascoyne, and Roland Penrose, *Scrapbook 1900–1981*.

164 'the most important': *New English Weekly*, 24 May 1934.

164 'to break down the barriers ... create a super-reality': *Listener*, 14 November 1934.

164 'Many painters ... have condemned themselves ...': *Spectator*, 2 November 1934.

164 'the constipation of logic': *Scrapbook 1900–1981*, p. 60.

165 'If as Dalí maintains ... modicum of sense': William Gaunt, op. cit.

165 Selling for an average of £200: *Standard*, 25 June 1936.

165 'the artist's return to full consciousness': T. W. Earp, *Daily Telegraph*, 1 July 1936.

165 'a ... very miniature gentleman': Levy, p. 175.

165 'beautifully rounded phrases': idem.

165 The Dalí-James menus: Philip Purser, *The Extraordinary Worlds of Edward James*, p. 67.

166 'It's very difficult to shock the world': interview with Hugh Casson.

167 The Dalí-Edward James incident: interview with George Melly.

167 History of *Swans Reflecting Elephants*: Edward James in a letter to Sotheby's, 2 May 1976.

167 'Surrealism would never ... cinemactor's moustache': *Time* magazine, 14 December 1936.

168 'No collective effort ... whole history of art': *La Femme Visible*, Jean, p. 209.

168 The very best restaurants and wines: PAR, p. 196.

169 Gala urged prudence: SL, p. 373.

169 'they would ... be forced to ... take everything out': SL, p. 374.

170 'carved his name': *New York Times*, 17 March 1939.

170 One of the richest artists: *Life* magazine, 17 April 1939.

170 From thanks to bafflement: *New Yorker*, 1 July 1939.

170 'a kind of slapstick'; 'Dalí's work is ... suavity and skill': *New Yorker*, 1 April 1939.

171 'I don't recall'; 'This creature's head ... in the root stage': *New Yorker*, 17 June 1939.

171 *Bottoms of the Sea*: *New Yorker*, 1 July 1939.

173 'all artists have ... work takes shape': *Looking at Pictures* (New York: Holt, Rinehart & Winston, 1960), p. 191.

173 'What's wrong with ... Narcissus!': Salvador Dalí, *Metamorphosis of Narcissus*, no pagination.

174 'I had lost the image': PAR, p. 241.

174 'Nothing is more important': PAR, p. 149.

Chapter 12: The Thinking Machine

175 'The thinking machine' (*la machine à penser*), was coined by Paul Eluard.

175 'I'm in a constant ...': BOS, p. 69.

175 To be near the good food in Bordeaux: SL, p. 381.

176 'nothing to panic about': interview with Léonor Fini.

177 'ten ruined villages ... miseries of war'; description of what he found; 'Everywhere, on the walls ... covering a whole panel': PAR, p. 196.

'worse than anything: ... you're your own master!': SL, pp. 398–9.

177 'he seemed to be pro-Franco': *Chips, the Diaries of Sir Henry Channon* (London: Weidenfeld & Nicolson, 1967), p. 144.

178 'It was as though ... Like being in a lunatic asylum': George Orwell, *Homage to Catalonia*, p. 198.

179 *'ce chien couchant'*: Ernst, p. 217.

179 'those ... nuts called buckeyes': *New Yorker*, 20 December 1952.

179–80 'Both small in stature ... indisputable genius': Anaïs Nin, *The Diary of Anaïs Nin 1939–1944* (vol. III) (New York: Harcourt Brace Jovanovich, 1969) pp. 39–40.

180 In the company of a tethered cow: *Life* magazine, 7 June 1941.

180 Easier than finding a fourth: *New Yorker*, 3 May 1941.

180 'full of inventions and wild fantasies': *The Diary of Anaïs Nin 1939–1944*, p. 41.

180–81 'sheer ... from the waist up': *Chicago Daily News*, 24 May 1941.

181 'Just imaginative!': *New York Herald Tribune*, 22 June 1941.

181 His face lit up with comprehension: *New Yorker*, 1 July 1939.

181 'The sheep she is losing ... you will be informed': *New Yorker*, 20 December 1952.

181 Applauded if they understood: BOS, p. 105.

181–2 He 'saddled a horse ... in the air': *View Magazine*, November 1940.

182 'Alas, there was no orgy ... and drove away': *The Diary of Anaïs Nin, 1939–1944*, p. 44.

182 'feat of willed obscurantism': *Nation*, 6 February 1943.

182 'almost ... modest about it': *New Yorker*, 2 January 1943.

182 'capitalize on the stupidity': *New York Times*, 17 January 1943.

183 'brought up in Ohio'; Harry Spencer, Charlie ... named Irma and Betty and Ruby': *New Yorker*, 27 February 1943.

183 'stillborn ... without emotion': *Nation*, op. cit.

184 'a glimpse of the terror': *Nation*, op. cit.

184 The Diaghilev of costume balls: Arthur Gold and Robert Fizdale, *Misia*, p. 238.

184 'On Dalí's side ... have been bad ones': *New Yorker*, 1 July 1943.

184 'a burlesque-flavored sauce': Jean, p. 209. The novel was not published in France until 1973. By then the original French version had been lost and it had to be retranslated, a factor that may have influenced its reception, which was much more favourable.

185 'only a genius could invent': *New York Times*, 16 December 1944.

185 Fees as high as $25,000: *Look* magazine, 7 June 1947.

185 The Princess felt comfortable: *Newsweek*, 26 April 1943.

185 Wished he still looked that way: Interview with author.

186 Dalí sued for payment and recovered: 25 August 1954.

187 'afraid ... I would go blind': interview with Mrs William Nichols.

187 Gaze that pierced bank vaults: George Melly.

187 'There followed an ... "Ah," she sighed'; 'He is the very first'; 'I agree': *Script* magazine, August 1947.

188 Gave the lurid details: PAR, pp. 144–5.

189 *'Tu es la merde'*: Ernst, pp. 152–3.

189 'old enough to be my mother': interview with author, 4–5 March 1985.

189 The better to inspire dreams: *Sketch*, 20 May 1942.

189 ' "When Dalí says "five" he means "ten" ' ': 'Trade Winds', *Saturday Review of Literature*, 22 March 1947.

190 Perceived as a 'commercial': *New Yorker*, 8 May 1943.

190 Advertising techniques mistaken for art: *Observer*, 2 December 1951.

190 Only two or three such exhibitions was he ever to receive in the US: The second was at the Gallery of Modern Art, New York, 18 December 1965–28 February 1966. There were other smaller exhibitions, such as the small group of paintings, drawings, etchings and objects, sponsored by the Print Club of Cleveland and shown at the Cleveland (Ohio) Museum of Art, 8 October–9 November 1947.

190 'in an odd way familiar': John Berger, *Réalités*, October 1953.

190 'adept at communicating ideas': *New York Times*, 23 November 1941.

190 'an absolute mastery': Robert M. Coates, *New Yorker*, 29 November 1941.

190–91 'the warmed over vermicelli ... TO BECOME CLASSIC!': under the pseudonym of Felipe Jacinto, 'The Last Scandal of Salvador Dali', The Arts Club of Chicago, 1941.

191 'hailed as a precursor'; 'moderated his disdain': James Thrall Soby, *Salvador Dali*, p. 26.

191 'in curl papers for the night': *New York Times*, 25 November 1945.

191 Passionate interest in integration: SL, p. 383: ('everything remained to be integrated').

192 'will prove the unity of the universe': PAR, p. 217.

192 'the key painting': *The World of Salvador Dali*, p. 212.

193 As symbolizing 'dematerialization': *New York Herald Tribune*, 19 February 1950.

193 The Pope 'was very pleased': *Tablet*, London, 3 December 1949.

193 'when he told me ... lacking in grace!': As quoted in Luis Romero, *Dali*, pp. 325–6.

193 Protesting that Gala was a whore: interview with Gonzalo Serraclara.

194 'and swinging his cane': interview with Benjamin Castillo.

Chapter 13: Avida Dollars

195 'Very few people know': *Arts*, 2–8 May 1956.

195 'How can I walk around?': interview with Prince de Fancigny-Lucinge.

195 'mad genius sells': *Life* magazine, 24 July 1970.

195 An estimated fortune of $10 million: idem.

195–6 'At any given moment'; new editions of the *Divine Comedy*: *Life* magazine, op cit.

196 Success at Woolworth's sale: interview with Mme Lucia Davidova.

196 Dalí called him crazy: *Life* magazine, op. cit.

197 'one dared not push him': interview with Joseph Foret.

197 'give it back': interview with Lionel Porlâne.

197 'we will give you another one': *Life* magazine, op. cit.

197–8 'She never thanked me': interview with Roland Balaÿ.

198 The master of stage tricks: idem.

198 'Do you know what a good steak costs?': Luis Buñuel, *My Last Sigh*, p. 185.

198 'I'll be waiting': *Washington Post*, 10 March 1976.

199 Half of the banknotes useless: John Richardson to author.

199 'The rustle of paper money . . . the cocktail lounges': *Arson*, No. 1, 1942.

199–200 Ought to be given a medal: *Paris Jour*, 9 December 1970.

200 'worked them inexhaustibly': interview with Reynolds Morse.

200 'the transformation of matter': PAU, p. 196.

200 'he . . . needs a huge cheque': BOS, p. 96.

200 'As Raimu always . . . more or less bitter truth': 'Salvador Dalí rétrospective 1920–1980', Centre Georges Pompidou catalogue, p. 199.

201–2 Interview at the Hotel Meurice with Pierre Desgraupes, *Le Point*, 28 January 1974, author's translation.

202 'starlets in Cardin breeches': *Life* magazine, op. cit.

203 'he was so voyeuristic': interview with Carlos Lozano.

204 'for a painter that is normal': interview with Jean-Claude DuBarry.

204 'she was really the crazy one': interview with Paula Pelosi.

205 'sitting on one leg': interview with Catherine Perrot-Moore.

205 'he didn't like the contact': interview with Jean-Claude DuBarry.

205 'curt, organised and formal': *Guardian*, 9 November 1973.

206 'Dali, modestly got up . . . is his latest discovery': *New Yorker*, 31 December 1955.

206 A rhinoceros horn on the table: Mahanoy City, Pa., Record-American, 17 December 1958.

206 'the hidden reality': *New York Herald Tribune*, 9 February 1966.

206 Forty pounds of bubblegum: *New York Daily News*, 22 March 1970.

206 Soaked in black paint: *Evening Dispatch*, Edinburgh, 9 April 1960.

206 Pelted with popcorn: *Illinois State Journal*, Springfield, Ill., 5 March 1960.

207 A Vermeer, cauliflowers and a book by Dali titled: *Prodigious History of the Lacemaker and the Rhinoceros, Extract from the Diary of a Genius*: *New Yorker*, 21 January 1956.

207 'not easy to ... know': interview with Naomi Sims.

207 'I am the source of God': *Women's Wear Daily*, 7 April 1975.

207–8 Friendship between Gala Dalí and Jeff Fenholt and his medical problems: described to author on 26 January 1985 and 10 December 1984; 'The bottom line is that': 26 January 1985.

208 She spat in his face: interview with Carlos Alemany.

208 'only interested in power ... and luxury': interview with John Richardson.

209 'with the light of eternity': SL, p. 302.

209 'At the mouth ... the anchored boats': Josep Pla, quoted in *Guide to the Costa Brava*, Romero, *Dali*, p. 327.

209 'He was always working': interview with Jean-François Fogel.

210 Guests were in for a shock: *Akron Beacon-Journal*, 2 August 1964.

211 Obsession with Picasso pathetic: *Daily Telegraph* magazine, 16 October 1964.

210–11 His memory of Dalí: interview with Edwin Mullins.

211 'How does it feel to be immortalized?': interview with Jacqueline Goddard.

212 Russell Harty's account of filming Dalí: in the *Guardian*, 9 November 1973.

213 'The progress of ... without any synthesis': Ades, pp. 173–4.

213 Dalí took on all of modern art: in *Dali on Modern Art*.

213 He did not have much to say: *New Yorker*, 6 December 1947.

213–24 'I think the trouble is': *New Yorker*, 8 December 1945.

214 'I suppose ... point of sacrilege': *New York Times*, 29 May 1950.

214 'The ostentatious display': *El Paso Times*, 5 April 1970.

214 'a lugubrious event': *Time* magazine, 15 May 1972.

214 'a very honest picture': *New York Times*, 14 January 1955.

215 Eccentric if not actually insane: interview with Fleur Cowles.

215 'professionalized through and through': *Saturday Review of Literature*, 14 May 1960.

215 The end of their association: Letter from Carlton Lake to author, 14 August 1984.

215 Retrospective exhibition: 18 December 1965.

215 A vindication of Dalínian prophecy: *New York Herald Tribune*, 17 March 1964.

215–16 'the dozens of ... over the decades': *New York Times*, 18 December 1965.

216 *Christ of St John of the Cross* attacked: On 23 April 1961 a young man slashed and seriously damaged the work. Ninian McGregor Menzies, aged 22, was caught by an attendant and charged with malicious damage. He was later sent to a mental hospital. (From newspaper accounts.)

216 'a very good athlete': *Evening Star*, November 1956.

216 'the most overrated': *ARTnews*, November 1977.

216 Not a very admirable canvas: Letter in National Gallery Archives, Washington, 14 December 1984.

216 'None I believe ... the real idiots': *L'Express*, 1 March 1971.
216 'Exactly, I advance masked ... dead, or not': *Le Point*, op. cit.

Chapter 14: Masked Faces

218 'If something is good': 'The Trouble with Prints' by Amei Wallach, *ARTnews*, May 1981.
219 'Every time you set boundaries': idem.
219 'That kind of technical training'; 'It is time someone': interview with Sylvan Cole.
219–20 The sequence of events concerning Dalí's *St George and the Dragon* established from the correspondence between Gala Dalí and Henry Sayles Francis acting for the Cleveland Print Club. Letter of John Taylor Arms to Francis is dated 9 December 1946. One of the best Dalí prints extant: interview with Martin Gordon.
220 Lucas Gallery association with Dalí: from conversations with Phyllis Lucas and information provided by her and the Dalí Museum, St Petersburg, Florida.
221 'I like to start the day': PAR, p. 267.
221 A ten per cent commission on sales: *Daily Telegraph*, 13 September 1984, *Observer* 14 October 1984.
221 'I've made a fortune': *Le Monde*, 24 September 1984.
221 Details on *Place des Vosges* print: Roger Passeron, *French Prints of the Twentieth Century* (New York: Praeger, 1970), p. 138.
221 'These plates have often ... as much as possible': Andrew Decker, 'Multiple Mania', *Art and Antiques*, October 1985.
222 Prints easily worth $1 billion: interviews with Michael Ward Stout and his comments in the *Wall Street Journal*, 8 March 1985.
222–3 Sales pitch: a New York mail order gallery, 24 January 1985.
223 Experiences of Detective Craig Frizzell: in conversations with author, 9 December 1985 and 8 February 1986.
224 Legal redress not easy for the buyer: Meryle Secrest, 'Memo to a Forger', *Saturday Review*, October 1983.
224 Miró was no match: interview with Pierre Matisse.
224 'It is too easy to put a gun': *Wall Street Journal*, op. cit.
225 'the customs duty in Mississippi': interview with Ronald Rolly.
225 'dealers are continually "taking" new people': interview with Martin Gordon, 22 May 1984.
225 'I am absolutely certain': interview with Michael Ward Stout, 18 February 1985.
225 'I stopped signing': from notarized statement made in Figueres, 1 June 1985.
226 'the artist sweated all night': *Wall Street Journal*, op. cit.
226 As many as 350,000 blanks: *Wall Street Journal*, op. cit.
226 The problem began after he left Dalí: Peter Moore in the *Wall Street Journal*, op. cit.
227 'the whole thing would have blown up': *Wall Street Journal*, op. cit.

227 'Business is not so good': interviews with Detective Frizzell.

227 'I cannot be held responsible': reported to author by Descharnes, Figueres, July 1985.

228 'cannot ... invoke French law': interview with Dalí's lawyer.

228 Would continue to defend its copyright: from an exchange of correspondence in the museum files, this letter dated 14 August 1984.

229 The author saw *The Dream* for sale during an exhibition 5–30 December 1984.

229 The author saw the print *Vertigo*, Figueres, July 1985.

230 Dalí's sculptures for Isidro Clot Fuentes: from information provided by Joan Kropf, curator, the Dali Museum in St Petersburg, Florida, and the *Dali Newsletter*, Salvador Dalí Museum, Winter 1986, vol. 3, No. 3.

230 Dalí's lawsuit involving his head of Dante, from interviews with lawyers representing both sides, 14 November 1984 and 27 October 1984.

231 Works spotted by Michel Jules Strauss: 22 March 1983.

231 'just repeating himself': Klaus Perls to author, 22 May 1984.

231 'Every time someone walks in': interview with Sotheby's spokesman, 15 February 1985.

231 Copyright infringement case in Rome involving Pierre Marquand: *Il Tempo*, 1 April 1984.

231 Liechtenstein publishing firm sued: *Wall Street Journal*, op. cit.

232 Dalí paper came with certificates: *Wall Street Journal*, op. cit.

232 'from Salvador Dalí's original master': *New York* magazine, op. cit.; *Observer*, 11 August 1985.

232 'the artist never touched': idem.

232 Worth from $5 to $20: *New York* magazine, op. cit. The signature would add slightly: idem.

232 On p. 18 of its Spring 1986 catalogue, Collectors' Guild was offering two 'limited edition lithographs' from Dalí's *Alice in Wonderland* series, hand-signed by Dalí and numbered, pulled in 1981–82, for $975 each or $1,755 the pair.

232 US Postal Service suit: from conversations with postal inspector Robert G. deMuro and a copy of the affidavit filed in the US District Court of the Southern District of New York on 22 April 1985, citing USC No. 1341 and No. 1343.

233 Information on the Convertine and Caravan Galleries arrests supplied by Lanie Accles, Deputy Press Secretary, Office of Attorney General Robert Abrams, State of New York.

233 'whatever you wanted, Enrique could do': interview with Felicie Balaÿ.

234 'people are always stealing': Mme Kalachnikoff, as told to Michael Ward Stout.

234 'We'd have to ... kiss and make up': interview with Reynolds Morse.

235 'rather ugly to watch': interview with Michael Ward Stout, 18 February 1985.

235 Not to talk to Sabater: interview with Felicie Balaÿ, 19 June 1984.

235 The transport not illegal: *El País*, 13 March 1981.

235 Found his employer signing: idem.

236 Collection exhibited in Vienna and Munich: *Le Point*, 16 August 1982.

236 Not the slightest doubt: *Nice Matin*, 11 October 1982.

236 Sixty drawings seized: *Nice Matin*, 22 October 1982; *Le Figaro*, 14 October 1982; *Le Monde*, 18 October 1982.

236 Moore countersues: *Nice Matin*, 22 October 1982; *Libération*, 9–10 October 1982.

236 Moore-Dalí settlement published: in *El Ultimo Dalí* (Madrid: Ediciones El País, 1985) pp. 258–61.

237–8 Information establishing existence of Sabater's companies from interviews with Alfons Quinta, Jean-François Fogel and James Markham, accounts in *El País* of 13 March and 20 March 1981, and also from a telephone conversation with Michael Ward Stout on 21 March 1986.

239 'concerned only with himself': interview with Jean-François Fogel.

239 One was sexually stimulated: Ted Morgan, *Maugham: A Biography* (New York: Simon & Schuster, 1980), pp. 421–2.

239 Regular doses of gamma globulin: *Le Dalí d'Amanda*.

239 His admiration never wavered: Cowles, p. 142.

239 Dalí sent a telegram of congratulations: *Libération*, 22 October 1980.

239 The death of a few was preferable: *El Último Dalí*, pp. 48–9.

240 'I never could . . . sell': interview with Jacqueline Goddard.

240 'had come to assassinate': Maurice Béjart, *Un Instant dans la Vie d'Autrui* (Paris: Flammarion, 1979) pp. 165–6.

240 'He began to look awful': interview with Robert Descharnes, Figueres, July 1985.

240 'Whenever I telephoned': interview with Albert Field.

240 'You should know, Gala': *New York Times*, 12 October 1980.

240 'This will be fatal': *New York Times*, 12 October 1980.

241 'a perfect being': idem.

241 He entered the Puigvert clinic: on 23 May 1980, cited in *Libération*, 22 October 1980.

241 Obiols incident: *New York Times*, op. cit.

241 Vidal Teixidor broke his leg: idem.

241 Puigvert diagnosed arteriosclerosis: *Libération*, 22 October 1980.

242 Melancholic and depressed: *New York Times*, op. cit.

242 Reading Spinoza and Leibniz: *Le Matin*, 1–2 November 1980.

242 'reduced to a shell': *New York Times*, op. cit.

242 'She gives Dali tranquilizers': *St Petersburg Times*, 14 March 1981.

242 'taken out in a wheelbarrow': *Paris Match*, December 1980.

242 Agreed to negotiate some business contracts: *New York Times* magazine, 12 December 1981.

242 'a friendship like that is not easily broken': *New York Times*, 2 February 1981; *International Herald Tribune*, 5 February 1981.

242 SPADEM contract signed: 21 January 1981.

243 'my confidence has been abused': *New York Times* magazine, op. cit.; *Le Figaro*, 19 March 1981; *Le Point*, 30 March 1981.

243 Most cordially received: Alfons Quinta to author.

243 Being treated by Dr Lermitte: *Le Point*, 30 March 1981.

243 Gala wanted a divorce: Liz Smith, *Dallas Times Herald*, 27 January 1981.

243 Accusing Dalí of impotence: *El Último Dalí*, pp. 271–2.

243 Two fractured ribs: *El País*, 21 February 1981.

243 Under his chin: interview with A. Reynolds Morse.

243–4 'She is 86 ... it's the same thing': *Elle* magazine, 26 January 1981, author's translation.

Chapter 15: The Labyrinth

247 He tried to alert: in *Le Figaro* magazine, 28 June 1980.

247 'he admits continuing ... struggle of rare essences!': *Wall Street Journal*, 8 March 1985.

248 His legal suit against *l'Express*: *El País*, 21 July 1985.

248 'Historic' lawsuit proclaimed: on 30 June 1985.

248 His Catalan radio broadcast: 20 July 1985.

248 Preferred to risk hurting their feelings: communication from Morses, 30 September 1985.

249 'It's quite something': from interviews with Robert Descharnes.

249 At least one visit to El Caudillo: *Le Monde*, 15 October 1968.

249 'kinetic Sainte Chapelle': *Le Monde* weekly, 17 April 1971.

252 'his sole remaining stimulus': interview with Antonio Pitxot.

252 'Dalí is not like the rest': PAR, p. 277.

252 His interest in cryogenics: PAR, p. 283.

253 'I am not dead': PAU, p. 50.

253 'I am ... the reincarnation ... remember the monastery': *New York Herald Tribune*, 24 January 1960.

253 'I do not yet have faith': SL, p. 400.

253 'Since I am not possessed of faith': BOS, p. 30.

253 'just wait five or six days': PAU, p. 45.

253 'I discovered ... infinitely small': *Libération*, 25–26 October 1980.

253 'the grace which is faith': Lake, p. 27.

253 Too terrified to swallow: BOS, p. 30.

254 Gala went into a coma and died the following afternoon: *Nice Matin*, 11 June 1982.

254 Details about transport of Gala's body from Port Lligat to Pubol: interview with Catherine Perrot-Moore.

254–5 Experiences of Renilde Hammacher-Van Den Brande in organizing a Dali exhibition: from interview with her.

255 They gave them just the same: *Le Matin*, 22–23 December 1979.

255 Tate Gallery figures: from the archives.

256 'packaging over contents': *Time* magazine, 3 March 1980.

256 Dalí vastly overrated: *The Times*, 19 June 1980.

256 John McEwen in the *Spectator*: 5 July 1980.

256–7 He returned to painting: *Paris Match*, 9 March 1984.

257 Little more than a signature: *Observer*, 14 October 1984.

257 'another matter entirely': interview with Michael Findlay.

257 'Catastroifome': corrected in Catalan catalogue to read 'Catastrofeiforme'.

257 'reversing many ... verdicts': *ARTnews*, December 1983.

257 'kinds of masterpieces': John Richardson to author, 4 June 1985.

257 He is a great figure: interview with Thomas Messer.

258 Lost in a park as a boy: *Sunday Times*, 16 September 1984.

258 The Daedalus legend: *Bullfinch's Mythology* (New York: The Modern Library, n.d.), p. 128.

259 'one stuffs it like a pudding': 'Salvador Dalí rétrospective 1920–1980', Centre Georges Pompidou catalogue, p. 190.

260 Cécile's threatened suit: Brian Mooney, Reuters, in *The Citizen*, Ottawa, 15 April 1983; her financial settlement, full details of, in *El Último Dali*, pp. 255–6.

261 'Dalí must now be the most forged': *Observer*, 11 August 1985.

263 'do not show me': *Paris Match*, 9 March 1984.

Select Bibliography

The following books and exhibition catalogues have been particularly helpful for this study. It is not possible to list the newspaper and magazine articles published in English, Spanish, Catalan, French, Italian, German, Japanese and other languages about Dalí since he first attracted attention in the late 1920s; they now number thousands.

Ades, Dawn, *Dali and Surrealism*. New York: Harper & Row, 1982.

Ajame, Pierre, *La Double Vie de Salvador Dali*. Paris: Éditions Ramsay, 1984.

Alba, Victor, *Catalonia*. New York: Praeger, 1975.

Alexandrian, Sarane, *Surrealist Art*. New York: Praeger, 1970.

Bosquet, Alain, *Conversations with Dali*. New York: E. P. Dutton, 1969.

Brassaï, *The Artists of My Life*. New York: The Viking Press, 1982.

Brenan, Gerald, *The Spanish Labyrinth*. Cambridge University Press, 1985.

Breton, Françoise and Lorea Barruti, *Conèixer Catalunya: La família i el parentiu*. Barcelona: Dopesa 2, 1978.

Buñuel, Luis, *My Last Sigh, The Autobiography of Luis Buñuel*. New York: Knopf, 1984.

Chadwick, Whitney, *Women Artists and the Surrealist Movement*. London: Thames & Hudson, 1985.

Cowles, Fleur, *The Case of Salvador Dali*. New York: Little, Brown, 1959.

Crevel, René, *Dali o el anti-oscurantismo*. Barcelona: Pequeña Biblioteca Calamus Scriptorius, 1978.

Dalí, Ana María, *Salvador Dalí visto por su hermana*. Barcelona: Ediciones del Cotal, 1983.; *Salvador Dalí vu par sa soeur*. Paris: B. Arthaud, 1960. *Tot l'Any a Cadaqués*. Barcelona: Editorial Joventut, 1951.

Dalí, Salvador, *A Dali Journal. Impressions and Private Memoirs of Salvador Dali*, edited and with an introduction by A. Reynolds Morse. Cleveland: The Reynolds Morse Foundation, 1962. *Dali by Dali*. New York: Harry N. Abrams, 1970. *The Conquest of the Irrational*, New York: Julien Levy, 1935. *Dali on Modern Art*. New York: The Dial Press, 1957. *Diary of a Genius*. New York: Doubleday, 1965. *El Mito Trágico del 'Angelus' de Millet*. Barcelona: Tusquets Editores, 1978. *Le Mythe Tragique de l'Angelus de Millet*. Paris: Jean-Jacques Pauvert, 1963. *Hidden Faces*. New York: William Morrow, 1974. *Metamorphosis of Narcissus*. New York: Julien Levy Gallery, 1937. *Procès en Diffamation*. Paris: Pierre Belfond, 1971. *The Secret Life of Salvador Dali*. London: Vision Press, 1948.

Del Arco, Manuel, *Dali in the Nude*. St Petersburg, Florida: The Salvador Dali Museum, 1984.

Descharnes, Robert, *The World of Salvador Dali*. London: Macmillan, 1972. *Salvador Dali, The Work, The Man*. New York: Harry N. Abrams, 1984.

Dopagne, Jacques, *Dali*. New York: Leon Amiel, 1974.

Eluard, Paul, *Lettres à Joë Bousquet*. Paris: Les Éditeurs Français Réunis, 1973. *Lettres à Gala*. Paris: Éditions Gallimard, 1984.

Eluard, Paul, and Louis Parrot, *Homage rendu à une amitié exemplaire par l'Académie des Lettres et des Arts du Périgord*. Périgueux: l'Atelier de Pierre Fanlac, 1981.

Ernst, Jimmy, *A Not-So-Still Life*. New York: St. Martin's/Marek, 1984.

Gateau, Jean-Charles, *Paul Eluard et la peinture surréaliste*. Geneva: Librairie Droz, 1982.

Gibson, Ian, *Federico García Lorca. Vol 1. De Fuente Vaqueros a Nueva York*. Barcelona: Ediciones Grijalbo, 1985.

Gómez de la Serna, Ramón, *Dalí*. London: Macdonald, 1984.

Green, Julien, *Oeuvres complètes*. Paris: Editions Gallimard, 1975.

Guardiola Rovira, Ramón, *Dalí y su Museo*. Figueres: Editora Empordanesa, 1984.

Haslam, Malcolm, *The Real World of the Surrealists*. New York: Rizzoli, 1978.

Ilie, Paul, *The Surrealist Mode in Spanish Literature*. Ann Arbor: University of Michigan Press, 1968.

James, Edward (ed. George Melly), *Swans Reflecting Elephants: My Early Years*. London: Weidenfeld & Nicolson, 1982.

Jean, Marcel, *The History of Surrealist Painting*. London: Weidenfeld & Nicolson, 1960.

Kaplan, Temma, 'Civic rituals and patterns of resistance in Barcelona, 1890–1930', *The Power of the Past: Essays for Eric Hobsbawm*, Cambridge University Press, 1981.

Lake, Carlton, *In Quest of Dali*. New York: Putnam, 1969.

Lear, Amanda, *Le Dali d'Amanda*. Lausanne, Éditions Pierre-Marcel Favre, 1984.

Levy, Julien, *Memoir of an Art Gallery*. New York: Putnam, 1977.

Lorca, Federico García, *Selected Letters*, edited and translated by David Gershator. London: Marion Boyars, 1984.

Lord, James, *Giacometti*. New York: Farrar, Straus, Giroux, 1985.

Lowen, Alexander, *Narcissism: Denial of the True Self*. New York: Macmillan, 1983.

Miller, Alice, *Prisoners of Childhood, The Drama of the Gifted Child and the Search for the True Self*. New York: Basic Books, 1981.

Miravitlles, Jaume, *Gent que he conegut*. Barcelona: Edicions Destino, 1980. *Més gent que he conegut*. Barcelona: Edicions Destino, 1981.

Morse, A. Reynolds, *Dali: A Study of his Life and Work*. Greenwich: New York Graphic Society, 1958. *Similarities and Contrasts: Picasso and Dali*. Cleveland: Salvador Dalí Museum, 1973.

Morse, A. Reynolds and Eleanor Morse, *Salvador Dali: A Panorama of His Art*. Cleveland: Salvador Dali Museum, 1974. *The Dali Adventure 1943–1973*. Cleveland: Salvador Dali Museum, 1973. *A Guide to Works by Salvador Dali in Public Museum Collections*. Cleveland: The Salvador Dali Museum, 1973.

Orwell, George, *Homage to Catalonia*. New York: Harcourt Brace, 1952.

Pañella, Márius Carol, Juan José Navarro Arisa and Jordi Busquets Genover, *El Ultimo Dalí*. Madrid: Ediciones El País, 1985.

Parinaud, André (as told to), *The Unspeakable Confessions of Salvador Dali*. New York: Quill, 1981.

Pauwels, Louis, with Salvador Dali. *The Passions According to Dali*. St Petersburg, Florida: Salvador Dali Museum, 1985.

Penrose, Roland, *Scrapbook 1900–1981*. London: Thames & Hudson, 1981.

Pla, Josep, *Homenots, Quarta sèrie*. Barcelona, Edicions Destino, 1975.

Poilâne, Lionel, *Guide de l'amateur de Pain*. Paris: Éditions Robert Laffont, 1981.

Puigvert, Dr Antonio, *Mi vida ... y otras más*. Barcelona: Editorial Planeta, 1981.

Purser, Philip, *The Extraordinary Worlds of Edward James*. London: Quartet Books, 1978.

Reed, Jan, *The Catalans*. London: Faber & Faber, 1978.

Rodrigo, Antonina, *García Lorca, el Amigo de Cataluña*. Barcelona: Testimonio Edhasa, 1984. *Lorca–Dalí, Una amistad traicionada*. Barcelona: Editorial Planeta, 1981.

Rojas, Carlos, *El Mundo Mítico y Mágico de Salvador Dali*. Barcelona: Plaza & Janes Editores, 1985.

Romero, Luis, *Dali*. Secaucus, NJ: Chartwell Books, 1979.

Santos Torroella, Rafael, *La Miel es más dulce que la sangre*. Barcelona: Seix Barral, 1984.

Soby, James Thrall, *Salvador Dali*. New York: Museum of Modern Art, 1941. *Joan Miró*. New York: Museum of Modern Art, 1959.

Sorlier, Charles, *Mémoires d'un Homme de Couleurs*. Paris: Le Pré aux Clercs, 1985.

Thirion, André, *Revolutionaries Without Revolution*. London: Cassell, 1972.

Valette, Robert D., *Eluard: Livre d'identité*. Paris: Henri Veyrier, Tchou, 1967.

Waldberg, Patrick, *Surrealism*. New York and Toronto: Oxford University Press, 1978.

Exhibition Catalogues

'Fantastic Art: Dada, Surrealism', edited by Alfred H. Barr, Jr, Museum of Modern Art, New York, 1936.

'Salvador Dalí rétrospective 1920–1980', with a preface by Pontus Hulten, 18 December 1979–21 April 1980, Centre Georges Pompidou, Musée National d'Art Moderne, Paris, 1979.

'La vie publique de Salvador Dalí', catalogue to the retrospective exhibition, 18 December 1979–21 April 1980, Centre Georges Pompidou, Musée National d'Art Moderne, Paris, 1979.

'Salvador Dali', with a preface by Simon Wilson, 14 May–29 June 1980 at the Tate Gallery, London.

'400 obres de 1914–1983: Salvador Dalí', in 2 volumes, Spring 1983, Museum of Contemporary Art, Madrid, published by the Generalitat de Catalunya/Ministerio de Cultura and the Centre Cultural de la Caixa de Pensions, Barcelona, 1983.

'Picasso/Miró/Dalí', Palais des Beaux-Arts, Charleroi, Belgium, 1985.

'Dali in Wien', exhibition of the Museo Perrot-Moore, Cadaqués, in the Palais Auersperg, Vienna, March–April 1982, foreword by Annemarie and Gerhard Habarta.

'Dali: Huiles. Dessins. Sculptures', collection of the Museo Perrot-Moore, Cadaqués, with a foreword by J. Peter Moore, curator of the museum, no date.

'Dalí, vist per Meli', with a foreward by Josep Valls i Grau, organized by the Fundación Gala-Salvador Dalí and the collaboration of the Generalitat de Catalunya and the Ajuntament de Figueres, Ediciones Fundación Gala-Dali, 1985.

'DALI fotograf; DALI en els seus fotografs', organized by la Generalitat de Catalunya and el Ministerio de Cultura, Centre Cultural de la Caixa de Pensions, June–July 1983, Barcelona.

'William Bouguereau', exhibition organized by the Musée du Petit-Palais, Paris, the Montreal Museum of Fine Arts and the Wadsworth Atheneum, Hartford, CT, 9 February 1984–13 January 1985, Nouvelle Imprimerie Moderne du Lion, Paris, 1984.

'Paul Eluard 1895–1952', published by the Marie de Saint-Denis, 1982.

'Eluard et ses amis peintres', exhibition at the Centre Georges Pompidou, Paris, 4 November 1982–17 January 1983, published by the Centre Georges Pompidou, 1982.

'Max Ernst', with a foreword by Jean-Louis Prat, exhibition 5 July–5 October 1983, organized by the Fondation Maeght, Saint-Paul, published by the Foundation Maeght, 1983.

'Dessins de Miró', with a foreword by Pontus Hulten, exhibition 20 September 1978–22 January 1979, Centre National d'Art et de Culture Georges Pompidou, Musée National d'Art Moderne, 1978.

'Magritte', by David Sylvester, exhibition organized by the Arts Council at the Tate Gallery, 14 February–30 March 1969, Arts Council of Great Britain, 1969.

'Hommage à Elsa Schiaparelli', exhibition 21 June–30 August 1984, organized by the Musée de la Mode et du Costume de la Ville de Paris, Palais Galliéra, at the Pavillion des Arts, Paris, 1984, no publisher credit line given.

'Yves Tanguy rétrospective, 1925–1955', exhibition 17 June–27 September 1982, organized by the Centre Georges Pompidou, Musée National d'Art Moderne, Paris, Draeger, Montrouge, 1982.

'Content, A Contemporary Focus, 1974–1984', with a foreword by Abram Lerner, exhibition 4 October 1984–6 January 1985 organized by the Hirshhorn Museum and Sculpture Garden and published by the Smithsonian Institution Press, Washington, DC, 1984.

Index